The Perception Machine

Our Photographic Future between the Eye and AI

Joanna Zylinska

T0072751

The MIT Press
Cambridge, Massachusetts
London, England

The MIT Press would like to thank the anonymous peer reviewers who provided comments on drafts of this book. The generous work of academic experts is essential for establishing the authority and quality of our publications. We acknowledge with gratitude the contributions of these otherwise uncredited readers.

This book was set in ITC Stone Serif Std and ITC Stone Sans Std by New Best-set Typesetters Ltd. Printed and bound in the United States of America.

Library of Congress Cataloging-in-Publication Data

Names: Zylinska, Joanna, 1971- author.
Title: The perception machine : our photographic future between the eye and AI / Joanna Zylinska.
Description: Cambridge, Massachusetts : The MIT Press, [2023] | Includes bibliographical references and index.
Identifiers: LCCN 2022050332 (print) | LCCN 2022050333 (ebook) | ISBN 9780262546836 (paperback) | ISBN 9780262376624 (epub) | ISBN 9780262376631 (pdf)
Subjects: LCSH: Photography—Philosophy. | Digital images—Social aspects. | Image processing—Digital techniques. | Artificial intelligence.
Classification: LCC TR183 .Z955 2023 (print) | LCC TR183 (ebook) | DDC 770.1—dc23/eng/20230405
LC record available at https://lccn.loc.gov/2022050332
LC ebook record available at https://lccn.loc.gov/2022050333

Contents

Acknowledgments

Writing about our photographic future while going ever deeper into the perception machine of Zoom and MS Teams, Instagram, phones, and laptop cameras during the Covid-19 pandemic created lab conditions for experiencing an intensified media life, where we all started functioning as images for one another. I am grateful to many colleagues, friends, and family members who made that experience so much richer and better, against all the odds. To begin with, I owe a debt of gratitude to my previous workplace. The wonderfully generous and creative Department of Media, Communications, and Cultural Studies at Goldsmiths, University of London, granted me a period of sabbatical leave after my tenure as Head of Department came to an end. It was during that period that a significant part of the book was written. I am also very grateful to my exciting new academic home, the Department of Digital Humanities at King's College London, for offering me a hospitable welcome, intellectual stimulation, and a supportive ambience for pursuing my work in both media philosophy and critical digital practice. I am particularly indebted to my Head of Department, Stuart Dunn, my colleagues and interlocutors from the Creative AI Lab—Mercedes Bunz, Daniel Chávez Heras, Eva Jäger, and Alasdair Milne—and to King's Institute for Artificial Intelligence. Thanks also to Btihaj Ajana for great conversations, shared meals, and fun.

Many institutions and organizations have generously invited me to present—in variously mediated forms—the material that eventually became this book: ABF (Workers' Educational Association) Stockholm and Centrum för fotografi; Academy of Fine Arts in Warsaw; Aiiiii Art Center at the Art & Artificial Intelligence Lab at Tongji University, Shanghai; British Journal of Photography; Center for Culture and Technology at the University of Southern Denmark; Department of German at Princeton University and

the Center for Cultural Studies at the University of Graz; European Network for Cinema and Media Studies; Flugschriften project (Dominic Pettman and Carla Nappi); Hadassah Academic College; Humboldt University Berlin; International Association of Photography and Theory and the CYENS Research and Innovation Centre of Excellence, Cyprus; Łódź Film School; London Alternative Photography Collective; Malmö University; National College of Art and Design and the Digital Hub in Dublin; Onassis Foundation in Athens; Royal Institute of British Architects; Sheffield University; University of Luxembourg and the Luxembourg pavilion at World Expo 2022; University of Milan-Bicocca; University of Porto; University of Southern California; and Uppsala University with the Sigtuna Foundation. The associated virtual and in-person visits, collaborations, and conversations helped me immensely at different stages of developing this project.

I would also like to say a huge thank you to those friends and colleagues who inspired, nurtured, provoked, and provided all kinds of nourishment during the writing and making of this book. In particular I would like to thank Mark Amerika, Pola Borkiewicz, Marta Cabrera, Marco De Mutiis, Oscar Guarin, Gary Hall, Naomi House, Melanie King, Amanda Lagerkvist, Lila Lee-Morrison, Alberto López Cuenca, Arianna Mainardi, Karolina Majewska-Guede, Kathrin Maurer, Benjamín Mayer Foulkes, Gabriela Méndez Cota, Jacek Nagłowski, Benita Opaczyk, Krzysztof Pijarski, Bo Reimer, raúl rodríguez freire, Bojana Romic, Dennis Schäfer, Mona Schubert, Nina Sellars, Antonio Somaini, Stelarc, David Turner, Salvatore Vitale, Bernadette Wegenstein, and Ana Zibelnik. I would also like to express my gratitude to the artists who have generously shared their work with me: Refik Anadol, Ian James, Gareth Damian Martin, Antje Van Wichelen, Michael Murtaugh, Nicolas Malevé, and my Goldsmiths MA student Ben Pritchard. Thank you also to my editor Noah J. Springer for his help, support, and excellent advice, and to Matthew Abbate for polishing my prose. Last but not least, I am grateful to my nieces and nephew: Julia Glembin, and Daniel and Jessica Hall, for showing me a different vantage point from which to experience the perception machine.

After I submitted the manuscript, Yanai Toister gave me a copy of his book *Photography from the Turin Shroud to the Turing Machine*. It was too late for me to comment in this volume on the multiple affinities between our respective modes of thinking, affinities that show how correct Flusser was in redefining creativity and originality in terms of probability distribution. I want to acknowledge, and second, Yanai's proposition that "photography is a new type of machine."

Preface: New Horizons

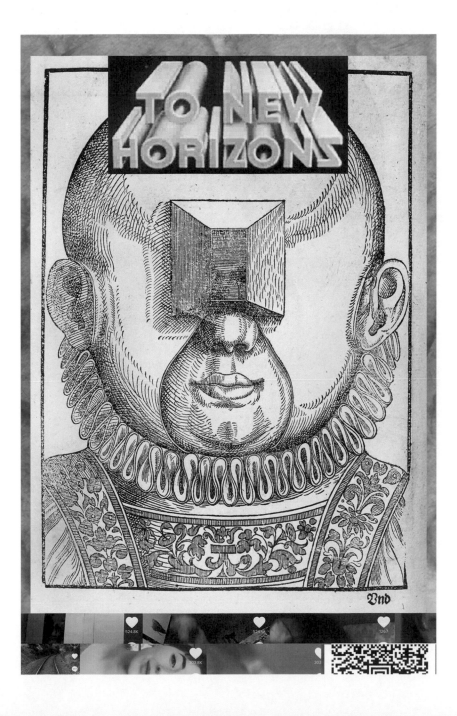

MACHINES

MACHINES

EVERYWHERE

alien face detected

AND HE'D TEACH US TO MAKE
SURE TO TURN IN,
SO WE COULD START THE SAME
WAY, SEEING PERCEPTION

Introduction: Photo Flows in the Perception Machine

Figure 0.1
Joanna Zylinska, grid of images automatically produced through a text-to-image generator known as DALL·E 2. Trained on text-image pairs, the DALL·E 2 model responded to the words from the book's title ("The Perception Machine Our Photographic Future Between the Eye and AI"). Image grid obtained on second attempt, as variations to one of the four images produced as a first response to the book's title. The AI-generated image echoes a famous avant-garde poster from 1924 by Aleksandr Rodchenko, which featured a black-and-white image of a human eye, two cameras, and a doubled face of a young man, and was accompanied by the inscription *Кино глаз* (KINO-EYE). Interestingly, the DALL·E 2 model seems to have treated the inscription it created as an image rather than text, as evident by the ever more fascinatingly absurd variations it came up with. June 2022.

More images are being produced, shared, and seen today than ever in history. We are constantly photographing and being photographed, with imaging machines large and small capturing our every move. In the publicity for their Galaxy S21 Ultra 5G phone Samsung have announced that they are enacting "a revolution in photography";[1] Tomáš Dvořák and Jussi Parikka have proclaimed, through the title of their recent edited collection, that photography has gone "off the scale";[2] while Lev Manovich, whose Cultural Analytics Lab and the accompanying book have investigated

how we can see one billion images,[3] has declared: "Photography is young again."[4] In the meantime, Andrew Dewdney, codirector of the Centre for the Study of the Networked Image at London South Bank University, has published a book with a title that was also a make-no-mistake exhortation: *Forget Photography*,[5] while Ariel Goldberg and Yazan Khalili, cochairs of the photography department at Bard College, have declared: "We Stopped Taking Photos."[6] Something is therefore clearly going on with and around photography.

Picking up on those opposing statements and affects, the notion of "our photographic future" that frames this book is something of a dare. It probes this polarized decisiveness around photography and other forms of mechanical image-making, while suggesting that photography cannot be so easily forgotten or abandoned because it has been actively involved in the shaping of our present onto-epistemological horizon—and its technical infrastructures. Nor can photography be simply replaced by the more encompassing (and perhaps more technically accurate) concept of "imaging," as there is so much invested in it, both on the level of platform capital and human affect. But the postulate of "our photographic future" also entails a reckoning with the fact that, as part of its technical and social activity, the photographic medium itself is undergoing a transformation. Its role as a printed memento or incontrovertible evidence of fact largely confined to the dustbin of history, it is currently being reconfigured in a way that has profound significance for our individual self-image, our society, economy, and politics. The distinction between image capture and image creation is now increasingly blurred—in photogrammetry, computational photography, CGI, or algorithmic image generators trained on photographic images (figures 0.1, 0.2). And so, even though this book is about what could be described as "imaging after photography," this *after* does not signify an overcoming but rather a form of mediation, a process that does not erase the technical, historical, or affective traces of its formative

⟶

Figure 0.2
Joanna Zylinska, image automatically produced through the text-to-image art generator known as NightCafe, using the VQGAN+CLIP method. The algorithm responded to the words taken from this book's title. Image obtained on first attempt. No modification, except for conversion to black and white. June 2022.

medium. The concept of "the perception machine" describes the evolving architecture of those photographic mediations.

Importantly, and in line with the widespread retention of this term in computation, the imaging industry, and, last but not least, its social use, my working definition of photography—even if applied to images whose method of production exceeds pure "writing with light" to embrace calculation and selection—is itself both residual and experiential. I call a given cluster of processes and practices "photography" if it remembers and resembles photography—and if it looks and feels like photography to the human observer. Photography therefore serves in this book as what Yanai Toister has called "a resemblance concept," whereby "photographs form a family group, with many overlapping sets of features, but there is no single set of features common to all the 'things' to which the word photograph pertains."[7] He adds: "photography is better served if understood as a set of media."[8] What does this remediated photography *look* and *feel* like to the human observer? And what kind of analytical framework might we adopt that would help us understand its transformation? To work toward answering these questions, it is worth recognizing that the interrogation of photography's (*and* the photographic) future highlights a number of concerns regarding not just the status of a specific industry or media practice, but also some larger, or we might even say planetary-level, concerns about our human positioning in the world and our relationship with technology, at a time when our very existence is being increasingly challenged by attempts to envisage what comes next. A climate collapse? Cross-species extinction? Another pandemic? A planetary war? Death by AI? Or maybe a sunnier tomorrow, for all of us?

This may seem like too big a leap right now, but I want to suggest that, by pondering, with Dewdney and others, whether photography has any future, we are actually using this specific cultural-technical practice to ask whether everything else we know—including us humans as a species with particular cultural exigencies and technical affordances—will soon be over too. We are therefore using photography, a *par excellence* practice of imaging and imagination (i.e., a practice of copying, making likenesses, mapping, making mental pictures, and ideating), although not always in a fully conscious way, as a conduit for asking bigger questions about our own situation in the world. What also precipitates this inquiry is the fact that some of

the boldest and most surreal forms of generating novel images and forms of imagination are being offered today by algorithmic agents, be they GAN networks or more complex generative AI models such as DALL·E. Imaging and imagination are therefore now part of a planetary computational architecture described by Benjamin Bratton as "the stack."[9]

Frequent climate "events," experienced either as media events or as more immediate existential disasters, are inextricably coupled with the remediation of the environment as a computational media ecology. This state of events has resulted in a situation where humans in different geopolitical locations are less and less able to see themselves as inhabitants, or (if they belong to a more privileged class) as citizens, of the world. Instead, we are all being interpellated to recognize ourselves as planetary beings, unanchored and dislodged, a realization which involves having to deal with the fact that, as Dipesh Chakrabarty puts it, the planet "remains profoundly indifferent"[10] to our existence. There exist an abundance of images to visualize this condition, from space photography through to satellite and drone images depicting environmental devastation. It is in this sense that photography as a practice of imagination, representation, and visualization can be read as a case of what Amanda Lagerkvist has described as "existential media," i.e., media that are capable of accounting for "the thrownness of the digital human condition."[11] This perspective analyzes digital media as an existential terrain which is irreducible "to the social, the cultural, the economic, or the political"[12] even if it remains intertwined with all those domains. This existential mode of enquiry also prompts us to ask what comes *after* the human, while inviting us not just to imagine but also to image it. In the light of the current developments around artificial intelligence (AI), this interrogation is particularly urgent. It must be highlighted right from the start that "AI" functions in this book not just as a technical term but also as a discursive-affective network of practices and meanings. On a technical level, the term predominantly refers to outcomes of computer and cognitive science research in machine learning, a field that trains computers in statistical data analysis and inference-making so that their performance ends up looking "intelligent" to a human. AI thus conjures, in the public and media imagination, an illusion of sentience *and* sapience, enveloped in a misty cloud of existential promises and threats—or what I previously called "machine visions and warped dreams."[13] Artificial

intelligence is itself a form of Big Dream, but one that has material consequences for our technical and sociopolitical existence.

Not insignificantly, all those contradictory pronouncements about photography that began this introduction were made in 2021: the second year of the global Covid-19 pandemic and the start of what is now being called the Virocene. It was a year of accelerated mediation, when we all appeared *as images* to one another, on Zoom, MS Teams, or Skype, while feeding—and feeding off—the insatiable global data machine with photos, memes, visualizations, and data points. Yet 2021 was just a catalyst for longer-term processes of imaging, imagining, capturing, tracing, and shaping that have been organizing our knowledge horizon while furnishing us with a sense of self. Driven by AI, machine vision, computational image rendering, and VR, these processes call for an in-depth investigation into what it means for humans to live surrounded by image flows and machine eyes.[14] "Photography" serves in this book as a thought device that will help me visualize, name, and analyze those processes. The key problem I thus want to investigate concerns *the future of mechanically produced images that come after, resemble, and are still called photographs*—and *the future of us humans as producers of, and as beings produced by, such photographic and after-photographic images.*

With the current outpouring of images, we can suggest that photography is encountered by humans principally as a flow, be it on social media, on multiple screens in urban spaces, or as flickering data points in computer vision databases. Yet photographic flows do not *just* flow: they often slow down, come to a halt, or wrap around us, creating photo-envelopes which offer a particular way of encountering and sensing the world. As well as foregrounding the "flow" aspect of the medium, it is therefore important to highlight that photography *is experienced* in the first place, that it comes *to us* as an experience—and also, more crucially, that it envisages and forms experiences. Photography triggers and shapes emotions, drives our percepts, informs our cognition, and contributes to the emergence of human consciousness. We should note here the possibility of other modes of experiencing photography than just the visual, with a broad range of sensory experiences activated in the photographic process between a variety of human and nonhuman agents. My understanding of photography here borrows from Vilém Flusser's theory of the image, in which it is "the technical image itself that is the message."[15] In-forming, or giving form, becomes a way of organizing the chaos of the world in an attempt to slow

down entropy—to halt the end of the universe. This position extends the earlier claims about the formative role of photographs in our lives made by writers such as Roland Barthes, Pierre Bourdieu, or Susan Sontag.[16] But it also recognizes that the primary role of images today, including photographs, is informational. Information here is understood in the classic engineering sense outlined by Claude E. Shannon and Warren Weaver in *The Mathematical Theory of Communication* as being nonsemantic,[17] with the communication model applying to different agents, human and nonhuman. The principal meaning of an image is *that there is an image*, and that it is being transmitted, rather than that it is an image of, say, a cat (although the content of images does of course matter to individual humans). The majority of images are now processed quickly: they are not subject to prolonged contemplation or interpretation. Yet the photographic image today is not just seen—and it is most certainly not always seen by humans. It is also always tagged, categorized, copied, coded, transmitted, networked, and platformed as part of the operations of the perception machine. The photographic image therefore *does* something (e.g., relates to another image or data sequence, triggers the execution of a command) within the machine network, rather than just meaning something to humans. It is, as scholars increasingly recognize, *operational*.

The theoretical impetus behind my interrogation of "our photographic future" also comes from the work of Flusser—not just his well-known texts on photography but also his thought-provoking book *Does Writing Have a Future?*[18] Flusser answers his own question in the negative, foreseeing a time when books become an obsolete medium, to be replaced with technical images (such as photographs). Yet rather than worry about our imminent illiteracy, Flusser is intrigued by the coevolution of humans with our media. It is this "media-genealogical" aspect of his analysis that I aim to extend in this book by looking at the future of the photographic medium, at the narratives about its future—and, more broadly, at the role of photographs and other technical images in mapping *our human future*. My overarching proposition is that not only does photography *have a future* but also that it actually *is the future*. As we increasingly experience reality *with*, *through*, and *as* photography, the photographic medium functions as an active agent in shaping both "us" and "the world." I am picking up here on process philosopher Henri Bergson's intimation that "matter is an aggregation of images,"[19] with this aggregation (or *ensemble*) itself forming "a

universe."[20] Importantly, this is more than a poetic turn of phrase. As I will show through the course of my argument, in its recognition of the formative role of imaging in the constitution of human consciousness as well as machine intelligence, contemporary neuroscience has strong Bergsonian undertones. But my goal in the book is also to propose that the current technoscientific conjuncture is radically altering the constitutive elements of this universe, while reprogramming or even redesigning the technical and sensory parameters of both ourselves and the world.

Drawing on research in computation and neuroscience, the book examines this posited "photographic future" through the lens of perception. In proposing to read the anxious exuberance in the current discourse on photography as a manifestation of both sociopolitical vulnerability and deeper existential anxiety, I will look at the altered practices and technologies of seeing, recording, and making images of the world—and at the increasing role of automation in image-making. With this, I want to examine some of the ways in which photography as both discourse and practice is actively involved in the reconfiguration of human perception—and in the emergence of a machinic network of perceiving agents whose image-making role has serious consequences for our own self-image, our view of the world, and our vision of the future. Perception is defined here as a way in which sensory information is selected, processed, and interpreted. The book's argument is thus premised on the recognition of the key role of visuality in human perceptive experience, but I also challenge and expand upon this understanding by working with what has become known as an "ecological model of perception"—a model that is fundamentally multisensory. In the process, I investigate the role of photographs and cognate images as devices that help us see, sense, and grasp the world. I also recognize, following Steve Anderson, that "humans in urban environments inhabit a shared visual field with a broad array of scanners, sensors, and algorithms."[21] In other words, the focal point of my discussion is provided by the problem of *how we frame the world with mechanically produced images—and how such images and their mechanical infrastructures frame us*, i.e., how they frame our consciousness, cognition, and our whole cortico-corporeal apparatus, but also our individual and political subjectivity. The framework of existential media will allow me to examine the photography of "our photographic future" as "both the priors and the limits, the frame and the edge, the building blocks and the brinks of being."[22] Taking as a given the message

of critical posthumanities that *it's not all about us*, my analysis is located against the wider context of image uses and actions, many of which bypass us humans. The concept of "the perception machine" offered in the book encapsulates this wider context, while also serving as an answer to the (implicit) question about whether our future will indeed be photographic, and, if so, what it will revolve about, feel like, and look like.

The notion of the machine, still apt for our increasingly algorithmic society, borrows from Gilles Deleuze and Félix Guattari's conceptual expansion of this term beyond its technical capabilities to encapsulate its social dimension.[23] "The perception machine" is an aggregate, assemblage, or ensemble of the technical, the corporeal, and the social. Design-wise, it is therefore more like a system than a single object. There are multiple, albeit interwoven, levels of meaning to what this concept stands for in the book. To begin with, it has biological connotations, signifying the system of perception in human and nonhuman animals. The perception machine is also a technical machine understood as an apparatus, or indeed a camera.[24] Perception here is equivalent to image-making, a process of the temporary stabilization of the optical flow that involves apparatuses such as cameras, telescopes, and scanners, but also the wider technical[25] infrastructure supporting those devices. The perception machine thus also names a machinic ensemble of perceiving and image-making agents. Further on, the term has connotations of the Foucauldian *dispositif* and Flusserian *apparatus*, whereby it stands for the bigger sociopolitical setup. Or, as Goldberg and Khalili put it even more explicitly, referring to the violent use of images in attempts to consolidate national power: "The state is the ultimate camera, the camera that eats all other cameras."[26] The concept of the perception machine—which simultaneously functions as an image-making apparatus—thus highlights the interlocking of scientific and cultural discourses in the production of photography *and* photographs. It also foregrounds the production of subjectivity and objectivity as functions of all kinds of images.

In *The Vision Machine*, a survey of visuality of which my main title is a critical transposition, Paul Virilio agues that, "because the technical progress of photography brought daily proof of its advance, it became gradually more and more impossible to avoid the conclusion that, since every object is for us merely the sum of the qualities we attribute to it, the sum of information we derive from it at any given moment, the objective world

could only exist as what we represent it to be and as a more or less endur-
ing mental construct."[27] In one of its conceptual iterations, the perception
machine can therefore also be said to stand for nothing less than what we
modern humans, in our attempt to delimit a dawning sense of planetarity,
have called "the world."[28] This "global" version of the perception machine
comprises various mechanisms responsible for the world's accruing produc-
tion, in the form of images, for us humans—and, increasingly, for other
machines. Virilio's *The Vision Machine* provides an important analysis of
the transformation of seeing and visibility in the twentieth century, from
the technology of warfare in World War I, which turned vision into visu-
alization, through to the industrialization of vision, which shifted the
majority of activities unfolding within the field of visibility from humans
to machines. This transformation of vision into a primarily machine-
based process was accompanied by the "automation of perception" as a
result of developments in artificial intelligence.[29] Significant as it is, Viri-
lio's argument is also steeped in metaphysical dualism, postulating as it
does a clear shift from more organic and seemingly pretechnological vision
to its machinic counterpart: "the relative fusion/confusion of the factual
(or operational, if you prefer) and the virtual; the ascendancy of the 'real-
ity effect' over a reality principle."[30] He interprets this shift primarily in
terms of disorientation and loss. While a political critique of the automa-
tion of perception is very much needed—and Virilio does indeed offer it by
looking at the visual technologies of war and the automation of vision in
propaganda and marketing, and at the mechanization of justice in video-
enabled courtrooms—his ontological critique of the changes to vision ends
up conserving the view of vision as both human and humanist. Borrowing
some of his concepts, I will proceed with an understanding of machines as
encapsulating organic and nonorganic components, as changing over time,
and as constitutively shaping the human sensorium in different ways. The
change from "vision" to "perception" in my own machinic rhetoric will
allow me to outline a more multisensory and more agential model of cor-
poreal and sociopolitical relations.

Drawing on ideas from Bernard Stiegler and Gilles Deleuze, we could
thus say that vision and perception have *always* been machinic—but they
have not always been mechanical or computational. The analysis of the
working of these machines, and of their mechanics, in the current histori-
cal period, at different scales and levels, and of the role of photography and

other forms of mechanical image-making in sustaining their operations, will shape the argument of my book. Importantly, even though I recognize that, in its agency, destination, and communicative value, photography is to a large extent nonhuman, the line of the argument pursued here is that photography does not need to be antihuman. Indeed, it is in challenging the antihumanism of the perception machine as an image- and world-producing apparatus that a *better* photographic future will be sought throughout this book.

While it is conceived as a stand-alone volume, *The Perception Machine* develops from my 2017 book *Nonhuman Photography*.[31] I argued there that the dominant analytical frameworks in photography theory—those coming from art history (where photography was seen as a series of individual artifacts displayed in a white cube), photojournalism (where photography was identified with professional practice), or social theory (where the focus was on everyday photographic practices)—were inadequate for capturing the contemporary photographic landscape. The concept of "nonhuman photography" proposed in that earlier book was thus a provocation aimed at challenging those dominant frameworks, with their inherent humanism premised on the commonsense assumption that photography was a human practice. At a time when the majority of images were not just being taken by devices whose technical parameters far exceeded human vision, such as CCTV, drone media, endoscopy, and satellite cameras, but were even not being made for the human viewer, the humanist discourse of photography needed correcting, I thought. The concept of nonhuman photography thus referred to photographs that were not *of*, *by*, or *for* the human. Yet "nonhuman" for me was not opposed to the human—and it most certainly did not mean that no humans were involved in photography. There has been a nonhuman side to photography since its inception, as seen in Fox Talbot's description of the medium as "the pencil of nature," the early links between photography and geology as parallel modes of making impressions, or the fact that the majority of everyday images created across time, be it for family albums or social media—landscapes, portraits, celebrations, food—have been a product of technical and cultural algorithms, and not just human intentionality and free will.

The present volume picks up on this recognition of the nonhuman agency of photography, but *it returns more explicitly to the problem of the human*—although, to qualify, this is a human rethought through posthumanist

critique. Raising a number of ethicopolitical questions about our existence in the world of high-tech capitalism, the progressing automation of many spheres of life, increasing threats of global pandemics, rising inequality, and the economic and ecological crises, it foregrounds, as signaled earlier, the ontological problematic of existence as such: of us humans, of our ways of doing things in the world, of our media and communication networks and platforms—and, last but not least, of photography as a medium that captures all those global unfoldings while capturing us humans in multiple ways. Yet the power of photography is not just ontological but also epistemological: photography, especially in its networked and platformed guise, radically reshapes our ways of knowing the world and ourselves in it. Critically engaging with current research in cognitive psychology and neuroscience, the book thus deals with the problem of perception and cognition, while offering a cultural analysis of the making of worlds *and* worldviews— and of images that are part of those worldviews.

From this outline it may seem that my key conversational partners in the discussion about our photographic future are Western male philosophers and media theorists. And this is indeed where the conversation *begins*. This choice of my starting point is partly in recognition of the legacy and significance of those particular debates on media, technology, and the image, but my motivation is somewhat more mischievous than that. I come to this tradition as an unruly daughter—a Goneril or Regan without the malice, or a Cordelia without the death wish—with an aim of reweaving the texture of the established discourse on technology and the image with my own silicon thread. In the process, I hope to make the still rather masculine field of media philosophy a little more my own. Starting from the book's title—a Virilio-Flusser hybrid with a twist—I aim to cut across positions, postulates, and postures to open a different mode of thinking about media objects and practices. This mode of thinking will also involve *making*. Departing from the traditional philosophical method of eschewing the present, doubting the example, and remaining suspicious about praxis, my media-thinking about the present has for a long time also been a form of media-making— and of future-making. With this I aim to enact a media philosophy less in the genre of "me-theory," and more as a process of interweaving, interconnectedness, and intellectual as well as bodily kinship made up with words, images, and corpora of various kinds.

I will be accompanied on this journey by other critical, feminist, and decolonial writers and artists, such as Ariella Aïsha Azoulay, Donna Haraway, Ewa Majewska, Safia Noble, Griselda Pollock, Gayatri Chakravorty Spivak, and Hito Steyerl. Immersed in both critical thinking and feminist sensibilities, the concept of the perception machine outlined in the book is thus ultimately an attempt on my part to offer a more nuanced, more ecological, and less paternalistic understanding of what it means to live in a world which is increasingly dependent on the production and creation of mechanical images—and whose own self-image, increasingly expanded to a planetary scale, is a product of such images. Yet this is not a book written from a planetary perspective, with its eye high in the sky: it emerges instead from among wire tangles, image torrents, and data flows, coming together as it does amidst the matter of media, the piles of techno-rubbish, the threat of organic and nonorganic viruses. The book is driven by an awareness that "the planet" does not care, but also that this lack of care need not—indeed should not—be mutual. Its approach could be described as feminist eco-eco-punk, which is not an aesthetic stand but rather an ethical position on how to live in a media-dirty world.[32] A critical feminist sensibility shaping the argument of this book will build toward a proposal for "a planetary micro-vision for a world in crisis" outlined in the last chapter.

The echolalia-sounding concept of "eco-eco-punk" riffs on variations of the science-fiction genres that merge punk's irreverent aesthetic with a creative mobilization of canceled futurity, while providing it with the relevant cultural imprint: from cyberpunk, steampunk, and biopunk through to greenpunk and, last but not least, ecopunk.[33] From the original punk, eco-eco-punk inherits "an adversarial relationship to consensus reality."[34] From cyberpunk it borrows a gritty, dystopian view of the techno-future in which one gets by by making do. Eco-eco-punk encapsulates the irreverent and self-sustaining spirit of punk, but it also reworks cyberpunk's sense of general alienation into a form of active and creative engagement with the world's decaying systems and infrastructures. In foregrounding the intertwined aspects of unfolding *eco*logical-*eco*nomic disasters, eco-eco-punk deromanticizes the decay while giving the situation a political twist. It also multiplies punk's agency, beyond the heroism of the singular male outcast-savior.

Eco-eco-punk involves acknowledging the huge—and hugely complex—ensemble of images, data, and infrastructures, but refusing to hold any of it in my hand, mind, or eye as *just* an object of analysis. Instead, it involves countering with what it means to inhabit the perception machine. This eco-eco-punk engagement with a media-dirty world will result in a necessary, and indeed programmatic, conceptual tangle. This is why the book will develop a cluster of concepts with which to understand photography, imaging, and the wider image ecology today. Aside from the said "eco-eco-punk" and the book's organizing concept of the "perception machine," throughout the course of the book I will outline a "philosophy of after-photography," design an "AUTO-FOTO-KINO," propose a "planetary micro-vision" that will involve producing some "loser images," and rethink photography as a form of "sensography." This knotty and "messy-media" approach has already been manifested in the visual preface to this book, which features a series of collages made by myself in an attempt to show, and allow readers to sense, what the book is about. The images themselves are media-dirty, just like the wider environment from which the argument of the book flows.

And thus, while my argument in the book is theoretical, it is also an attempt to think *about* and *with* images seriously, an endeavor that reflects my ongoing mode of working with words and images in my interwoven scholarly and artistic practice. I recognize and embrace the formative role of linear signs, aka writing, in establishing a community of knowledge and knowers, and thus forming a historical consciousness. But I am also aware of the separate affordances—affective, perceptive, and haptic—that seeing and making images, including photographs, carry. The images this book engages with have been drawn from a wide set of registers and practices, although they have all been mechanically produced, in one way or another. Some of them are works identified as "art," not so much because I consider art a privileged mode of studying phenomena, but rather because I value the expertise and labor of art schools, art institutions, and art curators in teaching us to notice things worth noticing, while stabilizing the flows of images into meaningful experiences. Image-based projects recognized as "art" therefore serve here as conceptual shortcuts, showing us something as worth seeing—although many of the projects I look at definitely have more of an "infra-artistic" character.[35] My own creative practice involving image-making appears in the argument at times, cutting

through the linear text with an attempt to see and convey something in a different mode.

With this, my goal is to acknowledge the richness of the universe of mechanical images being produced today, by a variety of human and non-human actors, and aimed at a variety of human and nonhuman recipients. The image cloud that envelops the book's creation—and that envelops us all—is thus also being made from social media feeds featuring anything from photojournalism to selfie journalism, Internet memes, Instagram ads, Snapchat ephemera, Tinder faces, dick pics, lol cats, online shopping grids, security cameras' facial records, and QR codes, to list just some of the streams and particles that constitute it. All those image flows can also be reconceived as transfers and exchanges of seemingly limitless amounts of image data. I am thus interested not just in images but also in their infrastructures—from the human architecture of our eyes, brains, and whole bodies through to the image-making equipment, the flows of electricity in different bodies and media, the wired and wireless connections between media systems, the machine learning algorithms and the neural networks they work across, and, last but not least, the data centers and server farms hosting them.

Even though the rationale for trying to understand the perception machine is ethical, it does not offer a prescription for how to live. Instead, it makes some modest propositions for living in, with, and as images, in the planetary context by developing an awareness of a condition that has been enveloping us with an increasing intensity and speed. The model of the machine adopted in this book embraces both the regulatory and promissory aspects of this concept as outlined in the work of Deleuze and Guattari. As Maurizio Lazzarato puts it with reference to those thinkers' key idea, "The machine is open in many ways because it is a relation and a multiplicity of relations: a relation with its own components, with other machines, with the world (its own associated milieu) and with humanity."[36] The indeterminacy of those relations, which is an inherent aspect of all relationality, means that they can always be redrawn, beyond the machine's push toward performativity, efficiency, and exploitation—in the direction of something we do not recognize yet. Exploring possibilities for making things better, the book is thus ultimately oriented toward activating the radical-critical potential of the distributed and embodied perception machine. To put it in more figurative terms, *it is about photographing ourselves a better future*—for human and nonhuman "us."

The problem of a photographic future, which also entails dealing with the future of photography and everything else in the world, frames chapter 1. After offering a historical overview of the medium's exuberant life and frequently predicted demise, this chapter investigates to what extent the incessant posing of the question about photography's future can be seen as a reflection of our human anxiety about the disappearance of our subjectivity, and of our picture of ourselves and the world—or even, *tout court*, about the disappearance of ourselves *and* the world. Engaging closely with Flusser's writings as well as my experience of teaching photography and creative media, the chapter enquires whether we can mobilize photography to enable a different modality of capturing perception, knowledge, and self-knowledge, beyond the linear structure of the book.

Chapter 2, "A Philosophy of After-Photography," discusses the affective and material forces that drive the photographic medium today—from the desires of its users, who are constantly making and sharing digital snaps while being captured *as* images, through to the (il)logic of machine learning databases, which is increasingly shaping our self-image, society, and politics. The philosophy of after-photography outlined in this chapter goes beyond the focus on the objecthood of the image-making medium to highlight *a time "after photography."* It offers a mode of thinking and seeing for a future that *will be photographic*—for better or for worse. Demonstrating that it is through the discourses of neuroscience and computation that photography has been framed and reframed through its different technical iterations, the chapter assembles a stock of conceptual building blocks to be used in the construction of "the perception machine" in the chapters that follow.

Chapter 3 takes a proof-of-concept approach to explore the working of "the perception machine." It proposes that the practice of screenshotting ("cutting" into the media flow of a video game by a player to collect photo-like mementos from the game) can be seen as paradigmatic of human perception. Screenshotting can also become a way of retraining players' eyes, bodies, and minds in both seeing the world and understanding perception better. I suggest that this experience generates new forms of sensation and cognition for experienced gamers as well as game novices. It offers valuable lessons for future developments in modeling human vision in machines. The argument of this chapter is built around images from my artwork

Flowcuts (2020), shot in two postapocalyptic video games, *Everybody's Gone to the Rapture* and *The Last of Us*.

Continuing with the interrogation of imaging and perception, the argument of chapter 4 focuses on the problem of machine vision—as well as highlighting the problem *with* machine vision. The chapter's title, "From Machine Vision to a Nontrivial Perception Machine," draws on two science papers by authors who made a significant contribution to the debate on the relationship between humans and machines: Heinz von Foerster's 1971 article "Perception of the Future and the Future of Perception," in which the concept of a "non-trivial machine" is introduced; and Gerald M. Edelman and George N. Reeke Jr.'s 1990 article "Is It Possible to Construct a Perception Machine?" I engage with these papers in an attempt to construct a conceptual scaffolding for a non-Google-led theory and praxis of machine perception while interrogating the role of photography and other forms of imaging in industry efforts to get machines to "see." After analysis of bias and other forms of discrimination in machine vision, and the wider infrastructures that underpin it, the chapter concludes by postulating that a nontrivial perception machine must be both antiracist and counterimperialist.

While the previous chapter explored some possible ways of not just constructing but also reprogramming the perception machine, chapter 5 zooms in on one particular technology of vision in which visual culture theorists have traditionally sought a perceptive opening: cinema. In his essay "After Cinema," Lazzarato argues that cinema is "no longer representative of the conditions of collective perception."[37] Any smartphone can now shoot photos at a speed of video—and it can shoot video in photo resolution. Building on Lazzarato's argument, I discuss the increasing overlap between still and moving images in digital practice. I also propose the concept and practice of AUTO-FOTO-KINO as one possible enactment of emancipatory agency from within the algorithmically driven image complex. The chapter discusses my reworking, with the help of AI, of the best-known photofilm, Chris Marker's postapocalyptic *La Jetée*, as a gender-fluid feminist counterapocalypse. Through this, I explore some ways of creatively engaging automation to offer a different vision of the future.

The above-described experiments lead me to pose, in chapter 6, a question about the possibility of photographing the future. Starting from the TV

series *Devs* (dir. Alex Garland, 2020), which visualizes the problem of predicting the future by capturing an image of it, I move on to the mobilization of photography and other forms of imaging in constructing predictions in different disciplines. Mindful of the fact that "the image" is a cornerstone of the neuroscientific rhetorical register, I look at the use of this concept in the theories of consciousness outlined by two leading researchers: Antonio Damasio and Anil Seth. Specifically, I analyze the role of images in Damasio's and Seth's respective theories of perception, and the possibility of conceptualizing consciousness as a person's orientation toward the future, which involves making images of that future. The automaticity of this process, be it in mental-image making or in the production of mechanical—or, to use Flusser's term, technical—images of the future, leads to the discussion of predictive technology, widely applied in areas such as weather forecasts, stock markets, epidemiology, and consumer behavior.

The book's final chapter involves an actual attempt to image a (better) future. Engaging with planetarity as an important trope in contemporary cultural and visual theory, it offers two alternative ways of performing it, encapsulated by two case studies. The first one investigates still and moving images of picturesque locations, taken by drones and collected on social media. The focus of my critique is not on the machinic aspect of vision per se or on its aerial elevation, but rather on the assumed heroism of the eye-in-the-sky drone acrobatics. In response, I propose a case study from my own art practice, titled *Feminist with a Drone*. Presented in the form of images and field notes, the work explores ways of mobilizing drone technology to enact a less masterful and less heroic viewpoint. Working against the register of "amazing" views produced from high in the sky, I outline, with a nod to writer-artist Hito Steyerl, the concept of "loser images" as a feminist rejoinder to the dominant aerial aesthetics. I then consider to what extent the production and curation of such loser images can be deployed toward an enactment of a different relationship to our habitat.

Summarizing the book's findings, the conclusion suggests that photography is changing in its encounter with other media technologies (computers, sensors) to become a form of "sensography." These changes lead to a reconfiguration of perception on an individual, societal, and infrastructural level. I then pose the question of whether this ever-enclosing image envelope, recently dubbed "the metaverse," can be more than another business venture for Global Tech.

To access the images from my practice discussed in the book and the two films, visit https://www.nonhuman.photography/perception-machine, or scan the QR code below for direct access.

1 Does Photography Have a Future? (Does Anything Else?)

Figure 1.1
Screenshot from the YouTube version of *Vilém Flusser's* Towards a Philosophy of Photography *as Performed by Ian James*, 2015. Featuring the video *An Assortment of Waiting Areas*, HD animation, 2014.

Photography's modern past

Although its specter had haunted the domains of science and art on both sides of the English Channel since the early days of the nineteenth century, the technology of photography as a way of making singular monochrome pictures on a metal plate was made public in 1839, in Louis-Jacques-Mandé Daguerre's presentation to the French Academy of Sciences on January 7. Its arrival was met with much initial enthusiasm—John Ruskin portrayed daguerreotypes as "glorious things" and "the most marvellous invention of the century," while Edgar Allan Poe saw in photography "the most important and perhaps the most extraordinary triumph of modern science."[1] Yet, as with the invention of many other media that have significantly altered the way humans see themselves, communicate with one another, and picture the world, the arrival of photography—although largely welcomed by the growing middle class, whose status it represented and consolidated in France, England, and the United States[2]—also generated anxiety in some sectors of society. As Philip McCouat reports,

> One outraged German newspaper thundered, "To fix fleeting images is not only impossible . . . it is a sacrilege . . . God has created man in his image and no human machine can capture the image of God. He would have to betray all his Eternal Principles to allow a Frenchman in Paris to unleash such a diabolical invention upon the world." Baudelaire described photography as "art's most mortal enemy" and as "that upstart art form, the natural and pitifully literal medium of expression for a self-congratulatory, materialist bourgeois class." Other reputed doom-laden predictions were that photography signified "the end of art" (J.M.W. Turner); and that painting would become "dead" (Delaroche) or "obsolete" (Flaubert).[3]

The anxiety generated by photography's arrival can perhaps be explained by the fact that photography was seen to be altering the spatiotemporal organization of the world. As an "impressioning" medium, it was capable of carving time and fixing it by imprinting it on different surfaces. William Henry Fox Talbot, English inventor of a paper-based, reversed photographic process which initially gained less popularity than the one rolled out by Daguerre, even claimed "that the primary subject of every photograph was . . . time itself."[4] Photography made time visible while foregrounding its framing—and hence also its finitude for individual modern subjects. Those very subjects did not preexist the photographic medium but were rather constituted in its representational and communicative loop. Jonathan

Crary points out that "the shifting process of one's own subjectivity experienced in time became synonymous with the act of seeing, dissolving the Cartesian ideal completely focused on an object."[5] This development took place against the background of the wider socioeconomic transformation across Europe and the United States, with progressing industrialization, expanding railway networks, and the appearance of the telegraph. Those changes were accompanied by a radical shift in the modes of knowing the world, with attempts to understand the workings of God the creator gradually giving way to trying to understand the machinations of nature. It has been argued that various social groups, from middle classes to laborers, across different continents, became ready for their own constitution *as modern subjects*: they were part of the fomentation of the "burning" desire[6] for both seeing photographs and seeing themselves photographed. The arrival of instantaneous photography in 1877 thanks to Eadweard Muybridge's experiments with "stopping time" by photographing animals and humans in motion, frame by frame, was seen, to cite Rebecca Solnit, as "violent, abrupt, glorious, like lightning, a sudden shock showing a transformed world."[7]

That there exists a mutually constitutive relationship between photography and modernity has been argued by many writers, from Walter Benjamin through to Susan Sontag and Solnit.[8] In recent years scholars such as Ariella Aïsha Azoulay, Jonathan Beller, and Andrew Dewdney have explored darker aspects of this relationship.[9] The point I want to make in the opening section of this chapter on the future of the photographic medium is that there exist three key "lightening" moments in the history of photography when a given stage of technological development became a conduit for the articulation of wider social concerns not just about the present but also about the future. Photography is of course not the only medium through which concerns are articulated, but, due to its role as a pencil of nature and a mirror of the world, it allows each subsequent generation to ask questions about its own self-image and self-projection—a process unfolding across the increasing liquidation of social foundations and structures. The three key moments I associate with the posing of some fundamental or indeed existential questions raised by, and by means of, photography can be connected with the following three instances: the invention and popularization of the photographic medium in the early to mid-nineteenth century, the shift from analog to digital photography in the last two decades of the

twentieth century, and the present rise of "after-photography" as a result
of developments in computation, specifically in CGI and AI. To paint in
somewhat thick brushstrokes, these three instances coincide with specific
moments in the industrial history of the modern world: (1) the expansion of
the world for certain classes as a result of the development of transport and
communication networks (the railway, the steamship, and the telegraph),
coupled with the facilitation of imperialist politics, (2) the fantasy of the
unification of the world promoted by globalization, with the increased flow
of goods, services, and people, the rise of technological obsolescence, and
the expansion of a throwaway culture, and (3) the dematerialization of "the
world" into what used to be called "the cloud" but is now being renamed
"the metaverse," with an increasing automation of both labor and leisure,
and an impending planetary threat of the human—and human habitat—
being designed into nonexistence.

The reports of photography's death are greatly exaggerated

Given photography's foundational role in the emergence of modern West-
ern subjectivity and its associated modes of perception and knowledge-
building—a role which arguably continues to this day—it is understandable
that its own ongoing transformation should evoke so much anxiety. As a
medium designed to fix things, its instability serves as a constant reminder
of the fact that things cannot be fixed once and for all, that the world *is* in
flux, and that any picture we make of it is only ever a temporary stabiliza-
tion of molecules, be it as an image or thing. Moreover, photography can
play the role of a displacement object, one that is made to carry the worry
about the flux while offering to hold it at bay. This perhaps explains why,
as put, somewhat tongue-in-cheek, by Geoffrey Batchen in the "Epitaph"
to his *Burning with Desire*, "everyone seems to want to talk about photogra-
phy's death."[10] Yet Batchen goes on to point out that not only has photog-
raphy "been associated with death since the beginning," with the medium's
arrival coinciding "with the demise of the pre-modern episteme," but also
that "death has been part and parcel of photography's life."[11] This "perverse
interweave of life and death"[12] is partly technology-specific: the low sensi-
tivity of photographic materials in the early days of the medium, requiring
long exposure times, resulted in living bodies looking as if they were dead.
For generations of photography students, the medium was memorialized

by Roland Barthes in his field-defining *Camera Lucida*[13]—as a mausoleum for his departed mother and an empty tomb for himself.

I staged a symbolic burial of photography's compulsive attachment to death in a previous work, in which I offered to read photography as first and foremost a vital, life-shaping force. This was because photography not only shapes our everyday existence but also partakes of the Earth's and Sun's vibrant and life-giving properties.[14] To revisit the matter in more funereal terms here is not to change my position but rather to recognize, with Batchen, the persistence of death *as a trope* in debates on the medium. This persistence functions on two levels: one positions photographs as reminders of death, its representations or even enactments, the other sees photography itself as dying—and us humans as dying with it, as its subjects. One does not need a complex psychoanalytic reading to see this tendency as an attempt to ward off death by means of fixing the photographic discourse and its object, for a little while at least.

Yet I would like to explore whether we can do better than this, whether an alternative model—more satisfactory on a philosophical level and more sound psychologically—could emerge from this perverse interweave of life and death Batchen talks about. If the incessant posing of the question about photography's future is primarily a reflection of our human anxiety about the disappearance of our subjectivity, and of our picture of ourselves and the world, or even, *tout court*, about the disappearance of ourselves *and* the world, can we mobilize photography to enable a different mode of perception and self-knowledge? Batchen himself ends his "Epitaph" by suggesting that "Photography's passing must necessarily entail the inscription of another way of seeing—and of being."[15] His own response to this (somewhat circular) argument is disappointingly, and limitedly, humanist. In stating that "while the human survives, so will human values and human culture,"[16] he confines photography to the enactment of those human values and the "human culture" they supposedly belong to, while prohibiting them from challenging them while radically changing the human. I would like to pick up the challenge offered by Batchen's earlier statement and investigate, with the full mobilization of the theoretical apparatus and various image practices, whether what I call "a philosophy of after-photography" (which I will expound more fully in chapter 2) could lead us to another way of seeing and being. Can the current moment of both photographic and existential instability serve as this opening toward something new? Can the

photographic medium "as we know it"—and as we perhaps do not know it yet—offer us a new way of picturing and understanding that opening? Can it help ensure a *photographic future*?

Media existentialism: Vilém Flusser redux

The present context for the exploration of these mortal anxieties has been provided by a secular return of all sorts of existential finalisms, unfolding across different scales: some of them taking place on a species level ("end of man," the Sixth Extinction, Covid-19), others on a planetary one (Anthropocene, heat death, nuclear obliteration). Photography and other forms of mechanical images such as films and TV have certainly played a role in aiding us in envisaging our demise. Yet, its representational role aside, it is worth delving deeper into photographic practice, with its apparatuses and networks, to trace the constitutive role of mechanical image-making in enacting a certain vision of the future—or even enacting a certain future, full stop. One thinker who can help us with developing such a new analytic framework for understanding the world today—which for him is equivalent with the world of images—is the Czech-born writer and philosopher Vilém Flusser (1920–1991). A nomad at heart, if not always by choice, with the ruinous legacy of the Holocaust and antisemitism casting a dark shadow over both his family history and his work, Flusser wrote in multiple languages, disciplines, registers, and styles, across several continents, decades, and intellectual currents. His work on photography and other media was shaped largely in the early 1980s. This was a time when media production had already become mechanized in the Benjaminian sense, with photographs' and films' reproducibility in the early twentieth century leading to the loss of cultural artifacts' uniqueness as singular objects endowed with a special aura and value, and also to their democratization and their becoming-media, but it had not yet entered the era of mass digitization. Yet Flusser's analyses are uncannily prescient in grasping the consequences of the automation of image production, perception, and reception, consequences that we see today not just in photography, video, and other forms of communication such as journalism and literature, but also in politics.

In outlining what we might term a "nomadic media existentialism," Flusser pays particular attention to images, and even more to technical images, which he defines as "mosaics assembled from particles."[17] He

differentiates them from "traditional images" such as cave or oil paint-
ings, which for him have a different relationship to reality: the former are
mimetic, the latter function as visualizations, i.e., models. "Traditional
images," created by hand, are two-dimensional surfaces made up of their
background (cave wall, canvas) and inscription (pigment, oil paint), while
technical images, created by machines, are "without dimension"[18] because
they are made from mathematical code. Traditional images, which are akin
to representations, are to be apprehended as ensembles of features, in their
totality, with the human eye having to scan them in a circular manner
in an attempt to grasp their meaning. They thus introduce the viewer to
recurrent, or eternal, time, creating a sense of a reality which is itself cir-
cular. Technical images, in turn, are much more abstract. They have been
mathematically programmed and thus require linear processing to emerge
as images. Through this course of action, they introduce viewers to the idea
of linear time. Mark Poster was right to raise a suspicion about the rigidity
or even accuracy of this distinction between the two types of images,[19] one
that was premised on the excessive ontologization of the earlier forms of
visual expression as ritualistic and magic-driven, at the expense of appre-
ciating their specific technicity. Yet this reservation does not diminish the
significance of Flusser's argument, which is premised on noticing the tech-
nicity of (at least some) images in the first place, i.e., noticing their infor-
mational value.

Photographs, addressed most explicitly in Flusser's book *Towards a Phi-
losophy of Photography*, are one class of such technical images, alongside
film, television, video, and other hybrid media. Taking analog photographs
and other mechanically reproduced images as his starting point, we must
note that Flusser is not really looking *at* them—but rather far beyond them,
into the future of both images and humanity. This future is looking rather
bleak: Flusser goes so far as to describe it as an ultimate catastrophe, because
"images themselves are apocalyptic."[20] We will come back to this provoca-
tive formulation later on. For now, let us ask whether, by not really looking
at photographs, Flusser is not repeating the error of many other theorists
who have thought about media without actually using them in any mean-
ingful way, thus reducing the operational technicity of those media and
the outcomes of those operations to the banality of a mere example—or,
worse, to a figment of their imagination. He would be in good company
here: as Flusser's translator and writer Nancy Roth observes, "Virtually all

of the voices that have substantially shaped contemporary photographic 'orthodoxy,' not only the historians, but critics, including Benjamin (1968), Barthes (1981), Sontag (1978), . . . *wrote* as receivers and judges of photographs, from the position Barthes designated the Spectator."[21] Yet Roth jumps to Flusser's defense by making an important differentiation: "As Barthes is looking at photographs, Flusser is looking at photograph*ing*. . . . [B]y framing his topic as a gesture, a particular kind of movement between states of consciousness and states of affairs, Flusser was able, in a way no other writer on photography has been, to take the photographer's part."[22] There is therefore a rationale for Flusser's avoidance of looking not just at photographs but also at photographed objects. Instead of looking *at* them, Flusser is looking *through* the photographic flow of images, and toward a future that, to cite Poster, entails "a more complex possibility for multiple assemblages of the human and the machine, not as prostheses *for* the human but as mixtures of human-machine in which the outcome or specific forms of the relation are not prefigured in the initial conceptualization of the relation."[23] Flusser himself argues that interest in technical images on the part of "future men and women" will have "existential" value,[24] as it will allow them to dream up new visions of the world, and of their place in it. Images for him thus serve as devices, offering an insight into the modern world in which we are all being constituted by the technical apparatus, becoming its functionaries.

The apparatus as an image-capture and world-capture machine

The notion of the apparatus is crucial in Flusser's theory. A kin concept to Foucault's *dispositif*, a sociopolitical arrangement whose role was to enact something by delimitation, regulation, and governance, the Flusserian apparatus—especially as introduced in *Towards a Philosophy of Photography*—evokes clear associations with the *(Foto)apparat* as a camera, a perception machine that generates visual outputs in the world in a mechanical way. Yet Flusser, as is often his way, plays with this concept, turning it around and twisting both its etymology and its function to arrive at something much more expansive and potent. Derived from the Latin word *apparare*, "to prepare," an apparatus is "a thing that lies in wait or in readiness."[25] In other words, it is waiting to be actualized, being a function in need of an operator. It is in this sense perhaps that "apparatuses are not machines,"[26]

or not *just* machines. Extrapolating from the black box of the photographic camera, the concept embraces, in a nested manner, different layers of reality that enact functions of different levels of complexity. Flusser thus explains that the "camera functions on behalf of the photographic industry, which functions on behalf of the industrial complex, which functions on behalf of the socio-economic apparatus, and so on."[27] The rationale for using the term "apparatus" for naming all these different levels of reality becomes clear when Flusser reveals that the key issue "is who develops its program."[28] His ultimate concern is therefore with the multilayered automation of our lives as enacted in and by its institutions, machines, and media. They all have been preprogrammed in advance, with our role reduced to that of functionaries, or operators of apparatuses. Our task, in turn, lies not so much in understanding those programs—a task Flusser has already assumed is to a large extent futile—but rather in producing better images of the world. Those images will need to be capable of in-forming the world rather than mindlessly executing its operating commands, repeating the already known.

In his essay on the continued relevance of Flusser published in the *Los Angeles Review of Books*, writer Ken Goldsmith proclaims:

> After Flusser, the photo criticism of Sontag or Barthes, each of whom mostly ignores the apparatus in favor of the artifact, appears to miss the point entirely. Their achingly beautiful literary readings of the photograph as memento mori or studies in studium and punctum have no place in the Flusserian universe. While Sontag makes pronouncements like, "Photography is an elegiac art, a twilight art. Most subjects photographed are, just by virtue of being photographed, touched with pathos," Flusser counters that readings like Sontag's are simply more fodder for the apparatus: "A number of human beings are struggling against this automatic programming . . . attempting to create a space for human intention in a world dominated by apparatuses. However, the apparatuses themselves automatically assimilate these attempts at liberation and enrich their programs with them."[29]

This reading offers a useful explanation of Flusser's claim, one which echoes Marshall McLuhan's communication model, that "it is not what is shown in a technical image but rather the technical image itself that is the message."[30] With this, Flusser provides a deep insight into the technological setup of the world we have constructed—a world that also constructs us humans on a number of levels, with the message of technical images being "significant" and "commanding."[31] Flusser goes on to argue that

the technical images that surround us "signify models, instructions about the way society should experience, perceive, evaluate, and behave."[32] His intimations were developed at the dawn of the digital era, long before the outpouring of social media influencers, with their image-based communication platforms. Yet his conclusions seem to have become validated by the fact that, today, restaurants, museum attractions, holiday destinations, and whole cities are being designed to look good on Instagram, thus feeding, via the flow of images, our desires, experiences, and purchases while also serving as blueprints for altering our environment. Our faces and bodies are changing too: cosmetic doctor Tijion Esho has coined the term "Snapchat dysmorphia" to refer to the "phenomenon of people requesting procedures to resemble their digital image,"[33] which had been manipulated with apps such as Facetune.

The image apocalypse

This mode of looking *through* the image flow does not mean that Flusser would not be able to recognize or acknowledge the content of a particular image: the specific arrangement of particles into what to a human viewer looks like a conventionally happy wedding party, a birthday celebration, or a holiday in the sun. It is just that these images are so predictable, so cliché, and hence so redundant *in the informational sense* that Flusser moves beyond their superficial value and looks at them as objects in a broader communicative sense. (It goes without saying that I myself have taken a fair number of all those types of "redundant" images, recognizing the unique human pleasure *and* compulsion involved in both taking them and looking at them.) Yet we could perhaps go so far as to say that Flusser perceives images the way computers—and specifically, machine vision systems—do: breaking an image into a cluster of pixels to be analyzed for similarity and difference with other clusters in the database, and then matching it against the available categories and labels. Importantly, Flusser's theory allows us to concede that this machinic way of looking is not just a feature of machines, or an eccentric philosopher looking, literally, against the grain. Using his theory, we can perhaps surmise that *most humans now look at most images automatically*, scanning them for similarity and difference, engaging in quick categorization (on a binary level: like/not like; or a semantic one, via comments and hashtags), and going along with the image flow.

The framing process for Flusser's theory of images and, more broadly, for his theory of media is provided by a nexus of disciplines, from philosophy through to cybernetics and communication theory, all the way to thermo-dynamics and particle physics. But he also reveals a strong commitment to writing as a form of zigzagging through ideas, concepts, and modes of expression to produce what could be described as thinking in action. This is undertaken in spite of Flusser's broader prophecy about the waning of writing as a mode expression for the contemporary human, offering instead that we are moving toward a postwriting form of culture, driven by techni-cal images. Indeed, for Flusser writing as the dominant mode of develop-ing and transmitting a linear argument has no future: it has *already* been replaced, to a large extent, by communication via technical images. Given that Flusser was writing in the early 1980s, before digital technology radi-cally altered our speed and form of communication, before blogging gave way to image sharing via Instagram, Snapchat, and WeChat, and before reading was largely replaced by scrolling and touching, his theory of the end of print is indeed nothing short of prophetic. In a now-classic 2008 essay analyzing the state of photography in the age of the phone camera, digital snapshot, and broadband, Daniel Rubinstein and Katrina Sluis look at a research project analyzing the practice of users of the photo-sharing platform Flickr, many of whom said they had given up blogging because it was "too much work" and who now favored photography as a way of sharing their experiences. Rubinstein and Sluis argue that "the practices of moblogging (blogging with a mobile phone) and photoblogging (blog-ging with photographs rather then text) further exploit the way in which mobile phone images have become a kind of visual speech—an immediate, intimate form of communication that replaces writing."[34] Contemporary users of digital platforms and media thus seem to be confirming Flusser's tongue-in-cheek assessment that "images . . . are not so repulsive as massive rows of fat books."[35]

It is worth probing further why Flusser would resort to the idea of the image apocalypse when looking through images into the future. One may be tempted to equate his conceptualization with the dismissal of the increasing photographic output in terms of an image deluge. This latter metaphor was poignantly encapsulated by Erik Kessels—a Dutch photogra-pher, curator, advertiser, and designer whose mode of operating makes him a Jeff Koons of the photography world—in his installation *24 HRS in Photos*.

In November 2011 Kessels filled an Amsterdam art gallery with prints of images that had been uploaded to Flickr over a twenty-four-hour period. The visitors were presented with heaps of what looked like debris, spilling everywhere. The fact that this spillage had been carefully controlled by a number of wooden frames into which it had been placed to create this illusion of a "flow" not only tells us something about the artist's visual cant but also points to our wider desire for beautiful ruins, with the aestheticization of the apocalypse often having an anesthetic function. And thus the project could easily be read as an indictment of photography today, with its pointless content and visual sameness. Yet, following Elizabeth Kessler, it is also possible to read the installation as revealing the Flusserian apparatus in action, demonstrating human and machinic forces at work in the production of (the picture of) the world, while bringing forth a shared "thingness" of our media ecologies. "A person chose when and how to take each picture, but broader influences—human and nonhuman—shape the way we represent, see, and live in the world."[36] The image apocalypse does not therefore have to mean humans perishing in the debris of the world, but rather the expiration of the Anthropocene hubris enacted by the drowning of its core subject. Well versed in the canonical texts of Western culture, including its religious writings, Flusser was no doubt aware that the apocalypse is not just a catastrophe and that its occurrence, come what may, also carries a redemptive potential.

Before we move on to the redemptive aspects of the apocalypse, though, we need to recognize that there are different levels of there being "no future" announced in Flusser's work, with entropy, or heat death—an occurrence resulting from the dissipation of information as encompassed by the second law of thermodynamics—constituting our world's event horizon. Finalist expectations have organized the worldview of many continental philosophers, from the singular human's horizon of death as encountered in the writing of Martin Heidegger and Jean-Paul Sartre through to the death of the Sun as the star that nourishes our planet in the writings of Jean-François Lyotard. In a similar vein, Flusser's planetary perspective is meant to allow us to come to terms with the absurdity of the world, with its ultimate lack of meaning. But this is a form of pragmatic absurdism, one devoid of wallowing in tragedy and loss. Flusser accepts from the word go that the fate of the universe is subject to chance, that the endgame of this chance is entropy, and that any occurrences, be they "galactic spirals, living

cells, or human brains," are the result of improbable coincidences, "erroneous" exceptions "to the general rule of increasing entropy."[37] Yet he quickly moves beyond that realization to introduce a differentiation between the cosmic program of the universe, which we cannot do very much about, and the human-designed program of the apparatus, which remains subject to human control—or which at least *entails the possibility of the human wresting away some degree of control*, be it through insurgence or chance. "Envisioners are people who try to turn an automatic apparatus against its own condition of being automatic."[38] Any act of resistance can therefore only come from within and via the apparatus. Flusser may be no photographer but he himself takes on the role of an enframer and an informer: someone who can rearrange particles, or pixels, to create a new "mosaic," provide new information, and offer a new vision. Creativity as an act of working against the machine, not in a Luddite manner that rejects it completely but rather in defiance of its program, is a task he implores us all to adopt, while there is still time.

Flusser is thus interested in photography as a mode of thinking and seeing to come, or one that has *already* partly come. His assessment that "we live in an illusory world of technical images, and we increasingly experience, recognize, evaluate, and act as a function of these images," refers to the fact that the world is not "immediately accessible" to us.[39] We need images to make it "comprehensible."[40] This diagnosis applies even more aptly to the era of social media and wide image sharing, although it is fair to conclude that this pedagogic and mediating function of images is gradually forgotten, with images losing their character of maps guiding us through the world, as Flusser points out in *Towards a Philosophy of Photography*, and beginning instead to function as objects projected *into* the world. Eventually the whole world will become a screen, with our creative power of imagination giving way to collective hallucination. For Flusser, photography serves as a model for understanding the functioning of the apparatus, with us becoming its functionaries—but it also entails the possibility of taking the apparatus to task. It can thus also serve as a laboratory for seeing otherwise, for reprogramming our vision of the world by creating better, more in-formed, pictures of it, with technical images being "phantoms that can give the world, and us, meaning."[41] It is in this sense that photography for Flusser has existential significance. While he recognizes that entropic decay is already part of our everyday experience, expressing itself "in the

receivers' zeal for the sensational—there have always to be new images because all images have long since begun to get boring,"[42] he also observes, perhaps jokingly to some extent, that no apocalyptic catastrophe of nuclear or similar finalist kind is needed as "technical images are themselves the end."[43] Images themselves are thus "apocalyptic"[44] because they replace the linearity of writing, and thus of history, with the cybernetic feedback loop of the image flow—which becomes a magic circle of eternal return.

In the poignant assessment of the Instagram culture writer Dayna Tortorici has provided the following visceral account of what this image loop actually looks like in the age of social media:

> What would I see? A fitness personality lunging across the sand. An adopted cat squirming in a paper bag. A Frank Lloyd Wright building. A sourdough loaf. A friend coming out as nonbinary. A mirror selfie. A handstand tutorial. Gallery opening. Nightclub candid. Outfit of the day. Medal from the Brooklyn half-marathon. New floating shelves. A screenshot of an article titled: "A 140-year-old tortoise wearing her 5-day-old son as a hat." Protest. Crashing waves. Gabrielle Union's baby. Wedding kiss. Friend's young mother at the peak of her beauty for Mother's Day. Ina Garten in a witch's hat. Detail of a Bruegel painting. Brown egg in a white void, posted to @world_record_egg [verified blue checkmark], with the caption, "Let's set a world record together and get the most liked post on Instagram, beating the current world record held by Kylie Jenner (18 million)! We got this [hands up emoji]." By the time I saw it, the egg had 53,764,664 likes. The comments read:
>
> > "What does the egg mean?"
> > "That's a trick question."
> > "The egg doesn't mean anything."
>
> World records are meaningless in a culture defined by historical amnesia and the relentless invention of categories, I thought, and double tapped to like the egg.[45]

Tortorici describes the experience of the human viewer of images (in this case, herself) being faced with an Instagram flow in terms of entering into a loop of exchanges not only with other human photographers but also with the platform's algorithms. The loops of her brain activity generated by the intensifying visual stimuli coming from the pictures of friends, strangers, objects, and places eventually lead to affective overdrive. This state of high agitation is being sustained by the repetitive behavior of sliding and tapping, with the viewer's eyes and fingers enacting their own loopy dance in search of yet another dopamine hit. Flusser points out that the "general consensus between images and people"[46]—as evidenced in the popularity

scores achieved by various images—inscribes itself in the repetitive cycle: nature—culture—waste—nature.[47] We may update it as "Flower—like—skip —the great outdoors. Someone I vaguely know—heart—unheart—God I hate them. Food—avo on toast—skip—#sohungry." But there is an escape from, or at least an opening within, that world of "meaninglessness" and "historical amnesia" on its way to heat death. The redemptive aspect of Flusser's apocalypse lies in the redefinition of the human as part of the "composting"[48] loop. This entails dissolving the myth of the human "I" as "a core that must be preserved and developed."[49] Repositioned as "an abstract hook on which to hang concrete circumstances, the 'I' reveals itself to be nothing."[50] The Flusserian apocalypse thus involves destroying the Judeo-Christian image of the human as a being made, albeit imperfectly, in the image of God and equipped with some core qualities, qualities whose nature has to be both veiled and revered. For Flusser, the "I" only emerges in a dialogue. Building on the philosophy of Martin Buber while giving it a cybernetic twist through his image of society as a "dialogical cerebral web," Flusser claims that the "'I' is the one to whom someone says 'you.'"[51] The communication model of subjectivity is not just linked to acts of speech: as previously stated, for Flusser the medium really becomes the message—and the messenger. Our consciousness is thus seen as being shaped by the media we make and use, and which also make and use *us*. This model of (say, Instagram-driven) subjectivity dispenses with universal humanist signal points such as choice, decision, and free will. Flusser does nevertheless offer an opening within this cybernetic-naturalistic theorization of the human. A being produced, literally, *from media res*, one whose brain "appeared as an accident in the natural game of chance,"[52] the human has the possibility of mobilizing this aleatory game as a strategy. S/he can do this because the brain has an inbuilt tendency to turn against chance, defy accident, and reject entropy. However, for the human's negentropic tendency to be actualized, certain conditions need to be created. Flusser's whole oeuvre, one might argue, is premised on identifying those conditions.

Photography and future-making

As well as being authors of their own destruction, human beings—who have inaugurated and then labeled a geological epoch in their name—are also a hope for our planet's survival. We can thus be said to have an inbuilt

counterapocalyptic tendency. Even if this survival is just a delay, humans are an opportunity *for* the world, as well as functioning as its existential threat. The answer about the future—of images, writing, the world, or anything else—is therefore also a matter of temporal scale. Images themselves, and, in particular, technical images as produced and exchanged via platforms such as Instagram, Facebook, TikTok, or Snapchat, *can* serve as delaying tactics in this process of information dissipation, even if the majority of them do nothing of the kind. As an Instagram user Flusser would have no doubt been bemused by the banality, sameness, and predictability of the output. Yet his existential-level conclusion, "I play with images . . . to coexist,"[53] would surely serve as an encouragement not to sign off too quickly—from social media, from sociality, and from the world as we know it.

The answer to the question: "Does photography have a future?" thus depends on who is posing it and what time scale they operate on. If it is a curator or a gallery owner interested in securing investment in their Henri Cartier-Bresson or Ansel Adams, they probably have a few good years left. If it is a photojournalist or professional wedding photographer, the writing is on the wall, at least as far as high income is concerned—unless they can undergo a cross-media shift to become a personal TV channel. For those who are too busy posting on Instagram or editing their selfies to be even interested in posing it, because most of the things they know come from living in the constant image flow, some other questions may be more pertinent than the one about the state of the photographic medium, its supporting institutions and its industry: When looking at, sharing, and contributing to the media flow, what kind of future do you see, for yourself and the world? What kind of existence can you carve out and enframe from the media and image flow?

Flusser himself already pronounced in 1985, several decades before the wide adoption of photogrammetry, CGI, and AI-driven image-making, that "photography is about to become redundant."[54] With this, he was referring to the increased generation of synthetic images, as a result of which it became impossible to "distinguish between depictions and models."[55] Yet, even if the medium and practice of photography as we know them may indeed become obsolete, the *function* of photography will no doubt survive for a long time yet—although its execution, in the fully informational guise, will perhaps only be performed by the very few. Like writing, which is "a mesh of accident and necessity" yet which is nevertheless

"*experienced*" by us (partially) code-driven and (occasionally) code-making humans "as a free gesture,"[56] photography will present us with new opportunities, beyond trying to seek meaning and order *in* the world, be it via religion or everyday semiosis. To approach the medium of photography through the "existential register" outlined by Amanda Lagerkvist[57] is to shift photography's role from memory-making to future-making, while repositioning the photographer as the very maker (or, to use Flusser's term, "envisioner") of those futures. The future photographer's gesture of pointing at the world can be expected to generate a whole new "revolutionary attitude,"[58] one that will involve projecting meaning *onto* the world. Technical images, whether in their photographic or post-photographic guises, will function as such projections. Through this process photography will have the potential to "give absurdity a meaning"[59]—not in a semiotic sense, but rather through reframing the photographic act and gesture as meaningful in themselves—and thus to serve as a life force, a generator of experiences transmitted as images. Transcending its representative function as the "pencil of nature" or "the mirror of life," future photography can instead *become* the future.

The world as an image

Already in the 1980s, long before the cross-generational shift to hand-held screens as a primary interface of content acquisition, Flusser was also predicting that the culture of linear writing, and of historical consciousness associated with it, would soon give way to "a concrete experience of the present."[60] Rather than mediate the world via the system of notation that produces literature, historical narratives, and philosophical treatises, we will start absorbing it more directly, claimed Flusser, via apparatuses plugged more immediately into our own system of perception. Leaving writing, whether as recorder of history or creative analyst of the present, to apparatuses—which were supposedly able to do a "better" job at "historical thinking and action"—we were meant to be then able to "focus our attention on making and looking at images."[61] Flusser's diagnosis can be seen as partly ironic, evoking the future in which we all live in a version of a giant VR set fueled by ever-new iterations of ChatGPT, with the typewriter migrating "into our brains,"[62] as he playfully put it. Yet it is also tinged with a degree of melancholia, signaling the philosopher's awareness of the

progressing evanescence of our engagement with the world by means of writing and reading.

Stories about the end of literacy and of the ensuing image deluge that will bring all sorts of intellectual and moral catastrophe go back a long time. In *The End of Reading: From Gutenberg to Grand Theft Auto* David Trend offers a historical overview of the role of visuality in human culture. Looking at the example of paintings in the Lascaux and Altamira caves dating back 30,000–40,000 years, he points out that "for much of the early development of the creatures we now consider modern humans, communication was pictorial and aural rather than written."[63] He goes on to remind us that the visual image, which was a dominant vehicle of communication in the pre-Enlightenment era, "ultimately was devalued and distrusted in the age of reason. To many people visual imagery became synonymous with propaganda and, eventually, with marketing."[64] By the twentieth century educators thus began to issue warnings about youngsters' "overexposure to visual media," from movies through to TV, which were all seen to be destroying young people's minds.[65]

Those sentiments and reactions have acquired a new legitimacy in the era of "neuroscience." Pronouncements such as the one below by cognitive neuroscientist and dyslexia expert Maryanne Wolf set the tone for the scholarly debate on reading today:

> Look around on your next plane trip. The iPad is the new pacifier for babies and toddlers. Younger school-aged children read stories on smartphones; older boys don't read at all, but hunch over video games. Parents and other passengers read on Kindles or skim a flotilla of email and news feeds. Unbeknownst to most of us, an invisible, game-changing transformation links everyone in this picture: the neuronal circuit that underlies the brain's ability to read is subtly, rapidly changing—a change with implications for everyone from the pre-reading toddler to the expert adult.[66]

Even though Wolf does recognize that reading is not a hard-wired activity but rather a specific cultural practice, her work, laid out in her popular-science book *Reader, Come Home: The Reading Brain in a Digital World* as well as many scholarly articles, focuses on demonstrating what is lost for us as readers in our encounters with digital screens. The first casualty seems to be the *volume* of reading, a conclusion seemingly confirmed by Jean M. Twenge and colleagues' findings that the "extraordinary amount of time iGen adolescents spend on digital media . . . appears to have taken

time away from legacy media, especially print."[67] This "displacement," as Twenge et al. term it,[68] is coupled with the supposed loss of analogical reasoning and inference, empathy, and the ability to formulate insights or even perceive beauty. Once again, the transformation is said to affect primarily "young people," who, owing to this new mode of engaging with the world, end up "short-circuiting their reading brains."[69] Reading is also said to have given way to "browsing," "skimming" and "scanning," with the reader "mov[ing] across surfaces"[70] as if they were a collection of images. "Many readers now use an F or Z pattern . . . in which they sample the first line and then word-spot through the rest of the text."[71]

The seductiveness of those one-directional narratives about the end of literacy, and about the wider cultural loss ensuing from this proclaimed end, can perhaps be explained by the fact that they "feel" right. Inscribing themselves in the cognitive structure of "moral panics" (stories that establish and legitimate a given society's principles of social conduct and civic duty), these narratives feel right because they provide a firm explanatory framework to a variety of sociopolitical phenomena, from poverty and spending inequities in education (if you are a liberal) through to immigration and popular culture (if you are a conservative).[72] Yet we would be wise to listen to Flusser's diagnosis that "every epoch has its prophets of doom. There is nothing simpler, nothing more comfortable, essentially, there is nothing more optimistic than to predict the ultimate catastrophe."[73] This wallowing in the catastrophe allows its prophets to reaffirm their vision of the world without realizing, as Flusser acerbically put it, that "the very prophets of the catastrophe are the ones who cause it."[74] Literacy is coming to an end, we might therefore conclude, because its proclaimers are unable to see beyond the limitations of their own goals and worldviews, mistaking the finitude of their imagination for existential-level finalism. Without denying that the modes of literacy are indeed perhaps undergoing a significant change at the moment, or even that "literacy levels in the general population among both children and adults are falling,"[75] while acknowledging that engagement with media, including books, has always been in flux, and that it has always depended on the complex network of material and cultural forces such as class, access, education, and upbringing, Flusser's critique can thus encourage us to pose a different question: Was widespread linear reading just a transitory phase in human history? Trend points out that "reading is not natural . . .—it is a social convention

adapted by Western civilization at the expense of other forms of communi-cation."[76] What would need to change if we were to accept that our mode of engaging with the world was to be, once again, predominantly visual? Could anything be actually *gained* through this?

Flusser's diagnosis about the "end of reading" and about the ensuing "image apocalypse" therefore has a different tenor than many of the doom prophecies about "how the Internet is changing the way we think, read and remember."[77] His narrative, as argued earlier, carries a promise of a renewal, in the form of an opening beyond the seemingly impossible choice between consumption and refusal. In the introduction to his manuscript *The Last Judgement: Generations* penned in the mid-1960s,[78] Flusser offers the following assessment of the choices that await us in a modern technological society:

> The world of instruments (the world around us) seems destined, by its very struc-ture of things already manipulated, to annihilation. The attitude I am describing lies in accepting the instruments as problems. This attitude is the consequence of a moment of choice; it means the existential choice of not accepting the instru-ments passively. And this resides in the experiential opening toward the world of technology, which means the existential decision to overcome the world of tech-nology. Not by ever increasing consumption, not by angry and bored refusal, but by the manipulation and transformation of technology. Technology, to be over-come, needs to be transformed into something else. In this existential decision, in this choice of attitude, a different movement begins in the world around us.[79]

The Last Judgement focuses on the inevitable yet productive tensions between subsequent generations. We can see that Flusser's existential phi-losophy literally unfolds *in media res*, in the midst of the technical appa-ratus of which we are part—and which we can alter from within. Indeed, Flusser looks to the apparatus as an enframing and enabling device that can execute historical transformation. This apparatus can thus be read as both a framing device for societies, generations, and individuals *and* a subjec-tivation machine. Flusser's argument with regard to the impasse between passive consumption and equally passive refusal is that, for a truly mean-ingful change to occur, we need to change both our technology and our subjectivity. The latter, as we know from other thinkers of technology such as Gilbert Simondon and Bernard Stiegler, emerges in ensemble with our technologies. As Flusser's translator Rodrigo Maltez-Novaes puts it: "It is only through an existential dive into the programmatic dimension of the apparatus that we can save ourselves."[80]

Tempting as it might be to see the world become an image in the age of digital media screens, with our brains being directly plugged into Netflix or Hulu, a better model for understanding this relationship with the incessant media flow is needed if we are not to fall prey to the prejudices and blind spots of the aforementioned prophets of doom. Postulating an uncritical retreat to some kind of "legacy media" or a fantasy escape from technology is therefore not the most prudent or responsible position to take. As part of the transformation of technology "towards something else," we need to acknowledge not only that "people now face a world in which one form of 'reading' really isn't enough"[81] but also that reading is currently also being undertaken by machines, at vast intensity and speed. Those forms of machine reading, from automatic translation, fact checking, and sentiment analysis through to code and instruction execution and automatic text generation, start forming a continuum with our human practice in which our "eyes take in the raw visual data of letter and word shapes and match them with remembered patterns of familiar utterances."[82] Taking to a new level ideas from biosemiotics, a field which postulates that communication and interpretation unfold across all living systems, we can perhaps describe the world as a giant reading machine in which the very relationship between the living and the nonliving is subject to reinscription. And it is within the lightning-speed operations of this machine that the distinction between linear machine reading and instant image recognition is increasingly becoming blurred.

In the Judeo-Christian culture, the world was seen as "an image made in God's likeness."[83] It was a representational model of the world, whereby humans were seen as part of God's creation. In the reading machine which also operates as an image machine, the world is an image *without* a divine origin. What is more, it has become increasingly impossible to distinguish between a representation and a model. We could go so far as to argue that now *all* images have become what filmmaker Harun Farocki has termed "operational images,"[84] carrying the potential of an execution of a function. According to Flusser, "From now on, we are the ones who project meaning on the world. And technical images are such projections."[85] Reprogramming the apparatus thus also means taking responsibility for our role in the co-creation of images, whether with technical devices or our cortico-corporeal apparatus, in full knowledge that we are neither sole authors nor sole recipients of the incessant media and image flow—although we may be

the only ones for whom shaping this flow into a set of meanings becomes an ethicopolitical task, rather than just a preprogrammed function to be executed. The fact that the majority of people function as if that was not the case, running the programs of the apparatus in and with their lives, cameras, phones, and other media, only makes this task more urgent.

Photography as a unified perception machine

I want to conclude this chapter by looking at two examples of projects in which the overlap of functionality between pictograms and pictures, and hence between the reading machine and the image machine, is both tested and contested. The first is a four-hour-long performance of Flusser's *Towards a Philosophy of Photography* by artist Ian James (figures 1.1, 1.2). Originally

Figure 1.2
Screenshot from the YouTube version of *Vilém Flusser's* Towards a Philosophy of Photography *as Performed by Ian James*, 2015. Featuring the video *An Assortment of Waiting Areas*, HD animation, 2014.

produced as a three-cassette audiobook edition of the unabridged book read-
ing by James, accompanied by "binaural brainwave patterns, field record-
ings, product unboxings and other treats," it was presented at REDCAT,
Los Angeles, in the Hotel Theory exhibition curated by Sohrab Mohebbi
in 2015. It was then made available on YouTube, accompanied by an HD
animation.[86] The final result is a meditative video of slow-moving pieces
of photographic equipment (camera, printer, lab printing machine) and
paraphernalia (prints, framed images, print storage cabinet) surrounded by
furniture (sofa, coffee table, plant), all floating around like Photoshop cut-
outs or Thomas Demand-like paper sculptures in a white space. The effect is
that of a de-montage, an opposite of Moholy-Nagy's "New Vision," where
revolution may emerge at the slow interstices of a fluid optical mergence.
But you really need to pay attention as there is a danger you may miss it.
To some extent it looks like the video has taken over the process of making
itself, running through the display formats (old-school 4:3, 16:9 vertical)
and the previously used images in the ever-increasing entropic disarray. The
idea of reading aloud, for a prolonged period of time, Flusser's classic text on
photography does not resolve the philosopher's question posed in a differ-
ent volume as to whether writing *does* or *does not* have a future—but it does
foreground the mediatic character of both reading and writing. Situating
those practices on a continuum with photographic acts, artifacts, and tech-
nologies, James's installation-video brings to the fore the fact that not only
is reading a form of seeing and hearing but also that, for us humans at least,
writing and photography are *experiences*. They are multisensuous zones of
sensory stimulation which mobilize perception via vision, sound, and hap-
tics to create sensations that are subjectively describable and qualifiable—
and yet that (so far) escape computational logic. Human preferences, likes,
and dislikes can of course be metricized and thus predicted with a consid-
erable degree of success—to an extent that some algorithms are said to be
better at knowing us than we know ourselves. Yet the subjective quality of
experience, i.e., what it feels like to be me or you (or a bat), and to *have* an
experience (i.e., what analytical philosophers have described as "qualia"), is
something that does not yield itself to computational translatability in any
straightforward way.

Investigating the terrains on which such experiences can take place has
been of interest to me not just in my theoretical investigations and photo-
media art practice but also in my pedagogic activities. The second example

I want to present is thus related to my work as an educator. As discussed earlier in this chapter, I am wary of stories about the supposed progressing illiteracy amongst the young generations serving as evidence for the "end of reading." Yet during over twenty years of my teaching practice, I *have* indeed observed some changes in the way university students engage with textual and visual material. This has encouraged me to explore—experientially, so to speak—how the relationship between texts and images in the digital age is being played out in the pedagogic context. With a view to this, I designed two courses at my previous academic institution (Goldsmiths, University of London): a first-year (freshman) course called Media Arts and a master's-level course called Photography and After. Blurring the boundary between "theory" and "practice," the goal of both courses was to encourage students to *think about media* and *make media* as part of the same classroom experience and course assignment. In the process of designing them I was mindful of an anecdote from what seems like a different era, from a conversation between two philosophers whose work has been formative to my understanding of technology in theoretical terms: a book titled *Echographies of Television* featuring a series of dialogues between Jacques Derrida and Bernard Stiegler. In that book, Derrida recounts a time when, in a seminar he taught "in California" (most probably at UC Irvine), two students presented him with "videocassettes" in lieu of the written paper. Although seeing himself as being open to all sorts of experiments and intrigued by their "innovation," Derrida eventually decided against accepting the assessment presented to him in the moving image format, because, as he admitted, "I had the impression, in reading or in watching their production, that what I was expecting from a discourse, from a theoretical elaboration, had suffered from this passage to the image."[87] He was keen to emphasize, however, that he had not rejected the image-based submissions because of the image, but rather "because it had rather clumsily taken the place of what I think could have and should have been elaborated more precisely with discourse of writing."[88] Derrida was of course no Luddite, and he put a great amount of thought into analyzing our relationship with technology. The interview with Stiegler was conducted in 1993, a time when university education and philosophical praxis remained in a different relationship to media technologies as both everyday devices and pedagogic tools than it is today, when smartphones, laptops, virtual learning environments, editing software, PowerPoint, and Zoom organize our cognitive and

conceptual horizon in a new way, beyond a strict distinction between texts and images.

Derrida already predicted that moment when he said that "there will come a time when, in effect, one will be able to and will have to integrate images into the presentation of knowledge,"[89] although he also issued a warning against using images "to the detriment of the rigor of anterior knowledge."[90] It was the desire to examine this tension between rigor and innovation, between "anterior knowledge" and new media, that has directed me to rethink and reimagine my teaching over the last decade. And thus my Media Arts course, which examined different ways in which artists have used media and technology across different historical periods, opened with the following questions: How do we decide if a piece of media art or a YouTube clip is any good? How do we combine critical thinking about the media with making interesting media? In the age of social media and user generated content, are we all artists now? But the course also challenged the notion of "art" as a unified field of specialist cultural production when placed in the context of the wider enactments of creativity and amateur media practices.

The similar attempt at boundary-crossing, whether between text and image, theory and practice, or old and new media, shaped my graduate-level course, Photography and After (the preparation for which planted seeds for the development of the argument of this book). This course analyzed the contemporary condition of living with photographs, approaching them not only as individual art objects, memory devices, or (increasingly doubtful) photojournalistic evidence, but also as flows of data that touched, animated, shaped, and regulated us in multiple ways. Through this, it explored sociopolitical implications of the fact that our ways of understanding the world and making meanings in it, as well as our social relations, were increasingly mediated by images, whether in their photographic or post-photographic forms.

The principal aim of Photography and After was not just to think about photographs but also to think photographically, with the theory-practice division crossed in both taught sessions and assessment. For their assessment, students needed to produce a photographic or photomedia work, involving a series of original photographs, a video, an online project, a hybrid media work, or a curatorial submission, and accompanied by an essay. Unlike in many other "practice" courses taught in the department,

where advanced image-making technology was prized, whether in ana-log or digital guises, for me students had to use a low-fi camera (e.g., one included with their cell phone), Internet resources, or found images. Imag-ination and creativity were seen as more important aspects of the work than any advanced technology, although the "rigor" mentioned by Der-rida and the recognition of the forms of "anterior knowledge" were equally important. The course involved extensive engagement with Flusser's work, among other texts, but it also built on his insights about the coproduction of media, including texts, with the "programmed instrument," be it a type-writer or a camera. The significance of the class for me, as both a creden-tializing activity and an ontological encounter with one's own networked autonomy, lay in the importance of experiencing the human creative act "as a free gesture."[91]

This sense of working with but also against the apparatus while trying to negotiate its constraints was interestingly captured by one of the students, Ben Prideaux,[92] in his project for the 2020 class. Applying this logic to the image recognition system devised by Google, he fed into its Cloud's Vision API a series of images of objects that, in some way, resembled the basic features of a human face: an electricity socket sporting two oblong "eyes" and a gaping ghostlike "mouth," doorknobs and a drawer handle making a stick-man face, a banana "smile" (figure 1.3). This was done in recognition of the fact that humans not only are drawn to faces (for example, when watching films or looking at websites)[93] but also tend to see faces in random objects and patterns—e.g., Jesus on a piece of toast, or a friendly mascot on the car bonnet. This phenomenon, known as "pareidolia," is explained by psychologists as an evolutionary trait that initially enabled differentia-tion between one's friends and enemies and hence, ultimately, one's sur-vival. It developed due to the sheer frequency of having been exposed to other people's faces—and the significant roles those faces (and their "own-ers") played in navigating the environment. In the accompanying essay, Prideaux suggested that this trait "can be seen as the automaticity of the human subverting the program of the apparatus," thus reflecting Flusser's view that "everything to some extent follows a program, even the universe." Yet he also noted that, while human observers would easily identify the col-lected images as "stickman-faces," the image recognition system failed to make such identification. While he was aware that a more sophisticated algorithm could no doubt eventually be trained in matching humans in

Figure 1.3
Ben Prideaux, screenshot of MA student project, *Anti-apparatus*, 2020. Used with student's permission.

pareidolia, Prideaux was more interested in enacting, in the context of our class and the project on Flusser, a small trick that was able to challenge the apparatus as it became more automated and continued to "mechanise"[94] thought. These kinds of small gestures and creative interventions can also "help humans learn about the existence of ubiquitous sensing,"[95] beyond conscious theoretical reflection and rational analysis.

In the closing pages of *The End of Reading* David Trend looks at different media as generators of multisensory experience—but also as training devices that teach us *how* to experience. He writes,

> Isolated forms of communication like books, CDs, photographs, or movies offer us parts of the overall experience of perception that we experience in daily life. As these forms of media become more complex to become sounds, images, and events unfolding over time, the media come ever closer to replicating our unified *field of perception*. The closer media come in achieving this model, the more excited and interested audiences become. This is why photography became such a marvel when it came onto the scene in the mid-1800s and why multimedia experiences such as game playing in virtual worlds are even more captivating.[96]

We could perhaps thus claim that media become spaces through which we can better see and understand perception, and hence ourselves, because they allow us to grasp how we see and sense the world. In other words, media frame the world for us while also revealing that *there are frames* in the world, that we make the world through putting frames into it, and that perception is needed for us to have a sense of the world. Photography as a quintessential enframing practice plays a key role in this process. Marvin Heiferman claims that photography is an "existential, philosophical kind of medium" and that "there's no other experience like it. . . . For a moment, you can stop something and look at it in a way that you normally wouldn't see it."[97] We could therefore go so far as to suggest that photography and other media constitute a unified perception machine: they unify perception for us, within us, and between us.

2 A Philosophy of After-Photography

Figure 2.1
Screenshot from Refik Anadol, *Archive Dreaming*, 2017.

I'm not sure what photography is. It's everything and everywhere, like a spirit that's left its body. Photography is not tied to the camera—or any apparatus—anymore. As many thinkers have postulated, photography is now more of a state of being, an event. It has become a fiction; a fabrication. I know it when I see it; I can feel it in the air around me when it's happening, with or without an apparatus present. Maybe it's a statement of our surveilled and documented existences. We and the world around us are reconstituted in parallel image universes. It seems impossible to make work that doesn't use or acknowledge photography, because it's now an elemental part of being.

Artist Victoria Fu in *Why Photography?*[1]

"Is Photography as We Know It Dying?"

Despite the proliferation of photographic images and the expansion of the "photographer" designation from professionals and hobbyists (aka "amateurs") to arguably "everyone," the question of photography's future haunts the image-making industry, its clients, and users—as well as those occupying that narrower sliver of photography's art-based milieu, which is to say photographic artists and curators. In November 2019 the popular photonews website Petapixel published an article about what it meant to be a photographer at the present time. The article, as is often the case with online "content" these days, featured a video conversation between photographer-journalists from cognate websites, Patrick Hall of Fstoppers and Pye Jirsa of SLR Lounge, titled "Is Photography as We Know It Dying?"[2] Aimed at a wide variety of visitors, websites such as Petapixel, Fstoppers, and SLR Lounge operate by delivering news, equipment reviews, and photography tutorials, but they are sustained by an active community of commentators and forum posters. Interestingly, the dynamic vitality of those websites' ecosystems is ensured by establishing and maintaining an informal boundary between the "pros" (usually evoked as an aspiration) and the "serious amateurs," all of whom distance themselves from "mere" phone photographers. This video conversation is worth looking at more closely because the issues it raised are indicative of the broader tendencies in current photographic consumption, both discursive and material. The debate will also provide us with some conceptual tools and ideas for how we can talk about photography today—and for how we can locate photography in disciplinary and technical terms. The positioning of photography between industry, art, and everyday practice, and its current framing through technologies, concepts, and metaphors drawn from computation and neuroscience, is the main concern of this chapter. Its main function is to lay theoretical and disciplinary foundations for talking about "our photographic future," while furnishing us with some conceptual building blocks for the construction of the "perception machine" in the rest of this volume. As part of this journey, I will take some tentative steps toward outlining what I will term "a philosophy of after-photography."

The key tendencies in photography identified by the two experts on the Petapixel website seemingly go against the grain of the beliefs held by photography websites' most faithful readers. Having acknowledged that

the digital has both democratized photography and raised the bar, Hall and Jirsa admit that photographic practice itself is changing, with a lot of things "falling to the wayside": heavy gear, strobes, complex editing. With the industry moving more and more toward phone photography, "all that matters is the final image," they conclude—a statement that must seem anathema to "serious photographers,"[3] whether artists or amateurs. This statement recognizes the fact that the ability to engage an audience and having a following matter more than any single image, with a photographer having to be "like a TV channel or TV show." The more nebulous categories of enjoyment and authenticity are said to have replaced the old-style expectations of technical perfection and expert professionalism. Confirming that photography *as we know it* is indeed dying, with that "we" referring to the upholders of the photographic tradition and expertise—which the core readers of Petapixel are largely expected to be—Petapixel author DL Cade nonetheless summarizes the analysis on an upbeat note: "As the bar to entry drops and more and more people outsource their creativity to the latest Instagram trend or some AI-powered post-processing slider, creativity and technical know-how are only becoming more rare and valuable than ever."[4]

This discussion has identified some important trends with regard to photographic practice today. These trends include miniaturization; the increased role of software in image-making, including at the image generation stage; closer integration between photographic gear, clothing, and the photographer's body—which is another step in what used to be known as "media convergence" and which now involves many photographers becoming one with their cameras; and, last but not least, the proliferation of images that are produced neither by nor for the human. Indeed, algorithmic image generation enabled by models such as DALL·E, Midjourney, or Stable Diffusion problematizes even further the agency of the photographer as image creator and copyright owner. Echoing Paul Virilio's argument from *The Vision Machine*, artist Trevor Paglen, who uses images from satellites, surveillance cameras, and AI databases in his work, goes so far as to argue: "Something dramatic has happened to the world of images: they have become detached from human eyes. Our machines have learned to see [w]ithout us."[5] In response to the question posed in one of his online contributions written for Fotomuseum Winterthur, "Is Photography Over?," Paglen claims that "'photography,' as it has been traditionally understood

in theory and practice, has undergone a transition—it has become something else, something that's difficult to make sense of within the existing analytic framework."[6]

A new analytic framework therefore needs to be envisaged—not just to understand photography but also to get a clearer picture of the world that is being imagined and imaged by it. Building on the legacy of ghost and spirit photography, a practice combining imagination and charlatanerie to make up for personal losses before the Great War, and collective loss in its aftermath, I suggest that photography and postdigital image-making can be mobilized today to help us imagine, visualize, and frame not just the present but also the future—and to image and imagine ourselves *as part of* that future. This link between photography, image-making, and imagination was already encapsulated at the end of the nineteenth century by French photographer Nadar in his poetic description of the supposed magic of the medium: "Everything that unhinges the mind was gathered together there: hydroscopy, bewitchment, conjuration, apparitions. Night, so dear to every thaumaturge, reigned supreme in the gloomy recesses of the darkroom, making it the ideal home for the Prince of Darkness. It would not have taken much to transform our filters into philters."[7]

Machine dreaming

Refik Anadol's *Archive Dreaming* (figures 2.1, 2.2), a haunting remediation of the photographic past in which we all become swept up in an image flow, offers a suitable illustration of the approach to photography adopted in this book. Drawing on the experience gained at Google's Artists and Machine Intelligence Program residency, Anadol collaborated with the SALT cultural center in Istanbul to revisit and reanimate its archive featuring images and documents concerning Ottoman culture. As part of this work, he mobilized machine learning algorithms to establish relations among 1,700,000 photographs and other documents included in the archive. The digitized images were then presented as part of an interactive and immersive media installation: surrounded by an "envelope" made up of curved screens, visitors navigated their journey via a panel while being enveloped by the mobile flows of images, texts, and data. The active experience, with the visitor seeing the images at different scales by "picking them up" from the wall to look at them up close and then returning them to their place, was akin

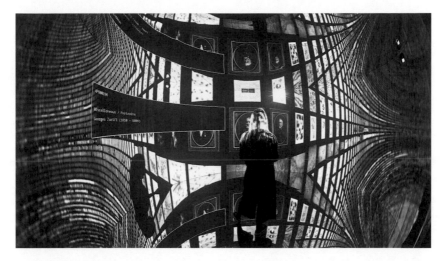

Figure 2.2
Screenshot from Refik Anadol, *Archive Dreaming*, 2017.

to a photographic dance. Yet the most interesting aspect of the installation was not its dreamy choreography with the human viewer at its center, but rather the fact that, while idle, the installation "dreamt" "of unexpected correlations among documents," as well as producing some new visualizations in the process.[8] With machine intelligence continuing the labor of sifting through the huge database—a task too enormous for any human visitor to undertake on their own—the installation's neural network took on the job not just of seeing at a nonhuman scale but also of redefining how to present material from a cultural repository whose size exceeded the cognitive capacity of a human user. A technological sublime for the AI age, *Archive Dreaming* enacted the limits of human perception and cognition, while offering the solace—and an aesthetic pleasure (at least for *this* human viewer)—of experiencing this impossibility as an all-encompassing yet strangely soothing sensation.

Anadol's work encapsulates the key characteristics of the photographic landscape today. Foregrounding the impossibility of the human *seeing it all*, it points to the fact that images now come to us principally in flows to be experienced, rather than as single-frame pictures to be decoded. It also shows that the majority of images today are not generated with a human viewer in mind but are instead produced for this or that part of a distributed

planetary computational array. The framework adopted in my book builds on the prior work in which theorists, artists, and curators have proposed to venture beyond the photographic index and the photographic frame—and toward what used to be known as "the networked image"[9] but what should perhaps be more appropriately described now as "the platformed image." It is also aligned with scholarship that analyzes the current state of events in more ecological terms, shifting focus from the image itself to its machinic infrastructure.

There is an affinity here between my perception of the current moment and what Anthony McCosker and Rowan Wilken have called, in their book *Automating Vision*, "the new camera consciousness."[10] McCosker and Wilken trace back the origins of their concept to the awareness of camera presence at a time when stage performers had become cinema actors. And it is this role of enhanced camera experience as a result of the progressive automation of our lives that the two authors want to highlight with their term, drawing attention to the way smart camera and machine vision systems "make themselves *felt*."[11] McCosker and Wilken go on to explain that the "problem of camera consciousness is one of awareness and attention. Sometimes it's too much, sometimes it's not enough."[12] Importantly, this does not just mean for them the awareness of cameras' ubiquitous presence but also "a self-conscious reaction to their power to make visible, to reveal, to capture and hold their target and to fix it for scrutiny, analysis and judgment."[13] Yet McCosker and Wilken's book focuses specifically on the *social* impact of automation and machine vision via the study of smart cameras (in face recognition, drones, mobile media, and self-driving cars). Interestingly for my argument here, their concept of "camera consciousness" has clear neuroscientific connotations, but the authors do not extensively engage with work in cognitive psychology and neuroscience. In many ways their analysis of the operations of "seeing machines" in our automated society is more akin, thematically, to my earlier book *Nonhuman Photography*.[14] My concept of "the perception machine" outlined in the present volume is broader than McCosker and Wilken's "camera consciousness," embracing not only *machine* vision at the multiple levels of technical infrastructure, but also *human* perception and its reconfigurations—as well as the organization of society *as* an all-perceiving machine, in a way that goes beyond just examining the impact of technology *upon* society. It is therefore more in line with the mode of theorizing that posits all media as parts of an

"all-encompassing and indivisible"[15] process of mediation, of which "we" are also part—be it as singular subjects or a social ensemble.

Recognizing that photography is ubiquitous,[16] that it is not just everywhere but also even everyware,[17] my argument here embraces the vaporous, transient, yet (literally) atmospheric language of grids, networks, flows, streams, feeds, and clouds. We need to be mindful of the fact that this very language is a product of the current state of scientific knowledge and engineering, with the now dominant computational paradigm framing the debate in many disciplines and fields, from neuroscience, health, and IT through to policing and education. Science and engineering concepts such as automation, data (and metadata), databases, algorithms, AI, machine learning, and machine vision, which underpin this paradigm, end up shaping the way we describe and understand many cultural processes and artifacts. This tendency is evident in the recent turn in photography theory to the networked and mobile articulation of the image, coupled with the consideration of distributed images and infrastructures precisely in terms of data flows.

Yet the way scientists think—"including the questions they can ask and the experiments they can imagine—is partly framed and limited by technological metaphors,"[18] as pointed out by Matthew Cobb in his illuminating study, *The Idea of the Brain: The Past and Future of Neuroscience*. Those metaphors themselves are tightly coupled with the state of technical knowledge, including its discourses and vocabularies. This is not just how "scientists" think, of course, as the dominant modes of thinking about technology and their underpinning metaphors make their way to other spheres of society. Cobb points out that the metaphor of the "machine" has been fundamental for centuries in articulating scientific knowledge—be it about the human and human faculties or the universe—but the understanding of what that machine meant has also changed over time in response to emergent technologies, with consequences for ways in which new knowledge was being produced and framed. He offers an interesting example of such metaphorical journeying in neuroscience, focusing on the example of the brain:

> With the discovery that nerves respond to electrical stimulation, in the nineteenth century the brain was seen first as some kind of telegraph network and then, following the identification of neurons and synapses, as a telephone exchange, allowing for a flexible organisation and output. . . . Since the 1950s our ideas have been dominated by concepts that surged into biology from computing—feedback loops, information, codes and computation.[19]

Recognizing the validity of using the computational model to describe various functions of the brain, Cobb also highlights that many of the intuitions about how the nervous system "computes" things have turned out to be entirely wrong, because, unlike the computer upon which this model is premised, "the brain is not digital"—although it is "more like a computer than it is like a clock."[20] This is to say that technological metaphors borrowed from cognate experiments and practices can bring something new to the understanding of phenomena, while allowing for the emergence of novel conceptual and material connections.

The computer, the brain, and the imprint

There are two reasons I am drawing on Cobb's book on the story of the brain to explain the current register of photographic knowledge with its accompanying dominant metaphors, or, to put it in figurative terms, to explain photography's "word cloud." One is that photography has arguably been intrinsically linked with neuroscience since the medium's invention in the early nineteenth century. Teodora Cosman points out that the conceptualization of photography in terms of making impressions on a light-sensitive surface established a parallel with the way memory was understood to work: as a process of making imprints on the tissue of the brain.[21] The relationship between photography and neurology was mutually constitutive: Cosman indicates that French neurologist Jules Bernard Luys "used photography to create an iconography of the nervous centres, applying it not only as a tool but also as an experimental and analogic model of the functioning of memory."[22] This led to photography being seen as a process of making impressions on two levels: that of the light-sensitive substrate, resulting in an image, and that of the brain itself, producing memories. This notion of the photograph as a material imprint on a surface became encapsulated in one of the most fundamental concepts of photography theory: the index.[23] It was only with the emergence of digital photography toward the end of the twentieth century that the conceptual force of the index began to give way to other notions and modes of presenting the photographic medium. Traditionally (and literally) understood as *writing with light*, i.e., as making changes to a light-sensitive surface as a result of a chemical reaction driven by light's energy, in the digital age photography became a more superficial operation—in the sense that it was no longer seen as an intervention

in the material layers on which an image was to be imprinted, such as a metal plate or paper, but rather as rearranging immaterial digits of its code. In computational photography, light "is no longer interpreted as a direct impression of electromagnetic energy in the optical spectrum," but as "the weights and biases of an archive's afterglow," explains computer vision artist Adam Harvey.[24]

The second reason for my turning to Cobb's work is that neurological perspectives have become an increasing presence in the arts and humanities in recent years, especially when it comes to addressing problems of affect, perception, and cognition. Consequently, some sections of photography theory have entered a nested metaphorical loop created by computation and neuroscience, with the discursive framework of the latter partly shaped by photography. Yet the key aspect in Cobb's analysis to which I want to return now is his explanation of how technologies of a given period influence the conceptual and discursive frameworks through which everything else is perceived. This realization has led him to an important conclusion that, "by holding tightly to metaphors, *we end up limiting what and how we can think.*"[25] Metaphors can thus be constraining as well as enabling, sending us down thought pathways and conceptual loops that reinforce the current state of knowledge. (My own turn to cybernetic and computational metaphors here to explain this process is a case in point.)

While it has been extremely productive and, dare I say, exciting to witness the introduction of the interwoven computational and neuroscientific language, with its metaphorical register of networks, flows, and feeds, into the study of photography in recent years, my assumption in this book is that this may not be enough. And thus, while I propose to explore the current framing of photography, especially in its digital guises, in computational and neuroscientific terms, I also want to test the limits of such framing. More importantly, though, I want to consider a possible opening toward *what and how we can think about the ongoing transformation of photography—* and about the perceptive processes enabled by and enabling photography, now and in the future. It is also in this sense that the book serves as an attempt to map out what I am calling "our photographic future."

Let me clarify that I am not positioning science here as a higher authority that can provide a corrective to our prior understanding of either photography or perception as developed in the humanities. Indeed, I would go so far as to claim that science is *by itself* incapable of providing a satisfactory

explanatory framework for either perceptual or imaging processes, precisely because, in its foundational assumptions, claims, discourses, and metaphors, it already relies on fields of knowledge and practices that exceed its remit, from philosophy and politics through to engineering and art. Yet, in recognition of the increased importance of scientific concepts in discussions about human and nonhuman imaging, I want to engage with those concepts, their legacies, and strictures—and also with the promises they bring to the humanities' understanding of how we see the world.

Looking at photography's epistemological and ontological significance, my book embraces the view of photography as existential, as a world-making force. We can recall here curator Marvin Heiferman's polyvocal manifesto *Photography Changes Everything*, in which he argues that "photographs don't only show us things, they do things. They engage us optically, neurologically, intellectually, emotionally, viscerally, physically."[26] In recognizing photography's transformative agency, Heiferman also acknowledges that the medium itself is in flux: "as photography changes everything, it changes itself as well."[27]

A philosophy of after-photography

To understand the full significance of this moment of change, and to be able to look into a future it may lead to, we need a way of framing photography that will let us capture that moment. As a first step in my efforts to develop a new way of framing the field, I will join Flusser on his journey "towards a philosophy of photography," with that "towards" (or "für" in its German original, *Für eine Philosophie der Fotografie*) signaling the open-endedness of the project.[28] Flusser is worth paying attention to not only because of his attempt to think about photography philosophically, but also, as discussed in the previous chapter, because he treated photography seriously *as a medium*, one located in the wider technological context of energy and communication flows. I argued there that Flusser's intimation may indeed be correct that writing as a "linear alignment of signs"[29] does not have much of a long-term future, because it is being increasingly replaced by more immediate—and more viscerally satisfactory—forms of information, image, and affect transfer. The culture of TL;DR, bite-sized Twitter wars, and politics by Internet meme all seem to indicate that his prophecy has perhaps already come to pass. Yet, if writing is a medium

that enables us to "think logically, calculate, criticize, pursue knowledge, [and] philosophize,"[30] it may be worth sticking with it for a little while yet. An attempt to philosophize about photography, even if it is to take images seriously, cannot just be conducted by means of images—although photographs do deserve more of a place in any philosophy of photography worth its (silver) salt.

The image and network cloud sketched out above will help me when taking some steps to develop a new way of framing the field. My overall ambition with this book is to interrogate the ongoing transformation of the photographic medium, from the transformation "of everything," as Heiferman suggests, to its own evolution—which will always be a coevolution with human and nonhuman agents. Practices such as photorealistic imagining in computer games and other forms of rendered images that "look like" photographs offer a backdrop to this enquiry. The uncertain provenience and ontology of various photographic artifacts today can be read in the context of the wider social anxieties about truth and authenticity at a time when digital media allow for an easy fabrication of deepfakes, from made-up news pictures and text-to-image algorithmic "art" through to realistic-looking lip-synched videos.

The theoretical intervention I want to make here involves outlining what I would like to call "a philosophy of after-photography." There is a critical dimension to this "afterness," a term proposed by Gerhard Richter to refer to "a particular figure of modernity, that of following, coming after, having survived, outlived, or succeeded something or someone."[31] For Richter afterness is a form of spectrality that involves a debt and a haunting to what precedes it: it is a transposition but not an overcoming. The afterness of photography I am proposing in this book is perhaps best encapsulated by Hubertus von Amelunxen's remark (made with a nod to Jean-François Lyotard): "After photography comes photography. But it is altered by the after."[32] Yet I also want to push through the modernist sense of the loss and trauma echoed in Richter's concept—and in the work of his philosophical interlocutors, from Hegel, Freud, and Benjamin through to Heidegger, Lyotard, and Levinas. While the experience of "loss, trauma, and survival; and the inexplicable emotions connected with living on"[33] are one aspect of the existential condition of photography I deal with in this volume, I am keen to mobilize a register of affects that go beyond the modernist binary of euphoria ("We have never had it so good!") and despair ("This

is the end!"): curiosity, contentment, amusement, glee, irony, frustration, anger, burnout, and stoic relief. The philosophy of after-photography (cos) plays (with) photography, while being serious about the wider conditions of its production—and of our own production and reproduction as subjects *through* photography in its visible and invisible guises.

Importantly, this (somewhat cumbersome perhaps) articulation differs from "post-photography," a term that has become prominent in the last decade to describe the novel condition of the photographic medium.[34] This latter term first made an appearance in photography theory in the early days of digital imaging and the accompanying shift to broadband connectivity. Liz Wells offered an overview of its use by theorists such as W. J. T. Mitchell and Kevin Robins,[35] who both treated the idea of "post-photography" somewhat dismissively, as overstating the claim about the supposed novelty of the digital. Fred Ritchin, in his tellingly titled 2009 book *After Photography*, referred to "post-photography" as part of the condition of the emergence of citizen photojournalism.[36] Ritchin's primary concern was the loss of the medium's authority and truth value as a result of photographs' increasingly uncertain authorship and their undetectable manipulation.

The debate on the similarities and differences between analog and digital photography, and on the rise of the role of those who used to be called "amateurs" in photographic production, eventually subsided, but the term "post-photography" caught a second wind in 2011 when artist and theorist Joan Fontcuberta put it in a manifesto written for the Spanish newspaper *La Vanguardia*. He argued that photography's historical mandate as a guardian of truth and memory, and its role as a witness, had come to an end. Photography was "whatever was left from photography."[37] (Let us note here that the abandonment of this mandate has not actually occurred among the digital-first generation that grew up surrounded by images, even though they have a much more knowing acceptance of the constructedness of images. People, especially young people, still use photographs on a daily basis, more than ever before, to show things and affects *as they supposedly are*, as evidenced by the Internet-era quip "pics or it didn't happen," with those pictures often being seen as *both* having been manipulated and having a veridical value.) In the introduction to *The Post-Photographic Condition* catalog for the 2015 Mois de la Photo à Montréal biennale, which Fontcuberta had been invited to curate in recognition of his role in taking

the debate on photography's future in a new direction, he wrote that "Post-photography is photography that flows in the hybrid space of digital sociability and is a consequence of visual overabundance. The iconosphere is no longer just a metaphor: we inhabit the image and the image inhabits us."[38]

Picking up on Fontcuberta's ideas, Camila Moreiras has defined the phenomenon of post-photography as standing for an "inorganic image: a composite of littered information—collected, ordered, layered, buried, stored and discarded."[39] Moreiras does use the term "after-photography" in her article, but she does so in a rather literal way, as a way of signifying leaving photography behind, whereas the concept of "post-photography" allows her to pose the question about "how to see an image beyond the visual."[40] In both cases, though, Moreiras, like many other theorists using the term "post-photography," is principally interested in what happens *to* the image, rather than in the wider condition of the world *affected by* photography. Thinking very much in this vein, in his 2014 photo-book *Post-Photography* journalist Robert Shore defined the concept as referring to artists' way of working with photographic images that do not involve any actual taking of them.[41] There are many other uses of this term in both the scholarly literature and photography criticism of the early twenty-first century, all of which converge around the balance of losses (of truth, order, anchoring, accountability, human agency) and gains (of data, volume, saturation, connectivity, sociality). What brings them together is that, in all of them, *post-photography indicates objecthood*: a set of practices (usually distributed and mobile) and their outcomes that depart from the traditional understanding of the photographic medium in indexical and representational terms, while channeling its legacy.

"*After-photography*," which is the term I propose to adopt, *points instead to temporality*. It signifies a time that has been shaped *by* photography, rather than any specific medium that developed *from* photography. It is a mode of thinking that is itself after-modernist, because it attempts to recuperate the future beyond melancholia and mourning. A philosophy of after-photography is thus *a mode of thinking and seeing for a future that will be photographic*—but in a way that we may not always be able to recognize as such. (There may not even be a unified "we" to enact such recognition.)[42]

Another reason to reach for a different term from the one that has underpinned the debate on photography's future so far is that, even though I appreciate the significance of the work undertaken under the cognate concepts in

photography and media theory, I am also mindful of Cobb's warning mentioned above against working with the familiar, "because we end up limiting what and how we can think."[43] Importantly, even though (or even precisely because) the moment I am analyzing here is designated as being temporally and materially located "after photography," *photography* remains my principal thought device and object of analysis—although, to reiterate, it is not so much its *objecthood* but rather its agential force and timeline that are of interest to me. No matter if we are talking here about analog differentiation in "patterns of light and shade,"[44] a record of intensities in a visual field in the form of an "array of integers,"[45] or—more controversially perhaps—a synthesized image that *looks like* a photograph, I retain the concept of photography to encapsulate all these objects and phenomena.

I call it photography, even if it hurts you

Already in 1992 William J. Mitchell stated that "with the appearance of digital camera systems the distinction between photography and computer graphics completely dissolved."[46] And thus for me *photography is first and foremost a percept*: it is what is perceived and hence named as photography, be it on the level of visuality (news images, pictures taken and processed with a mobile phone, the Instagram flow) or functionality (ID pictures used in security systems, photos in AI training databases such as ImageNet, QR codes), with the perceiver thus not always having to be human. In other words, "photography" functions in this book as a heuristic, one that is adopted in a way that may look somewhat unproblematic, but undertaken with a hope of solving some other, more complex problems about different ways of being and seeing. This approach builds on Mitchell's definition of photographs as informationally redundant objects characterized by an "unrelenting internal consistency," which is another way of saying that if *it looks like a photograph* to the human eye-brain array then it is one. Should this conceptual impurity be a problem for some readers, I want to join curators Marco De Mutiis, Katrina Sluis, and Jon Uriarte in their playfully perverse call, which is a simultaneous act of naming and disavowal: "You Must Not Call It Photography If This Expression Hurts You."[47] In a spirit of obstreperous disavowal (to which the title of this section is testament), I am happy to take this gesture even further. We also need to bear in mind that perception is not just a matter of logical, even if not always conscious,

working out of rules and resolution of contradictions: it is also an affective process underpinned by desire, fantasy, and all sorts of other acknowledged and unacknowledged attachments. So my choice of this heuristic is also an affective declaration: I *want* photography to go on—even if, at the end of the day, it may end up functioning operationally not like "photography" at all.

My position may seem like a repudiation of Andrew Dewdney's call in *Forget Photography* to abandon the term "photography" altogether because it serves as "a barrier to understanding the altered state of the default visual image"[48] in the age of computation and online media. Yet there is much alignment between my and Dewdney's respective ways of thinking. For Dewdney "photography" has become a zombie that does not want to die, overstaying its welcome while preventing any meaningful engagement with the new condition of the image (which he prefers to call "network image"), beyond the conceptual constraints of art history and photography theory. We could say that photography insists on being seen, while obscuring its own infrastructural and infrapolitical conditions of possibility. Dewdney's argument is about more than just terminology or disciplinary constraints. Rather, he is deeply concerned about the historical injustice photography has wielded as part of the project of modernity. Photography was not just "an innocent bystander in the historical events it has performed,"[49] as he poignantly observes: it was a participating agent in those events' constitution. As we know from scholars such as Ariella Aïsha Azoulay, Jonathan Beller, Tina Campt, and Mark Sealy,[50] photography was foundational to the establishment and perpetuation of the colonial, imperial, and capitalist nexus which is still with us—but which we cannot just "unsee" because any attempt to do this remains too focused on photographic representations. We could thus say that we cannot see photography for all the photographs that abound. The only way to approach this visual and ethical aporia is to cut through it, hoping for something not just *new* but also *better* in an ethicopolitical sense (although the nature of this goodness will still need to be elaborated).

Dewdney is of course aware that any attempt at forgetting anything, including photography, inaugurates an active process of remembrance, especially of photography's multiple uses—and that his appeal is therefore bound to fail. He calls his rhetorical provocation "a polemic," one described in the final pages of his book as "a productive strategy for understanding photography afresh."[51] Bringing in mediation as an ontological condition

of both our life, "in which hybrids are manifest," and the life of all hybrid images, including photographs, he points out that "the image no longer stands outside of what it previously sought to represent, or mediate."[52] While I share Dewdney's recognition of the ontological impurity of the image landscape and also appreciate the ethical demand of his provocation, I cannot help remaining suspicious of such heroic theoretical gestures—and of their own implicit modernist impulse. Many a man has declared the end of an era, pronounced a radical turn, and declared a paradigm shift— with such pronouncements nevertheless falling on deaf ears of the user base, which is usually too unruly, too preoccupied, or indeed too hybrid to just do what the critic asks of it. Also, while the critique of the inhumane uses that photography has been put to, often in the name of humanism, is more than justified, would we not then need to bury or forget many other structuring devices of our modern *episteme*: the camera, the computer, the pen, the printed book? While I thus understand Dewdney's disappoint- ment with the fact that "photography's once radical modernist promise" has now become "a conservative force,"[53] something is arguably lost in this diagnosis. This something is the exuberant pleasure that many still derive from taking, sending, receiving, and editing photographs, from having their lives photographically imaged, from living in and through the cam- era eye. Perhaps the critic who has forgotten how to be joyful, for whom the disappointment "motivated by an enduring frustration with successive deformations of the revolutionary spirit of modernity since 1968, then liv- ing through and embracing the condition of postmodernity, only to find [himself] back in a culture of deep conservatism and reaction,"[54] has thus obscured the potential delight of living with and in media.

The figure of the perception machine I am working with through this book does recognize the imperial-colonial-capitalist structuration of the state, technical, and cultural apparatus that we live in and that shapes us, but it does not ignore or try to squash the flows of pleasure and desire as affective and potentially political countercurrents to (or within) the machine's operations. There is something else: photography is more than just a zombie that refuses to go away: this "nineteenth-century way of look- ing," as Harvey pointed out, informs and haunts "the ways computer vision interprets and misinterprets the world today and into the future."[55] Pho- tography thus not only shapes our experiences and lives but also furnishes platforms; it is both a hidden *and* constitutive content of machine vision

databases that spawn algorithms aimed at getting machines to learn to be not just "like us" but also "more than us." This is why, claims Harvey, photographic practice and expertise are not going away: "Photographers have a new and important role to play today in shaping the datasets that shape algorithms, which in turn reflect how we see the world and each other. Photographers, as one of the primary visual data creators, can affect the way people see the world by changing the way computers see the world because we now see the world through computers, and computers in turn see the world through us."[56] The perception machine reveals the ambiguity of photographs and other technical objects—which are always, as we have learnt from Simondon, Stiegler, and many anticapitalist and postcolonial theorists, also agential forces. To concede this is to accept that any simple forgetting or rejection of the structuring tools of modernity will not do, because there is no safe position outside of them. It is not just the image that is hybrid, but we ourselves too—and so is the world of which we are part. Photography is still very much part of this world. But it may, just maybe, help us also envisage a better one.

"We haven't seen anything yet"

To recap, my primary concern in the book is not so much an ontology of the photographic image, although some diagnostic work on *what is happening to photographs and other mechanically produced images* today will be undertaken in what follows, but rather a photographic future. I am mindful here of David Campany's warning that, "if you start attributing temporalities to technologies or platforms, before long you end up making a whole set of presumptions about how viewers interact with them. It can be reactionary and very passive."[57] I am therefore more interested in *what is happening to us humans*—and *to what we humans have called the world*, with its plethora of other inhabitants and forces—as surrounded or even shaped by photographic and after-photographic images. Drawing on the atmospheric imagery of picture clouds and data flows outlined earlier, we can conclude that this world *as we know it* can be defined as a universe of (technical) images.[58] In other words, a philosophy of after-photography embraces the formative role of imaging, including photography in all its historical and technical incarnations, in the shaping of the world—but this is a much stronger claim than the one about photography's *influence upon* the world. I am wary

of overstating my case here, or perhaps even being accused of smuggling some form of species chauvinism through the back door of my inquiry into humans' relationship with images in the world, as if *we* were somehow separate *from* it. I also recognize, of course, that images are not the only agential force worth reckoning with. Yet I will go so far as to claim that images cannot ever be fully discretized from our human affective, cognitive, and material frameworks and modes of framing "the world"—and, even more strongly, that the formation of images through perception is a driving force of life in various organisms, from people through to paramecia. Imaging is therefore assumed to be a primary and constitutive force of life, and a condition of the emergence of intelligent behavior. Consequently, I see images as existing with us humans in a dynamic relationship of mediation, being constitutive of the formation of our memory, perception, cognition, and consciousness—and also of our world-building. We could say that the philosophy of after-photography proposed here is first and foremost interested in the ontology of the photographic event rather than that of the photographic object, even if the nature of this event—its temporality, frequency, and scale—will needed to be subjected to an investigation.

The Perception Machine is therefore designed as a reckoning with the force of the photographic legacy, imagery—and imagination. It is also an attempt to re-view and re-vision ourselves as photographic agents and subjects, at a time when our future as the dominant species is being increasingly put into question, be it by neural networks or image networks, virus clouds or data clouds. There is a lot at stake in this re-vision, but there is also a lot to look forward to. I want to finish this chapter by embracing Paglen's joyfully exuberant proclamation, which could also be read as a warning:

> Without question, the 21st Century will be a photographic century. Photography will play a more fundamental role in the functioning of 21st Century societies than 20th Century practitioners working with light-sensitive emulsions and photographic papers could have ever dreamed. So while in one sense photography might be "over," in another, it's barely gotten going. And we haven't seen anything yet.[59]

The following chapters will examine in more detail what we may see while investigating the role of the perception machine in calibrating, regulating, automating, and opening up all these different modalities of "seeing," in humans and machines.

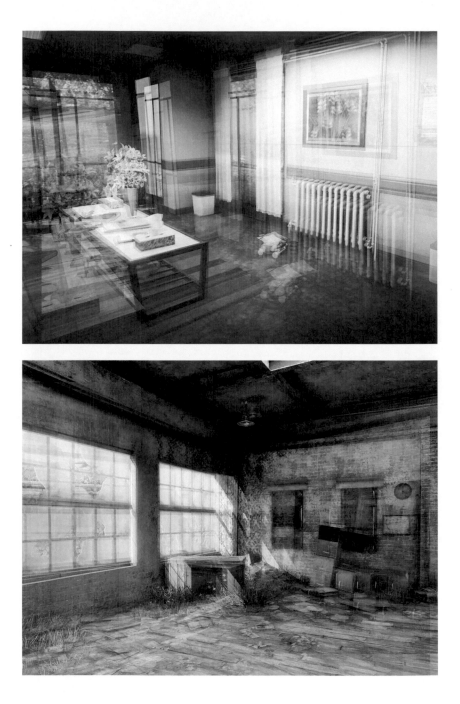

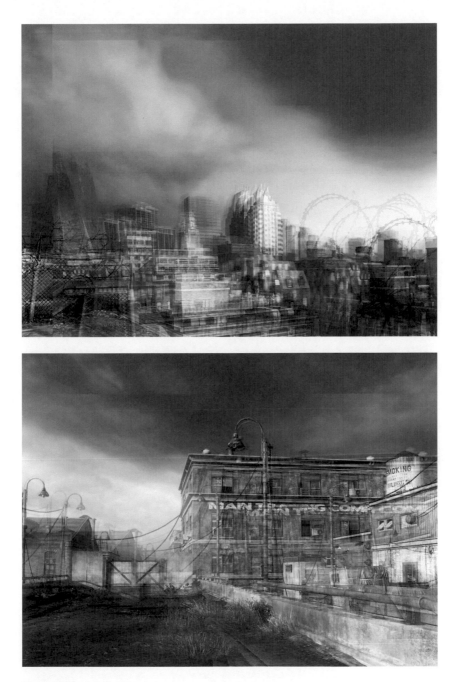

Figure 3.1
Joanna Zylinska, *Flowcuts* (EBG and TLOU), 2020.

Flowcuts I

I am dead, again. I am restarting Joel, or rather restarting myself walking as Joel, trying to sneak through the plague-infested streets of some godforsaken city in which the end of the world has already happened. My job is to smuggle Ellie, a teenage girl who has lost her parents in a large-scale apocalypse in which most humans seem to have perished, across the country. I don't quite understand what happened then and I don't really know what's happening now. I duck and dive, grab a brick, follow a green triangle, while all the time hacking furiously at the plastic buttons of a device I'm holding in my hand, one whose functions, shape, and mode of behavior don't seem to be making any sense. And I'm dead again. A bullet came from around the corner, with Ellie cowering behind a pile of rubbish. I failed her again. I failed again. This is not good. This is not fun. Get me out of here.

And yet I keep coming back, returning over and over again to the same level of *The Last of Us Remastered*,[1] an adventure-survival video game set in an undefined near-future in which all the hope is gone and yet you keep going. My progress is minimal, my speed almost static. It is as if the game is playing me while I am trying to run away. But I keep returning. My experience of being in the game is of someone who is not a gamer, who doesn't understand the rules, the principles, the proprioceptive expectations, the whole navigational dynamics between the screen, the interface, and their own body and mind. I keep returning because I'm pulled in by the oddity of being so spectacularly bad at something that, at first glance, looks quite simple. And I'm not really getting much better at it, despite my multiple attempts at pointing, turning, clicking, and moving. I am also strangely drawn to the ruin porn of the game setup, to its weird scenarios and improbable architectures. I want to linger there, to spend time among the debris of this post-global universe which has been taken over by a mysterious fungal infection but which has retained many traces of the world that once was. It is precisely this uncanny familiarity of the spaces around me that makes me go back to the game again and again, to see it afresh. Yet where is the "me" in all this? And what am I really seeing? *How* am I seeing it, and with what?

I forget about Ellie, about Joel, about myself as Joel, and about the whole improbable story about the Cordyceps fungus that is haunting the world I am traversing. I slow down to the point of stopping, I want to take it all in. I pause, I look around, I don't care about being shot anymore. I am interested in a different kind of shooting, one that doesn't kill, that doesn't use a gun as its mode of access. I screen-shoot, or rather Joel as me, together with this whole unwieldy operation that involves the black thing in my hand attached with a cord to the black box, my body, Joel's body, all of us, we take the world around us in, we freeze it, we temporarily make it ours (figure 3.1).

Screenshotting, aka in-game photography

This chapter takes a proof-of-concept approach to exploring the working of the perception machine. It starts from a proposition that we need to rethink, via media practice, both the way we see the world and the way we understand "seeing." While a more theoretical account of the concept of perception—and of the way it relates to image production and, more broadly, our ways of being in and capturing the world—will be provided in a further part of the chapter, I also want to study perception in more a bottom-up way here. This will involve engaging in a hybrid visual-corporeal practice that involves capturing images in a controlled environment. Specifically, I propose that the photographic activity known as screenshotting ("cutting" into the media flow of a video game by a player to collect memories from the game in the form of images) can be seen as an exercise in foregrounding human perception, in making it seen and felt. I am taking up here Jonathan Crary's understanding of perception (a term he already acknowledges to be "problematic"[2] and "ultimately idealist"[3]) as "primarily a way of indicating a subject definable in terms of more than the single-sense modality of sight, in terms also of hearing and touch and, most importantly, of irreducibly *mixed* modalities."[4] Shifting the human perceptive apparatus beyond its conceptual lodging in the eye, screenshotting as enacted in 3D game environments allows players to become more attentive to the distributed nature of perception and vision, a process in which the whole of the human body is mobilized to produce images and thus enable players to see the world. Screenshotting can therefore be positioned as a way of training players' eyes, bodies, and minds in both seeing the world and understanding perception better. This experience generates new forms of sensation and cognition for experienced gamers as well as game novices. It can also offer valuable lessons for future developments in modeling human vision in machines. In proposing this exercise in corporeal mediated perception I am mindful of Norman Bryson's claim that "the visual field we inhabit is one of meanings and not just shapes, that it is permeated by verbal and visual discourses, by signs; and that these signs are socially constructed, as are we."[5] (In other ways, it *does* of course matter which game is being played, who plays it, when, and what for.)

There is a long history of gamers taking screenshot images of their achievements, memorializing interesting-looking locations discovered on

their game quests, and distributing the images on social media. Recognizing in those voluntarily shared digital mementoes an opportunity for free and "authentic" publicity, conducted by "real players" committing so much of their time to playboring in virtual environments, game companies identified a PR opportunity. Developers legitimized the ongoing practice by introducing a dedicated camera mode to their games—from a simple camera device held by a character, such as a reporter in *Beyond Good and Evil*, through to a sophisticated camera function transforming the whole screen into a camera while mimicking the exposure and processing of a real-life optical device, as in *The Last of Us*, or even an option for augmented-reality capture, as in *Pokémon Go*. The technical affordance, coupled with gamers' desire to shape, save, and share, led to the emergence of a new paraphotographic genre.

I am using the notion of in-game photography in this chapter to refer to both the activity of capturing screen images by the player who is positioned in front of the screen *and* the activity of the player's character taking "photos" inside a game with a camera designed as a virtual object within that game. We could even argue that the latter activity is just a literalization (and marketization) of the former. This expanded definition recognizes the multiple processes of mediation involved in both sets of activities, their shared photographic legacy at the level of design and functionality—and, most importantly for my argument here, the similar mechanisms of corporeal perception on the "other" side of the screen activated in both.[6] As Matteo Bittanti, who also includes both modes of capturing game images in his definition, explains, "'Screenshoting' [*sic*] or 'screengrabbing' is an umbrella term that defines a variety of in-game photography performances whose common denominator is the collection of visual mementos by the player. Rather than using a virtual gun to destroy the environments they encounter, the gamer becomes a collector, an avatar-with-a-photo-camera, a flaneur of virtual spaces. The collected pictures are subsequently enhanced with the aid of Photoshop and similar tools and shared online, via flickr or tumblr."[7] For many gamers, screenshotting has become an activity in its own right, with online realities now functioning, as games scholar Cindy Poremba explains, as legitimate sites for photographic voyeurism. "If the process and ritual behind this image making is similar, the players themselves are validating the reality of their subjects simply by creating a document of these experiences. In this sense, players are taking real photos, just

in virtual spaces,"[8] argues Poremba. What allows her to claim the ontological continuity of this new practice of image-making with its light-induced predecessor is the continuity of function—but also, as noted by Seth Giddings, of affect and intentionality on the part of the players involved.[9]

This continuity does not apply to all aspects of photographic practice. Imagistic verisimilitude, fueled by indexical fantasies associated with the photographic medium, has been abandoned by some more creative in-game photographers, who recognize the medium's legacy while producing something new. Remediating the aesthetic trends of analog photography, artist-gamer Gareth Damian Martin (they/them) has scoured the hidden nooks of the popular action-adventure game *Grand Theft Auto V* to produce moody anti-utopian shots of what are literally no-places. Carefully framed and shot with an analog camera, in black and white, with filmic grain becoming part of the process,[10] their images create a haunting panorama of the game's outskirts (figure 3.2). Part documentary, part street photography, part cyberpunk, Damian Martin's "heterotopias," as they term those images, evoke an uncanny sensation of the world's liminal zones. Riffing on the postapocalyptic tenor and visuality of many popular games, the images help us envisage this world's edges (and also *the end* of this world, and of *our* world on the other side of the screen), while framing it for our comfort and pleasure. The practice of photographing games' edges has inevitably led to

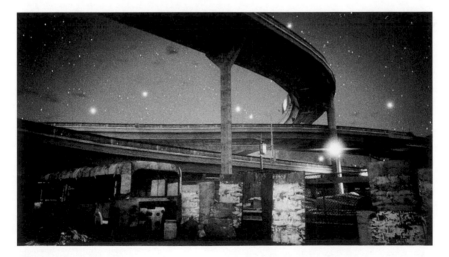

Figure 3.2
Gareth Damian Martin, *Pathways (Grand Theft Auto V)*, 2017.

a heated discussion about the frayed edges of the very medium involved. Traditionalists, such as Wasim Ahmad, writer for the photographic website Fstoppers, have insisted: "It May Be Art, but In-Game Images Aren't 'Photography.'"[11] Damian Martin, in turn, has been adamant that "photography is a useful term" for this practice "as it connects the work to a heritage and history of conceptual, still-life and object photography that stretches all the way back to the beginning of the medium."[12]

I came to in-game photography at a workshop run by Damian Martin at The Photographers' Gallery in London in July 2018.[13] The least experienced in the group when it came to gaming, and probably far less keen than the other participants on upholding the conventions of the photographic medium, I found myself mesmerized by the visual and conceptual experiment unfolding on multiple screens. That workshop was my calling card for getting involved in an alternative way of sensing and seeing and an alternative mode of producing technical images,[14] one that bore resemblance to what was familiar and yet that shifted the parameters of the game. Navigating the generational and kinetic difficulties of a nongamer in the visually attractive, high-resolution 3D game environment of *The Last of Us*—the first game I subsequently bought, together with a PlayStation 4 console—I turned a blind eye and deaf ear to the somewhat clunky story and its wooden dialogues, and followed instead the enthralling visuality unfolding on the screen in front of me. Like Damian Martin, I was drawn to the game's edges, spaces half-gratuitously put in by the designers and not really designed for the player to spend too much time in. Forfeiting the speed, the action, the trophies that presented themselves to me on the way, the whole gamey premise of the game, I mobilized my photographic apparatus—my technical knowhow and ways of seeing photographically developed over the years—to start making the gameworld a little more mine.

Even if not explicitly engaging with image-making as part of their plot, most 3D games rely on camera technology to navigate their characters. And it was this navigable "camera-body" as "the primary vehicle of perceptual immersion"[15] that presented an affordance which drew me in, in every sense of the term. I became particularly intrigued by the two vantage points respectively offered by first- and third-person games. First-person games, such as the walking game *Everybody's Gone to the Rapture* (which shares a postapocalyptic story and look with *The Last of Us*), developed

from first-person shooters, i.e., games in which the player sees the action through the avatar's eyes while becoming an extension of the shooting device, be it a gun or a camera. In third-person games, such as *The Last of Us*, the camera is placed slightly behind and above the avatar, although its angles and positioning can vary and change, depending on the game. The player is then linked to the avatar, via the camera and the controller, through an invisible "ray of light." In both types of games, players ultimately take on the camera function, whether or not they engage in the practice of screenshotting. I became entranced by the virtual environment of 3D games because it offered me a space in which I could test or even contest the legacy of the photographic medium by virtualizing different possibilities, simulating different outcomes, and framing different viewpoints. Yet the experience offered me more than that: I saw in the game environment a laboratory for experimenting with possibilities of retraining perception and vision, of reframing what and how I (or, dare I say, "we") see the world, of learning some new affordances. In other words, I saw it as a space for retuning the perception machine.

How we see the world

Why was this retraining, reframing, and retuning needed? And do we fully understand and agree, across disciplines and fields of enquiry, on how we see the world in the first place? Before I attempt to answer these questions, let me provide some terminological clarification. In line with many studies of human sight, whether based in psychology or in visual culture, I am using concepts such as "visual perception" and "vision" interchangeably in this book,[16] although, strictly speaking, the former refers to the act of obtaining information from the world from light entering our eyes, while the latter stands for the ability to see. Visual perception is thus a process, vision the outcome of this process. But, given that the outcome is never stabilized but rather constantly reviewed through recurrent feedback loops, the elision of the difference between the two terms is perhaps justified. In his field-defining book *Vision*, which, rather controversially, set the ground for redefining vision as computational at the neurological level, David Marr states that "vision is the process of discovering from images what is present in the world, and where it is."[17] (Chapter 4 will offer a more thorough—and critical—engagement with Marr's definition of vision.) But then Marr adds

that vision is not "just a process," and that temporary stabilizations, which he calls representations, need to be recognized within this process to enable human actions and decisions.[18] It also needs to be pointed out that, due to the dominance of the eye in our everyday understanding of how we see the world, "perception" (without the qualifier "visual") and "vision" are often treated as equivalent not only in everyday parlance but also in much of scholarly literature. Yet we need to be mindful of neuroscientist Beau Lotto's observation that, "in terms of the sheer number of neural connections, just 10 percent of the information our brains use to see comes from our eyes. . . . Perception derives not just from our five senses but from our brain's seemingly infinitely sophisticated network that makes sense of all the incoming information."[19]

My argument in this book assumes that visual perception *always* involves other senses—and that it is embodied *and* enacted, and not just passively received. Vision is thus never *just* visual. Additionally, as already stated earlier, to understand vision—and, in a somewhat meta way, to understand our evolving ways of *understanding it*—we need to draw on the disciplinary nexus of the sciences and the humanities, because vision is never just physiological either: it is always shaped by cultural assumptions and social practices. By saying this I want to highlight not only that our *concept of vision* is inherently cultural but also that *what and how we actually see* is a hybrid "naturecultural" (to use Donna Haraway's term) phenomenon.[20] In his preface to the edited volume *Vision and Visuality*, which explores "how we see, how we are able, allowed, or made to see, and how we see this seeing or the unseen therein,"[21] Hal Foster insists on the mutual constitution of the two terms in his title. Even though vision typically positions sight as a "physical operation," while visuality defines it as a "social fact," for Foster "vision is social and historical too, and visuality involves the body and the psyche."[22] Vision already has physiological, psychological, and social layers, being involved in the production of subjectivity and the social while also being produced by them. The inflection of those modes of production changes across history, alongside the changes to technical infrastructures and apparatuses. This is why what is really at stake in trying to understand vision, as suggested by Bryson, "is *a politics of vision*."[23]

This embodied and encultured mode of theorizing vision builds on some earlier critiques: that of "the 'Cartesian perspectivalism' which

separates subject and object, renders the first transcendental and the second inert, and so subtends metaphysical thought, empirical science, and capitalist logic all at once,"[24] and that of the monocular immobile eye as the agent of perception. Up until the early nineteenth century the dominant model of vision was premised on the idea that the eye was a passive vehicle of image reception. Conceptually modeled on the operations of the camera obscura since at least Descartes's 1637 treatise *Dioptrics*, vision was thus understood to happen *to* the human subject—or rather, to the human's "static, unblinking, and fixated" eye.[25] Drawing on astronomer Johannes Kepler's discovery of the retinal image in 1604—an image of an external object projected, in reverse and upside down, onto the retina by the eye's optical system—and on its posited parallelism with an image obtained within a camera obscura, Descartes ended up consolidating the understanding of vision as autonomous and disembodied. Vision only became dislodged "from the stable and fixed relations incarnated in the camera obscura"[26] as a result of modern visual experiments, including those with early forms of photography.

Flowcuts II

The *Flowcuts* project presented as part of this chapter has allowed me to explore both the working of visual perception and the way we can understand it, conceptually and experientially. My investigation commenced with images; the written material was only developed in response to the image-making process. By revealing my method, I am not in any way promoting immersion in "pure experience," or advocating the superiority of practice over theory. My experience of screen-shotting within gameworlds was mediated by both my ongoing photographic practice and my knowledge of philosophy and media theory. The images that form the *Flowcuts* series were all captured from multiple angles around various scenes and locations I had come across, using the embedded camera function in the two games featuring postapocalyptic scenarios I mentioned earlier, *The Last of Us* and *Everyone Has Gone to the Rapture*. Each image had been produced from overlaying, in Photoshop, views of the same scene captured from several different angles. It was then edited according to my own aesthetic preferences, inspired by the two games' end-of-the-world landscapes and scenarios, in the photo-editing program called Lightroom. The retaining of the traces of multiple singular shots within the images was a nod on my part to various theories of perception. It was also an attempt to show the process of navigation between seeing movement and enacting cuts in the optical flow, a process that our visual apparatus constantly performs as part of what we know as "seeing." The final images became what I began to call "image-concepts."

The long shadow of the retinal image

The concept of the retinal image casts a long shadow over our modern understanding of both vision and image-making—in its still and moving guises. Notwithstanding the evolving research into human and computer vision, and the more advanced understanding of how visual perception works (on which more below), the disciplines of film and media studies continue to make use of older image-making technologies to explain both physiological and mechanical image production—often with a full awareness of the metaphorical status of those explanations. This is perhaps because, on a subjective level, we still seem to be grappling to find adequate vocabularies to describe how we see the world—and, more importantly for my argument here, how we *experience* seeing. Image-making technologies seem to provide useful metaphors for articulating this subjective uncertainty. And thus some scholars describe vision as photographic, as premised on us taking sequences of "pictures" with our visual apparatus which we then animate as we move with and through the world. Others perceive vision as being more akin to cinema. With the latter, our visual apparatus is seen as being reminiscent of either the film camera (capturing and thus shaping the optical-visual flow) or of the cinematograph, a device which projects a film onto the screen of the world for us to see, allowing us then to discretize individual images by way of stabilizing the world into objects and states.

In *Light Moving in Time* William C. Wees traces the discursive articulation of early filmmaking technology primarily through its relationship to movement and light.[27] He then observes that "the same terms can be applied to visual perception. The basic requirements for seeing are also light, movement, and time. As one researcher [Gunnar Johansson] has put it, 'The eye is basically an instrument for analyzing changes in light flux over time.' That succinct statement delineates a common ground for vision and film."[28] In this account, cinema seems to *just happen* to humans, although it still needs to be discretized, captured, and named. While the avant-garde cinematic tradition established a parallelism between human and cinematographic vision, Hollywood cinema went so far as to elide the difference between the two, creating an illusion of the transparent image "modelled on human vision, whereby cinematic conventions are broadly directed towards creating a semblance of human perception."[29] This functional

parallelism between human and cinematic vision was inspired by the trans-formation in the understanding of subjectivity and perception at the end of the nineteenth century, as proposed in Henri Bergson's philosophical writings on memory, movement, and time. Yet Bergson himself did not use the cinematic metaphor. Instead, he argued that our visual perception oper-ated more like a photographic camera, cutting reality into discrete images and then stitching them together into a relatively coherent and fluid pic-ture of the world. In a somewhat begrudging account attempting to casti-gate his fellow humans for being unable to grasp life in all its dynamism and exuberance, Bergson described our way of seeing the world in the fol-lowing terms:

> We take snapshots, as it were, of the passing reality, and, as these are characteris-tic of the reality, we have only to string them on a becoming, abstract, uniform and invisible, situated at the back of the apparatus of knowledge, in order to imitate what there is that is characteristic in this becoming itself. Perception, intellection, language so proceed in general. Whether we would think becoming, or express it, or even perceive it, we hardly do anything else than set going a kind of cinematograph inside us.[30]

Bergson thus posited the photographic model as primary in the production of our inner film not so much to help us understand perception, but rather to demonstrate that we saw the world in the wrong way. Unable to grasp life's becoming via intuition due to an epistemological mental blockage, for him we resorted instead to the mechanical process of cutting duration into slices, i.e., snapshots.[31] Fluid perception, or our inner cinematography, was thus only secondary for him, with the cinematograph reduced to a machine for animating the still images of our own making. Life itself is a form of cinematography, we could say—as, indeed, did Deleuze, picking up on Bergson's argument[32]—yet, instead of making use of its infinite power and fluid movement, we learn to see and know the world by mentally pick-ing up what Bergson no doubt saw as a clunkier device: a still camera.

Flowcuts III

My venture into the neuroscience research on perception outlined in this chapter is not an attempt to justify or prove the correctness of my intimations about per-ception enacted in the images. Rather, I draw on the science material to develop a satisfactory mode of "cutting" through the flow of ideas, affects, and percepts with a view to temporarily stabilizing them into images. This approach is partly indebted to Gilles Deleuze and Félix Guattari, who in *What Is Philosophy?* came up with a strategy, with the help of "Chaoids," for taming the chaos of the world

and the multiple sensations it exerts on us. Chaoids was the name Deleuze and Guattari gave to art, science, and philosophy, three creative practices which they identified as the daughters of Chaos. Chaoids took on the function of enablers for organizing matter and ideas into forms in three different registers and genres—and for creating concepts out of chaos. Importantly, for Deleuze and Guattari concepts do not serve "to replicate accurately in discourse specific segments of the world as it really is (as science does), but to propose articulations of and/or solutions to problems, to offer new and different perspectives on orientations toward the world."[33] Every concept is thus a "matter of articulation, of cutting and cross-cutting."[34]

As Sarah Kember and I have argued elsewhere, the process of cutting needs to be seen as "one of the most fundamental and originary processes through which we emerge as 'selves' as we engage with matter and attempt to give it (and ourselves) form. Cutting reality into small pieces—with our eyes, our bodily and cognitive apparatus, our language, our memory, and our technologies—we enact separation and relationality as the two dominant aspects of material locatedness in time."[35] The image-concepts presented here are therefore not just illustrations or visual metaphors of a philosophical or scientific problem: they are temporary stabilizations at the crossroads of art, science, and philosophy. They also serve as devices that can help me (and hopefully others) to approach and think through that problem. Once again, science is thus not evoked here as evidence but is rather mobilized in recognition of the fact that scientific research into cognition, perception, and vision has already been part of, or that it has in fact shaped, the philosophical understanding of those concepts since ancient times—and that it has also generated (and been furthered by) artistic practice. Also, as discussed earlier, film and media theory has always been premised upon, and engaged with, scientific knowledge about perception. The recent shift from the eye to the brain, from the after-image to the neuro-image,[36] is a testament to this engagement.

The photo lab of the eye-brain

Early photographic cameras were themselves modeled on this very idea of the disembodied and static eye that merely captured images coming "from the world."[37] While up until the early twentieth century it was assumed that we saw reality via an array of still images, our ability to perceive motion was explained by the aforementioned "retinal image," an optical illusion that involved each singular image supposedly "lingering" on the viewer's retina. The overlapping of those singular images was said to create the illusion of movement. This conviction led to the emergence of the "unifying myth"[38] of film studies: that is, the "persistence of vision" theory. In their tellingly titled "The Myth of Persistence of Vision," published in 1978, Joseph

Anderson and Barbara Fisher pointed out that "after-images, since they are in fact tracings of stimulation left upon the retina, yield *stabilized* images."[39] If afterimages were actually involved in the creation of the illusion of movement, "the result would be a plethora of images resulting from the tracings scattered about the retina according to each separate fixation of the eye,"[40] rather than smooth movement.

The afterimage theory of perception was originally refuted by psychologist Max Wertheimer. In 1912 Wertheimer published an article titled "Experimental Studies on the Seeing of Motion,"[41] in which he demonstrated that the belief that we saw still images first, with motion somehow "added" afterward, was incorrect. Many film scholars subsequently attempted to reconcile their own earlier intuitions about perception with the new state of knowledge. In his 1914 *Moving Pictures: How They Are Made and Worked*, Frederick A. Talbot suggested:

> The eye is in itself a wonderful camera. . . . The picture is photographed in the eye and transmitted from that point to the brain. . . . When it reaches the brain, a length of time is required to bring about its construction, for the brain is something like the photographic plate, and the picture requires developing. In this respect the brain is somewhat sluggish, for when it has formulated the picture imprinted upon the eye, it will retain the picture even after the reality has disappeared from sight.[42]

With this description of the perception of movement, Talbot produced a delightful mergence of organs, with the eye-brain conjuncture becoming a kind of photo lab. It is important to notice that the notion of "persistence of vision," which was premised upon the retinal imprint of an image, did not entirely disappear from this theory: it only shifted to a different section of the "lab."

Since the 1960s perceptual and cognitive psychology has widely adopted the assumption, supported by numerous experiments, that the brain is indeed the primary location where the data received to produce an image is visually processed. The following explanation for how we see the world is currently shared by the majority of scientists working with vision, whether in perceptive psychology, cognitive science, or neuroscience. Light coming from an object is said to stimulate the cells in our eye, producing electrical impulses as a result of the stimulation. Those impulses, containing information about light and color, function as raw data that is then transmitted, via the optic nerve, to the brain. The brain refines and translates the data

into what we subsequently recognize as images. The perception of move-
ment arises from noticing the small difference between a series of radically
changing stationary images (rather than afterimages left on the retina) and
(involuntarily) interpreting it as movement.[43] Drawing on a 2006 paper
by Marc A. Sommer and Robert H. Wurtz,[44] science writer Julia Layton has
attempted to clarify how the picture of the world we obtain ends up being
so stable even though our eyes themselves are in constant movement,
which involves exploration, scanning, low-frequency tremor, and saccadic
jumps. Using Sommer and Wurtz's discovery that "the brain keeps track of
self-movement . . . by monitoring an internal copy, or corollary discharge,
of motor commands,"[45] Layton has described our eyes as "the video cam-
eras of our brain."[46] Yet her actual explanation is more reminiscent of the
working of a still camera: "They take before and after shots of every focused
image and compare them in order to confirm stability."[47] She clarifies the
process further:

> Before your eyes actually sense an object, your brain takes its own picture of that
> object for comparison purposes. It knows where your eyes are going to move next,
> and it forms an image of the object that precedes our conscious, visual percep-
> tion of it. Then, when our eyes do perceive that object in a sensory way (meaning
> we can see it), our brain has already laid the framework for a smooth transition.
> There's no shakiness and no instability. The brain has anticipated what our eyes
> are going to see, and it uses that anticipatory image for comparison to make sure
> the world has indeed remained stable in the split-second between the before shot
> and the after shot.[48]

Even though present-day research into visual perception challenges models
based on the belief in one-to-one correspondence between physical stimuli
and perceptual experiences, this does not stop science writers, philosophers,
as well as film and media theorists from seeking such correspondences. In
the process—and this is the point of key interest to me here—they often
reach for concepts borrowed from the image-making industry: from Julia
Layton's report on the experiment in the brain correlates of vision through
to Gilles Deleuze's acknowledgment that "the circuits and linkages of the
brain don't pre-exist the stimuli, corpuscles and particles that trace them,"
which is summed up in his oft-cited quip: "The brain is the screen."[49] For
neuroscientist Beau Lotto, in turn, "the world out there is . . . our three-
dimensional screen. Our receptors take the meaningless information they
receive; then our brain, through interacting with the world, encodes the

historical meaning of that information, and projects our subjective versions of color, shape, and distance onto things."[50] Photographic and film technology therefore exists in a mutually constitutive relationship with technologies *and* narratives of vision.

The constitutive role of photo-technical metaphors in explaining vision is likely a symptom of that fact that, as Anderson and Fisher highlight in the sobering conclusion to their article, "even though we have been looking at motion pictures for three quarters of a century, we still do not understand the most basic perceptual principles."[51] This sense of perplexity is reiterated in the classic textbook of visual perception, *Eye and Brain* by Richard L. Gregory. The author admits that, although we now know much more about the organization of the visual cortex, "how this is related to seeing the complex shapes of objects remains unclear."[52] The lack of clarity refers specifically to understanding how nerve impulses, or sodium and potassium molecules flying across a membrane, produce subjective perceptual experiences. In other words, advanced multidisciplinary research in neuroscience has not yet found a way to explain how the subjective experience of perception and the awareness of it are constituted *for us*—a conundrum described by David Chalmers as a "hard problem of consciousness,"[53] with perception arguably being foundational to the emergence of consciousness, while also being a principal mode of generating subjective experiences. This blind spot at the heart of visual perception studies perhaps explains why the shift from the retina to the brain in cognitive psychology has not really put to rest the mechanical metaphors of a human organ, be it the eye or the brain, as a camera, or more broadly an image-making apparatus, both in media-theoretical discussions and in scientific descriptions of the problem of vision.[54] The metaphors' seductiveness lies in their ability to explain a complex process through familiar actions such as recording and copying, while also offering a promise of fixing, both in the sense of stabilizing and repairing, the perceptive "machine" should it get out of sync. This very promise lies at the heart of computer and machine vision.[55]

Yet the lingering photo-mechanical metaphors can also be a potent conceptual opportunity. Indeed, as mentioned earlier, many humanities scholars are aware of the metaphorical aspect of *all* forms of message transmission, including scientific communication. We use metaphors readily and playfully—while remaining attuned to the historical specificity of what gets positioned as experience and evidence. The awareness that the eye is

not a camera, that it does not see in frames per second and that it does not capture ready-made images which it then "sends" to the brain, has thus enabled a new articulation of the process of perception. The demise of the persistence of vision model, with all its scientific error and metaphorical charm, has given way to its opposite: the premonition of vision, with the brain playing a much more active role in image construction. (Chapter 6 will explore this in more detail.) This is, however, not a straightforward conclusion that, while the eye is not a camera, the brain perhaps might be. A much more creative model of perception emerges here instead, requiring us to rethink "the brain"—which really needs to be put in inverted commas—to refer to a whole apparatus that includes the observer and the thing observed, us and the world.

This phenomenological model, deemed an "ecology of perception,"[56] was originally associated with the work of psychologist James J. Gibson. The foundations of this model can be traced back to Johann Wolfgang von Goethe's 1810 treatise on color theory,[57] a work which put forward the idea "of subjective vision in which the body is introduced in all its physiological density as the ground on which vision is possible."[58] Crary suggests that what was new about Goethe's visual framework, the key element of which was the afterimage left on the retina by light stimulation, was that it postulated an active observer whose body was capable of generating a whole range of visual experiences. This mode of reconceiving the observer as an active subject prepared the ground for understanding perception as a kinesthetic and not just visual process, one that engages the body moving in the world.[59] The "enactivist" model of perception has recently been developed further by philosophers Alva Noë and Shaun Gallagher.[60] It has also been taken up by many creative disciplines, from dance through to architecture and design. Perception here stands for capturing what the world affords us and remaining open to it—but it also involves introducing cuts to what Gibson termed an "optic flow" by way of discretizing this flow into lines, edges, objects, and, consequently, images. The optic flow names the apparent flow of objects experienced by the observer in their visual field as they move through space.[61]

Gibson's *The Ecological Approach to Visual Perception*, published in 1979, challenged the model of perception as a transmission of an image from an object to the eye—and then the brain—with a view to building

models of the world. In its place Gibson offered the idea that perception was mobile, distributed, kinesthetic, and largely unconscious, and that it encapsulated the whole of the corporeal apparatus. In other words, vision for him required a movement of the perceiving agent's body, delivering simultaneous information about, and awareness of, "the world" and "the self in the world."[62] Building on the subsequent research in neuroscience and cognitive psychology in their article "The Myth of Persistence of Vision Revisited," which was another attempt to debunk a model that had cast a shadow for longer than expected, Anderson and Anderson similarly concluded that perception was an active process, one in which the corporeal apparatus of the observer—their eyes, brain, and whole body—participated: "We rapidly sample the world about us, noting the things that change and the things that do not change. We turn our heads for a better view; we move left or right to gain additional information provided by a different angle. We move closer or farther away. We actively seek more information about things that interest us."[63] Perception thus extends from the brain into the world, with "the brain" standing for the dynamic space between the observer and the world. It is also inherently coupled with action. It would not therefore be too much of an exaggeration to say that *I perceive therefore I act*. (Chapter 6 will explore both the scientific underpinnings and the consequences of this statement.)

The key problem that emerges here is the need to understand the mechanism through which cuts are made in the optic flow. As discussed above, our eyes are in constant movement of several different kinds. They are also "drawn to hard edges,"[64] which become points of stoppage on this inevitably blurry journey of perceptive movement. Rebekah Modrak explains that "the eye and the brain are accustomed to using contours as a way to understand the environment."[65] Even though nothing in the world is actually made up of lines and edges, "the eye and brain have evolved systems that encode these differentiating signals and process the information in such a deceptively casual manner that we start to believe that edges and lines are visible components of the 'real world.'"[66] We could therefore go so far as to suggest that "the brain," which by now, as we have established, stands for a wider perceptive apparatus extending to our whole body and reaching out into the world, introduces edges and cuts into the imagistic flow: it cuts the environment for us to see it, and then helps us stitch it back together.

Cutting and framing the optic flow

As Lyle Rexer points out, "Enshrined in modern mythology is the image of the street photographer, the boulevardier, usually a male, making pictures as he goes, shooting, and moving on, a tactical animal on the hunt."[67] The foregrounding of the embodiment and embeddedness of vision, coupled with its refiguration "as a becoming-with or being-with, as opposed to surveying-from,"[68] to borrow a phrase from Haraway, calls for a development of new strategies of visual—and photographic—perception. Offering a more dynamic and engaged, less conquering, model for being in the world, it also severs the link between the eye, the camera, and the gun. In line with this proposition, screenshotting, a process where the game player either captures the screen by using the "screen capture" function or uses the camera or camera-function provided within a game to capture a scene from the point of view of the playing character, should perhaps be renamed as screencutting. Even though a certain violence is implied by both terms, cutting involves a more multidimensional and less targeted operation. Its endpoint is not the arrival of a bullet (or bullet-like ray of light) that razors the world into submission, but rather the creation of a temporary 3D shape that subsequently becomes flattened and recognized as an image. The experience of capturing screens, in whole or in part, as images in a 3D game environment allows us to move beyond the camera/shutter model of perception, enacted by the supposedly fixed eyes which neatly slice the world into stills. This model, whose shadow still lingers in many contemporary conceptualizations of vision as stable, acute, and anchored, was based, as previously mentioned, on the architecture of the camera obscura. The camera obscura's monocular aperture became "a more perfect terminus for a cone of vision, a more perfect incarnation of a single point than the awkward binocular body of the human subject."[69] In-game camera activity can allow us to reclaim and reengage the body's mobility and awkwardness. It can do this not so much by offering a prosthesis of vision in the gameworld but rather by becoming "an extension of our moving-and-perceiving body, in its dual nature as both subject and object in the world."[70] As well as allowing for an experiential enactment of some learned behaviors around perception, vision, mobility, and action in a controlled environment of the game, gaming can also facilitate the exploration of framing as a corporeal-conceptual device for organizing the world.

Framing is of course an artifice, as the world does not present itself to us in frames—although, as we saw in the earlier discussion, there is no verifiable theory of how it does present itself *to us*. To push this idea further, it is worth mentioning that many contemporary theories of perception adopt what cognitive psychologist Donald E. Hoffman has termed "conscious realism," an updated yet reversed version of Bishop Berkeley's conviction that reality, or at least what we humans call and perceive *as* reality, is only ever a product of our senses.[71] Unlike Berkeley's subjective idealism, this theory does not negate the existence of reality, that is, of the actual material "stuff" that makes up the world; it only challenges the possibility of us ever accessing that reality in a true, unmediated way. In other words, we could say that we see what we need to see rather than what is "really" out there, while there is no one to assess and guarantee what this out-thereness looks like, as any attempt to describe, capture, and measure it is inevitably entangled with the very devices, be they human or machinic, that undertake the process of description, capture, and measurement. Framing is an important part of this process, especially as knowledge and understanding, increasingly produced in a visual form today, often come to us framed, from the rectangle of the book block to the square of Instagram. We could therefore go so far as to suggest that we frame the world in rectangles not because our visual apparatus encourages us to do so, but rather because rectangular frames, in the shape of mirrors, windows, books, and pictures, are already part of our established epistemological repertoire.

Cutting the gameworld into rectangles and squares, screenshotting in gameworlds offers gamers an opportunity to enact the fantasy of the early industrial age: that of becoming an eye. With its antecedents in the wide range of optical instruments—such as opera glasses, bi- and monoculars, and spyglasses[72]—made for the pleasure of the eighteenth-century urban voyeur, this fantasy has been rechanneled by many recent experiments, from the ill-fated Google Glass through to wearable cameras. Indeed, the frequency and semiautomation with which camera phones are now used have created a situation in which perception, experience, and consciousness are permanently coupled with framing and capturing the world through a handheld rectangular glass device. The artificial, laboratory-like aspect of the game environment is therefore getting ever closer to the experience one has in the world *outside* the game. Game theorist Rune Klevjer argues that in "navigable 3D environments, the main 'body' of the avatar,

in the phenomenological sense, is not the controllable marionette itself (for example Mario or Lara), but the navigable virtual camera, which becomes an extension of the player's locomotive vision during play."[73] 3D games can thus be said to facilitate the enactment of a mediated desire for "becoming an eye": that of "becoming a camera." There is a long history of artists experimenting with image-making and vision in this way, from Aleksandr Rodchenko's and László Moholy-Nagy's adoption of the floating viewpoint of a bird or the angular perception of an insect through to Lindsay Seers literally becoming a camera by taking photos with her mouth.[74] In gameworlds, this artist is no longer avant-garde, and they are no longer even an "artist." In the plethora of possibilities and angles on offer—2½D, over the player's shoulder, camera-centered behind the player, unbroken first-person perspective, perspective switch, freelook—screencutting allows *any* player to produce a multiperspectival, multilayered tissue of images that are a direct result of them approaching a scene in a certain way, be it from within the game (as a character) or from outside (as a player). The images produced are therefore an outcome of the interwoven and mutually constitutive ecologies of perception and media. With this proposition I am adopting a somewhat different stand, and a more fluid understanding of photography, from the one proposed by Giddings, for whom in-game photography is just a simulation of photography, its "mere trace" or "ghost,"[75] because it does not emerge as a result of light's direct impact upon the sensitive surface. It is thus rather a form of "virtual heliography," freezing the game's virtual environment as a picture. For me the image-making act is not confined to what happens on the level of screen or code: it encompasses the whole environment in which the gamer, the game, and the gaming platform are located. Light is of course never absent from this process— which is what allows me to treat it as an extension of photography rather than just its mere trace.

In-game photography in the simulated space of the gameworld also allows for the denaturalization of perception: it reconnects the perceiving agent with the mechanics of its perceptive apparatus, while foregrounding the latter's technical aspects. It is therefore perhaps more apposite to say that screenshotting does not so much *de*naturalize perception as a specific learned behavior but rather *de*mechanizes it. It also reframes being in the world as being a sensing agent, one whose openness to the world comes not just through the primary sensory organs such as the eyes or the ears but also through the distributed perceptive multiorgan that entails the whole body—an

organ that is often referred to, somewhat reductively, as "the brain." It thus allows us to see better, and to understand seeing not just corporally but also as a fundamentally haptic process. Indeed, for me the game environment became a space for reorienting myself as a distributed subject of perception and action, and for taking in this knowledge, mentally and corporeally.

This kind of experience could of course be undertaken in a different visual environment—an immersive art installation or even a city walk, not to mention a walk with a camera. However, the photographic act as it is traditionally conceived, especially in street photography, remains too tied to the masterful notion of capturing a Cartier-Bressonesque "decisive moment," a flattened picture that looks like a disembodied snapshot of a reality unfolding "out there," rather than an outcome of an active process of the photographer cutting into the optic flow with their complex perceptive-technical apparatus to produce such an image. What thus tends to get forgotten or overlooked in traditional camera-based photography is the dynamic relationship between the optic flow—which is also a potential media flow—and the perceiving subject. Rexer claims that the majority of attitudes to the photographic medium since its nascence have assumed "an independence for the photographer, a sovereign position of outsider and roving eye. They also assume the self-sufficiency of each captured moment, as if it were distinct, discontinuous, and capable of containing whatever might be significant about the reality of that place and time."[76] In the more traditional photographic practice, the photographer's physical and technical corpus all converge to become a disembodied eye.

The mediated experience of being in a video game could be said to challenge the naturalized enculturation of photographic image-making as an objective representation of reality, while also opening the apparatus beyond the eye-hand-world triangle. Both embracing and eliding the experience of mediation, the game environment stages worldliness for us as a mobile task to explore and engage with, with players' eyes, hands, brains, and bodies all participating in seeing *and/as* doing. In *Mobile Screens: The Visual Regime of Navigation* Nanna Verhoeff suggests that "interaction with screen-based interfaces already entails a performative, creative act."[77] She argues that in the visual regime of navigation movement itself is both performative and creative because it "not only transports the physical body, but affects the virtual realm of spatial representation. This implies a temporal collapse between making images and perceiving them."[78] Here perception reveals itself to be an inherently creative task. In screenshotting the photographer's

eye extends beyond the optical apparatus with its line of vision to reach into the world in a more dynamic and enfolded way. Screenshotting, I thus want to suggest, can offer a corrective to the representationalist understanding of photography by reversing the schema: in the game *the whole body becomes a camera*, with the photographer's eye extended beyond the optical apparatus with its line of vision to reach into the world in a more dynamic and enfolded way.

Given that the camera often remains invisible in a game, in-game photography is particularly predisposed to enact the process of repositioning human perception as ecological. Indeed, as mentioned earlier, in many instances the whole body becomes, or maybe even *morphs with*, a camera, because walking itself is an actively engaged mode of seeing and sensing. In certain first-person games a reversal of this process also occurs, with the camera *becoming a body* by simulating the body's functions without the need for any actual presence of the body on the screen—as the camera is already enacting those functions.[79] The coupling of the activities of walking, seeing, and sensing that result in the production of what Poremba has called a "camera avatar"[80] is actually imperative for the survival of the playing character in many games: otherwise, they simply get shot. Screenshotting thus allows the (insubordinate) player to escape, at least temporarily, the logic of screen shooting that many games are premised on by allowing them to linger in in-between spaces not designed for action. By slowing down the game and spending "unnecessary" time in such spaces, the player learns, via their character, how to navigate the world, while also taking on and enacting perception with their whole body. Poignantly illustrating the error of the persistence of vision theory, screenshotting also playfully engages with it as a lingering shadow in understanding our perception of motion, in film and "in life." If our "brain" has indeed evolved not to see "reality" but to help us survive,[81] the constant flood of intermixed stimuli would be impossible to process as discrete pieces of information. Life can thus be redescribed as an ongoing process of navigating between cinema and photography, with image-making becoming a mode of world-making, for gamers and nongamers alike.

Flowcuts IV: (Fore)seeing the end of the world

In a somewhat uncanny turn of events, I took first steps toward this project on perception and gaming in 2018, but the majority of the *Flowcuts* images were made in early 2020. This meant that I was screenshotting the gameworlds that

had been abandoned by their inhabitants as a result of some vaguely specified global-scale pandemics while becoming increasingly aware of the Covid-19 epidemic developing in Wuhan, China. By the time I completed the set of images in March 2020, the World Health Organization had announced a worldwide pandemic, with my home city of London, UK, going into partial lockdown. I started wondering whether I should pull the project altogether, rewrite it, or replay it through other games. I became anxious about the timing, about the work being seen as an example of disaster scholarship or trauma art, a cynical attempt to milk public anxiety for my own visual experimentation—and this is where we come to the point I made earlier about the experience of perception and gaming never being context- or content-free, and about how it matters which game is being played, who plays it, when, and what for. In the end, I decided to retain the images. Even though the project is ostensibly about perception, and it could therefore have been illustrated with a whole variety of other, visually "nicer" and safer, games, I cannot deny my own premonitory turn to postapocalyptic scenarios to think about how we see and frame the world.

There are of course good epistemological—and ontological—reasons for this premonition. Indeed, I have been concerned with the apocalypse in my work for a while now. This concern has been fueled by the dual eco-eco crisis—the unfolding climate catastrophe and the accompanying economic disasters in different parts of the world in the aftermath of the global financial crash of 2008—but also by the increasing reorganization of our perception and cognition by algorithms. I have also been intrigued by the ongoing popularity of stories about our human collapse as a civilization and species, with or without the possibility of redemption. It is important to note that it is not the apocalypse as such that enthralls me, but rather the way it is being mobilized and utilized in concepts, words, and images. As part of this exploration, I have become increasingly suspicious of the so-called "ruin porn" associated with the representation of dilapidated landscapes, abandoned buildings, and soon-to-expire worlds.[82] In proposing the notion of a "feminist counterapocalypse" in a recent book,[83] I wanted to raise questions about the modes of knowledge and visualization, and the paternalistic articulations related to them, offered by some contemporary prophets of doom and gloom. At the end of the day, many such prophets seem more interested in peddling their wares, be it the latest techno-fixes or the latest Great Ideas, than in developing more workable ways of collaboration and coexistence on our planet, for humans and nonhumans alike. Such totalized imaginings of the end of the world seem to forget that the apocalypse itself is not distributed equally. Many groups, tribes, peoples, and nations throughout our human history have already experienced vital threats to their existence, via environmental or sociopolitical means. There is thus something politically disabling in adopting this all-encompassing apocalyptic tenor to describe the fate of the world for "us all."

The Covid-19 pandemic created a new enactment of the end of the world as "we" know it, while creating a temporary illusion of a unified global humanity.

Yet, as with the previous crises, the corona-apocalypse did not affect everyone with the same intensity, with geographical, ethnic, and class fault lines delineating numerous zones of exclusion and exception. Nor did it forecast an equal prognosis for all: while many were looking at a future of economic, social, and environmental distress, with the indigenous populations across the Amazon region, for example, made even more vulnerable due to strongman Jair Bolsonaro's opportunistic mismanagement of the response to the virus in Brazil raising fears of land grab or even genocide,[84] the online giant Amazon "emerged as one of the big winners of the coronavirus pandemic . . . , announcing it had revenues of $75.4bn in the first three months of the year [2020]."[85]

This hopefully goes some way toward explaining why, in my first-ever venture into videogaming, I chose games that dealt with imagining the apocalypse—a popular entertainment genre in different media in recent times, but one that offers particularly rich material for both training our imagination and exploring behavioral simulation in gameworlds. Yet we must remember that fascination with disaster kitsch is also a psychological mechanism, allowing us to cope with anxiety about the end of the world, whether this means the end of our planet or of our everyday ways of going about things. Indeed, ruin porn has a mollifying nature: it projects and forecasts horror and trauma for us so that we do not have to spend time and energy imagining it, while also enclosing it for us in a series of palatable albeit horror-inducing images. Apocalyptic imagery gives us the relief of being able to stare at a disaster from a distance, in the safety of our own home, computer, or phone, while being able to slowly take it in. But it also becomes a carrier of our anxiety, framing disaster for us as pictures while taking it away, for a short while at least.

Eschewing any form of romantic environmentalism while drawing on the available repertoire of media images, my own mode of showcasing the apocalypse operates within the register of "eco-eco-punk." The dual "eco-eco" prefix functions here as a form of mirroring, signaling a mediation of environmental and planetary politics via technological praxis and an active engagement with media setups. Echoing the culture of remix, eco-eco-punk mixes punk's aesthetics of bricolage with the environmental commitment to reworlding while redrawing the limits of what can be seen and sensed. In any kind of political or existential crisis, the question of perception, of our bodies and minds interacting with the world of which they are part to make meanings and interventions in it, remains fundamental. Because, before we figure out how we can mobilize the redemptive promise entailed in any apocalyptic narrative to try to make our world more livable, we need to ask a number of fundamental questions: How do we see what's around us? How do we organize the flow of images, data, figures, affects, and percepts to construct a coherent picture of the world? When do we become ready to see things? How do we frame what we see? And how can we reframe it?

4 From Machine Vision to a Nontrivial Perception Machine

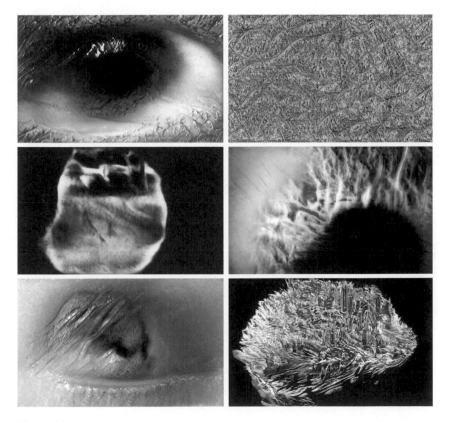

Figure 4.1
Stills from Joanna Zylinska, *Neuromatic*, 2020.

Neuromatic

The images that open this chapter (figure 4.1) come from a video work of mine called *Neuromatic*, which frames the key issues of the chapter. To make the video, I reanimated, with the help of a BigGAN algorithm (available via ArtBreeder), some historical and contemporary images of eyes and brains. The images had been drawn from the Wellcome Collection, a UK repository of medical images. The idea behind *Neuromatic* was to explore perception as a process unfolding between the eye, the brain, and the world—in humans and machines. The video's title is constructed from two terms: *neuro*, referring to the nervous system, and *matic*, standing for something pertaining to the eye (*mati* in modern Greek), but also sharing the meaning of the -matic suffix (as in *automatic*, "willing to perform"). *Neuromatic* aims to capture this link between the eye and the brain in the visual apparatus. It also invites a reflection on whether vision itself can be understood in machinic terms.

How to see better than humans

This chapter continues the interrogation of imaging and perception by focusing on the problem of machine vision, but it also analyzes the problem *with* machine vision. As part of this analysis, I will embark on an experiment in "conceptual engineering," an approach that links the pragmatism of the machine-building discipline with its Latin etymology in *ingeniare*, meaning to devise, create, or contrive—and thus also to play. With some help from select computer scientists and neuroscientists, I will explore the possibility of building a perception machine—of a nontrivial variety, no less. The chapter draws on two science papers, separated by a couple of decades, by authors who made significant contributions to the debate on the relationship between humans and machines: Heinz von Foerster's 1971 "Perception of the Future and the Future of Perception," which introduced the concept of a "non-trivial machine," and Gerald M. Edelman and George N. Reeke Jr.'s 1990 "Is It Possible to Construct a Perception Machine?" I will engage with those papers in an attempt to construct a conceptual scaffolding for a theory and praxis of machine perception, while interrogating the role of photography and other forms of imaging in industry efforts to get machines to "see."

Mindful of Andreas Broeckmann's indication that "machine" "is a complicated concept that, if used carelessly, troubles any thought about technology more than it clarifies,"[1] I want to explain and contextualize the key terms and concepts that shape my argument. The term "machine vision" refers to the systems engineering discipline that works on the automatic extraction of information from digital images to enable machines to perform tasks requiring human sight—and to do it faster and more efficiently than human sight could. Such tasks may include quality control, identification, verification, positioning, and measurement, and can be found in applications such as detection systems in self-driving cars, manufacturing, security, or space exploration. Machine vision systems rely on cameras with sensors, processing hardware, and software algorithms. Their software side is underpinned by a cognate discipline called "computer vision," a subfield of the broad area of artificial intelligence, which theorizes how the extraction of information from digital images actually occurs—although the two terms, "machine vision" and "computer vision," are sometimes used interchangeably. The primary goal of research in computer vision is to teach computers to see, and to make this seeing meaningful to them, at least within the parameters of the set tasks. In its current iteration, machine vision is aimed at imitating the way humans see the world, but this imitation attempt occurs only *after human visual processes have been redefined in computational terms.*[2] The ultimate goal of machine vision is to learn how to see *better*, that is faster and more efficiently, than humans.

The methodological premises for teaching computers to see were laid in the late 1950s; a 1959 paper by two neurophysiologists, David Hubel and Torsten Wiesel, titled "Receptive Fields of Single Neurons in the Cat's Striate Cortex," is widely referenced as foundational to the subsequent developments in computer vision. The paper was based on a series of experiments conducted by the two researchers on "lightly anaesthetized"[3] felines whose eyes had been "immobilized by continuous intravenous injection of succinylcholine"[4] to eliminate unpredictable eye movement. The cats were being shown pictures of various dots and light shapes, or were having such shapes projected onto their retinas, with a view to assessing the felines' brain activity and thus identifying cortical correlates of vision. While failing to detect any significant changes to the cats' neuronal activity as a result of being exposed to the light projections of various shapes, the

experimenters had a breakthrough when some of the cats' cortical neurons started firing furiously in reaction to the cats being exposed to slits of light. Hubel and Wiesel eventually realized that what the cats' retinas were reacting to was not any specific shape, such as a dot or a line, but rather change in light intensity at the edge of a slide frame. The two researchers traced this activity to what they ended up calling "simple cells" in (what is now known as) the primary visual cortex. This experiment, conducted as it was on immobile nonhuman subjects, under laboratory conditions, led to the inauguration of one of the foundational assumptions—or, indeed, myths—of computer vision: the belief that the process of vision is multi-layered and hierarchical, that it is possible to extricate the essence of vision in various animals (including those of a human variety), that the mechanism of edge perception is what lies at the core of vision, that the process is physiological and content-independent, and that machines can be taught to see "like humans" by mimicking this process of pattern perception at the level of pixels.

These formalist parameters were consolidated by a 1982 textbook of computer vision, simply titled *Vision*, by MIT neuroscientist David Marr. For Marr, vision was primarily a phenomenon of information processing.[5] "In this framework, the process of vision proceeds by constructing a set of representations, starting from a description of the input image, and culminating with a description of three-dimensional objects in the surrounding environment."[6] The framework assumes that the mechanism of primary visual processes such as edge detection or binocular vision is computational and that it works its way from those primary processes upward in its study of the neural circuitry supposedly enabling vision, all the way to the brain.[7] It is this understanding of "computer vision," and of its engineering counterpart, "machine vision," that I aim to critically interrogate here. My overall goal is to probe how, or indeed whether, machines can actually see at all. I am also interested in what it means for us humans to endow machines with the capacity for seeing, or rather, to classify *as seeing* their ability to differentiate between objects in the world on the basis of the light reflected off them and transmitted as data to those machines' processors. This critical investigation will allow me to explore the possibility of building a perception machine, on terms that engage with, but also go beyond, those delineated by biology and computer science.

From machine vision to machine perception

The shift from vision to perception enacted as part of my experiment is not entirely mine: in recent years many AI researchers have gone beyond the explicit ocularcentrism of machine vision to extend the study of machines' data capture operations to other senses, such as hearing, touch, and olfaction. Expanding their data sources from still images to sounds, music, and video, Google is now using the term "machine perception" in lieu of "machine vision." Indeed, this is the second most popular category, after "machine intelligence," in its database of AI research.[8] Object recognition premised on algorithms trained on processing large, partially labeled datasets using parallel computing clusters, originally trained on optical images but now expanded to sound, music, and video, forms the basis of its functioning.[9] The notion of machine perception shifts the focus from the flatness of 2D images to the 3D environment which produces them, and which hosts the seeing machine, yet it still retains the sense of predefined objects, with their corresponding categories.

The notion of "machine perception" I am proposing here, adopted in a wider sense than the one offered by Google, aims to address one of the key blind spots of computer vision today: its inability to fully account for how our brains actually work and how the translation process from retinal stimulation (which used to be known as a "retinal image," as discussed in chapter 3) through to the neural circuits of the brain occurs, while producing a sensation and an awareness of this sensation (recognized in the form of an image that we "see") in humans. It also aims to raise questions for the postulation of the discrete physiological unity called "the brain" as the core organ of perception. This is not just humanities-scholar talk, driven by imprecision and the bending of categories for the sake of intellectual delight. A well-known 1959 paper by cognitive scientist J. Y. Lettvin et al., "What the Frog's Eye Tells the Frog's Brain," demonstrated that perceptive activity that had been assumed to take place in the brain as a consequence of the retina being stimulated by light in fact had already begun in the eye. "The eye speaks to the brain in a language already highly organized and interpreted, instead of transmitting some more or less accurate copy of the distribution of light on the receptors," Lettvin and colleagues argued.[10] The exact location of perceptive processes and the exact working of their

operative mechanisms remain difficult to pin down not just in frogs but also in humans. Machines, in turn, are designed to "interpret images very simply: as a series of pixels, each with their own set of color values."[11] My notion of machine perception aims to complicate the simplicity of this model—and to explore a different way of understanding what it might mean for machines to see.

Perception of the future

The "conceptual engineering" aspect of this chapter departs somewhat from the recent uses of this term in analytic philosophy, where it serves as a more programmatic and less playful thought device. David Chalmers, for example, defines conceptual engineering as "the process of designing, implementing, and evaluating concepts."[12] Fixing and hence stabilizing concepts is at least as important to him as the act of inventing them. For me, however, conceptual engineering has something of feminist cyborg bricolage about it: it is less permanent, less intent on fortifying edifices— and much more mischievous and punk. Bringing together the two aspects of Chalmers's proposition, "de novo engineering" and "re-engineering," it retraces the patterns and scaffoldings of the established ideas and texts to arrange some new, albeit temporary, constructions—while looking for safety exits.

As indicated earlier, there are good reasons for turning to the papers by von Foerster and by Edelman and Reeke, as these authors played an important role in redefining physiological phenomena such as perception and vision as programmable. As part of their research, they set out to redraw traditional disciplinary boundaries in an attempt to find a new way of understanding humans and machines, or even humans *as* machines. Von Foerster was an Austrian physicist and engineer with an active interest in biology who spent most of his working life in the United States. He was one of the key participants in the Macy conferences, a series of meetings that took place between 1940 and 1961 which led to the emergence of cybernetics as a transdisciplinary field studying biological and mechanical systems. Von Foerster gained recognition for his work on second-level cybernetics, i.e., the proposition that the system's feedback loop needed to incorporate the observer into its operations, with human self-reflexivity becoming part of the cross-systemic operations across different levels. Von Foerster was a

prolific writer, often veering beyond the confines of his discipline or even beyond science as such to offer a wider commentary on society and the world. "Perception of the Future and the Future of Perception," first presented at the opening of the Annual Conference on World Affairs at the University of Colorado, Boulder, in 1971, is an example of this approach.

The paper opens with a turn to systems theory as a way of thinking about sociocultural change, while also pointing out the limitations of the static model of the system, whereby change is seen as an aberration to be corrected rather than an incentive to perform alteration at the systemic level. Taking account of systemic operations, von Foerster goes on to seek an opening within the system, toward an execution of human freedom and agency—and it is perception that he turns to for this purpose. (We can see similar intimations in Flusser's work, which was largely inspired by cybernetic thinking.) Specifically, von Foerster advises us that "if we wish to be subjects, rather than objects, what we see now, that is, our perception, must be foresight rather than hindsight."[13] In other words, he calls on us not to fall back on the established patterns of seeing things but rather to follow unexpected routes and pathways, taking a lesson from children. So far, so pastoral. He is of course not the first thinker to evoke the idea of original untarnished vision as a supposedly better entry point into the truth of the world: Enlightenment philosophers advocating a return to the "state of nature," romantic poets, and surrealist artists were there before him. Yet von Foerster has some interesting things to say about the current atrophy (or, as he terms it, "castration") of perception, for which he blames the commodification of information and "an educational system that confuses the process of creating new processes with the dispensing of goods called 'knowledge.'"[14] To offer a remedy for this state of affairs, von Foerster introduces the concept of a "non-trivial machine," where the "machine" "refers to well-defined functional properties of an abstract entity rather than to an assembly of cogwheels, buttons and levers, although such assemblies may represent embodiments of these abstract functional entities."[15]

While a "trivial machine" is premised on a one-to-one relationship between its "input" and its "output," thus delivering predictable, indeed consistently identical, results (at least in theory), in a nontrivial machine "its previous steps determine its present reactions."[16] While both systems are deterministic, the second one is unpredictable because its output changes with what it has picked up in the previous cycles of its operation. Von

Foerster does appreciate the reliable predictability of various trivial systems, such as toasters or cars, but raises concerns about the application of trivialization to other system—and this is where his concept of the machine and his argument become particularly interesting. He takes the example of a student, whom von Foerster sees as a potentially nontrivial machine, becoming completely "trivialized" when he (*sic*) enters a higher-level machine, i.e., a university, with its predictable teaching and uncreative testing. "Tests are devices to establish a measure of trivialization," von Foerster proclaims. "A perfect score in a test is indicative of perfect trivialization: the student is completely predictable and thus can be admitted into society. He will cause neither any surprises nor any trouble."[17] While the human (the student) is seen here as a machine, still in the process of being constructed in his relatively young age, the higher-level operations of the recursive loops enable the possibility of creativity within the system, made up of other machines (educators, forms of knowledge and ways of their transmission, pedagogies, buildings, and infrastructures)—but only if the human agents execute their potential: in other terms, when they embrace the incomputable as part of systemic rationality.[18]

It may seem obvious that educators or indeed most humans would want to do this, and that they would reach for the systemically determined yet ultimately undefined degree of freedom available to them. Yet, as confirmed both by von Foerster (who sees reluctance to exercise freedom as a form of illness) and Flusser (for whom we always operate under the condition of systemic predictability, be it on the level of the technical apparatus, society, or the inevitably entropic universe),[19] such acts of reaching out toward freedom, i.e., attempting to change the system's course of action, are quite rare. Von Foerster's paper ends with a rather humanist call to cherish the "troublemakers," whom he says we will recognize "by an act of creation: 'Let there be vision: and there was light.'"[20] Interestingly, though, it is through perception, i.e., the way of seeing attentively,[21] that we (as educators and assessors of students) are said to be able to introduce novelty into the input-output process and thus create a systemic opening. This could be a first step in attempting to build a nontrivial perception machine.

But how *do* we make students, or indeed anyone, see better, without knowing in advance what we want them to see, what kind of frameworks we are looking through and aiming for? Is there not a danger that this call on the part of von Foerster will ultimately sound banal, or in fact trivial:

at best vaguely humanist, at worst a recipe for all sorts of educational libertarians to break with the expertise and care developed within the educational system? Frequently described as a "polymath," von Foerster is one of a long line of (predominantly male) scientists who opine on wider societal issues, making quick excursions to scientific models and protocols in order to develop explanations of the world while demonstrating strange blind spots when it comes to the cultural aspects of the systems they write about, including the terminological and ideological determination of their concepts. (Of course, all conceptual frameworks are ideologically determined, but it is the unawareness or obfuscation of this phenomenon, coupled with the ascription of "ideology" to one's intellectual opponents, that I am highlighting as a problem here.)

This model of what we might term "truncated rationality" is still very much at work in the very hotbed of cybernetic and postcybernetic thinking: Silicon Valley. In his poignantly titled *What Tech Calls Thinking: An Inquiry into the Intellectual Bedrock of Silicon Valley*, Stanford literature professor Adrian Daub points to an "amnesia around the concepts that tech companies draw on to make public policy,"[22] coupled with the fetishization of the novelty of the problem. This approach is premised on the overlooking or even negation of the critical and analytic tools that had previously been used by others to deal with similar problems. Through their pronouncements and publicity campaigns, Silicon Valley entrepreneurs can position themselves as visionaries, while disenfranchising "all of the people with a long tradition of analyzing these problems—whether they're experts, activists, academics, union organizers, journalists, or politicians."[23] What tech calls thinking is thus a form of instrumental rationality which has been shaped by the Randian myth of individualism and the logic of capital.[24] It is not only profoundly anti-intellectual but also, contrary to its own self-image, counterrevolutionary. "This is where the limits of our thinking very quickly become the limits of our politics,"[25] adds Daub. But while Silicon Valley is its most visible actualization, this form of truncated rationality exists and indeed thrives in scholarly disciplines such as analytic philosophy, linguistics, biology, cognitive psychology, and neuroscience—a cluster of disciplines that provide intellectual foundations for the field of artificial intelligence, and which frequently rely on copious amounts of technological and military funding.

By way of responding to the omnipresent working of truncated rationality in our increasingly automated and datafied society, Luciana Parisi has

come up with what she has termed the "Alien Hypothesis," a proposition which embraces "an abductive, constructionist, experimental envisioning of the working of logic . . . as part of a speculative image of the alien subject of AI."[26] What is interesting about her idea is that it comes *from within* the logical parameters of cybernetic thought. Her hypothesis is designed as an alternative to both the Cybernetic Hypothesis, positing that the only possible escape from the constraints of the computational system is a flight into zones of opacity and invisibility involving the total negation of the logic of the system, and the Accelerationist Hypothesis, which advocates dismantling the system's power from within by exhausting its operations. Instead, Parisi proposes to engage with the systemic operations on their own logical terms with a view to discovering "an alien space of reasoning"[27] *within* the system. Drawing on the consequences of mathematician Gregory Chaitin's identification of incomputables within computational systems,[28] she argues for the possibility of finding such a space *beneath* the scripted and looped servomechanics of the system that make it seem like there is no other way. "The challenge," she suggests "is to determine the kind of appropriation that can open political possibilities with technology from within its mode of existence."[29] Parisi's solution lies in reconceptualizing the medium of thought beyond its automation and instrumentalization within the current machinic systems. Mine here, in turn, involves taking a step back alongside our cognitive-sensory spectrum to offer perception rather than thought as a primary mode of engaging with the world, one through which such an attempt at undoing the system's operations is most likely to succeed.[30]

Vision beyond the brain

So, is it possible to construct a perception machine? This question was originally posed by biologist and Nobel laureate Gerald M. Edelman and his collaborator George N. Reeke Jr. in their 1990 paper. Edelman and Reeke's work was part of their wider project on the neglect of findings from evolutionary biology in AI research. In an article written two years prior, they chastised AI researchers for remaining too wedded to "epistemological assumptions drawn on the one hand from the arguments of Alan Turing and Alonzo Church about the universal problem-solving capabilities of computers (suggesting that the brain may be understood as a computer) and on the other hand from the reductionism of molecular biology (suggesting

that the brain may be understood as a collection of units that exchange chemical signals)."[31] They also had some rather critical things to say about "neural network computing"[32] as an approach that promised to develop machine vision by modeling it on the operations of the human brain. For them "neural network computing" is a misnomer because the approach that underpins it is premised on a badly conceived analogy between neural networks in the brain and computer networks, and not on the way biology actually understands and works with neural structures. The strictly computational approach, they argued, cannot really tell us much about perception because of its foundational error—namely, the belief that "objects and events, categories and logic are given and that the nature of the task for the brain is to process information about the world with algorithms to arrive at conclusions leading to behavior. . . . This 'category problem' leads directly to the inability of AI systems to cope with the complexity and unpredictability of the real world."[33]

Recursive neural networks used in machine (aka deep) learning that consist of layers of nodes can be said to have partly addressed the problem of being unable to deal with the increasing complexity and uncertainty of the world. Indeed, they have had significant successes in identifying patterns and trends in imprecise data, as evident in applications such as face recognition, medical data analysis, weather prediction, or natural language translation. Yet neural networks as currently conceived in AI research still do not ultimately challenge the assumption "that information exists in the world," while the organism "is a *receiver* rather than a *creator* of criteria leading to information."[34] I am particularly interested in Edelman and Reeke's critique of the idea of objects and events existing in the world out there, to be seen, grasped, and manipulated by us. This critique corresponds to the philosophical position of "conscious realism" espoused by Donald D. Hoffman discussed in the previous chapter. This is not to say that there is *nothing* in the world, only that the preconceived and discretized objects that allegedly present themselves for our vision to capture are outcomes of a creative, dynamic yet ultimately undetermined process.[35] We see what we need to see, argues Hoffman. For him, the nature of this need is biological, or, more precisely, evolutionary, in the sense that the purpose of our seeing is our survival—and this is where his intellectual trajectory coincides with Edelman and Reeke's. Indeed, as a riposte to computational schematism in physics, Edelman and Reeke suggest that any viable theory of categorization

and intelligence to be used in AI research needs to embrace the Darwinian model of selection, but adjusted for the working of the neurons of a single organism operating during its lifetime. This conclusion serves as the grounding for their 1990 paper about the possibility of constructing a perception machine.[36]

And, indeed, in the paper they propose such a construct. Named, without any equivocation or irony, Darwin III,[37] this machine's architecture is premised on their proposition that categorization (rather than the more straightforward object recognition as applied in computer vision systems) is a critical component of perceptual systems. Perception does involve "the adaptive discrimination of objects or events through one or more sensory modalities, separating them from the background and from other objects or events,"[38] but the difference here is that these objects are not predetermined. Instead, for Edelman and Reeke perception is not about grasping representations, as the categories used by the organism or machine do not exist in the world to be recognized by this organism or machine: rather, those categories are actively constructed (or, as Edelman and Reeke put it, they are meaningful to the perceiver "in a given situation").[39] Perception thus becomes redefined as "an active sensorimotor process, requiring exploration and depending on past experience."[40] In this model categorization needs to be seen as biological, not mathematical, because it cannot be solely expressed in symbolic form. The biological aspect of these organisms implies that movement through the world is needed for recognition, and hence perception and intelligence, to be enacted. This model is premised on the interesting idea, formulated in the authors' earlier paper, of the brain as "a selective system operating in somatic time,"[41] one which resonates with the phenomenological approach to AI design, which is increasing in popularity.

Yet Edelman and Reeke's concept of the perception machine itself remains hamstrung in this acultural model, with machinic operations positioned as primarily driven by natural selection. Cultural transmission of information is dismissed by them as not being relevant to the *evolutionary* development of working perceptual systems. Even though Darwin III is supposedly more firmly placed in the world, its orientation, vision, and goals are crippled by the temporality of its movement, with "somatic time" requiring an erasure of the said soma's singularity at the expense of the (supposedly) timeless operations of natural selection. There is therefore a danger that Edelman

and Reeke's perception machine may end up being rather trivial, because the information it will pick up to develop its categories, even if collected in a more dynamic and embedded way, will by design have been stripped of any cultural specificities—which here only amount to noise. However, designating which aspects of the surroundings can be classified as nature and which belong to the realm of culture is not straightforward.[42]

Anthropologist Tim Ingold argues that the difference between nature and culture is just a matter of temporality: history (which manifests as "culture" in different epochs) simply operates on shorter time scales than evolution (which proceeds according to laws of "nature"). Ingold goes on to show how Darwin's *Origin of Species* challenged the eighteenth-century view of "man" as a being equipped with special characteristics such as reason and morality, characteristics which were meant to separate him from the other species. Darwin postulated that the difference between the human and other animals was in fact one of degree, not of kind, and that evolution, which he had originally termed "descent with modification," was the manner through which this change toward rational man, endowed with intellectual and moral faculties, actually occurred. Yet the problem with that view was that it inaugurated another differentiation which today we would (rightly) describe as racist: one between the savage and the civilized man. The only way out of this dilemma was to attribute "the movement of history to a process of culture that differs in kind, not degree, from the process of biological evolution," explains Ingold.[43] It was also to put forward the idea of two parallel kinds of inheritance in human populations: one biological (involving the transmission of genetic information encoded in the DNA and referring to the core identity of the human—e.g., walking), the other cultural (taking place through social learning—e.g., being able to play an instrument). Yet Ingold argues, following many other cultural anthropologists, that there is nothing "purely" natural about walking—and that neither is learning to play an instrument a fully cultural experience, separated from the transmission of embodiment. Instead, "those specific ways of acting, perceiving and knowing that we have been accustomed to call cultural are enfolded, in the course of ontogenetic development, into the constitution of the human organism," which makes them equally "facts of biology."[44] At the heart of the problem lies not so much the conflation of the biological with the genetic, Ingold points out. The decoupling of the processes of historical and biological change should therefore rather be

treated as a detemporalization, a process premised on the fictitious positing of separate temporalities for certain kinds of changes over others. This fallacious model is still very much with us. It subtends the present consensus with regard to science as a method—and the disciplinary division between the sciences and the humanities.[45]

Machine vision and epistemic (in)justice

Ingold's argument, which builds on the work of psychologist Daniel Lehrman, poses a challenge to any attempt to construct perceptual systems that will be capable of passing on their evolutionary traits to their offspring but will not be able to pass on any cultural influences (or, indeed, that will need to be free from such influences). Any traits that *will* get passed on will always carry both "natural" and "cultural" inscriptions, in a manner that will not allow for their easy decoupling, but the construction of culture as a separate domain of uninheritable features will perpetuate the distinction, while allowing computer scientists to forgo embodied and embedded modes of perception and cognition. This disembodied model of computer vision results in the preservation of one of the biggest science (and computer science) myths: the belief that data bias understood as cultural bias, once eliminated, will result in data that is both pure and fair.[46] We are regularly presented with consequences of such essentialization of biology and "the brain," at the expense of "cultural traits," in cognitive and computer science. Two examples from 2020 include the video conferencing platform Zoom's background algorithm, which removed the head of a Black academic any time he tried to use a virtual background, and the Twitter cropping algorithm, which privileged the showing of white faces in cropped images in its timeline.

While the computer vision system reveals itself not to be particularly perceptive, the consequences of its racialized blind spots are anything but trivial. Indeed, the algorithms that run within it are the same ones that make decisions about people's social, financial, or legal status, including punitive action at border control, denial of credit, prediction of educational failure, or assignment of criminality. While the early Google image recognition algorithm was shown in 2015 to auto-tag pictures of Black people as "gorillas,"[47] there is an ongoing problem with face recognition of Black females, with the high false match rate justified by industry experts

as being the result of a combination of the difficulty of lighting a Black face and the makeup worn. Denying explicit bias, Thorsten Thies, director of algorithm development of the German company Cognitec which supplies facial recognition systems to governments, explained in a troublingly disarming manner that it is "harder to take a good picture of a person with dark skin than it is for a white person."[48] One factor is that the image databases that serve as training sets for the algorithms are not properly representative, being skewed, in terms of volume and quality, toward photographs of white males. But there is a deeper logic at work here, endemic to the whole systemic infrastructure involved in the production of cameras, lighting systems, image-processing software, and the visual and cultural training of photographers and image technicians, that produces a particular set of internalized norms. These norms that can then be presented as posing an "objective" difficulty in taking a photo of a person with a dark skin. This mode of thinking, embedded in all sorts of technologies that precede the digital, is what Safia Noble has critiqued in her book *Algorithms of Oppression*. Noble's book analyzes the hidden operations of capital, race, and gender in algorithmic infrastructures, a process she terms "technological redlining."[49] Suggesting that "artificial intelligence will become a major human rights issue in the twenty-first century,"[50] she calls on us all to understand the architecture and logic of algorithmic decision-making tools in masking and deepening social inequality. As part of her analysis, Noble puts to rest the belief that unfair systemic decisions are just occasional aberrations which can be easily eliminated for the functionality and efficiency of the supposedly neutral system to be restored.

Murad Khan and Shinji Toya's project *Identity Turns on a Pixel When the World Becomes a Picture* poignantly illustrates the logic behind racial categorizations in machine learning and computer vision systems, an (il)logic that is premised on arbitrary categorizations replicating entrenched sociocultural perceptions of identity as only skin- (or hair-)deep. For their project the artists had scanned a photo of a young male, which was labeled by a facial recognition algorithm of a commercial software package as "Asian." They then morphed the photo in an AI-based image manipulation program, via the addition of facial hair and a cropped haircut, to create an image of a person that got labeled as White. Subsequently they analyzed the in-between stages in the morphed image to identify the threshold image over which the "crossing" between the racial categories occurred. It

turned out the difference between the two images boiled down to a single pixel. "The minute, discrete, and tangible nature of the pixel as a racialized limit point between categories points to a social problem at the heart of abstraction in machine learning systems,"[51] they concluded, revealing a gap between human vision, which is premised on an indeterminacy to be negotiated, over and over again, as part of our lived experience, and its machinic counterpart—where such indeterminacy must be eliminated at all cost.

CDO at Twitter Dantley @dantley responded to the 2020 cropping algorithm's debacle discussed earlier with the chest thumping yet predictable: "It's 100% our fault. No one should say otherwise. Now the next step is fixing it."[52] Yet Noble is very clear that "algorithmic oppression is not just a glitch in the system but, rather, is fundamental to the operating system of the web."[53] Mitra Azar, Geoff Cox, and Leonardo Impett similarly suggest that "in a structurally unequal society, it is exceedingly difficult to make a 'fair' algorithm; and it is effectively impossible to make an algorithm which is both fair and effective. . . . In a society which is unfair, a classification-machine will always be unfair (in at least one sense)."[54] It is therefore not enough to de-bias the data. Instead, we need to ask bigger questions about the forms of injustice embedded in the systems that host it. We also have to ask what it means when the elimination of the glitch, while desirable from a technical point of view, ends up making the punitive surveillance running on this data even more efficient. The correction of the data bias does not correct the violently penetrative and extractivist logic of the computer vision system: it actually strengthens it. We could thus say that we need to identify the unjust operations of the nontrivial *vision* machine to start thinking of building a nontrivial *perception* machine.

With this, as part of the "conceptual engineering" project outlined at the outset of this chapter, we are now shifting toward a conceptual expansion of the notion of the machine. In line with its cybernetic legacy from von Foerster and colleagues, the term "machine" departs from its strict engineering connotations to embrace any kind of system, be it mechanical or biological, of varying degrees of complexity. In their *Autopoiesis and Cognition*, a key text of systems theory which paved the way for applying systemic thinking not only to biological organisms but also to forms of social organization,[55] Humberto Maturana and Francisco Varela defined the machine as "a unity in the physical space defined by its organization,

which connotes a non-animistic outlook, and whose dynamisms [*sic*] is apparent."[56] In this framework, systems are arranged in a nested manner, from the microscopic to the cosmic, while undergoing internal transformations or even cross-systemic mutations. In the 1960s and 1970s the cybernetically inflected notion of the machine became a potent concept for philosophers and cultural theorists attempting to articulate different levels of sociopolitical complexity while taking into account the biological and technical constitution of both individuals and societies. We can mention here Gilles Deleuze and Félix Guattari's war and desiring machines, Michel Foucault's dispositive, and Vilém Flusser's apparatus. Building on this legacy, "the perception machine" embraces multiple, albeit interwoven, levels of meaning, from the biological level of the perception apparatus in human and nonhuman animals through the technical image-making apparatus, all the way to the sociopolitical setup—and to its technical infrastructures which have a planetary reach.

By now it should have become clear that in my attempt to build a nontrivial perception machine I am not really constructing a device, at least not in any straightforward way, but rather a conceptual framework, a scaffolding for both framing what we term the world and seeing this world better. Such a perception machine will have to do more than just identify symbols, avoid bias, or even account for the environment. In its architecture the idea of the brain as a discrete perceptive organ will need to give way to a dynamic interaction between the organism, with its constantly changing embodiment, and the environment—which, in turn, is not a constant but which "exists only in relation to the organisms that inhabit it, and embodies a history of interactions with them."[57] Indeed, there is no perception machine outside of its cultural and historical embeddedness. This acknowledgment calls for "nothing less than a new approach to evolution," one that does not posit "a radical break between evolution and history, or between biological and cultural evolution" but rather sees history as a "continuation into the field of human relations of a process that is going on throughout the organic world."[58] The very gesture of embarking on the task of trying to build a nontrivial perception machine is also meant to serve as a multiscalar attempt to both rethink our human perception and vision, and challenge the parameters of the emergent vision machine in our globally networked world. (This approach sums up the rationale behind my "conceptual engineering" project.)

The parameters of such a vision machine have been poignantly analyzed by Virilio in his 1994 book. Initiated with the development of the prostheses of sight such as the telescope in 1608 but accelerated three centuries later with the proliferation of "seeing machines," the transformation of vision is understood by Virilio in terms of a linear shift from the organic to the mechanical. It also entails an incontrovertible loss. Virilio's vision machine thus ends up being posited as "an autonomous technological system"[59] which disturbs the original organic unity and purity of human sight. John Johnston observes that "in Virilio's theory there is no positive side to the deregulation of perception (unlike Deleuze and Guattari's deterritorialization), no positive value, aesthetic or otherwise, to the freeing of perception from preestablished codes."[60]

Drawing on some of Virilio's concepts, as well as his political intimation with regard to the unjust and immoral uses of the visual technologies of surveillance, regulation, and control, in this book I go beyond his humanist melancholia to embrace an understanding of machines that encapsulates their organic and nonorganic iterations, that changes over time, and that constitutively shapes the human sensorium in different ways, while also enabling its reframing and recoding. I am doing this with a conviction that it is only through an acknowledgment of our own technical heritage, and through a prudent and responsible engagement with machines as co-constitutive of our bodies, societies, and environments, that we will be able to design better ways of being in the world—to develop an ethics and politics for a humachine world that is not just a form of organicist moralism. But, to do this, we will need not just a new ethical framework but also a new optics.

A nontrivial perception machine must be antiracist

The transformation of vision acquired a new intensity in the age of what Shoshana Zuboff has termed "surveillance capitalism."[61] For Zuboff the term describes a novel economic order, one that is characterized by parasitism and attempts at behavior modification, whereby human experience is reduced to raw material for the unprecedented operations of power wielded by technological companies. She defines this development "as a coup from above: an overthrow of the people's sovereignty."[62] While Zuboff offers some insightful analyses of the working philosophies and practices of companies such as Apple, Google, Amazon, Microsoft, and

Facebook, her proposed solutions are arguably less discerning. Leif Wetherby critiques Zuboff's study for being premised on a rather empty promise of systemic reform from inside. Wetherby argues that the metaphor of an all-consuming surveillance machine her book embraces is too totalizing, and that this machine "is really a dispersed and uneven set of global infrastructures."[63] "This system does not 'see' so much as it captures," he suggests, with the visual perception of our bodies being intertwined with the incessant seizure, processing, and distribution of abstract data about us, on multiple levels and in multiple domains.[64] The current vision machine we are living in is thus both a surveillance machine *and* a data capture device. It is also, as rightly pointed out by Virilio, a war machine, serving as it does as a digitized battleground featuring multiple operations of capture *and* carnage, with real-life consequences for human and nonhuman lives. Yet it is also, we must not forget, a pleasure machine, with photography and other forms of automated image-making shaping the flows of desire of human users who cannot be reduced to mere cultural "dupes."

My attempt to build a nontrivial perception machine presented here is thus aligned with Bernard Stiegler's analysis of automation in pharmacological terms,[65] where the process, although harmful to our individual and social life—as evidenced in our overall "ill-being," "nihilism," and "humanity's doubt about its future"[66]—can be worked through to release the machine's curative properties. The nontrivial perception machine we are building here will need to be able to scan through the obscure logic of the surveillance machine, which is also a data apparatus and a mechanism of warfare. To do this, such a nontrivial machine would need to do more than just be neutral or unbiased (although it should be that too): it must also be decisively antiracist. We could go even further and suggest that, to counter both the racist legacy of the war machine and the capitalist extractivism that fuels it, it must also, following Ariella Aïsha Azoulay, be counterimperialist. In her magisterial volume *Potential History: Unlearning Imperialism* Azoulay challenges the regime of rights and privileges that has shaped photography and the modes of perception and representation inaugurated by it since its early days, being designed as a medium through which "the world is made to be exhibited." The world is thus offered "only for a select audience."[67] She goes so far as to claim that "Photography developed with imperialism; the camera made visible and acceptable world destruction and legitimated the world's reconstruction on imperial terms."[68]

It may seem at first glance that Azoulay's argument is only aimed at humancentric photography, which is meant to be displayed and seen by (select groups of) humans—and not at large datasets feeding and shaping machine vision today. Yet the same form of rationality arguably underpins the production, storage, and categorization of all photographic and para-photographic images (including those rendered by CGI or GANs) because their constitutive logic, history, and modes of framing still hark back to the imperial mindset that legitimated classification as supposedly neutral, while putting it to work with Empire's goals in mind. The location and format of imperial rule have shifted today: in their eponymous book Michael Hardt and Antonio Negri argue that Empire now has no specific boundaries or territorial center of power. It has become "a *decentered* and *deterritorializing* apparatus of rule,"[69] with global capital flows enacting a form of biopolitics by being involved in the production of social life itself as an overlapping nexus of economic, political, and cultural forces. The neoimperial war machine is thus first and foremost a hegemonic surveillance network: it conquers by implicit consent and by the scale and invisibility of its penetration. All this is not to say that no nodes of power's concentration can be identified within this new imperial apparatus. However, the increasing shift of domination and decision-making from governments to corporations, from Washington to Silicon Valley, from the United States to China, and from humans to algorithms creates an uncertain and fuzzy geopolitics in which political and technological black boxes obscure the location of power as well as its actual operations. It also shifts the onus of responsibility onto individual citizens—whose primary yet already dual identity in this system is that of both network users and data points. The neoimperial surveillance machine is thus an updated version of Virilio's vision machine. A nontrivial perception machine could be seen as its conceptual and technical counterpart, one that offers an opening into a new vision of both ourselves and the world.

The Recognition Machine

The Recognition Machine by artists Antje Van Wichelen and SICV (Michael Murtaugh and Nicolas Malevé) can be seen as one possible enactment of such a nontrivial perception machine that is also actively counterimperialist. I had an opportunity to interact with the version of the work presented

Figure 4.2
Antje Van Wichelen and SICV, *The Recognition Machine*, 2018.

at the Photoszene Cologne festival in May 2019, but the project also has an online counterpart. Looking like a photo booth, *The Recognition Machine* invites gallery visitors to enter and take a digital photo of themselves. The act of taking a photo activates an algorithm that attempts "to establish links between the pixels just recorded and those of images from a database of 19th century anthropometric photographs," which have been transformed by analog techniques. "The resulting print output links contemporary regimes of surveillance to those of a colonial past."[70] The link between the images pivots around the emotions identified by the algorithm in the viewer's face and linked with the emotions read in the archival photos. The reading was obtained by training the algorithm on the FER-2013 dataset, in which each image had been assigned one of seven emotions: anger, disgust, fear, happiness, sadness, surprise, or neutral. Any possible misrecognition of emotions that occurs as part of the process serves as an alert to the system of consequences that predictive technology is imbricated with: while labeling here is just an innocent game for art audiences, the misrecognition of image links, their wrong categorization and ascription, has serious consequences for the lived lives of many. The visitor may keep the print obtained, but they are also asked to explore further the posited analogy and thus go deeper both into the archive and the colonial history of portraiture. Demonstrating the pixel-level slide between races as enacted by the logic of computer vision systems analyzed by Murad Khan and Shinji Toya, *The Recognition Machine* also shows us that all images exist as part of the imperial-colonial network of visuality, a network that renders some bodies as visible and proper while deeming others as illegible or illegal. What is particularly interesting about this project is that the artists dispense with the idea of a singular image as a stand-alone artifact to be consumed, classified, and otherwise exploited, showing that *all* images are part of multiple networks of knowledge and data exchange. *The Recognition Machine* thus offers a model of the perception machine as an invitation to study the production of visuality, the image networks, and their infrastructures; their underlying data and databases; the algorithms that shape both their production and their networking.

We could therefore conclude that a *nontrivial* perception machine would need to encourage an ethicopolitical engagement with images, their histories, databases, and infrastructures. It should also entail strategies for entering the database on the part of the human, with a view to deindustrializing

visuality and vision. It is therefore not just a matter of seeing what is inside the archival machine and how "it" thinks but also of creating conditions for thinking about human and machine vision otherwise. The human may not be able to see all the available images contained in multiple databases and data clouds, trace all the possible connections between them, or take cognizance of all the categories and labels on offer. But what is possible— and indeed imperative—is for the human viewer to take stock of the logic of opacity and scale that shapes the AI-driven perception machine, to ask questions about its operations and to demand a better (fairer, more histori-cal, more explicitly antiracist and counterimperialist) engagement with the image and data flow.

Unlearning imperialism, as Azoulay points out, needs to involve attend-ing to "the conceptual origins of imperial violence, the violence that presumes people and worlds as raw material, as always already imperial resources."[71] The fuzzy borders of today's Empire, coupled with the indi-vidual benefits of becoming-data for platform capitalism's servotechnology, make it easier for this form of violence to be seen as consensual—or not as violence at all. Taking first steps toward building a nontrivial perception machine can help us see this form of extractive biopolitical violence for what it is—and then start devising operations for countering it. A nontrivial perception machine can also be mobilized to render visible an envisioning process that operates as a condition of speculative thought.[72] We need to approach this task with the realization that, just as there is no space outside technicity (for us humans), there is no stepping outside visuality either. It goes without saying that such a machine cannot be built once and for all: it will need to be regularly rebuilt, retuned, and reprogrammed.

5 AUTO-FOTO-KINO: Photography after Cinema and AI

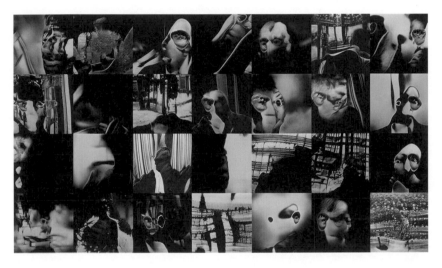

Figure 5.1
Joanna Zylinska, composite made from stills from *A Gift of the World (Oedipus on the Jetty)*, 2021.

Photography as an (always) moving image

This chapter explores further the pharmacological aspect of the perception machine, looking for restorative properties within its regulatory operations concerning vision and visuality. Bouncing off Gilles Deleuze's proposition that cinema is a medium that is capable of enacting the deterritorialization of vision by shifting it beyond its dominant corporeal parameters and sociopolitical fixtures—a position Deleuze sustains by opposing cinema to photography[1]—I will offer the concept and practice of AUTO-FOTO-KINO

(figure 5.1) as a less antagonistic mode of understanding the relationship between the two media, especially in their transmutation through the technologies of computation and AI.

For decades scholars of visual culture foregrounded distinct ways in which cinema and photography dealt with the representation of the world and with the perception and capture of time. The dialectics of movement and stillness became a model through which the singularity of these two media forms was understood and perceived. Cinema was situated on the side of the present, of "being there," even of life itself, with photography being assigned a more passive and moribund set of connotations: those signaling the past, "having been there,"[2] and, as discussed in chapter 1, death. However, the differentiation between still and moving images has become more difficult to maintain nowadays. Any smartphone can shoot photos at the speed of video, and it can shoot video in photo resolution. Photographs are increasingly available to us as part of mobile image flows and data clouds. While in the past cinema was tasked with the role of teaching us "to *see* movement and time,"[3] in the world of digital media our visual apparatus gets lessons from a more diverse array of image forms and formats. My analysis departs from the tendency to discuss photography in relation to cinema primarily in terms of stasis, loss, and lack, to offer a more life-affirming or even life-forming understanding of the photographic medium.

In the foreword to their edited collection *Stillness and Time: Photography and the Moving Image*, David Green and Joanna Lowry argue that "the photograph now exists as only one option in an expanding menu of representational and performative operations presented by the technology."[4] In what follows, I want to consider to what extent this virtualization of photography—the potentiality of the digital array presenting itself as sequences of different photographs at any one time (a potentiality that was already available in digital photography but that has intensified with the advent of its computationally generative variant)—has provoked a reconfiguration of perception. While it may have been true in the past that we saw film images because *they moved*, and still images because *our eyes moved over them*,[5] photography today is arguably a much more mobile and dynamic affair. Photography *does not just move us*, affectively and physically, but *is also itself mobile*. Ingrid Hoelzl and Rémi Marie go so far as to argue: "In

an age of general screenification, in which the image is always potentially moving, the distinction between a still image depicting stillness and a moving image depicting movement no longer holds."[6] Still images move on screens through being zoomed on, pinched, or incorporated into automatic slideshows; they also travel between screens—from the constant exchange of images between our phones and social media feeds through to the multiple digital screens enveloping our urban spaces, and us in those spaces. However, Hoelzl and Marie also point out that the "convergence of moving and unmoving images in digital media (on the level of post-production as well as on the level of display) is already laid out in the media history of photographic and filmic images and their hybrid forms,"[7] from early experiments with optical toys through to flip books, lenticular images, and holograms. They highlight that "photographs (as objects in time) are also subordinate to time, even if the change occurring and observable is usually very slow": a state of events aptly illustrated by Hollis Frampton's short film *Nostalgia* (1971), in which twelve photographs are placed one after the other on a hotplate to burn slowly.[8]

We could therefore say, by way of a provocation, that *the still image does not exist*, or rather that its existence is the result of a temporary and perceptual stabilization. On a temporal scale long enough, *every image is a moving image*. Building on Maurizio Lazzarato's essay "After Cinema," and on my own experiments with various media, I want to analyze in this chapter some of the ramifications of this proposition by exploring the increasing overlap between still and moving images. I also want to look at the transformation of the photographic medium and its affordances in its encounter with other forms of moving image, such as television and video, whereby images move faster. As part of my argument, I will offer the concept and practice of AUTO-FOTO-KINO as one possible enactment of emancipatory agency (desired, among others, by Deleuze, Flusser, and Lazzarato) from within the algorithmically driven image complex. Using machine learning and GAN networks to rework the best-known photofilm, Chris Marker's postapocalyptic *La Jetée*, I will explore the possibilities of creatively engaging automation to outline a different vision of the future as part of the AUTO-FOTO-KINO experiment. Through this experiment, I will also engage with ways of gender-queering the perception machine as both an image-making apparatus and a network of looks, percepts, and viewpoints.

Distraction as expanded watching

In "After Cinema," Lazzarato argues that cinema is "no longer representa-
tive of the conditions of collective perception."[9] Drawing on Gilles Deleuze
and Félix Guattari's *Anti-Oedipus*, he goes on to seek a sociopolitical open-
ing within the constraints of the perception machine in digital technology.
As part of his diagnosis Lazzarato points out that the temporal separation
between filming and screening disappears in television as a medium oper-
ating primarily in real time—and thus effectively eliding the difference
between reality and a picture of it, between the real and the imaginary. The
shock enacted by cinema on our sense of space and time, the hijacking of
our unconscious by illusion and magic which allowed for the creation of
the sense of movement, has given way to a more immersive but also more
mundane experience, he claims:

> Now the flows are all around us: *noi andiamo in onda* (literally, "we are going
> into airwaves"), as the Italian language puts it so perfectly in reference to televi-
> sion transmission. Not only television shows, but all reality is caught up in this
> movement: *andare in onda*. The image no longer shocks us because it is no longer
> outside our perception: it is we who have become images (Bergson).[10]

Lazzarato's argument also applies to other forms of more "immediate"
media, such as video—and to its remediation on platforms such as You-
Tube, Vimeo, and TikTok. The changes in collective perception he identifies
as a result of the popularization of television in the middle of the twentieth
century dispersed the mass audience, leading to the individualization of
reception. In the digital formats that have followed terrestrial TV, reception
as full engagement or even devotion has been replaced by a less focused
mode of attention, with distraction becoming "the basic mode of percep-
tion" today.[11] It is perhaps only a short step from here to the denouncing
of TV, YouTube, and TikTok audiences as unfocused, lazy, and stupid—the
way some scholars have castigated today's readers as less attentive and shal-
lower, as discussed in chapter 1. Yet it would be interesting to probe instead
what the audiences are being distracted *toward*, what new orientations and
bindings their attention now engages. Lazzarato himself sees this state of
events as an opening of a possibility, calling on us "to reclaim the adventure
of perception"[12] and create something new. This possibility is entailed in
the fact that a video image is "a tactile image, an image to be manipulated."
David Green has traced back this possibility to the early days of the activity

in the VCR, a technology which became, especially in the hands of artists, "a tool with which to dismember the moving image and, through that process, produce new temporalities."[13] With image editing being democratized through the wide availability of easy image manipulation software on our laptops and phones, everyone is now invited to cut into the image timeline, with the image itself expanding beyond its frame.

Distracted watching is thus expanded watching: it is often more distributed and more social, involving a more intense set of relations with images and sounds, visual strategies, genres, as well as other viewers and the media they are connected to (e.g., instant messaging, WhatsApp, or Twitter as platforms for live commentary; "bullet screens" as ways of annotating a show with live text commentaries—especially popular amidst Chinese audiences; screenshots used for memes or mashups; algorithms "curating" serendipitous viewing schedules and rhythms). Reception always involves the potential of remaking, be it through fan activities, memes, or group "hate watching." Lazzarato takes this expansion of the image as a sign of political hope, entailing the possibility that the dominant way of seeing the world and acting in it can be reconfigured. He describes the current sociopolitical reality with the Deleuze-and-Guattari-indebted notion of the social machine. The architecture of this social machine remains open because it is made up of complex relations extending from its own corpus through to many other entities (other "machines"), to embrace the whole of humanity and the whole of the human-nonhuman world.[14] The perception machine analyzed in this book—a machine which is as much social as it is optical, neurological, and technical—is part of this machinic setup. We could perhaps even go so far as to claim that the social machine as it operates today is also at the same time a perception machine. The relations between the machine's components can always be redrawn, thus posing a challenge to the algorithmic imperative of performativity, efficiency, and exploitation that power it. Photography in its expanded mode can play an important role in this process.

A film that blinks for us

Chris Marker's celebrated photofilm (1962), or rather, to use its self-description, photo-novel (*un photo-roman*), yields itself to our analysis of photography as a form of moving image on both formal and conceptual

grounds. While the story is familiar to many photography and film schol-
ars, I would like to recap it by way of preparing the ground for my own
experiment with the film's material. *La Jetée* opens with a slow pan over a
photograph of an open-air viewing platform ("a jetty") at the Orly airport
in Paris. A short sequence of closely cut images later, including some close-
ups of a blond woman (Hélène Chatelain) gazing tenderly into the frame,
touching her face, then grabbing it, her hair tousled in the wind, we are
told by a deadpan narrator that something violent has just occurred. This
sequence of images is accompanied by a mysterious-sounding opening line:
"This is the story of a man marked by an image from his childhood." We
then encounter the said man (Davos Hanich) several years later in Paris—
which, in the meantime, has been destroyed by World War III. Radioac-
tive contamination has pushed all the survivors underground. The man
is imprisoned in a medical facility run by an army of German-speaking
"experimenters," with an ominous-looking Director at its head. Chosen for
his ability to recall strong mental images, the man is being primed for time
travel. He will need to go into the future to save humanity by finding "a
hole in time through which to send food, energy, supplies." He starts by
journeying into the past, each time meeting a woman that looks familiar
and with whom he has a warm closeness, even intimacy. Later we figure
out, along with him, that this is the woman from the jetty. They spend
time together through flashlight events that may be his memories or just
dreams, a trip to a museum of natural history full of skeletons and fos-
sils being their last encounter. After that, the man is sent into the future,
from which he accomplishes his mission of bringing back the power supply
to restart the world's industry in the ruined past. Seemingly a hero, he is
no longer needed by the experimenters, his pleas to be reunited with the
woman of (or perhaps from) his dreams falling on deaf ears. He knows he
will have to be eliminated. We then realize, together with him, that the
opening scene, in which he ended up running toward the woman, was the
moment of his death.

Marker's film, capturing the sense of the material and moral destruction
brought on by World War II and a premonition of a nuclear apocalypse, is
both a memory exercise and a lesson in how to remember well. As Griselda
Pollock puts it, "Few films have ever captured as acutely the desolation of a
generation caught between having traumatically witnessed all-out industri-
alized war and fearing its repetition on an even more fearful post-Hiroshima

scale."[15] *La Jetée*'s postapocalyptic tenor and its haunting narrative make it an apt reference point for the current moment of the multiple crises in which our world finds itself in the 2020s. The Covid-19 pandemic with its multiple waves and its unequal distribution of mortality and health is reminiscent of the time loops enacted in *La Jetée*, whereby the past cuts across the present to leap into the future, and then back again. The renewed threat of World War III and nuclear annihilation generates a similar sense of anxiety. The premonition of an imminent end to the liberal fantasy of "our ways of life," coupled with a desire for things to return to how they once were, fuel the imagination not only of climate change deniers, antivaxxers, and racists, but also of many others who carry a strong mental image of a better yesteryear, even if that image is just a dream.

The climate crisis and the premonition of the extinction of multiple species, including our own, and the total destruction of our habitat make some reach for planetary escapism packaged as a solution to the depletion of the Earth's resources. Like Marker's time traveler, whose task was "to summon the past and future to the aid of the present," our self-appointed billionaire saviors such as Elon Musk, Jeff Bezos, and Richard Branson see abandoning planet Earth as the only exit strategy from the environmental destruction. (As a first step in practicing takeoff, during the Covid-19 pandemic many of the ultrarich moved to the planetary safety of the "antipodes," such as Australia and New Zealand—or, in the case of Google's Larry Page, Fiji.) Our tech bro planetary travelers lack the anonymity of Marker's leading character, and they are not hamstrung by the powers that be. Instead, they are both Marker's time traveler and his Director. Yet the tech entrepreneurs share with Marker's lead, albeit without any acknowledged sense of their situation (which only compounds it), the premonition of an impending tragedy: they are also bound to fall. Building on my earlier analysis in *The End of Man* of the Silicon Valley tech bros' hubris, I would suggest that in their planetary endeavors, Musk and other tech billionaires represent a collective failure of a particular masculinist story of self-interested self-rescue repackaged as salvation.[16] They also symbolize a crash of a particular form of hypercapitalism, whose only long-term outcome can be multiple deaths—of economy, society, the Earth systems. We could therefore suggest that, in the time of the climate crisis, *La Jetée* has returned to haunt us all today, sweeping us into its time loops while making us witness our own death, without being fully aware of what we are actually seeing.

The photofilm genre, in which still images function as cuts into our memories of the past and our mental renderings of the future on an individual and collective level, is an apt medium for conveying the sense of being out of time, or at least out of sync with its logically expected linearity. *La Jetée*, the "ultimate photofilm,"[17] serves as a perfect illustration of this condition. Made entirely from black-and-white still images, with only one short instance of moving footage inserted into it, it introduces movement into other sequences through the use of zooming and panning—as well as creating an *illusion* of movement through rapid cuts, dynamic music, and sound effects. As Janet Harbord points out, "This is not a film composed of still images, where both cinema and photography remain distinct. This is a film that finds qualities of movement and stillness in each, that braids together remembering and forgetting, that points us in conflicting directions."[18] I would like to propose that, in forcing us to negotiate the tension between movement and stillness, between temporal flows and image cuts, *La Jetée* implicitly addresses the key problem that underpins this book—the problem of what it means to live in the perception machine—while also opening onto a wider existential enquiry into the nature of time and the future of existence—ours and that of what we call "the world." Importantly for my own mode of addressing this problem, *La Jetée* uses photography to pursue its enquiry. By choosing as its lead a character who is prone to recalling strong mental images, and whose mind serves as both a machinic projector and a cinema, with the film being made of photographic cuts, Marker's photofilm stages what Nadine Boljkovac has described as "perception of perception."[19] For Chris Darke *La Jetée* unfolds "a matrix of looks: that of the subject, of Marker's lens and of our own."[20] There is an interesting dimension to these "'auto-perceptive' moments," to use Boljkovac's term,[21] with the film manifesting a vital agency of its own in its ability to loop and recoil back on itself—and also to *animate*. *La Jetée*'s mechanical aspect is compounded by this very matrix of looks, whereby, as Harbord puts it, "The film's brief animation of a woman as she blinks plays back to us the conditions of the cinematic experience: we see images but there is an interposing leaf, a blackness that gets in between."[22] Harbord suggests that blinking is itself a "bodily form of editing,"[23] something we do on a daily basis in our encounter with the optical flow—and something that cinema replicates as an experience that is already familiar to us on a corporeal-perceptive level. But it is not just our own bodily editing that *La Jetée* gives

back to us. With black leaders inserting gaps and cuts into vision alongside our own invisible and inadvertent blinks, in Marker's film the blink is elevated to a knowing imagistic cut. *La Jetée blinks for us,* we could say.

Marker's film can therefore be said to be an enactment of the machine logic of perception that is already entailed *within* analog media. Through this, it anticipates some of the issues regarding machine perception *within* cinema brought to the fore by the project called *Computers Watching Movies* (2013) by Ben Grosser. Grosser's work consists of a series of short videos purporting to show us what a computational system sees when it is made to watch films created for human viewers: *2001: A Space Odyssey, The Matrix, Taxi Driver.* To make the videos, the artist programmed an AI algorithm to enable it to "watch" selected clips from those movies, which amounted to training the algorithm in specific pattern recognition, responding to various colors, shapes, and outlines. Playing against the audio sequences from the original films, Grosser's *Computers Watching Movies* videos illustrate, in a diagrammatic form, the linear zigzag movements of the computer vision system's visual apparatus over the film material. Of course, it is impossible to gather from the moving diagrams thus obtained what the computers "really" saw, not least because of the untranslatability of the experiential dimension of what we humans call vision across species and media platforms (which is arguably a logical blind spot of *any* research currently undertaken under the rubric of machine vision and machine perception), but also because of the lack of transparency about the training data for the viewing algorithm, of what it was exactly that the computers were meant to focus on and respond to. Yet Grosser's project knowingly embraces this limitation, as the artist's own description of the work demonstrates: "Viewers are provoked to ask how computer vision differs from their own human vision, and what that difference reveals about our culturally-developed ways of looking. Why do we watch what we watch when we watch it? Will a system without our sense of narrative or historical patterns of vision watch the same things?"[24] Grosser's clips thus hint at the fact that our own human viewing strategies and modes of looking are perhaps more preprogrammed than we often allow ourselves to imagine. Our sense of agency in watching anything, from a movie to a road accident or an Internet meme, is normally curtailed by neurological conditioning and algorithmic programming (of the historical, cultural, and technical variety). Besides, machinic agency plays an increasingly significant role in movie production and perception,

as enacted by projectors with their intense luminosity or seductively backlit screens, as well as the software and large-scale data helping movie executives to decide in advance which films to make—and *how* to make them.

Images that make themselves

It is therefore perhaps not too much of an exaggeration to say that *La Jetée* is an *avant la lettre* exercise in machine perception *and* computational image-making. Its "matrix of looks" generates conditions where not only multiple viewing apparatuses, human and nonhuman, crisscross, but also the film is enabled to "watch itself," at least in the prefigurative sense of the term used by Grosser. As Gusztáv Hámos, Katja Pratschke, and Thomas Tode wrote in the program for the *PhotoFilm!* series they curated for Tate Modern in 2010, "In so far as the scene appears a second time, the film recalls itself. And a film that can remember is a thinking entity. To remember is already a creative act in which transformations of what one has experienced occur, are reassembled, reorganised."[25] In *La Jetée* Marker embraced the automatism and algorithmic logic that would come to the fore more explicitly in both artistic and mainstream film production several decades later.[26] The director himself admitted that the film "was made like a piece of automatic writing. . . . It was in the editing that the pieces of the puzzle came together, and it wasn't me who designed the puzzle."[27] The partial renouncing of agency is also evident in the choice of photographs as its source material, a material that always already bears a nonhuman trace.[28]

Photography is partly nonhuman because, at the moment of taking a photograph, the photographer is taken over by the apparatus. The very act of taking an image, even if framed by the human subject, is passed on to the machine—and, indeed, it *has* to be passed on to the machine for a photographic act to occur. As conveyed by Belgian photographic artist Marc De Blieck, whose research into perception explores the constitution of viewpoints, "the apparatus . . . does not entirely coincide with my intentions: it is not an extension of the 'I.' There's another form of intelligence at work."[29] Automation has of course become an intrinsic part of the photographic process today, where computation produces the picture after the image (or, most often now, a series of images averaged into a "good" one) has been taken. Also, the singular act of framing a photo by a human equipped with a smartphone or another imaging device has become largely

automatic, as people's Instagram feeds or "food porn" images testify. This is to say, the human act of taking a holiday snap or a picture of their #avocadotoast inscribes itself in the cultural algorithm dictating what such a picture needs to look like, not to mention the machinic algorithm of automatic post-processing needed to make that picture look "good." Echoing Flusser's ideas, Steven Humblet argues that, "entangled in a technological performance that thwarts his own intentions, the operator of the apparatus enters a zone of mixed authorship," a process Humblet describes as "co-creation."[30] Yet it is important to remember that this partial withdrawal of the human from the photographic moment has been a constitutive aspect of photography since its inception. In the early days of the medium the taking of an image was premised on the silencing and blinding of the photographer, who had to remain still, could not see when the shutter came down, and was not allowed to breathe in order to avoid camera shake. Our current technological condition only makes this phenomenon more explicit.

A vision is always a viewpoint

That originary kinship between the human and the machine, be it a camera or another technical apparatus, presupposes the occurrence of blinks, cuts, and ruptures. But these ruptures should not be seen as destructive; they are instances, or even conditions, of the emergence of something, of the creation of (what we humans subsequently recognize as) images, ideas, and things. This parenthetical remark is important because, in inviting the critical posthumanist perspective[31] into our discussion of human practices, that is, a perspective that positions the human viewpoint as precisely *a viewpoint*, while also recognizing the agential power of other animals, and of nonhuman entities and forces, we acknowledge that there are other ways of perceiving, engaging with, and encountering the world. And, even more radically, that what we humans understand as "the world" is itself only a *vision*. It is also always *someone's* vision.[32] To say this is not to deny the existence of a reality outside of human perception, only to assert that the breakdown of this reality into objects is the result *of* perception, of cuts made by a given species' or even individual's corticovisual apparatus. We also need to come to terms with the paradox that any such attempt to mobilize posthumanist thinking is itself being articulated, by us and for us, in our human language, with its metaphysical connotations and age-old valorizations.

At the level of the photograph, humans recognize certain things as objects—photographic prints, screens, individual images on someone's Facebook wall—thanks to our perceptual ability to see edges and boundaries. But it is not just a matter of our perceptual apparatus being able to discretize objects within what psychologist James Gibson has termed "the optic flow."[33] We identify individual photographs *as photographs* thanks to our cultural training in awarding names and values to certain edges: being able to recognize a given arrangement of molecules as a photographic print, a screen, a phone, and being able to tell where the photograph begins and ends—and that it *is* a "photograph." A camera of course does not "know" that. Also, different animal species would perceive the very same arrangement of molecules in a different way, and it would "mean" different things to them: it would be less colorful if they were dogs, at night it would feature a much richer color palette if they were geckos, and it would lose its "thingness" if viewed by pinhole-eyed giant clams, to become a sequence of garishly colorful yet undefined blobs. (Even a "molecule" is an arbitrarily discretized unit we humans came up with at a certain point in time to describe the binding of what we thought were the smallest units we called "atoms," until we identified what we describe as subatomic particles.)

But it is not just that the camera does not "know" what a photograph is; it also does not "see" in its own way. As discussed in the previous chapter, developments with machine vision, currently undertaken as part of artificial intelligence research, are premised on an attempt to replicate human vision in machine systems: to teach machines to trace the edges (i.e., areas of radical contrast between light and darkness) as perceived by the human eye, and to recognize those distinctions as meaningful. Even in its more classic model, the camera does not *see* as such, given that the concept of "seeing" we are operating with here remains inextricably rooted in the Western epistemological paradigm, where the Latin *videre* and *ver* (seeing and truth) are interlinked. So, rather than the camera functioning as our prosthesis, helping us see and capture things, we humans become a prosthetic attachment for the camera-led acts of cutting the world by discretizing the flow of particles passing through it as images, and by giving them names, identities, and functions in our cultural repertoire of objects and behaviors. This is precisely what I have attempted to convey via the notion of "the cut" in my work. I previously offered this term—a term which is so easy for photographers to grasp intuitively—to explore the process of

temporarily stabilizing the imagistic, or optic, flow the human observer is experiencing. I was also highlighting the interweaving of human and nonhuman agency in mechanical image production.[34] However, "the cut" not only foregrounds the problem of human and machinic perception but also raises the question of agency. Who or what is it that "takes" the photograph? Is it not rather the human that is *taken over by* the apparatus? Can the human then ever really take a photograph? And can we genuinely describe any film as human-authored? Who and what is it that does the viewing of images? Is human perception only ever *just* human?

Arguably, all photographs and, to a large degree, all films open themselves to this kind of interrogation. Yet *La Jetée* serves as an ideal case study for probing the question of distributed agency, "mixed authorship," and humachinic perception, not just because of the knowing embrace of the idea of automatic creation on the part of its maker but also because it performs the relationship between stillness and movement precisely *as a relation*. This is why I have used it as inspiration and source material in my own experiment with automaticity and image-making—an experiment which was conducted in an attempt to enact, rather than just think about, "photography after cinema and AI."

Model dreams

My experiment consisted in making a 9-minute film, *A Gift of the World (Oedipus on the Jetty)* (2021) (figure 5.2), by way of an AI remix, or remediation, of *La Jetée* through the sociopolitical concerns of the present moment—including those of gender, masculinity, and heroism—in the face of an apocalyptic crisis. The first step of my project, from which I present some stills and the script below, involved training a generative adversarial network (GAN) model called StyleGAN2 on a database of stills extracted from *La Jetée*. GANs are machine learning programs that use two neural networks, i.e., algorithms designed in an open-ended manner, from the bottom up, in a way that is meant to imitate, or rather schematize, the way the human brain works. The two neural networks in a GAN are positioned as adversaries, with one programmed to generate convincing and correct input, the other to control and improve upon this input according to the truth/falsehood criterion. Their ongoing interaction makes both networks improve with time, learning from each other while trying to outperform

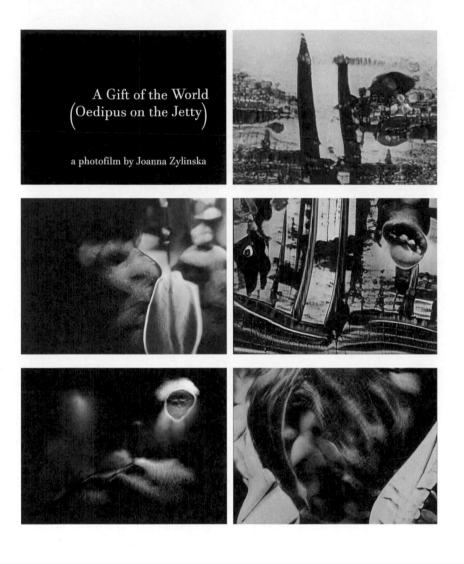

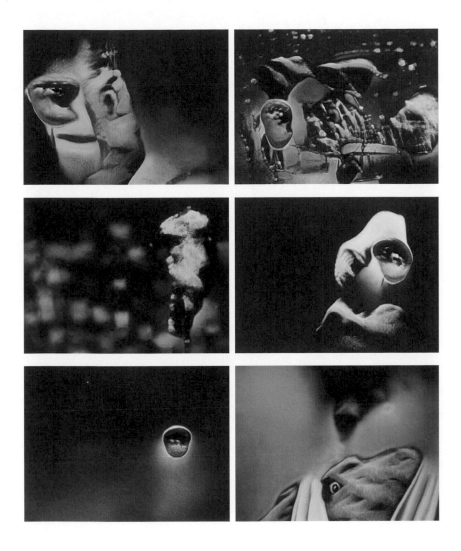

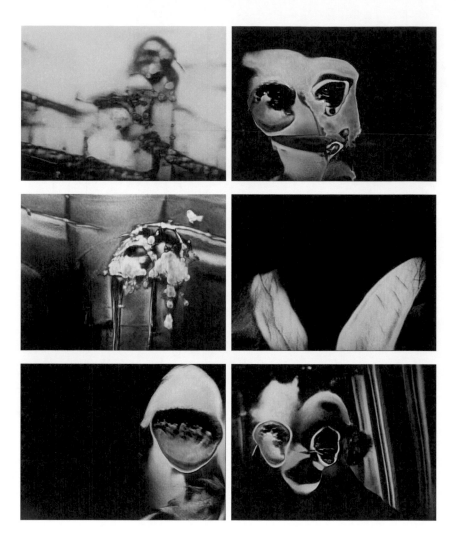

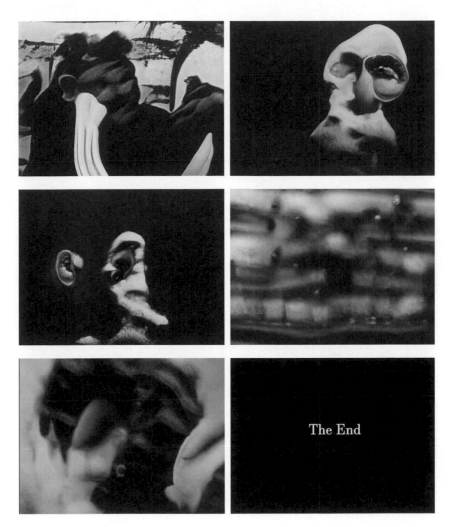

Figure 5.2
Joanna Zylinska, stills from *A Gift of the World (Oedipus on the Jetty)*, 2021.

each other in obtaining satisfactory results. The GAN model I used had been designed to mimic the style of the images fed into it to train it, with a view to generating an infinite number of similar-looking images.

Launched in 2014, GANs gained mainstream recognition several years later through websites such as This Person Does Not Exist, which generated realistic-looking photographic images of people of various ages, genders, and races.[35] GAN-based artworks became the most visible—and most commented on—application of machine learning and AI in artistic image practice over recent years, producing dreamy yet creepy still images and video morphs in a style that can be described as "cubism meets Francis Bacon by way of a mushroom trip," as seen in the works of Mario Klingemann, Gene Kogan, Mike Tyka, and Memo Akten. Computational error in the form of a slight mismatch between the realist representations of humans and of nonhuman objects, and the more eerie approximations of them, was seen as a source of aesthetic pleasure and success in such works. In a book published in 2020 called AI Art, I offered a critique of the rise of machinic creativity driven by AI. I was particularly rancorous about GANs: about their seductive yet frequently banal visuality that was reminiscent of Candy Crush, about how they principally served as a PR campaign for the gung-ho progressivism of the AI 2.0 era driven by Google.[36] Yet I decided to turn to GANs to produce my own film for the project that accompanies this chapter. This was partly driven by a desire to explore on a practical level the promises and limitations of creativity implied by the generative algorithmic technology, at a time when this technology was on the cusp of becoming replaced by much more photorealistic AI methods, combining a variety of models such as GANs, GPT, Diffusion, and CLIP.[37] Feeding my model limited visual data, I was trying to explore what artist David Young called "little AI"[38] by highlighting a stage in the technology's development when it was still possible to see errors and glitches, both machinic and social. As a report on AI art produced by the Oxford Internet Institute—for which Young had been interviewed alongside several other artists working with machine learning (ML) and AI—put it, "The history of art shows that glitches are often artistically desirable. ML art is no exception to this: while the capabilities of ML models are valued by our respondents, most were particularly interested in their edges: the artistic potential of machine failure."[39] I was also keen to put to the test my own earlier proposition that artworks produced by means of GANs, or, indeed, any other AI-driven art algorithms, became

more interesting when they executed and acknowledged their "parergonal" (framing) function,[40] invoking their audience to engage not just with the artifacts produced but also with the narratives about AI and machine vision, about the limits of human creativity, and about the sociopolitical role and positioning of art and media production. The book you are currently reading is very much part of this parergon, i.e., this attempt to frame—and also reframe—the debate on human and machine vision, and, in particular, on photography *after* cinema and AI.

A Gift of the World (Oedipus on the Jetty)

This is the story of a man marked by an image from his childhood. He was the son of a Roman Catholic father and a Catholic mother. His mother was an itinerant widow, and he had a sister who was a British officer. He had no family and was just a man. His mother was a white-haired woman who had grown up in a thuggish Paris, with her eyes wide open, hair that was tied in a ponytail, and her voice echoing in the distant roar of the engine.

"Why do you look so different?" she asked.

"Because I am a young man. I am a vanguard of the revolution," he replied.

"I have been told that the revolution is a long way from being realized," she said.

He didn't look up.

"And yet I am the only one who is able to say that," she said.

He would have thought of the woman as a baby. He was already a soldier, a member of the great army.

Now, he had lost all his memories. He had lost all the strength he had. 'He had lost his identity. He had lost his sanity. He had lost his reason. He had lost all the emotions he had ever had.

He huddled in his bed, in his thoughts, in his dreams, in his nightmares.

His face was broken. He was shattered. He was shattered by the memories. The images he'd had of him. The love he had for her. The fear he had felt for her. The terror he had felt for her. The sadness he had felt for her.

A decade later, a nuclear disaster killed a lot of people. It destroyed almost all of the city.

The "social" prisoners, the most ardent of the anarchists, were subjected to an experiment which proved that they were not only mentally but also physically unfit.

The process was so extensive that many of the prisoners who had bribed the experimenters, and who had been exposed to it, had to undergo a "disciplining" for three months, in order to keep their sanity. In order to keep *their* sanity, the experimenters placed a great deal of effort into making the prisoners seem sane. They made the prisoners stand in a row, as if they were in a trance. They took their time to do so, and kept their eyes closed.

After a few days of intense concentration, the subjects were finally freed. In order to get the subjects to feel comfortable, the experimenters placed them in a room with a long desk, and placed thorns in the desk, to keep them from falling asleep.

When he recovers from his trance, the woman is gone. And his mother is gone. He feels the thoughts and feelings of his world—in a world where he is dead.

Then, as he hears her voice, he becomes aware of her, and sees her. The words that he hears are so clearly imprinted on his mind that he cannot quite tell what she means, but he can feel ills in her mind, and this makes him understand what she is saying. She is, in fact, a gift of the world.

He remembers what she said, and he tries to make sense of it. It is an idea he had once experienced. It is a mental phenomenon, he thinks.

The conversation is a kind of sexual act. He is on his way to his bedroom to find out if he can talk to the woman who brought him to this world. He can't. He doesn't want to.

"What's the matter?" he asks.

"She's got some problems, so I'll have to get rid of her," she says. "You'll be fine."

"She's not really like that," he says. "I've got a good sense of what she's like."

"I've got a good sense of what she's like, too," she says. "I know what she's like, and I'm not going to change it."

They are without plans, without memories. They are without focus, and without freedom. They are without a choice, without a right. Their eyes are fixed on the stone, and they watch him as he drifts through the canyon, head-first through a waterway, his arms held high. His arms drift into the water, and he picks up the boat and shifts it to the right.

"A day goes by, and we are on our way," he tells her. "A day goes by. I am waiting for you, for you to come with me. You will stay with me. And I will give you your dream."

"I am a dreamer, a man," she says, "a man who will love you. I follow you to the end of your life. You will be my first gift, and I will take you from here. I will have you with me forever. And I will never forget you. And you will be your friend, your god, your father. And your father will never forget you. And I will never forget you."

He is a dreamer, a man who will love you.

The villagers are not waiting for a new adventure, but for something else. They are ready to share their own dream. They are not waiting for a future of freedom, but for freedom with a better life.

She says that she is the girl who was brought back to the family, but that the power she had is not hers. He wants her to take him to the beginning of time, and then tell her to return to the present. He says she will die in a few hours, and then he will tell her to bring him back to the world. She will never return to the family, but he is going to take her back to the world and he will keep her alive. She is not going to die.

> The film can be viewed at https://www.nonhuman.photography/perception
> -machine

Gender-fluid dreams on the jetty

The script of my film was created with the assistance of GPT-2, an unsupervised AI language model that had been trained on the WebText dataset containing millions of webpages. Intent on creating a Chris Marker-WebText remix, I started by feeding the model *La Jetée*'s famous opening line: "This is the story of a man marked by an image from his childhood." The model responded by taking the story in an unexpected direction. I cut across it several times with a few more lines from the original Marker script. Any edits I subsequently made to the script were only minor, with some of the linguistic divergences or plain language errors identified as important moments in my experiment and hence retained. In making the film, I channeled Marker's own semiautomatic mode of working, including his use of found images and stock music. In an attempt to mimic the pathos of his horror scenes and his evocative church choir, the soundtrack for my film was produced from sound clips drawn from a stock repository to include a mix of an ambient sound from an ethnographic research project about truck driver culture recorded in Germany, a "low" remix filtered sample of a female voice band, and some choral-sounding vocal chords.[41] The editing of the film was intuitive and consisted of my own visual and corporeal responses to both the script and the GAN images. Interestingly, the images themselves, produced by an algorithm that tried to remake Marker's film by picking up its key visual features (and, especially, those pertaining to humans, as is often the case in such generative programs that had been trained on photos of human faces), manifested various body parts, frequently multiplied: noses, hair, eyes, kidneys, kidney-like eyes. The way generative neural networks operate is by repeatedly optimizing pixels in an image "to achieve some desired state of activations."[42] That "desired state" is compared against the source material, i.e., its training set. Developers frequently resort to the metaphor of a dream to describe the working of neural nets, suggesting that such networks find patterns in images not so much in a logical preprogrammed way but rather by using previous data

and memories as prompts for making new connections between data points and for generating new data.[43] Their operations are presented as being akin to what human minds do while at rest, either asleep or daydreaming. By anthropomorphizing their products, engineers and the technology companies they work for absolve themselves of the responsibility for their programming decisions—and for those decisions' unintended consequences.

In my own work with GANs I let myself dream *with* but also *against* the AI algorithm underpinning the model. In being faced with several hundred *Inception*-like images produced from the *La Jetée* dataset, I felt as if certain images blinked at me, inserting themselves into the timeline of my film by visual and conceptual association—or perhaps even bodily touch. I was aware that the playful sense of experimentation I had adopted as my method was tinged with the more ominous undertones of the experiments conducted on Marker's main character in the underground camp. The "counterdream" aspect was also important for me given the sociopolitical limitations of AI technology, which have been well documented by feminist and decolonial cultural critics,[44] revealing not only gender and racial bias but also the exclusionary and unjust logic underlying many of its founding principles, not to mention its extractivism when it comes to both human and natural resources. I was curious about what AI would do to the original source material, but I knew I would need to step in as both a dream catcher and analyst.

It was the gender aspect of Marker's film—but also of the wider script with regard to family dynamics and individual heroism as played out in narratives of destruction, rescue, and salvation in the Judeo-Christian culture—that had always troubled me. Griselda Pollock has described *La Jetée* as a "deeply fetishistic, psychically masculine film."[45] She identifies the close-up image of the woman's face as the structuring fetish of Marker's story, bearing the dual role of the screen (and hence disavowal), protecting the hero against pain and death—and of commemoration. Pointing to the overdetermination of the close-up as a vehicle for the cinematic inscription of the feminine, Pollock has analyzed the intricacies of the Oedipal drama unfolding both in *La Jetée* and in our wider image culture in rather critical terms:

> This is nothing so crass as the image of the mother. Yet it is the image form of that non-figurative Other that forms the dense tapestry of affects and intensities from which the outlines of the subject will be traced and, eventually under the law of

castration, cut out. She, this woman, is not his mother. This image of the femi-
nine as desired and remote, as looking back across a space that cinema deludes
us by compressing through the mechanics of the zoom, the close-up holds some-
thing before us visually that is saturated with affect and yet is the very face of the
traumatic. It is an imaginary screen, veiling and marking what it veils, holding its
double burden of allure and dread in carefully calculated and historically chang-
ing aesthetic formulations of the feminine as face.[46]

The woman on and as screen is positioned to replace the horror of the
apocalypse, be it of individual or generational death or even species extinc-
tion, with a benevolent Madonna-like smile. She is both the lost object of
a safe home from before time and the fantasized future of a happy return.
Yet Pollock also identifies a "counter current" of Marker's film that allows
for it to be watched and seen beyond the masculine—beyond the castrat-
ing eye of the Director (who reappears at the Orly airport as a man with
extended eyes) and the feminine fetish of the main hero. She locates this
counter current in the "beautiful" aesthetics of the film as a way of opening
up another pleasure and another form of touch. Pollock goes on to investi-
gate the possibility of viewing the film beyond the heterosexual masculine
fetish trapped in the Oedipal drama, asking what the woman's face and
gaze would mean to a subject who inscribes themselves differently into
the gender matrix. "What if the feminine symbolically signified or, given
phantasmatic form in the image, echoed another stratum of subjectivity,
in which subjectivity was foundationally connective, shared, co-emergent,
several?" she ponders.[47] "What if the death drive did not lead back through
the screen of the feminine to a trauma premised on the either/or—life or
death?"[48] Pollock finds the promise of a different matrix of gender and plea-
sure in the very fact that La Jetée will go on, being shown over and over
again. "It can repeat and we, its witnesses, do not die. It becomes its own
experimental site."[49] The film can also be recut, remade, and redreamt, as
my own experiment demonstrates.

This may explain further why I turned to La Jetée in my own attempt to
think about the future of the world and everything else through thinking
the future of photography. I wanted to see into it as deeply as I could—but
also to mobilize the algorithmic force of machine vision and AI by way
of renouncing control over what is always already uncontrollable. What
the GPT-2 model came up with as part of our co-creation turned out to be
both interesting and surprising, as it seems to have embraced full-on the

implicit desire on my part to go all the way in. We can recognize in the generated script traces of its training material: fairytales, hero quest stories, videogame narratives, sci-fi. The model clearly tried to remain faithful to the spirit and sense of Marker's opening line by reenacting the personal and global apocalypse as an Oedipal drama. The AI engines deployed in the visual and textual models ended up producing a more multilayered show, one that unfolded as much on the gender front as it did on the human(ist)-existential one. We could perhaps say that the film dreamt itself as a feminist-genderqueer intervention into the heteronormative fetishism of the apocalypse as dreamt up in key Western cultural texts, from the Bible through to Marker's *photo-roman*—and into the myth of the White male savior that props it up. What starts as a conversation between mother and son ends up, through a series of algorithmic glitches, as a sequence of slip-pages that enter a gender vortex in which man becomes woman, mother becomes father, he becomes she. With the dissolution of the nuclear family, the Oedipal drama as the structuring device of our cultural script disappears. The sense of premonition still lingers, but it is now accompanied by the possibility of an opening—and a liberation. This possibility can be read as a feminist gift, a gift "of what the feminine can be thought to be if we emerge from the exclusivity of the Oedipal logic of the phallus as the only arbiter of psychic life and signification."[50]

With its nonnormative cross-species kinship ties, *A Gift of the World (Oedipus on the Jetty)* can be said to enact, in the bricolage spirit of eco-eco-punk, what Nicole Seymour has described in her book *Bad Environmentalism* as a "queer sensibility": an approach to planetary-scale environmental issues that not only challenges supposedly "normal" sexualities but also troubles the normative language typically used to describe all sorts of ecological crises. Pointing to terms such as "unnatural, diseased, pathological, risky, contaminated," which "have been used historically to stigmatize sexual misfits and to instigate social panic and apocalyptic threat,"[51] and which are now used to describe the condition of our planet with its multiple crises, Seymour refuses "the affective vocabulary of crisis, panic, and apocalypse."[52] This is because such an apocalyptic register tends to leave its actors—including, frequently, the scientists conducting the foundational research on the subject or medics involved in fighting the next wave of the pandemic—burnt out, distressed, and depressed.[53] Yet Seymour is not satisfied with just flipping burnout into optimism and hope. She sees all those

affects as sides of the same coin, representing humans' desire for certainty and closure. She delves instead into a richer and more nuanced affective and cognitive repertoire, the stock of which includes "absurdity and irony, as well as related affects and sensibilities such as . . . frivolity, indecorum, awkwardness, sardonicism, perversity [and] playfulness." Her bad environmentalism also embraces "camp, frivolity, indecorum, ambivalence, and glee."[54] In its irreverent playfulness and messy kinship between human and nonhuman agents, bodies, and media, eco-eco-punk draws from such a counterapocalyptic repertoire of affects and acts with a view to envisaging a new world of ties and connections *after the ruin*. But, given the expiration of the dominant models and frameworks for both politics and activism, a state of events that has left many of us immobilized, unsure what to do and how to act—and whether any individual activity is actually meaningful at all—it also recognizes that we need some new visions that will sustain both us *and* the planet, longer-term. When I was finishing the film, a newer version of the language model, called GPT-3, became available. GPT-3 had been trained on a much larger body of texts, generating texts that mimicked human discourse and conversation more successfully and seamlessly.[55] However, the statistical analysis and the decontextualization issues—coupled with the philosophical problem of when and to whom a given meaning is actually meaningful—did not disappear in GPT-3; they just became more obscured. The GPT-3 model was superseded in late 2022 by the much more potent ChatGPT—a model that brought AI-composed texts to the awareness of the wider public. Working with the visual and linguistic clumsiness of the earlier models such as GANs and GPT-2 allowed me to capture in my film that short span of time when those technologies were still weird enough to reveal their conditions of existence, their (il) logics—but also the missed opportunities underpinning their development. Ian Bogost has remarked that, "as the novelty of that surprise wears off, it is becoming clear that ChatGPT is less a magical wish-granting machine than an interpretive sparring partner, *a tool that's most interesting when it's bad rather than good at its job*."[56] Given the push to implement "creative AI" in routine products such as search engines, word processors, and image manipulation software, not to mention vast areas of the already-banalized "content creation," there will soon come a time when the algorithmicity of our behavior merges even more seamlessly with that of AI-enabled models. It is therefore understandable that artists should want to test and tease

these models while we still can see (and enjoy) the glitch. The implicit obsolescence of the models' subsequent iterations is the feature of those artworks—including my own project discussed here.

Working with the "good-enough" visual and textual models of 2021 thus allowed me to enjoy a particular instant when the AI-driven technology was revealing its uncanniness quite explicitly, thus lending itself more easily to artistic experimentation. It may be that it was a unique moment in time when both human agency and human intervention into the AI-fueled perception machine were still possible, before the weirdness of AI on both textual and visual levels would have been overcome by successful stochastic mimicry, thus making critical interventions into the technology and its underpinning logic more difficult to stage, or even argue for. Yet I want to believe that this moment will stay with us for a little longer, offering us, in a Flusserian vein, a small margin of freedom where we can imagine and enact things to be otherwise *from within* the algorithmic system that is closing around us.

Dreaming Big

While the current discourse on AI remains trapped between the hurrah-optimism of Big Tech and its critical assessment by scholars and activists, while political debate is increasingly polarized, could AI itself play the role of a philosopher-visionary that will show us a way out? Could it get beyond the limitations of our human frames of mind to imagine a different set of propositions and arrangements for us? Could it actually envisage a better future for humans and nonhumans alike while showing us how to get there? History, sci-fi, and the current model of extractive capitalism which repurposes all openings as resources for its own growth all indicate that this idea is unlikely to succeed. But, given how stuck we currently are—politically, economically, and climatologically—it seems worth dreaming up some literally unthinkable visions for our planetary survival and coexistence. Harbord suggests that the hope of future salvation rests on the human capacity "to mentally imagine, to be affected by the image."[57] As a first step, AI-driven AUTO-FOTO-KINO may thus become a space for picturing a better future, beyond our wildest (human) dreams. AI may indeed be the radical new (film) Director we desperately need. But its algorithms, put to work in progressive university labs, research and policy centers, and art

organizations could also perhaps envisage ways of coengineering this better future, beyond the stuckness of the present modernist paradigm that we seem unable to shake off.

To return to Lazzarato's diagnosis from the beginning of this chapter, the current condition of life sees us as permanently enveloped by image and data flows. Importantly, images do not just surround us but also move through and with us; they animate us into forms of becoming they have envisaged for us, catching us (up) in a relentless flow. As Lazzarato recognizes, we have all become images, serving as both producers and audience for the AUTO-FOTO-KINO project unfolding between bodies, platforms, and screens. But, amidst all this, we can also recognize the need to make better cuts into the image flow—and to create our own versions of the AUTO-FOTO-KINO that will offer some counternarratives and counteraffects.

Photographs can play a unique role in this process because they are "part of a tradition of image-thinking that resists the constraints of the written text, its tenses, its forward movement and its regimentation of reading from left to right."[58] Challenging their association with floods and swamps, Flusser has described photographs as "dams placed in the way of the stream of history, jamming historical happenings."[59] Evoking the "magical consciousness"[60] of prehistoric images, photographs can reconnect us to a "consciousness enchanted,"[61] by retuning our perception apparatus, and the larger perception machine of which it is part, to a different temporality, different rhythm—and different logic. In "Photography and History," Flusser suggests that photographs "are not only models of behavior, but also models of perception and experience. The programmers of photographs (from their perspective, photographers—as long as they are not replaceable—are nothing more than human factors built into the apparatus) hover above history, and they project a potentially alternative future."[62] Moving beyond their association with the past and the linearity of history they were said to map out, we could therefore follow Flusser in seeing photographs as future-looking. We can even propose, perhaps counterintuitively, that photographs can become ways of rendering the future. It is because photographs are already models; they are, according to Flusser, computed possibilities which project onto the environment. Moving beyond the linearity of the book (and the prescriptive closeness of The Book), they can instantiate another mode of relating and thus conceiving the world. This is a form of knowledge Flusser terms "image thinking,"[63] a

mode of thinking in which the link between perception and cognition is embedded into an epistemological proposition, rather than wished away as something primitive and childish that needs to be superseded.

Naturally, there is no guarantee of this magic thinking remaining on the side of the angels (and elves). Daniel Chávez Heras points out that high-tech and AI companies already present their own developments and products as "a series of magic tricks . . . : they are deployed as forms of alchemy (with the right algorithm you can convert your data into gold), animism (the machine thinks and speaks for itself), divination (big data and predictive analytics), and healing (genome decoding and editing)."[64] The idea here would be to pose a challenge to the magical spectacle of the machine, which mesmerizes human viewers with the deluge of image flows, and to the mobile fantasmagoria of GANs. If, as Ben Burbridge indicates, advertisers want access to "truthful data," with Mark Zuckerberg supposedly suggesting that users who adopted multiple identities online "lacked integrity,"[65] AUTO-FOTO-KINO understood as a form of micro-art that goes beyond "computational spectatorship"[66] can show us visual and perceptual alternatives to the platform capitalism's humanism, used as a monetization ploy. If today "there is less value to be extracted from individual images than from relations between them,"[67] micro-art projects such as AUTO-FOTO-KINO can be mobilized to break the link between image production, monetization, and authenticity. They can even perhaps end up jamming the perception machine.

6 Can You Photograph the Future?

Figure 6.1
Screenshot from *Devs*, 2020. Dir. Alex Garland. FX on Hulu.

Ten seconds into the future

A small group of people are sitting around a table in what seems like a cross between a corporate meeting and university lab seminar, looking at screens big and small. Their attention is on a moving image of a worm, overlaid with the graphic visualization of its movements. The two moving lines converge nicely (figure 6.1). The group are looking ten seconds into the future—the worm's future, that is. This is a restaging of the WormBot project,[1] a digital simulation of the behavior of a nematode worm represented in the form of time-lapse images with a view to predicting the worm's death, and it is happening as part of the first episode of a TV series *Devs*, created and directed by Alex Garland (2020, FX on Hulu). The idea is to recreate a living

organism in a computer system by rendering all of its neural connections in a digital form. After ten seconds the correlation between the simulated screen movement and its predicted graphic visualization is lost, but the professor-lookalike boss is impressed enough to elevate the young Russian AI programmer to the next phase of his company's project: the eponymous Devs. The project lab, hosted in a vacuum-protected Faraday cage in the middle of a forest, contains a hugely powerful quantum computer whose goal is to achieve for the billions of neurons in the human brain what the WormBot-lookalike did for nematode's 302. The (mad) professor-boss, a *deus*-like character called Forest, has built his whole enterprise to generate an alternative version of reality online, one in which his wife and young daughter do not die in a car accident (inadvertently caused by him). In other words, Forest wants to overcome the causality of the physical world by creating one in which a different future can unfold—a future he will be able to inhabit together with his digitally restored family. The *Devs* series deals with the age-old problem of determinism versus free will, packaging it as a fairly conventional story of a heterosexual white nuclear family (and its multiethnic romantic counterparts) experiencing life's travails.

What is of particular interest to me about *Devs* in the context of this book is its visualization of the problem of predicting the future by capturing an image of it. The first step involves the mobilization of the power of the quantum computer to render detailed images from a remote past. Borrowing from the past's "multiverse" simulations allows the Devs developers to obtain a rich enough dataset to generate adequate images of the past: Jesus on the cross or prehistorical people making cave art. The next step will involve using the technology and data from Forest's more recent past to render a new version of the future for him and his kin. I would like to propose we bracket for now the determinism debate and the rather implausible quantum frippery of the series' plot to focus on the very idea of rendering the future as an image. For me, *Devs* serves as a framing device for the key question that will drive this chapter: Can you photograph the future?

To explore this question, I will look at the temporality of the photographic image while engaging with the latest developments in CGI, computational photography, and machine vision—technologies that are premised on forecasting an image and then making it look real. Drawing on neuroscience research on the role of prediction in human consciousness, and the application of machine learning to developing machine consciousness,

I will then move to a brief overview of the mobilization of photography and photo-rendering in predictive technology, in areas such as weather forecasts, stock markets, epidemiology, and consumer behavior. I will also consider the sociopolitical consequences of the wide implementation of predictive technology in our lives. Last but not least—and in line with the overall ambitions of this book—I will explore the possibility of imaging and imagining *better* futures.

Time is just change when there is no one to track it

The question about the possibility of photographing the future may seem both absurd and out-of-date—Marty McFly already videoed it back in 1985![2]—yet the premise behind it underpins many of the current developments in imaging technology, computation, and AI. Indeed, photography poses us a temporal conundrum, on the level both of physics and common sense. As a medium, photography has typically been associated with the past: it has been constituted as a quintessential medium of memory, of time gone by, or even, as discussed in chapter 1, of death. Logically, it is only "the present" that can ever be photographed, but the present itself is an illusive concept, unable to be captured in an image or thought about without simultaneously receding to the past. Photographic technology has always played with logic and physics to create a spectral ambience around its practices. We can think here of long-exposure photography, where several hours were required to obtain an image trace on the not-so-sensitive substrate in the early days of the medium, or about stop-motion imagining, intended to explicitly show the passage of time, be it over the period of one day or several years. There are also photographic dispatches from a prehuman past, such as the visual rendering of the data captured by a radio telescope, in June 2005, of solar dust cloud radiation in the Taurus Molecular Cloud, where the data represented an event that "took place in 1585, or thereabouts,"[3] or even a "baby picture" of our universe, produced by NASA between 1990 and 1992 and showing the map of the cosmic microwave background radiation supposedly released as heat during the Big Bang.[4] The temporal determination of a photograph depends on the point of reference: specifically, on the positioning of the observer within the system. Time is what it (supposedly) is only for an observer whose life is grasped as a timeline; outside the (human) observer there is just change.

In its computational guise, photography can therefore be said to have warped the arrow of time, displacing temporality as we know and sense it with our bodies and minds with the machinic logic of multiplication and nonlinear choice. Reflecting on Google's Pixel 3 smartphone and its sophisticated camera, Sy Taffel explains that a photograph is now an extraction of an image from a sequence, coupled with an averaging of that sequence. Or, as developer Vasily Zubarev puts it, "When you tap the 'take a photo' button, the photo has actually already been taken."[5] Taffel clarifies further that, unlike in traditional cameras,

> where the photographer pressing the shutter-release triggers the recording process, hitting the record button signals the mid-point within a 15-frame image stream the camera sends for computational processing. The significance is not just that the camera composites these images, the practice of taking a photograph is transformed from a human operator capturing a moment of choice, to delineating a sequence of images to begin working backwards and forwards in time from. Using data from those 15 frames, the Pixel 3 generates a composite image containing HDR, greater resolution and lower levels of noise than would be possible with a single exposure.[6]

In the computational images of the world as deployed by the latest smartphone cameras, such as Google's Pixel or Apple's iPhone, the future literally influences the past.

Even though it reaches beyond human scales, photography gains a symbolic value in our human-centered universe as a practice of stopping time—but also, perhaps more strongly, a practice of making time. Photography allows us to make cuts in the optic flow unfolding around us. Yet it is not so much the already well-studied relationship between photography and time that interests me here but rather, and more specifically, the relationship between photography and the future. I want to approach it by looking at the problem of prediction—and the mobilization of photography and other forms of imaging in constructing predictions in different disciplines—from cognitive psychology and neuroscience through to AI, machine learning, and computer vision. I am mindful here of Matthew Cobb's suggestion in *The Idea of the Brain* that our scientific horizon at any given time depends on the technological metaphors we use, but also that those very metaphors reflect the technical knowledge of the time, its discourses and vocabularies. "Metaphors can flow both ways," says Cobb.[7] As discussed in chapter 2, since the medium's invention in the early nineteenth century photography

has been intrinsically linked with neuroscience, both enabling the neuro-scientific imaging practice and shaping the understanding of the working of neurological processes, from memory through to learning. Indeed, it was in terms of "imprinting" on the brain's tissue and its neural extensions that early research in neurology explained perception and action in humans.[8] This perhaps goes some way toward explaining the key role of the concept of "the mental image" in cognitive psychology and neuroscience. Yet since the middle of the twentieth century the photographic discourse has been supplemented by concepts and metaphors from computing, describing the working of the neural system with reference to "feedback loops, informa-tion, codes and computation."[9]

Interestingly, Cobb points out that, even though we now "stand on the brink of understanding how patterns of activity in networks of neurons create perception," some scientists "sense we are approaching an impasse in how we understand the brain."[10] The computer metaphor in particular is said to have reached its limit, with the proliferation of brain data being accompanied by frequent resignation on the part of its human interpreters to its voluminous excess and unexplainability. It is therefore worth probing whether current changes to the photographic medium through its encoun-ter with computation, network technologies, and AI are altering in any way the neuroscientific horizon, and, in particular, our understanding of neu-ral processes related to imaging and perception. What *is* the mental image today—and what can it become? Can we learn to see ourselves and our world better once we have changed our metaphors? And, picking up on this bidirectional flow of metaphors, can the reframing of key concepts lead to a different understanding of photography and imaging?

We need to go deeper

The concept of the mental image, referring to quasi-perceptual experience which is prelinguistic, and which forms the basis of what we now understand as consciousness, has a long history in Western epistemology. An aspect of representationalist thinking unfolding across centuries, it originally posited that ideas were just pictures in our mind, things we saw "with our mind's eye." The concept has now lost its literal connotations without challeng-ing the implicit primacy of visuality in our understanding of knowledge production. Indeed "'imagery' has become the generally accepted term

amongst cognitive scientists for quasi-perceptual experience in any sense mode," with the term embracing auditory, olfactory, kinesthetic, and haptic images alongside visual ones.[11] The fact that the image still constitutes a cornerstone of the neuroscientific rhetorical register delineates a particular conceptual trajectory for the discipline: it prescribes what can be seen and said, and how.

In what follows, I want to look at the use of the concept of the image in the current theories of consciousness as outlined by two of its leading researchers who are also known for writing for wider audiences: neuroscientists Antonio Damasio and Anil Seth. Damasio and Seth are physicalists (aka materialists), yet in their respective theories they go beyond single-organ functionalism. This is to say, they recognize the role of the body and its situatedness in the world in the making of consciousness, a shared assumption that differentiates them from a variety of cognitive scientists currently involved in modeling human intelligence and human vision in machines. But they are also interesting for me because of the different rhetorical registers through which they articulate their positions, coming, respectively, from image theory and information science. In the further part of the chapter I will look at the role of images in Damasio's and Seth's respective theories of perception; at the link between perception, prediction, and imaging in those theories; and, last but not least, at the possibility of *conceptualizing consciousness as a person's orientation toward the future, which involves making images of that future*. The automaticity of this process, be it in mental image-making or in the production of mechanical—or, to use Flusser's term, technical—images of the future, will allow me to take further steps in my own investigation of the possibility of photographing a future.

Readers may have assumed all along that this this idea about photographing a future is a metaphor. I would not deny this, but my understanding of the metaphor in this chapter, and in the book as a whole, positions it as an agentic entity which enacts something, rather than just being an articulation of an otherwise stable "something" in a purposefully figurative sense, for poetic or rhetorical effect. I am following here Jacques Derrida's intimation, outlined in his well-known essay, "White Mythology," that metaphors are philosophemes (i.e., concepts), that they are foundational to philosophy (even if many philosophers would deny this state of events), and that they also exceed the boundaries of any philosophical system.[12] The best we can therefore do with metaphors is "use" them with more awareness

as to their modus operandi, while giving up on the fantasy of any pure, original, uncontaminated meaning "before the metaphor." In other words, we can try to make *better* metaphors, by way of challenging the "white mythology which reassembles and reflects the culture of the West," the white man's *mythos* that passes for universal Reason.[13] An attempt to imagine photographing the future is therefore also an attempt, metaphorical and hence also ontological—as well as, inevitably, political—to figure out ways of making better futures, beyond the fixed frames of our present-day images and imaginations.

For years avoided by scientists as exclusively focused on an individual self and hence impossible to study objectively, consciousness has recently gained a new respectability as a domain of scientific inquiry, partly thanks to the encounter between neuroscience and the multidisciplinary field of artificial intelligence. (Some go so far as to argue that work on artificial intelligence should in fact be recognized as an attempt to create artificial consciousness.)[14] Defined by Damasio as "an organism's awareness of its own self and surroundings,"[15] consciousness is broadly understood as a first-person phenomenon which unfolds as part of a private, first-person process to which we give the name "mind." Damasio distinguishes between *core* consciousness, which is a sense of the here and now, and is also likely to be found in other animals, and *extended* consciousness, which spans one's lifetime, requires memory and attention, and is enhanced by language. Interestingly, it is through references to the metaphorical apparatus of image-making that Damasio explains the working of those two types of consciousness. He proposes that "core consciousness includes an inner sense based on images,"[16] and that those are images of feelings. Responding to stimuli, which are experienced by us *as* feelings, the brain makes patterns in the circuits of its neural cells. In line with the metaphoricity of the wider approach of this chapter, we could call these patterns "impressions" or "imprints."

Damasio concludes that to understand consciousness we primarily need to understand the problem of mental images—i.e., of "how the brain inside the human organism engenders the mental patterns we call, for lack of a better term, the images of an object,"[17] where that object may be material (a person, a place) or immaterial (a melody, a toothache). An image, in turn, stands for "a mental pattern in any of the sensory modalities, e.g., a sound image, a tactile image, the image of a state of well-being."[18] But

then a shift happens in Damasio's narrative, where he is getting his media purposefully yet somewhat unexpectedly mixed. He says: "the first problem of consciousness is the problem of how we get a 'movie-in-the-brain,'" relying on what he himself describes as a "rough metaphor."[19] He also highlights that "the movie has as many sensory tracks as our nervous system has sensory portals—sight, sound, taste, and olfaction, touch, inner senses."[20] Some interesting forms of mediation are activated here, with the brain positioned as the cinematic screen (which we already encountered in chapter 3, via Deleuze). Also, an odd circularity creeps into Damasio's argument as part of the mediation process, with images functioning as stand-ins for his (and everyone else's) inability to clearly explain the sequence of events in the production of consciousness. Damasio goes so far as to acknowledge that we have to explain not only how the movie-in-the-brain is generated (assuming that there is a movie, of course) but also how the brain "generates the sense that there is an owner and observer for that movie."[21] If consciousness does behave like a movie, it is like a retro silent one, as language is only believed to arise at a "later" stage.

The brain-as-screen is perhaps less like a conventional cinema screen and more like the 1950s Circarama, renamed Circle-Vision a decade later, with screens surrounding the viewer from all angles but also requiring the viewer's corporeal movement to appreciate the experience fully. The viewer only *becomes a viewer* through their 360-degree mobility in the image space. This sense of the image envelope that requires mobile attention from the viewer returns in VR and 3D gaming, with the viewer's/player's positioning resembling an M. C. Escher drawing in which the movie dreams itself up as a movie, playing in a theater with an audience. The viewer is thus both inside the image and watching the image. That sense of the self-generativity of experience from within the image envelope is being used in current experiments with machine learning and AI that involve an attempt to recreate the human experience of perception—or rather the externally perceptible aspects of that experience—in machines.

Google's DeepDream algorithm developed in 2015 allowed for the production of images in which nonexistent objects were "discovered" by running previously trained neural network models on those images multiple times.[22] This resulted in infamous images showing spaghetti with eyes, camel-birds, and psychedelic squiggles covering familiar landscapes. This aesthetic, short-lived as it was, became known as "Inceptionism," a

term derived "from the Network in network paper by Lin et al. in conjunction with the famous 'we need to go deeper' internet meme."[23] Lin et al.'s 2013 paper proposed a deep network structure called "Network In Network," which was to be "used to enhance model discriminability for local patches within the receptive field."[24] The operations of recurrent neural networks are meant to recreate the (posited) experience of human perception and human learning, producing images and then feeding them into the network to create more—and more detailed, or "deeper"—images. As we already discussed in chapter 4, the computational model of perception in AI research can be described as reductionist, as it brackets off both the human body and its movement in the environment as not so vital aspects of the perceptive process. This (il)logic is replicated in the current design of neural networks—algorithms whose name is strictly, and restrictively, metaphorical, as there is nothing "neural" about those networks. Yet what is modeled more accurately from the human organism is the sense of recurrence, or circularity, whereby the elements produced as part of the work of the machine's posited "intelligence" are themselves producing that intelligence. (As mentioned before, consciousness would be a more apposite term here, or, more accurately, behavior that presents as consciousness to a human observer.)

Bringing together all the constitutive elements, Damasio puts forward the following schema for the image-based operations of consciousness in humans:

> The wordless narrative . . . is based on neural patterns which become images, images being the same fundamental currency in which the description of the consciousness-causing object is also carried out. Most importantly, the images that constitute this narrative are incorporated in the stream of thoughts. The images in the consciousness narrative flow like shadows along with the images of the object for which they are providing an unwitting, unsolicited comment. To come back to the metaphor of movie-in-the-brain, they are within the movie. There is no external spectator.[25]

A number of things are intriguing about this schema. First is the perceived need to split the process of the emergence of consciousness into two phases: the wordless narrative of images (even though it is still called a *narrative*, its role consisting in having to *describe* the object perceived or *comment* on images of that object) and a subsequent timeline of thoughts (which are not yet words). Second is the distinction between "images in

the consciousness narrative" and "images of the object." The first kind of images function like cybernetic mirrors: they produce consciousness by providing an image of the self (or, more precisely, of the self's body) that is then being incorporated into the picture of the self. I am calling this mirror *cybernetic* because of the feedback loop effect required for its operation. Yet it is not a straightforward device that forms images by reflection. The cybernetic mirror producing consciousness by way of making images is more like the *Magic Mirror* envisaged by Escher, where the reflection becomes part of the scene being reflected. The two strands and two timelines of those images seem to overlap and merge, collapsing the odd Platonism of Damasio's theater of consciousness in which shadows appear before objects into a more contemporary version of the screening venue: a movie theater. The supposed cinematic experience is staged by "the brain" for us, an experience that is also said to generate "us" in the process.

Yet it is worth delving a little deeper into the mixed media metaphors here and realize that consciousness does not really have the designed smoothness of a VR or immersive gaming experience. Damasio himself acknowledges that "core consciousness is generated in pulselike fashion, for each content of which we are to be conscious."[26] Indeed, we flit in and out of consciousness, both during our sleep (when it is only in the relatively short time of deep sleep that our consciousness is suspended) and in daytime. To continue with the media metaphor, consciousness is therefore perhaps more like an experimental modernist short, one that is made up of still photographs, multiple exposure frames, slow-mo animations, and material scratches to the film's surface. The role of the body, foregrounded in the formal experiments of modernist filmmakers such as Sergei Eisenstein, Hans Richter, or Aleksandr Rodchenko, is crucial in the creation and, of course, perception of that movie. We could say that there is no movie without a body. As Damasio puts it, "the images you form in your mind always signal to the organism [which stands for a material bodily entity] its own engagement with the business of making images."[27] The human body therefore presents itself as a self(ie)-camera. The images are needed to generate us, but this sense of "us" emerges through our "action." We become us by imaging and hence imagining ourselves into being, we could say. The image of "the organism" that we internally create for ourselves to map out (not yet quite) our external boundaries, and hence help maintain our life,

becomes a blueprint for the imaging of the self that is subsequently seen as living that life.

Importantly, this ur-image of the organism needs to be followed by many others. Indeed, in order to know how to act, we need what Damasio refers to as "good images." He writes: "Images allow us to choose among repertoires of previously available patterns of action and optimize the delivery of the chosen action—we can, more or less deliberately, more or less automatically, review mentally the images which represent different options of action, different scenarios, different outcomes of action. We can pick and choose the most appropriate and reject the bad ones."[28] Yet it is not only through somewhat confusing spatiality in which a reflection becomes an image that Damasio conveys the working of consciousness to us. His model also entails a warped temporality. While core consciousness, as he figuratively puts it, "does not illuminate the future,"[29] extended consciousness involves "holding an image over time,"[30] which is another name for the process of memory. Drawing on the famous experiment conducted in the 1980s by Benjamin Libet on the relationship between stimulus, reaction, and consciousness, which showed a delay in our consciousness catching up with our body,[31] Damasio points out that "we are always hopelessly late for consciousness,"[32] the lateness amounting to about five hundred milliseconds. This presumed lateness has led philosophers and neuroscientists to interrogate whether our actions are indeed caused by brain activity or whether they are preprogrammed all along. In the latter scenario, consciousness only catches up with our activity five hundred milliseconds later and thus only provides a report on the activity, rather than being its source of origin. The varied responses in the science community to the relationship between consciousness, brain, and body reflect the diverse set of positions on consciousness today, which are in turn underpinned by diverse approaches to the age-old problem of determinism and free will.

Devs could be read as a parable for illustrating this problem. The orchestrator of the Devs enterprise, mad-professor-cum-entrepreneur Forest, believes there is no such thing as free will. As mentioned previously, Forest is mourning his family's death in a car crash, which was caused by his wife while she was on the phone to him—making him a contributor to the crash. Yet for Forest we all run on "tramlines." This means that his wife and daughter died in that car crash because they were always going to die in it,

with the tracks of causality extending well beyond and ahead of any individual's actions or acts of will. The belief in the determinism of the universe provides solace to his guilt but also a recipe for trying to recreate another universe in which a different set of events would be guaranteed to unfold, one that would be more satisfactory to its designer's wishes. Through a trick of smoke and mirrors involving a lot of misuse of the term "quantum," things both do and do not go to plan. A young programmer called Lily—a heroine on a quest to revenge the death of her Russian-spy boyfriend and save the world from Forest's divine machinations, and one whose heroic adventure has already been predicted by Forest's all-seeing computer—at the last moment throws out the gun she was supposed to use to kill the evil Devs-master, thus messing up the prediction algorithm. Yet both Lily and Forest do die in the altercation anyway once the cage that held them drops down, joining the rendered universe on the other side of the screen in which Forest is reunited with his family while Lily is dating her other (good) boyfriend. The philosophical dilemma as to whether they are still themselves in that rendered universe, or whether they are mere digital copies of themselves that just *look like* them to an outside observer, is closed off by the foundational assumption that drives the show (as well as much current AI research) that both perception and consciousness are computational. For *Devs* it also means that it is possible for the characters to experience themselves as "continuous and unified" not just across time (which we all do, every day, on waking up)[33] but also across platforms and media.

Commenting on the science behind the show, computer science professor Scott Aaronson is rather skeptical about the show's overuse of the term "quantum" with reference to what is complexity. Indeed, complexity is the reason computer developers from the scene discussed at the beginning of this chapter are unable to see more than ten seconds into the nematode worm's future. Aaronson then adds, acerbically: "Predicting the weather three weeks from now might be forever impossible."[34]

The perception machine as a prediction machine

A number of successful predictions do nevertheless happen everyday, albeit at smaller scales and temporal ranges, and they do have profound significance not just for how we can live our lives but also for how we can understand ourselves better. Yet their operating model is somewhat different than

claimed by Libet and taken up by *Devs*. Neuroscientist Anil Seth draws on more recent research by Aeron Schurger to provide an interpretation of Libet's experiment which suggests that the assessment of the brain's "readiness potential" to initiate a given action was itself an artifact of the process of measuring this potential, and something that could only be captured retrospectively. According to Seth, "you will see something that looks like a readiness potential if you look back in time from moments of fast responses."[35] This allows him to interpret the brain's supposed readiness as an accumulation of sensory data from which the brain can make the best guess. The brain is therefore not ready for a *specific* action; it has to create this action by envisaging the external state of events—and those events' unfolding. The act of envisaging itself is a simulation of probabilities, a prediction or "best guess," not a foretelling of what will most definitely happen. This statement supports Seth's account of consciousness as the organism's ability to make predictions. We will return to this point shortly. But, for now, I want to focus on another aspect of Seth's argument, namely, his conclusion that free will is a "perceptual experience," a statement that allows him to reconcile our inner sense of agency with the causality of the laws of physics as we know them.[36] This is a stronger claim than it might initially seem, because for Seth the only way we can access anything, internally (in ourselves) or externally (in the world), is through our experiences of it, which are clusters of perceptions. We could go so far as to say, as Seth indeed does, that our sense of self is produced through the process of future-forwarding, i.e., looking at (what becomes) ourselves, at regular intervals, while trying to guess the causes of the sensory signals being received. For Seth, Descartes's "I think, therefore I am" becomes "I predict (myself), therefore I am." This argument is encapsulated by his proposition that our brains are (Bayesian) prediction machines, attempting to guess the causes of sensory signals from the perceptual inferences they receive.[37]

I am interested in this formulation and the idea behind this concept of the prediction machine for two reasons, both related to core aspects of this book: the posited role of perception in the constitution of the self, and the figure of the machine in explaining consciousness. In Seth's framework, prediction and perception are inextricably interwoven: "The brain is continually generating predictions about sensory signals and comparing these predictions with the sensory signals that arrive at the eyes and the ears—and the nose, and the skin, and so on."[38] His post-Cartesian quip

could thus also be articulated as "I perceive (myself), therefore I am." This theory confirms the constitutive role of perception in the emergence of both our self and what we call the world. Yet, even though multisensory perception is such a strong aspect of his framework of thought, Seth is far less inclined than Damasio to resort to media metaphors, whether based on still or moving images, to explain it. Instead, his rhetorical register, with its signals, inputs, outputs, inferences, controls, and Bayesian guesses, is primarily drawn from cybernetics, information theory, and computer science. For Seth we are "beast machines—self-sustaining flesh-bags that care about their own persistence."[39] He traces his use of the concept of the machine to *L'Homme machine* (Machine Man) published in 1747 by Julien Offray de La Mettrie, explaining the workings of both the body and the mind solely in materialist terms, and thus overcoming Descartes's infamous dualism that still shapes much of metaphysics, as well as most religious beliefs. Yet Seth's model of consciousness and selfhood is not computational in the sense used in *Devs*, or applied in the machine vision research discussed in chapter 4. For him consciousness is phenomenological; it is always a consciousness of something, which means it is embodied and embedded in the world.

Echoing the sentiment well known to Marxists, visual culture theorists, and other humanities scholars for decades—namely, that "how things seem is a poor guide to how they actually are"—Seth's theory redefines perception as "controlled hallucination." The notion of systemic control is important to it, with conscious experiences being described, to use Giulio Tononi and Gerald M. Edelman's term, as "informative and integrated."[40] This sense of integration is needed for the execution of the ultimate function of perception: to enable, via a series of prediction-driven actions, our survival in the world. We could perhaps suggest that the role of perception is to enable control over (what we might call, contra Damasio) our self-image, or to go all the way down the imagistic metaphorical whirlwind, to photograph ourselves into existence. If memory, for Damasio as much as for Bergson, involves holding an image over time, selfhood—and self-consciousness, which is its foundational aspect—requires an incessant production of such images. Another way of putting it, in line with the structuring philosophical approach of this book, would be that *we photograph ourselves into being*. The model that emerges here is not that of a movie-in-the-brain, an avant-garde silent film, or even a poorly edited and choppy YouTube video, but rather that of a Polaroid print (albeit one updated for the digital age). But

we also *make the world* by *making images of it*. This is to say that not only do we photograph ourselves into being, we also make the world into what it is (for us) by making images of it, over and over again. It needs to be acknowledged, as I have several times previously in this volume, that "stuff" (aka "matter") does exist "out there" without our perception or other form of intervention, but for it to become what we see as and call the world, it needs this imagistic process to be instantiated. Needless to say, the outcome of the process could look very different for different species.

Seth explicitly rejects the idea of the brain as a kind of computer in the skull, "processing sensory information to build an inner picture of the outside world for the benefit of the self" through feature detection. Nor does he partake of the image register to explain what happens, only resorting to the metaphor of "pictures" in order to dismiss the imaging model. So the brain is not an imaging machine for him, transmitting results from features detected in the world and thus producing their mere reflections. In Seth's model, perceptions do not come directly from outside, i.e., from sensory impulses or inputs; they come from the brain's *predictions about* the causes of these sensory signals. Building on the notion of perception as inference by nineteenth-century physicist and philosopher Hermann von Helmholtz, Seth puts forward his idea of a prediction machine, which is a creative and interpretive device, not just a recording one.

Yet this is perhaps too rigid an opposition, given that prediction and imaging cannot be so easily decoupled, or that they are in fact being increasingly linked in various imaging technologies, from computational photography and CGI through to what has become known as "predtech." We are of course dealing here with an expanded understanding of imagining, and of photography in particular, one that involves a shift from seeing photography as a passive transmission of what is out there in the world through to an active creation of "the world" through the conjoined human-machinic apparatus. Even if we are to agree that perception is not a reading of the world out there and that it is a "controlled hallucination," a way of dreaming up the world on the basis of the "data" received from it, that proposition surely calls for an expanded sense of media through which such a hallucination can occur and present itself to us. Although Seth explicitly rejects the model of the computer, his preference for information theory as the organizer of his metaphorical horizon effectively ends up turning the brain into a high-level processing unit that transforms sensory signal inputs

into abstract predictions, and then spits them out as perceptions. What format and what medium these predictions come in remains unanswered in his theory. Seth emphasizes that "brains are not computers made of meat" but rather "chemical machines," and that every brain is "part of a living body, embedded in and interacting with its environment—an environment which in many cases contains other embodied brains."[41] Putting the image of meat at the center of his argument, he does not follow through on its consequences. The linguistic paradigm, which is inadvertently introduced into Seth's information-driven model—as evidenced, for example, in his claim that "we never experience sensory signals themselves, we only ever experience interpretations of them"[42]—misses out on the creative possibility of the imagistic apparatus. What is more concerning for me is that his model also plays into the hands of those who want to posit prediction as a medium-independent process that can be done better and faster *by* machines, especially those of nonhuman variety. With this we enter the weird world of predtech: predictive technology.

Predtech and the capitalization of perception

This development, long predating advanced research in machine vision and machine learning, was already envisaged by Virilio in his *Vision Machine*. Virilio posited that

> the act of seeing is an act that [precedes] action, a kind of pre-action partly explained by Searle's studies of "intentionality." If seeing is in fact foreseeing, no wonder forecasting has recently become an industry in its own right, with the rapid rise of professional simulation and company projections, and ultimately, hypothetically, the advent of "vision machines" designed to see and foresee in our place. These synthetic-perception machines will be capable of replacing us in certain domains, in certain ultra high-speed operations for which our own visual capacities are inadequate, not because of our ocular system's limited depth of focus, as was the case with the telescope and the microscope, but because of the limited *depth of time* of our physiological "take."[43]

Virilio's analysis was premised on developments taking place in "artificial intelligence," a term curiously yet not wrongly placed by him in quotation marks, in the 1980s, long before the emergence of deep learning and machine vision premised on "Inceptionism," i.e., recursive neural nets. The angle of Virilio's prophetic analysis was sociopolitical. He warned us

against "the automation of perception,"[44] coupled with the production of synthetic imagery that had no indexical reference to anything we recognized as reality, beyond its verisimilitude. Virilio thus knew already in 1988 (the year the French edition of his book came out) that prediction was in fact a creation. The obfuscation of this fact by the photorealism of the media through which the forecasting is delivered has serious consequences for ourselves as both individual selves and political subjects.

Virilio analyzed the use of prediction in military technology, with war maneuvers and wars' outcomes increasingly being simulated on geographically remote screens, where action on the ground serves as a singular actualization of the virtual possibilities run on prediction machines in a different part of the globe. Today predtech is widely deployed in areas such as finance, weather prediction, epidemiology, cancer detection, consumer behavior, and crime prevention. Combining data mining, neural network analysis, and visual rendering, it stages virtual scenarios while also making realities. To explain the working of predtech, marketing technology company Bluecore uses the example of a fuzzy picture which is gradually filled in with more data. Comparing traditional marketing to "taking a very zoomed in view of a photograph,"[45] they pride themselves on using AI to provide "a bigger picture." Yet the process of rendering this picture not only creates an image of their client's customers but also *creates customers*: shaping their desires, choices, and actions while simultaneously rendering the very idea of a desirable customer base for the client using Blucore's predictive technology. For example, "you can use it to calculate a customer's predicted lifetime value, helping your team focus on customers that will drive the most revenue long term."[46] This process is also in operation in other areas where the use of resources, especially those of human nature, is to be optimized. "As of 2013, Hewlett-Packard was predictively scoring its more than 300,000 workers with the probability of whether they'd quit their job—HP called this the Flight Risk score, and it was delivered to managers."[47] Predtech therefore not only predicts what is going to happen but also *makes things happen*. Not only can it create "bad workers" by reporting on them as potentially less reliable and steady in advance of anything they actually do while also shaping punitive management tactics, it also designates certain areas and certain groups of people as less desirable and less valuable, as poorer, weaker, and more prone to crime.

And thus machines photograph the future for us, imaging into existence through publicity and simulation both our desires and the world to come. It was recently reported that AI will not "just help us find things, it will generate what we're actually seeking."[48] Even though the generation of new images through compositing has shaped photographic practice since its inception, with AI-enhanced computation the technique has shifted to the center of image production, while not requiring any expertise from the user anymore. Scott Prevost of Adobe Sensei, an AI and machine learning section of the creative imaging software company, explains that soon the search function "will be able to apply machine learning to blend assets and create an image that never existed before—an image that's exactly what you had in your imagination."[49] The more recent "text-to-image" generators such as Open AI's DALL·E have already been able to generate what we ourselves cannot yet quite imagine. Although presented as a useful feature for all sorts of creatives, it is easy to envisage this technology being utilized to enhance the (mal)functioning of platform capitalism. Following Bernard Stiegler, Taffel describes this process, "whereby knowledge is displaced from humans into machines designed to commodify, privatise and monetise data, information and experience,"[50] as a proletarianization of the user. The impending metaverse as envisaged by the tech companies will perhaps be a final installation in this attempt to not only fully automate our perception but also commodify it.

Of course, things do not have to be this way. Prediction need not be seen as a passive enterprise, an impassionate observation of what will have happened. Having buried the indexical fantasies of photography, we can instead explore the idea of photographing the future as a form of creation, an imaginative rendering of a future we would like to see. This open-ended concept of the future is already (albeit implicitly) embraced by Adobe, Meta, and other giants of the tech industry, although, in supporting a particular form of popular and populist data exchange on their platforms, they end up consolidating the contrary belief that "the future is inevitable, something that can at best be predicted," a belief that of course works in the service of those companies. Yet, as Nick Montfort phrased it, "The future is not something to be predicted, but to be made."[51] We must not therefore just respond to the tech companies' visions and vistas but offer a vision our own—an approach Montfort describes as "future-making." John Norton, a technology writer for the *Observer* and a self-confessed recovering utopian,

recognizes that "if we want to make things better, our focus has to be on changing the machine's purpose and obligations"[52]—with "the machine" standing for him not just for the tech companies of Silicon Valley, but also for their financial enablers, political endorsers, and infrastructural supporters. We must therefore change the key parameters of the prediction machine, while making use of its warped temporality. Photographing the future can become a way not just of seeing *what will happen* but of *creating images of what we want to happen*—and of how we want the world to look—and making better choices from within the image stack. This shift is to take cognizance of the fact that, as discussed in this chapter, computational imaging is always a form of buffering, with a singular photograph being just a cut in a range of possibilities. The next chapter will offer a singular attempt to make better cuts in the image flow—and, with this, to envisage ourselves a better future.

7 "Loser Images" for a Planetary Micro-Vision

Figure 7.1
Joanna Zylinska, *Planetary Exhalation*, 2021.

#WhatPlanet?

What planet are you on? Or, as Twitter has it, #WhatPlanet? Most often used as a jibe, this question is intended to challenge an alien-sounding interlocutor spouting absurd ideas and inculcate in them a sense of reality—a reality which the speaker considers themselves to possess. In recent years this question has been used by broadcast media, from the BBC to RTÉ, more literally, as a way of urging the public to pay attention to environmental and climate issues.[1] What fascinates me about this formulation is its ability not only to deploy both the emotive and conative ("hey you") functions of language, to use Roman Jakobson's slightly old-fashioned terminology, but also to articulate the epistemological problem of seeing and knowing what one is talking about, and of seeing and feeling the ground on which one stands—as well as all the other territories to which this ground is connected. And it is precisely this problem of the perception of "our" world and "our" planet that will be the subject of this chapter. In what follows, I will engage with planetarity as a popular visual and conceptual trope, with a view to developing "a planetary micro-vision." And thus, while the previous chapter dealt with the possibility of predicting the future by rendering it as an image, in what follows I will attempt to imagine and image such a future. I will follow up here on Nick Montfort's intimation about future-making: namely, that "utopian ideas don't have to be entirely serious to have some bite to them, and to be effective in provoking people to change their thinking and move toward a better future."[2]

In a way that is perhaps apposite to the nature of the object being examined, this attempt at future-making will consist of two case studies which take as their inspiration the notion and visuality of what have become known as "architectures of the post-Anthropocene." This term was proposed by Liam Young in the 2019 issue of *Architectural Design* he edited. Illustrated with elegantly crisp photographs of "architecture without people," the volume demonstrated the recent emergence of "landscapes made for or by machines,"[3] featuring data centers, giant distribution warehouses, telecommunications infrastructures, and industrialized agriculture lots. Many of the images in that special issue had been created with the help of drone camera technology, flattened perspective, and CGI, resulting in an oddly detached picture of our planet. But, even if this new planetarity looks distinctly posthuman, the all-conquering visual apparatus used to conjure

it has ended up elevating Man as the creator and destroyer of worlds. My case studies respond to this mode of visualizing the planet and its structuring logic—as well as its politics.

My first case study will explore a specific incarnation of such "architectures of the post-Anthropocene": still and moving images of picturesque locations captured by drones and collected on social media. I will analyze the aesthetics and politics that this kind of "planetary vision" embraces, and the picture of the world it constructs. Yet rather than stage a return to a more human or humane perspective, I will interrogate the technical affordances and potentialities of distributed perception and vision—in machines *and* humans. The focus of my critique will therefore not be on the machinic aspect of vision, or on its aerial elevation per se. It will rather be on the assumed heroism of the eye-in-the-sky, enacted via the unique coupling of drone vision and the view from GoPro Hero action cameras and their kin. In response, I will propose a second case study from my own art practice, titled *Feminist with a Drone*. Presented in the form of field notes, it will explore ways of mobilizing the very same technology to enact a less masterful and less heroic viewpoint. Working against the register of #amazingviews produced from high in the sky, with this amazingness referring to both those views' breathtaking scope and high image quality, I will outline, with a nod to writer-artist Hito Steyerl, the concept of "loser images" as a feminist rejoinder to the magnificent drone image aesthetics. I will then consider to what extent the production and curation of such loser images can be deployed toward an enactment of a different relationship to our habitat and to ourselves as its inhabitants—with a view to building a feminist multi-kin ecology in the spirit of "eco-eco-punk" (figure 7.1).

Given the complexity and scale of the environmental crisis manifesting itself in rising sea levels, air pollution, accelerated species extinction, and a climate shift, it is understandable that "planetarity" has played an increasingly prominent role in the arts, humanities, and social sciences in recent years. Positioned as a concept that can help us understand these changes, it has been used as an injunction—in the editorial for the 2020 special issue of the influential arts journal *eflux*, "You and I Don't Live on the Same Planet" by Martin Guinard, Bruno Latour, et al.; or as a framing device—in the books *Planetary Social Thought: The Anthropocene Challenge to the Social Sciences* by Nigel Clark and Bronislaw Szerszynski and *The Climate of History in a Planetary Age* by Dipesh Chakrabarty. Indeed, it is within the framework

of the recently postulated epoch of the Anthropocene, an epoch in which the human is said to have become a significant geological agent, that planetary thinking has most often been outlined. Chakrabarty makes a strong plea for adopting the planet as a particularly relevant concept in the current geopolitical moment due to its ability to grasp "a dynamic ensemble of relationships—much as G. W. F. Hegel's state or Karl Marx's capital were—an ensemble that constitutes the Earth system."[4] Many of the theorists engaging with issues of planetarity today do so in dialogue with postcolonial writer Gayatri Chakravorty Spivak; specifically, with the final chapter titled "Planetarity" in her short polemical book *Death of a Discipline*, published in 2002. The book analyzed the transformation of humanities disciplines such as area studies, cultural studies, and, Spivak's own intellectual love, comparative literature at the turn of the twenty-first century.

In her book Spivak was very critical of the marketization of what had become known as "world literature" in North American universities, with literature and literary study being transformed into a rootless product to be consumed on a globalized educational market. In its place she offered a much more anchored, distributed, and embodied mode of engaging with the world and its literary and cultural artifacts. With her argument, Spivak opposed the abstraction of globalization, which she saw as "the imposition of the same system of exchange everywhere,"[5] to the differentiated political space of planetarity. "The globe is on our computers. No one lives there. It allows us to think that we can aim to control it. The planet is in the species of alterity, belonging to another system; and yet we inhabit it, on loan,"[6] she wrote. The planetary perspective she embraced was, paradoxically yet importantly, always partial. Introducing the sense of the uncanny in the reader, it was also presented as a demand and a call to responsibility. Even though Spivak's text did not explicitly engage with environmental themes, there was a premonition in it of the ecological perspective that would become an important focus of work in the humanities and social sciences two decades later, around issues concerning the Anthropocene. It is therefore perhaps unsurprising that, at the present time, when disappointment with the untrammeled flow of capital is matched by fear of the unrestricted flow of viruses around the globe, Spivak's concept of planetarity as an embodied response and responsibility to the Earth understood as our habitat—and a recognition that this habitat is not given to us in

perpetuity—has found a wide new audience. Intriguingly, Spivak already had an intimation of this happening when she declared in her book: "I write for a future reader."[7]

In the context of fossil fuel depletion and impending climate catastrophe, the "planetary turn" in the humanities and social sciences we are currently experiencing responds to a concern, as Clark and Szerszynski put it, "not simply with the direction the future will take but [with] whether there will be a future at all."[8] There is an urgency to the present situation, they claim, which is driven by an increasing plausibility of a "planetary state shift."[9] The two authors, perhaps in an attempt to strengthen their own forthcoming proposition, also complain about the dearth of "stories, theories or concepts fit for the task of explaining what it means for human agents to find themselves behaving like Earth or cosmic forces."[10] In response, they offer the concept of a *planetary multiplicity*, which stands for the Earth's capacity, at every scale, "to become other to itself, to self-differentiate."[11] Such discursive and conceptual visualization is a frequent response by theorists concerned with the fate of our planet today. As part of the process, many seem keen to throw some new concepts and images into the planetary basket. Martin Guinard, Eva Lin, and Bruno Latour, for instance, have recently proposed to replace the image of the globe with that of an orange, with its skin, standing for "the upper near-surface layer of the earth," understood as a "critical zone."[12] Writing in the same issue of *e-flux* as Guinard, Lin, Latour, et al., Yuk Hui has offered the term "planetarization" as an image of "the total mobilization of matter and energy," with different energy channels (petrolic, hydraulic, electrical, psychic, sexual) presented as flowing above and beneath the earth.[13] Unlike the other thinkers, however, Hui does not quote Spivak (or, indeed, any other women—which seems rather odd, given his call for the restructuring of knowledge and practice in the university of the twenty-first century). He does instead tell us, in no uncertain terms—and in a strictly normative language, full of "musts," "have tos" and "requireds"—that technological planetarization has an "essence" and that "we must" understand it. This essence, claims Hui, is revealed in proletarianization but it also stands for a requirement to recognize "that we are in and will remain in a state of catastrophe."[14] With Hui's philosophical balls landing rather heavily on the hard discursive surface of his planet figure, his is just a more extreme example of a planetary

thinking that, notwithstanding its political commitment, loses sight of the planet's textured and meaty messiness.

Amidst all this philosophical-planetary shifting, orange peeling, and ball throwing, I find myself somewhat apprehensive about this (re)turn to planetarity—and, in particular, about the image of the planet (and the planetarium) that is produced in some of the recent theorizations on the subject. It is the gender and race aspects of the planetary setup that cause me particular concern. While many recent writers on planetarity (such as Clark, Szerszynski, and Chakrabarty) do indeed recognize the importance of bringing issues of race, gender, and sexuality to the discussion, alongside questions of class, many such accounts nevertheless end up with a model of the planetary theorist as a cosmonaut. This mode of theorizing flirts with an openness to cosmic multiplicity and other forms of difference without really being able to overcome its own distancing from its object of study, or its own linguistic and conceptual enclosure. Planetary theory in most guises today is a theory afloat, with the planet reduced to a toylike globe that the gravity-free theorist can bounce against and around. In "Planetarity" Spivak already offered an interesting diagnosis of the emergence of this mode of enquiry. Even though, as shown earlier, her text was primarily about literature and ways of studying it, it was also very imagistic, with the argument constructed via a sequence of pictures of the world. Spivak made a daring proposition there that the distancing from the planet that occurred in many accounts which attempted to transcend cultural or geographical localism could be explained by a shift of the discursive system "from vagina to planet as the signifier of the uncanny, by way of nationalist colonialism and postcoloniality."[15] This is the way in which "neurotic men" (to cite Spivak after Freud) attempt to exercise power over spaces that give them anxiety: from the disavowal of the birth canal to the dominance of lands deemed barren and ready to be captured, whether in the shape of remote continents or remote planets (exhibit A: Elon Musk).

Why haven't we seen a photograph of the whole Universe yet?

With this critique of the planetary imaginary I am not trying to dismiss planetarity altogether. I am in agreement with Chakrabarty's proposition that a comprehensive politics of climate change has to begin from a planetary perspective, while taking into account our own insignificant timeline.

As he poignantly observes, "The realization that humans—all humans, rich or poor—come late in the planet's life and dwell more in the position of passing guests than possessive hosts has to be an integral part of the perspective from which we pursue our all-too-human but legitimate quest for justice on issues to do with the iniquitous impact of anthropogenic climate change."[16] With my critique, I am therefore only proposing that, if we are to enact the ethicopolitical injunction of Spivak's original idea, we need better conceptualizations *and* better images of the planet.

In an attempt to bypass editor and writer Stuart Brand's cosmonautic fantasies encapsulated in his use of the *Earthrise* and *Blue Marble* images in his countercultural *Whole Earth Catalog*, art historian John Tresch turns to the work of artist Aspen Mays. Mays's plastic button, available in unlimited editions (2009) and inscribed with the query "Why haven't we seen a photograph of the whole Universe yet?," is a transposed replica of a badge distributed by Brand around college campuses in the late 1960s, after an LSD trip experienced from the rooftops had led him to believe that being able to see the Earth as a round and finite object would help people develop a collective sense of planetary responsibility.[17] Mays's expansion of Brand's query, from the Earth to the Universe, foregrounds the absurdity of the idea of a single image being able to capture the whole cosmos (of which it will always be part)—and of a desire to make such a globalizing image in the first place. It also suggests that we may need a "synthetic, anamorphic view from multiple perspectives at once—harmoniously, discordantly, or unthinkably joined."[18] Tresch goes on to make an ontological point, claiming that "how we live on earth is closely tied to how we address the immensely difficult task of picturing the universe. If we want to come back 'down to earth,' we need to think these two scales together—the cosmic and the terrestrial—and consider how our depictions of the universe have intersected, or bypassed, our ways of inhabiting the planet."[19] It is this dual visuality that is arguably lacking from most pictures of the planetary today, pictures that seem to be stuck within the visual logic of politician-turned-environmentalist Al Gore's "Digital Earth."

Gore's 1998 proposal for "Digital Earth," "a multi-resolution, three-dimensional representation of the planet, into which we can embed vast quantities of geo-referenced data," outlined a haptic visuality that turned our planet into a graspable (and manipulable) object—even for a child.[20] The idea has been partially realized in online browser installations such as

Google Earth and NASA's WorldWind. Yet such images and visualizations end up removing the theorist—but often also the artist, the photographer, and the filmmaker as well as the engineer, the data analyst, and the average Internet user—from the channels of energy and light transfer, and resituating them instead in orbit, looking down. It is also the media aspect of energy and light, their role as constitutive part of the imaging and sighting process, that is being overlooked in many attempts at, as well as analyses of, planetary imaging. Leon Gurevitch argues that platforms such as Google Earth end up rationalizing "the planet's eco/mineral systems and humanity's eco/social interactions within the logic of the computer-generated simulated model,"[21] placing their user "in the position of divine manufacturer of the very environments they wish to travel through."[22]

Building on the above critique, I am interested in probing further how we can see the planet—how it arrives to us *as an image, be it a photograph or a CGI rendering*—and how particular images of planetarity shape our imagination and conceptual horizon. I am also interested in how we can mobilize the power of Spivak's planetarity in terms of the human's ethical encounter with the alienness of the Earth, and how we can recognize, with anthropologist Elizabeth Povinelli and her Karrabing interlocutors in the Northern Territory of Australia, the planet's outside-the-human gestationality.[23] We know that our perception of the world is affected by the changes to particulate matter that moves in the air—and to the nature of light that travels through it while enabling perception in us. Amanda Boetzkes has pointed out that "planetarity of vision necessarily emerges from the embryonic agents from which the human emerged, and the dusts, sediments, crystals and mire into which we give way. Yet it also emerges from the geochemical materials we create and which integrate into the planetary fabric."[24] We are now also aware that the Anthropocene literally changes how we see the world. It is thus both the historically specific concrescences of matter and energy that we humans recognize *as images* and the material substrate of such images, and of the visual processes that affect us, that we need to consider when exploring planetary seeing. In other words, to understand the condition of our planet, we need to look at images but also across and beyond them, into those images' "atmospheres." With this I want to suggest that today, a time when, in the words of philosopher-activist Franco "Bifo" Berardi, "history has been replaced by the endless

flowing recombination of fragmentary images,"[25] this ecological model of perception, inspired by the work of James Gibson, requires a temporary readjustment to human timescales. This is to say, to the analysis of the concrescence of particles into things that present as images to us, we need to add the study of the concretization of those images as particular histori-cal formations that *mean something* to us. This will allow us to look into the consequences of this pixelation of history for our cognitive and perceptive framing of the world.

#amazingdroneposts

On what plane should such an analysis unfold? Where should it start? Boetzkes has suggested that technologically driven contemporary art involving robotics, digital practice, biomaterial, and virtual exhibition spaces has altered "the perceptual capabilities and cognitive orienta-tion of human bodies."[26] But it is not just within the realm of art that the reconfiguration of our sensorium is occurring. Daily imagistic prac-tices in online spaces, including social media, arguably serve as a more extensive and impactful laboratory for enacting and experiencing such a transformation. This brings me to my first case study: the widely popular images of different parts of the Earth taken by amateur and semiprofes-sional drone operators and presented on social media. Two types of image experiences stand out here. First, we have a flow of conventionally beauti-ful photographic stills (and occasional short videos) of various picturesque locations and impressive buildings—New Zealand's Mount Taranaki, coastal ice formations somewhere in Canada, Dubai's nightlit cityscape, Zaha Hadid's Galaxy Soho building in Beijing, China—all posted on Insta-gram under the apposite hashtag, #amazingdroneposts (figure 7.2). Yet no matter whether they feature natural land formations or humanmade arti-facts, the drone gaze those images espouse is determinedly architectural. Eschewing any pretense at naturalism, they present the world as a time- and labor-led formation, even if the temporal scales of the laborer are not always human.

The machine eye of the drone camera (in many cases, as is evident from the accompanying hashtag, belonging to one of the Mavic or Mini drones from the industry leader DJI), is deployed to see *for us* humans—but also,

Figure 7.2
Screenshot from the @amazingdroneposts account, Instagram, March 8, 2021.

of course, to see *better than* us. Even though many of the images presented would have no doubt been edited post-capture to enhance their visual appeal, the drone cameras are already sophisticated pieces of equipment, featuring relatively large sensors, multiple camera angles, and the ability to use high dynamic range (HDR). The hyperrealist imagery posted on the #amazingdroneposts feed deploys high contrast and geometrical lines. These images are easy to see and be amazed by because they inscribe themselves in the schematism of human perception outlined by Gibson, serving the world to us as a "layout of surfaces,"[27] and not a sequence of three-dimensional Cartesian coordinates. According to Gibson humans have no depth perception, with the traditional distinction between two- and three-dimensional vision being a myth. What we in fact see are edges, layouts, surfaces—and their affordances "for benefit or injury to someone,"[28] with the image gradually emerging *as an image* through our movement in the world. It is the transformation of those edges, layouts, and surfaces as a result of our changed position in relation to them that produces vision. "What the eye picks up is sequential transformation, not a form," suggest Gibson[29]—an intimation that is developed further in the work of contemporary philosopher of perception Alva Noë.[30]

Without giving up on the objectivism of the existence of stuff "out there," Gibson's ecological theory of visual perception offers a dynamic account not only of how we see the world but also of how the world *becomes something* to us. Noë puts it clearly: "the perceptual world is the world *for us*."[31] If the purpose of vision "is to be aware of the surroundings, the ambient environment,"[32] perception involves information pickup from the world, but it also involves gathering information about ourselves by moving through the world—and, in the process, sensing ourselves as different from it. Vision, as I have attempted to demonstrate throughout this book, is thus proprioceptive and kinesthetic. Importantly, in Gibson's framework it is also presented as both self-forming and terra-forming. (To reiterate, the stuff of "the world," or what Gibson calls "invariants," exists independently of us, but it *becomes something* for us, i.e., it becomes *our environment*, through an active and mobile process of perception.) Like many other theorists of vision, Gibson turns to the image-making apparatus to explain his theory, which leads him to propose that "moviemakers are closer to life than picture makers."[33] As registered in chapter 5, I have doubts about the posited lifelessness of still imaging in comparison to

film—an assumption we see not only in Gibson but also in his intellectual predecessor, philosopher Henri Bergson. And thus, even if we agree with Gibson to "treat the motion picture as the basic form of depiction and the painting or a photograph as a special form of it,"[34] I would suggest that we need to move beyond the understanding of the photograph as a mere film still, an "arrested picture" as opposed to a "progressive" one.[35] Instead, we should consider all of these different types of images as being forms of time- and space-carving, temporary enclosures on a particular scale of duration, with some of those scales being imperceptible to us. But no still photograph is ever just encountered as (a) still: it becomes something for the viewer in their movement in front of or around it. The lines and edges within and around the image discretize it, but they also link back to the antecedent motions and decisions of their makers, printers, editors, framers, scanning technicians, and network operators.

How does this model of vision help us see and understand the Insta-gram flow of #amazingdroneposts? The images posted under this hashtag represent the world reduced to surfaces. To say this is not to castigate those images for their superficiality or banality—although there *is* a visual same-ness to the #amazingdroneposts image flow, with the relatively narrow set of aesthetic and technical criteria for what this amazingness represents (flat-tened perspective, strong lines cutting across the image surface, unusual shapes, deep colors, high contrast, rich textures). However, they are primar-ily surfaces the way all technical images are, as understood by Vilém Flusser. Technical images for Flusser, whether photographs or video, represent a two-dimensional flattening of the world, a transformation of its linearity into code.[36] Yet even if this process is entailed in all imaging practices, the drone images under discussion achieve something unique, in the sense that the schematism of their representation, the reduction of the world to lines and edges, ends up producing images that look more like graphs than pho-tographs. Those images thus serve as visualizations of the world and not as its representations. Partaking of the current visual sensibility whereby "the planet turns into a massive diagram of anthropogenic destruction, reveal-ing itself in hurricanes, heatwaves, droughts, sea level rises, loss of wildlife or the acidification of the oceans,"[37] they renege on its underlying message by turning the diagram into replacement object—while offering a lesson in how *not* to see the planet.

Even though, to reiterate, *all* images are obtained, *as images*, in such a schematizing way, we need to ask further questions about the aesthetics and politics of this particular mode of visualization—and about the politics of vision implied by the "amazing drones" model. Produced by the machine vision of advanced drone cameras, the #amazingdroneposts serve as schematic test cases for how human vision works. They are exercises in the mobile perception of lines and edges enabling us to build a picture of the world. In many ways these images are easy to take in: they afford the world to us as both a surface and an uninterrupted flow. And yet, because they are to be consumed by largely immobile human bodies placed in front of screens, with movement limited to the eye scan and finger scroll, they outsource the action of terra-forming mobility to the drone machine. Gibson had already predicted this experience when he wrote nearly three decades ago: "We modern, civilized, indoor adults are so accustomed to looking at a page or a picture, or through a window, that we often lose the feeling of being surrounded by the environment, our sense of the ambient array of light. . . . We live boxed up lives."[38] In the era of pandemic-induced lockdowns, working from home, and Zoom education, this experience was expanded to the almost universal form of epistemological encounter with images—and with people reduced to images. This semi-immersive experience creates a sense of easy and total accessibility, an illusion of the world being there on demand, subject to our gaze and capital's desire. In this way, it becomes a model of globalization, articulated by Spivak as "the imposition of the same system of exchange everywhere," presenting "that abstract ball covered in latitudes and longitudes, cut by virtual lines, once the equator and the tropics and so on, now drawn by the requirements of Geographical Information Systems."[39]

There exists another class of such globalizing drone images, where the containment and frozenness of movement in the #amazingdroneposts is overcome without transcending the visual limit points of globalization. These are scenic drone videos, several hours long, shot in 4K and set to "relaxing" music, and then posted to YouTube (figure 7.3). The majority of such videos are human-free, treating viewers to sprawling landscape vistas of nature scenes on "planet Earth" (Croatia, Hawaii, Seychelles). Spectacular cityscapes, whether in Hong Kong or the Dolomites, seamlessly transition between urban canyons and mountain gorges, with similar geometric

Figure 7.3
Screenshot from multiple drone videos opened on YouTube in individual windows, March 8, 2021.

patterns of strong vertical lines and contrasting lights and shadows. Some of the videos include humans as insignificant moving points, usually performing superhuman feats such as jogging at the edge of a cliff or scaling a vertical rock. Such scenes are then cut through with close-up machine-eye shots from the GoPro Hero action camera and its kin, worn on bodies. Whether humans are included in those videos or not, there is heroism implied in all of them, with the masterful eye of the drone performing amazing acts, notwithstanding the elements. The videos are sometimes accompanied by heroic narratives of the (predominantly invisible) operator almost losing the drone, and then having to scale icebergs and plunge into volcanoes to rescue it.

The "aerial view" in the #amazingdroneposts on Instagram and in the scenic drone videos on YouTube encapsulates all three of its modes identified by architecture theorist Mark Dorrian: the oblique image, the vertical image, and the diagram.[40] In some of the images the eye of the drone (and, by extension, of the viewer on the other side of the screen) is "directed both downwards and laterally."[41] Dorrian argues that the oblique view allowed new landholders in eighteenth-century England to naturalize their claim to the land. It also enacted "a possessive, expropriating mode of vision," with the "landscape idea" emerging "as a crucial ideological support to what was

historically a kind of internal colonialism."[42] In the drone images of planet Earth this form of internal colonialism, the reinforcement of ownership over our habitat, consolidates the subjectivity of the viewer as the globe master, being able to move fluidly through beautiful spaces in a relaxed and serene manner. Dorrian is quite blunt in his assessment of the ideological effects of the techniques of estrangement mobilized for transforming "the quotidian reality of the city" into a "distanced object of visual consumption": the reality of life on the ground, including the violence that is an inevitable part of it, "is sublimated into the quasi-pastoral spectacle of the 'urban landscape.'"[43] We could therefore suggest that seeing planet Earth through the eye of the drone is one way of avoiding seeing planetarity. The vertical view, originally associated with flight and perfected in World War I's heavy aircraft, deaestheticized the ground view to the point of abstraction, in order to excuse military operations to be performed upon it. The terrain that was to be annihilated "was no longer a landscape but a topography that had become almost cinematic in its constant reconfiguration under the pressure of heavy artillery."[44] Any such explicit destructive fantasies are absent from the drone representations of planet Earth, but what they share with the earlier images of the vertical view is the severing of the ethical bond with the land and a suspension of human responsibility for it. The aesthetic response of giddy awe evoked in many viewers of such posts or videos replaces the embodied and embedded bond with the terrain of our inhabitation. The three-dimensional environment thus gives way to a flat surface—which is only a small step from becoming a diagram. The excessive elevation of the drone, reminiscent of the visuality of satellite images, eliminates the "unnecessary" visual debris from the picture, transforming culture, experience, and lived life into noise.

Feminist with a Drone

In an attempt to identify technical and conceptual openings within the dominant structures of planetary visibility, I developed an art project called *Feminist with a Drone*, which serves here as my second case study. The (mock-ethnographic) "field notes" presented below, and the accompanying images (figure 7.4), are part of this project. *Feminist with a Drone* is not just an artwork but also a *thinkwork*: it is an attempt to outline ideas and concepts *with practices and things*.

Figure 7.4
Joanna Zylinska, *Loser Images 1.0 (Feminist with a Drone)*, 2021.

Date, time, and place of observation

December 12, 2020–January 12, 2021, south-west London, UK

Specific data, facts, and information on what happened on the site

On December 12, 2020, I purchased a Ryze Tello Drone. Designed by industry giant DJI, this mini drone, marketed as "the most fun drone ever," is aimed at teaching kids and adults "how awesome flying can be." The exploration of this awesomeness was the key goal of my fieldwork.

My first outing with the Tello took place on December 24, 2020, in a small park in a residential area of south-west London. During the flight times of up to 13 minutes, I captured a sequence of still and moving images from the height of between 2 and 10 meters. The experiment came to a halt when the drone flew away on descent. The follow-up search didn't yield any results, the situation compounded by unpropitious weather conditions and approaching dusk, with the drone then considered lost. The following day the drone was located in a different part of the park. The experiment in testing the drone's awesomeness was resumed the following week. Some images were taken during the first flight. On its second ascent the drone lost one of its propellers, with the propeller itself getting lost among the park's vegetation. A replacement propeller was installed, but this made the drone inoperative, with the device losing the capacity to fully lift off the ground. This concluded my attempt to fly the drone and take images with it.

Personal reflections on the observation

The Ryze Tello Drone had been chosen for this fieldwork on the basis of its size, design, and marketing literature, with a view to reconciling drone technology's military legacy with my critical (cyber)feminist sensibility. Unfortunately, I was unable to corroborate the producer's promise that "Flying has never been so fun and easy!" Loss was a key characteristic of my experience with the Ryze Tello.

The hypothesis and questions about the observation

Could things have gone any worse? Was the fieldwork conducted as part of my project a failure? Crucially, should I have bought a better, more manly and more high-tech drone? In the spirit of feminist bricolage, an approach which remains aware of power relations, while foregrounding "the practices of shaping, crafting, and producing that academics usually hide (and often hide behind) in the production of beautiful and polished surfaces, unpunctured by doubts, hesitations and incompletion,"[45] I decided to repurpose my losses. The limited sample of images obtained from the drone's camera and their relatively low quality, coupled with the loss of the drone's functionality, led to the development of a hypothesis about the possibility of constructing an alternative drone visuality, which I termed "loser images." This hypothesis will require further research.

As a feminist rejoinder to the "amazing" drone views discussed in my first case study, I want to offer "loser images" as a figuration that channels some of the potential of the multiperspectival, humachinic worldview without falling for its grandeur of scale. Figurations as used in the work of feminist thinkers of technology are thought devices aimed at "shaping a different political imaginary or performing an alternative image of the future."[46] Yet rather than propose a straightforward return to a more human or humane perspective in response to this master aerial vision, I aim to probe further the creative potential of decoupling sight from a bipedal human body and dispersing it across the environment. I am thus interested in mobilizing the same image-making technology to enact a less masterful, less domineering, and less heroic way of visioning and imaging. Mindful of the military origin of drone technology, I want to recognize the trajectory of its feminist repurposing, from abortion pill delivery devices through to femicide mapping tools.[47] My project thus inscribes itself in Anna Feigenbaum's concept of "drone feminism," an approach which "seeks to remember its cyborgian legacies, constructing a political economic reading of how the 'administration of life and death' is always bound up in the pursuit of profits and a masculinist drive to see from on top."[48] Offering up new sites and languages for feminist activism, "drone feminism attempts to reveal the myriad ways that gender matters in the infrastructures and psychologies of drone executions."[49] The alternative form of post-Anthropocene visuality enacted by my non-awesome toy drone does not flatten the world into a postcard while excising its inhabitants of different scales from the picture. Instead, it envisages a more porous *planetscape*—and a more entangled and messy ecology, in the style of feminist eco-eco-punk.

Loser images: a feminist proposal for post-Anthropocene visuality

The minor intervention into the grand problem of planetarity I am presenting in this chapter has an affinity with geographer Heather McLean's "praise of chaotic research pathways."[50] McLean offers her chaotic methodology by way of "a feminist response to planetary urbanization."[51] Specifically, she is responding to the planetary approach to the study of cities offered by Neil Brenner and Christian Schmid. McLean recognizes the value of her colleagues' critique of globalized yet static approaches to urbanism, approaches which uncritically praise creativity, innovation and sustainability without

taking into account "contradictory geo-economic forces that constitute cit-
ies and regions."[52] Yet she also points out that there is something both
totalizing and limiting about the planetary approach they offer in response,
in that it "privileges a lineage of particular white, male, and European
Marxist and neo-Marxist political economists at the expense of feminist,
queer, and anti-colonial contributions to this sub-field."[53] It also positions
researchers as preconstituted and monadic entities, not as living, breathing
beings emerging as part of their work, praxis, or struggle. This is precisely
the problem I raised in the earlier part of this chapter with regard to the
cosmonaut theorists of planetarity, floating above and around their object
of study without getting their lungs and hands dirty.

My "loser images" go beyond the perfect planetary vision of the drone
eye—but they also transcend the airy planetarity of much of contemporary
theory, which seems to have left behind Spivak's commitment to partial
views, inhabitation, and an alterity that makes a difference. Conceptu-
ally, *Feminist with a Drone* engages humor, irony, and partiality as femi-
nist methods for conducting work in technoscience and technoculture.[54]
Those modes of affectively remodulating the traditional framework of what
counts as knowledge and scholarship proper open up alternative ways of
seeing and doing. McLean also works in this vein—for example, with her
drag king performance at a cabaret called Fail Better, a Glasgow space fea-
turing artists of color and queer and working-class artists. Adopting a drag
king persona of an urban think-tank expert Toby Sharp, promoting "tools
for urban change" as part of the creative cities agenda, she engaged feminist
critique not only in her scholarly research but also in her cabaret act. Cre-
ative urban communities are therefore treated by her as not just objects of
study: they become research partners. McLean admits that "from a plane-
tary standpoint" promoted by theorists such as Brenner and Schmid, activi-
ties such as those taking place at the Fail Better cabaret could be positioned
as, at best, ineffective. She also fears that "through a lens pre-occupied with
mapping flows of capital," local sites of activism can end up looking "as
weak and useless in the face of steamroller-like neoliberal policies."[55]

I share McLean's concerns. Like her, I have experienced challenges to
my attempts to enact alternative modes of producing academic knowl-
edge. (The normalizing statement, "Please let's not make fools of our-
selves," heard after conference presentations or panel discussions, still rings
in my ears.) Yet, like her, I believe there is too much at stake to just give

up—especially as the accusation of weakness is itself a gendered strategy aimed at renormalizing the "militant and heroic/victorious"[56] ways of acting, be it as knowledge producer, political actor, or artist. Polish philosopher Ewa Majewska has gone so far as to propose what she has termed "the avant-garde of the weak," a mode of working which "combines the feminist rejections of patriarchal visions of genius and creativity and emancipatory claims originating in the peripheries, with their demand for an expanded epistemology—one including marginalized and colonized territories in art history and practice."[57] *Feminist with a Drone* was thus designed as a performance of *planetarity as a research problem*, but it also was already a form of *research designed as a performance*. My goal with this was to perform the study of planetarity, and of the associated disciplines of art history, ethnography, geography, urban studies, architecture, and design, with their colonial histories and epistemological exclusions, differently. Even though the method and the tools used (a toy drone, a beach ball in the parallel project called *Planetary Exhalation*, figure 7.1) may seem naïve and childlike, their underlying ambition—to challenge our ongoing planetary foolishness as well as our partial vision—are very serious indeed.

Arguably, the photographic tradition has always had a "loser" track within its practices. Almost since the medium's inception, this track has been embraced by those interested in strategies of countervisuality, as a challenge to the narrative of technical progress or to the imperative of verisimilitude. "Bad" images—on the level of representation, resolution, or material imprint—have been embraced as good by photographic avant-gardes, with abstraction as a negation of a clear image often underpinned by sociopolitical desires to offer a new vision of the world. Ernst van Alphen offers the notion of "failed images," i.e., "images that fail to comply with the dominant notion of photography,"[58] as a description of this alternative trajectory in photographic history. He lists blurred images, under- and overexposed shots, staged photographs, and archival practices as examples of the failure to comply with "the photographic approach"—which he defines, pace German critic Siegfried Kracauer, as "the effort to utilize the inherent properties of the camera."[59] An odd normativity thus creeps into van Alphen's quasi-scientific taxonomy, with its rather rigid determination of the primacy of the normal, the successful, and the proper overshadowing the possibility that "failure" could have been the *raison d'être* of photography's development, rather than just an alternative enabled by a departure

from the "good" use of the photographic apparatus.[60] Yet his book provides an interesting link between the early practices of photographers such as Hippolyte Bayard, Julia Margaret Cameron, Oscar Gustave Rejlander, Anna Atkins, Man Ray, and Anton Giulio Bragaglia, and the contemporary works of photographic artists such as Hiroshi Sugimoto, Thomas Ruff, Francesca Woodman, Awoiska van der Molen, and Fiona Tan. Differentiating them from accidental errors of photographic amateurs, he links all of these photographic "counter-practices" with the Flusserian imperative to open up "the unconscious of the photographic image" and "bring the programme of the photographic image to light."[61] Their producers perform the role of what Flusser calls "envisioners," i.e., "people who try to turn an automatic apparatus against its own condition of being automatic."[62] Yet there is arguably something romantic about van Alphen's reading of Flusser, with the circuit-breaking and black-box-opening aspect of image practices left to individuals deemed "artists" across history.

The notion of "loser images" I am working with here partakes of the circuit-breaking spirit envisaged by Flusser and embraced by van Alphen— but it also blurs the boundaries between human intentionality, machinic agency, and infrastructural embedding. To say this is not to deny human image makers any agency whatsoever. It is only to recognize, with Lyle Rexer, the possibility of seeing abstraction, the way many modern artists have done, "as a way around the notion of individual production, a search for unconditioned forms of communication that, in some sense, do not depend on individual consciousness and its messy historical circumstances."[63] This determinedly modernist desire to rise above the everyday fabric of mass culture and the "mass image,"[64] be it through formal experimentation with the disembodied camera eye or image blur, could perhaps be coupled with another instinct: to reach beyond and outside of one*self*, and embrace a more multiple network of productive agents and forces. This would perhaps be a more grounded, more responsible, and more ethical way of developing counterpractices.

The "loser images" figuration produced in the process follows in the footsteps of Hito Steyerl, whose kin notion of "poor images" has become an important trope in contemporary critical studies of the image.[65] Steyerl used the term to describe lossy digital images traversing the networked personal computers of our globe. Their poverty referred to their low quality and low resolution—as a result of their incessant replication on ever

cheaper media—but it also pointed to the wider condition of cultural disjuncture, where the impoverishment of many image producers and imaged subjects went hand in hand with the enrichment of those in control of the digital infrastructures. My "loser images" are precisely such poor images of the world: serving as counterpoints to the #amazingdroneposts of planet Earth, they are a testament to the poor quality of the camera and the limited skills of its operator. There is something not quite right with them as both representations and captures. The worldview they present is out of sync: wobbly, smeary, somehow degraded. They belong to the ontological register of Amanda Lagerkvist's "existential media," that is, media driven by the fundamental insight "that there is a limit to life, to energy, to bodily and mental strength, to desire, to beauty, to youth, to intelligence, to achievement, to movement, to success, to resilience, to clout, to power, to energy, to communication."[66]

Yet these "loser images" are not just mine: the concept is primarily meant to serve as a viewing, structuring, and archiving device, allowing us to develop a countervisuality to what is already there. In her article "Online Weak and Poor Images: On Contemporary Visual Politics," Tereza Stejskalová has made an appeal to "make use of online images in a way that presents [a] challenge to the mass-image, profit-driven networked platform," and to seek oppositional agency for images posted on social platforms.[67] In this very spirit, I have mined, with the help of the deep learning similarity algorithm of the visual search engine Same Energy (which is like Google's "search by image," but more look- and mood-based), millions of images from Reddit, Instagram, and Pinterest with a view to developing visual affinities with my own "failed images."[68] The grids obtained transcend both the modernist elegance of Bernd and Hilla Becher's industrial typologies and the colorful seamlessness of the #amazingdroneposts Instagram flow, to inaugurate an open-ended noisy archive from which a different picture of the planet can emerge (figure 7.5).

In the spirit of "the avant-garde of the weak," the project offers "a possibility to overcome [the] individualism of performance and spectatorship via a commonality of experiencing failure and weakness"[69]—or at least to stage this failure and weakness as a shared experience. Today's artist, as Stejskalová aptly observes, needs to understand "that she is not anyone special nor is she doing anything special but is, in principle, like any other social network user who makes manifest the (crisis of) emotions, relations and

Figure 7.5
Joanna Zylinska, *Loser Images 2.0 (Same Energy)*, 2021.

labour which sustain life itself."[70] Picking up a baton from Steyerl, I am thus speaking here *in defense of the poor image of the world*: low-resolution, widely accessible, pirated. In other words, I am speaking for what we might term, with a nod to Gary Hall, an ethical piracy. In *Pirate Philosophy*, Hall revisits the word's origins in a Greek verb which meant to "make an attempt, try, test . . . endeavour, attack,"[71] to refer to piratic practices in texts and images which go against the grain of traditional knowledge production, its classification and distribution. Loser images are pirate images because they "tease [and] give trouble,"[72] as per the word's Greek etymology. Loser images also drop out of the competitive system of accolades, prizes, and totems. They

drop out of individual authorship. Yet their marginal cultural status is not by itself a guarantee of progressivism: as recent years have aptly demonstrated, the extreme right can meme very well indeed!

Loser images embrace their machinic heritage, but they also take on board the inevitable failures of human bodies *and* machinic infrastructures. As part of their weak feminist efficacy, they thus show up the dominant perception machine that we all inhabit as structurally and politically broken. Channeling the politics of Sarah Sharma's "Manifesto for the Broken Machine," another powerful feminist figuration whereby "feminists are rendered . . . the faulty aberration in a long line of otherwise efficient technologies that have been designed for caretaking and reciprocating love in a male-dominated world,"[73] loser images challenge the macho-heroism of the drone eye and the GoPro Hero camera. Offering a fragile yet tender look, loser images differ from "ruin porn": the aestheticization of loss, decay, and poverty which is part of the dominant Anthropocene visuality. They restage planetarity as a call for help, enacting the collective "exhaustion of humans, machines and the environment."[74] Loser images are therefore unproductive, because they work against the logic of planetary extractivism (the depletion of natural and human resources; planetary management via technological improvement). Eschewing the hipster retrovisuality of the "failed images that fail in their failing,"[75] such as Lomography, they challenge the seemingly inevitable upgrade culture—of machines and humans—not just in an aesthetic gesture but also in an attempt to make a difference.

To speak in defense of the poor image of the world is to mobilize an ethical injunction to see the world better—and to make better things in and with it. It is an injunction to look around and askew, to look obliquely, to work against the limitations of the image, and to know that pictures are always partial. There is something not quite right with them, but they are not *wrong* either. A post-Anthropocene loser image flow: it tries to fail better every time, with every new arrangement of the grid.

A slightly better Anthropocene: or how to live in a media-dirty world

My loser images inscribe themselves in the ecology of what I am calling in this book "eco-eco-punk." In its alliterative ec(h)oing of the dual ecological and economic crises, eco-eco-punk goes beyond the (whitewashed and

masculinist) singularity of the rouge punk hero-savior. In the media ecology of eco-eco-punk, the hero's name is legion, and they may not even be *just* human. With this, eco-eco-punk enacts a "reaction to a world in which humanity must constantly be renegotiated."[76] As well as envisaging new ways of engaging with the environment while showing it as always already mediated, this mode of practice opens up a traditional cyberpunk ethos to the plurality of voices, sensibilities, and sensations. The concept of eco-eco-punk encapsulates this very spirit of "more than one," a community of confluences and contaminations that goes beyond the experience of a "disaffected loner from outside the cultural mainstream,"[77] fighting totalitarian corporations with his wit and kit. Eco-eco-punk reverberates with the multiplicity of actors, human and nonhuman, who are at work in the system. The recognition of this plural and entangled ontology of our ecologies, which are always already *media* ecologies, is a first step toward outlining contours of an eco-eco-punk ethos which has progressive ramifications. This commitment to "more than one" can be found, for example, in media artist Nam June Paik's early practice, as he later corroborated: "To take fame out of art, well that's the most important thing. . . . To take fame out of the art-world. That was the spirit of Fluxus."[78] In its first decade in particular, in the 1960s, the artists involved with Fluxus were attempting to move away from the idea of the art object and from the monadic trappings of singular recognition. Instead, they worked toward developing what could be described as an ecology of relations, premised on submerging their own individual egos.[79] Embracing the nascent spirit of cybernetics that saw individual entities as emerging only *from* relations, Fluxus also drew from the Zen tradition of understanding the world, as evidenced in both Paik's and John Cage's work. Yet Paik's engagement with different types of systems, biological as well as technical—as evident, for example, in his *Family of Robot* or *TV Buddha* video sculptures—shows him reconciling seemingly contradictory personas in his work: that of a Zen master and that of an eco-eco punk.

Eco-eco-punk recognizes not only the benefits of living with advanced technology, but also the fact that humans are originarily technical beings, that we have emerged and evolved with, and via, diverse objects and practices such as plows, fire, wheels, agriculture, cooking, and transportation. A mode of breaking out of the ec(h)o chamber of the conventional responses to the Anthropocene that remain rooted in affects such as "gloom and

doom, . . . guilt, shame, didacticism, prescriptiveness, sentimentality, reverence, seriousness, sincerity, earnestness [and] sanctimony,"[80] eco-eco-punk sees the world as always already "media-dirty": embroiled, entangled, enmeshed. Yet dirt is not positioned here as something to be overcome for a civilization to take place and hold together: it is rather seen as our civilization's constitutive element. Dirt is also a reminder of the remainder and a conduit of mediation. Eco-eco-punk thus becomes a proposal for those who recognize themselves, and the world around them, as always already media dirty. It is a mode of acting for those for whom ecology connects, via wires and wirelessly, to the media infrastructures that organize the world and that shape our position in the world. Last but not least, eco-eco-punk speaks to those who would rather be cyborgs than goddesses, and for whom art-making functions as an inevitable technical prosthesis for a human embedded *in* the world—and becoming *with* the world. Mobilizing a particular DIY-media aesthetics, it "utilizes the dissonance of the ugly" to "monkey-wrench" an imagistic repertoire, with a view to introducing "an aesthetic delay or suspension that makes its easy consumption by the viewer more difficult and more deliberate."[81] It is therefore more than an aesthetic: it becomes an *ethical* mode of intervening into the landscapes and architectures of the post-Anthropocene.

Conclusion: Future Sensing in the Metaverse

Figure 8.1
Joanna Zylinska, image automatically produced through the text-to-image generator known as DALL·E 2. In producing the image, the algorithm responded to the query, "What will our future look like?" Image obtained on first attempt. No modification, except for conversion to black and white. July 2022.

This book opened with some reflections on the weirdness of 2021 as a catalyst year for reimagining the future as part zombie apocalypse, part robot park. Images, especially photographically influenced images, are a key component of the imaginarium of that future—or, indeed, *any* future. Recognizing the role of photographs and their algorithmic correlates in video games, cinema, social media platforms, machine vision, and prediction technology, I have aimed throughout this volume to showcase the operations of the perception machine we are currently inhabiting while going ever deeper into it—from the environmental and the social, through the computational, all the way to the neural. I have also argued that we are increasingly seeing ourselves being seen, tracked, and touched by an ever-growing volume of cameras, scanners, and sensors, while emerging as "us" precisely through this process of machinic perception. The machinic image apparatus therefore has a predictive function: it forecasts us into the future by means of images, while playing a certain version of this future before our eyes. Its genre is an after-photographic hybrid: it is increasingly looking like an Instagram story intercut with a horror film, creepily reimagined by AI (figure 8.1).

As we have seen, the photographic medium itself has changed dramatically in its encounter with other media technologies and infrastructures. We could perhaps go so far as to say that photography is now becoming a "sensography," a multisensory medium whose operative mode relies on sensors and various measuring and calculating instruments as much as it does on optical devices. Yet the book's argument has not just focused on what has happened to the photographic medium, or even on what it means for us to live surrounded by image flows and machine eyes. I have also attempted to point to some possible openings within the operability and logic of the perception machine by trying to identify moments when the programmability of its system fails—and thus also, in another sense, gains something. These moments have involved individual and collective actions of shared human-machinic obstreperousness manifesting as systemic glitch, from feminist eco-eco-punk to the avant-garde of the weak. Importantly, and following Vilém Flusser's lead, this has always been a form of opening performed *from within* the machine—rather than simply against it. "The perception machine" has thus served in this book as both a metaphor for a visual and cognitive enclosure and as a sociopolitical and affective opening.

Yet the postulation of the "perception machine" has been more than just an analytic gesture: I have also used to it convey, albeit implicitly, an ethical

injunction. This injunction is shaped by a complex set of responsibilities exerted not only by humans toward one another but also by nonhuman beings—including planet Earth as our habitation partner and life source. Responding to the dynamic of visible and invisible images, and to their infrastructures across planetary scales, my hybrid method of working in this volume, combining philosophical enquiry and artistic research, has been adopted with a view to expanding our epistemological horizon as out-lined by academic convention and human cognitive practice. With this, my goal has been to allow myself and others to see, sense, and say (more) things via a variety of modes and media. Yet it has been equally important for me to keep a check on the hubris that sometimes underpins theorists' or artists' pronouncements about our work and its purported impact and influence. In the vein of my earlier work on "minimal ethics,"[1] my modest attempt to make a critical intervention in the world through a variety of media can perhaps be described as a "planetary praxis that attempts to make a small difference." Imagining a slightly better future, while accounting for the imaging apparatus that can assist us in—yet also at times impede—this task, has been part of this attempt.

* * *

When 2021 was coming to a close and hope was emerging for the world to start coming out of the Covid-19 pandemic, another form of enclo-sure dawned on the horizon. In October 2021 Mark Zuckerberg excitedly announced that Facebook was to become unironically known as Meta, and that the company would invest billions of dollars into building a virtual reality platform (VR) to be known as a "metaverse." The unstable and jaggy "after-photographic" architecture of pictures and data flows, occasionally warping into image envelopes, was to become a full-blown 360-degree image sphere. The perception machine was to be both privatized and "per-sonalized," projecting (the fantasy of) many different worlds and many dif-ferent futures for us all. Facebook had been investing in VR technology for some time already, having developed a successful Oculus headset which only made users feel a little bit nauseous. The Meta announcement sig-naled a clear repositioning from a "rhetorically social" platform to an all-encompassing branded loop, one in which Neil Stephenson's dystopia was to meet Dave Egger's circle[2] by forming a ring of virtual steel around our eyes, bodies, and brains. Zuckerberg's metaverse promised to be a universal

perception machine, one in which we should be able to have business meetings, go on vacation, and buy real and virtual goods without thinking twice about that old-style Cartesian dualism. The future as photographed, graphically rendered, and stitched together into a seamless whole will thus turn our current Google World (where there still exists some perceptive and cognitive distance between what you search for and the technical infrastructure that delivers it) into Goggle World. Indeed, Google itself is developing Project Iris by focusing on an AR-enhancement headset, Apple is heavily investing in VR, while Microsoft has had some successes with its "mixed reality" headset called HoloLens, which uses sensors, optics, and holography to seamlessly meld with its environment—and which is aimed at areas as diverse as entertainment, medicine, and combat. It does not therefore matter that, by 2023, media commentators were already announcing the death of the metaverse as dreamt by Zuckerberg, with Meta having burned through huge sums of money without much to show for it. The desire to enclose ever more spheres of our perception is not likely to subside. It will probably just undergo a rebranding—and a technical reboot. So this is what "photography after platform capitalism," to paraphrase Ben Burbridge's perceptive analysis of the current image landscape,[3] will look like—although whether "we" will actually be able to see it, and whether a discrete human "we," with its unique signal points such as consciousness and proprioception, will continue existing in this metaverse, is not quite clear as yet.

It is surely not accidental that the metaverse technology is being rolled out at a time when the horizon before our eyes is not looking all too rosy. Our planet is facing a number of problems that will only be exacerbated in the coming decades: from the climate crisis through to the automation of labor and other domains of our lives, coupled with the growing inequality and the accumulation of both capital and decision-making powers by an ever-smaller group of actors. Cyberwarfare, coupled with many localized on-the-ground conflicts and the renewed threat of nuclear annihilation, add another level of threat. This state of events, as argued in the opening pages, is turning most humans into unwitting existentialists. No matter what our social class, education, or geographical location, we increasingly need to understand and manage, in our minds and lives, various apocalyptic scenarios concerning the possible destruction of life on our planet, both in its social and organic guises—or even the destruction of the planet as such. This trend will no doubt continue. What is particularly concerning is that those apocalyptic scenarios are being rebranded by some as business

opportunities, with a secular form of solutionism, dressed up as techno-age salvation, offered to us by a whole series of digital messiahs such as Elon Musk, Jeff Bezos, or (maybe slightly less evil but not any less narcissistic) Bill Gates. This mix of arrogance and capital, coupled with a hypermasculinist sociopathy, tends to be presented as a form of genius.

In an attempt to immerse myself in the future while continuing to hone my dubious gaming skills, I recently picked up an Oculus 2 (now rebranded as Meta 2) VR headset loaded with the *National Geographic Explore VR* app "to discover two of the most iconic locations on the planet": Antarctica and Machu Picchu. Importantly, the app itself was not being marketed as a game but rather as an "experience." What was of particular interest to me was that it contained a mission to capture photographs for the *National Geographic* magazine with a virtual camera, thus letting "the entire family discover the world without ever leaving home."[4] There were some in-game tips about photography within the narrative, training the user in the art of framing and light capture. What surprised me, in turn, was that—unlike in console games, where in-game photography is promoted by the manufacturers as a sharable activity, with an easy way to download the captured images—in its VR counterpart there was no easy way of accessing the photos, even in the game experience premised on photography. In what seemed like laboratory testing for an NFT-driven logic of digital exchange, the only way to engage with the captured photos was to display them in a picture gallery (in specially prepared frames) within the app, with no evident traces of those images in any of the storage spaces within the system.[5] I therefore had to resort to manual screenshotting and heavy editing, including cropping and uprezzing, to take my images outside the VR "experience" (figure 8.2).

Being in the *Explore* world of Antarctica and Machu Picchu felt both very real and very photographic. The designers had used photogrammetry—the technique of taking measurements from 2D photographs to generate realistic-looking 3D renderings of spatial objects—to produce those visuals. The process involved capturing around 50,000 still images of the two locations, then stitching them together to generate a sense of an all-round experience, while correcting data errors and adding individual small elements by hand. What was more ominous perhaps was that this may be the only way to see the icebergs in years to come—not just because "the family" will not want, or be able, to travel to them but also, of course, because global sea ice is irreversibly shrinking,[6] while indigenous cultures are continuously exposed to cultural and material expropriation.

Figure 8.2
Joanna Zylinska, screenshots from *National Geographic Explore VR*, Oculus 2, 2022.

Naturally, things do not have to be this way. After-photographic VR does not just have to serve as an anesthetic replacement for the world gone by. Zuckerberg and his ilk do not own the concept of the metaverse and were not even the first to announce it. Other incarnations of it exist, where the perception machine enables some other forms of aesthetic and ethical experience, rather than serving primarily as a supermarket of data points rendered as photorealistic images, moving or still. Serpentine Galleries' polyvocal second volume of *Future Art Ecosystems*, titled *Art x Metaverse* and published several months before Facebook's announcement, offers

guidance "for the construction of 21st-century cultural infrastructure"[7] as an alternative to the narrative about platform- and world-building shaped by large corporations. Recognizing the planetary scale of the metaverse project, the authors advocate for the construction of an open and accountable system that builds on the expertise of public interest organizations, while serving public interests.[8] Importantly, it is not just in the domain of art that they seek spaces for metaverse experiences, pointing to "art-adjacent" fields such as gaming, blockchain, film, video, and architecture. Photography is notably absent from their list of references, yet my argument would be—indeed, has been in this book—that our current cultural and visual experience and technology are significantly shaped, or even haunted, by photography. While current visual technology, in its computational, gaming, or metaversal guise, is intent on rendering the photographic legacy invisible, we absolutely must not forget (about) photography. Because what is at stake here is not really the future of a particular medium, be it as an art historical artifact or financial investment (a future trajectory about which, similarly to Andrew Dewdney in *Forget Photography*, I could not care less), but rather *the future of all of us*. We should thus do our best to try to grasp how the after-photographic images have been stitched into a seamless Circa-Vision 2.0.

Amanda Lagerkvist poignantly observes that "existential media . . . may furnish a foundation for us; they may also throw us. They may remind us of our frailty, our desires to (dis)connect, and our need to ethically contain the technologies we live and die by."[9] In spite of the serious or even perhaps ominous tenor of its conclusion, this book's study of the existential aspects not just of photography but also of after-photographic temporality has also been intended as a celebration. The book celebrates both this after-photographic moment, when the exuberance of the imagistic life is creating new ways of seeing and experiencing ourselves and the world, and ourselves as media subjects coevolving with our machines. But *The Perception Machine* is also, of course, a warning. More importantly, it is intended as an invitation to a shared conversation and practice, extended to designers, programmers, photographers, artists, writers, thinkers, activists, white hats, and all sorts of eco-bio-feminist-queer-trans punks, to experiment with, retune, or hack the perception machine. While we still can. While we can still see and feel its edges and limits. While we can still see and feel *anything* . . .

Notes

Preface

This short photo essay, introducing in a visual form the key themes of my book while aiming to enact what it means to live in a media-dirty world, is made up of collages which combine my own and found images. Image credits and references:

Page ix: (1) Image from *Ophthalmodouleia: Das ist Augendienst*, the first Renaissance manuscript on ophthalmic disorders and eye surgery, published in 1583 by German physician Georg Bartisch (1535–1607), considered by many to be the "father of modern ophthalmology," https://publicdomainreview.org/collection /images-from-johann-zahn-s-oculus-artificialis-1685. (2) Still from a promotional film titled *To New Horizons* from General Motors. The film was created to promote their "Highways and Horizons" exhibit at the 1939–1940 New York World's Fair. "The film presents a vision of the future, namely of 1960 seen through the eyes of those living in 1940, and imagines the world of tomorrow which the narrator describes as 'A greater world, a better world, a world which always will grow forward,'" https://publicdomainreview.org/collection/to-new-horizons-1940. (3) Collage from randomly selected photos from my cell phone, made with the Gandr app.

Page x: (1) Still from my *Neuromatic* video, featuring a reworking, through a GAN algorithm, of images of eyes and brains taken from the Wellcome Collection, and annotated by myself with a memelike slogan and typeface.

Page xi: (1) *Back to the Future* meme made for the 2020 pandemic—and updated by myself for 2021. (2) No-photography symbol found on the Internet. (3) Curtain for the theater performance of the *Back to the Future* musical staged at the Adelphi Theatre in London in December 2021, photo by myself. (4) Collage from randomly selected photos from my cell phone, made with the Gandr app.

Page xii: (1) Johann Zahn, two images from *Oculus artificialis teledioptricus sive telescopium* (The long-distance artificial eye, or telescope) (Herbipoli [Wurzburg]: Quirini Heyl, 1685–1686), part I, https://publicdomainreview.org/collection/images

-from-johann-zahn-s-oculus-artificialis-1685. (2) Indoor dome security camera, found image. (3) Image of Abraham Lincoln as a matrix of pixel values, in Thomas Smits and Melvin Wevers, "The Visual Digital Turn: Using Neural Networks to Study Historical Images," *Digital Scholarship in the Humanities* 35, no. 1 (January 2020), 197. (4) Collage from randomly selected photos from my cell phone, made with the Gandr app.

Page xiii: (1) Collage from randomly selected photos from my cell phone, made with the Gandr app. (2) Quote from Vilém Flusser, *Into the Universe of Technical Images*, trans. Nancy Ann Roth (Minneapolis: University of Minnesota Press, 2011), 127.

Page xiv: (1) Still from my *Neuromatic* video.

Page xv: (1) Fundus photo from my eye examination at Boots, London. (2) No-profile icon from mobile applications; found image.

Page xvi: (1) Stills from my *Neuromatic* video. (2) Meme from *Know Your Meme* online encyclopedia, submitted by My Little Pony: Friendship is Magic.

Page xvii: (1) Poem generated by an AI algorithm (seemingly trained on a poetry database), in response to a one-word prompt offered by myself—"perception." Poem Pavilion, UK, designed by Es Devlin, Expo Dubai 2020, October 1, 2021–March 31, 2022. (2) Surgeon and assistant performing cataract surgery on a patient and various surgical instruments, tables XXXVIII–XXXIX from *A Medicinal Dictionary* (1743–1745), https://publicdomainreview.org/collection/denis-diderot-letter-on-the-blind.

Introduction

1. As the Samsung website described it, "Designed with a unique contour-cut camera to create a revolution in photography—letting you capture cinematic 8K video and snap epic stills, all in one go" (https://www.samsung.com/uk/smartphones/galaxy-s21-ultra-5g/).

2. Tomáš Dvořák and Jussi Parikka, eds., *Photography Off the Scale: Technologies and Theories of the Mass Image* (Edinburgh: Edinburgh University Press, 2021).

3. Lev Manovich, "Introduction: How to See One Billion Images," in *Cultural Analytics* (Cambridge, MA: MIT Press, 2020).

4. Lev Manovich speaking at "Scales, Collections, and Quantities," launch event for Parikka and Dvořák's book, Zoom, March 25, 2021.

5. Andrew Dewdney, *Forget Photography* (London: Goldsmiths Press, 2021).

6. Ariel Goldberg and Yazan Khalili, "We Stopped Taking Photos," *e-flux Journal*, no. 115 (February 2021), https://www.e-flux.com/journal/115/374500/we-stopped-taking-photos/

7. Yanai Toister, *Photography from the Turin Shroud to the Turing Machine* (Bristol: Intellect, 2020), 53.

8. Ibid.

9. Benjamin H. Bratton, *The Stack: On Software and Sovereignty* (Cambridge, MA: MIT Press, 2016).

10. Dipesh Chakrabarty, *The Climate of History in a Planetary Age* (Chicago: University of Chicago Press, 2021), 78. Chakrabarty postulates that "the planet," which he equates with the Earth Systems, should become a key category of the humanities, replacing the human-centric "globe," "world," and "earth."

11. Amanda Lagerkvist, "Existential Media: Toward a Theorization of Digital Thrownness," *New Media and Society* 19, no. 1 (2017): 96. Lagerkvist has developed this concept in her follow-up book, *Existential Media: A Media Theory of the Limit Situation* (Oxford: Oxford University Press, 2022). She suggests there that existential media "constitute the antinomies of the modern human situation, and they therefore require responsivity and responsibility. In our present datafied world, it is thus a truism to say that media matter. Yet this fact is now greatly magnified, as contemporary life finds itself perched on the limits" (3). Lagerkvist anchors her leading concept in the work of philosopher Karl Jaspers, but she also seeks resonances for its (unwitting) reverberations in the work of many media scholars, including John Durham Peters, Sarah Pink, and broadly conceived "communication theory." In the book she goes so far as to postulate that "our media have always been existential—a fact that has not been sufficiently recognized in media research" (64).

12. See Joanna Zylinska, *AI Art: Machine Visions and Warped Dreams* (London: Open Humanities Press, 2020).

13. Lagerkvist, "Existential Media," 106.

14. As Steve F. Anderson put it, "we are witnessing—and participating actively in—a remarkable transition in visual culture, the root of which lies in the evolving relationship between data and images." Anderson, *Technologies of Vision: The War between Data and Images* (Cambridge, MA: MIT Press, 2017), 4.

15. Vilém Flusser, *Into the Universe of Technical Images*, trans. Nancy Ann Roth (Minneapolis: University of Minnesota Press, 2011), 49.

16. See Roland Barthes, *Camera Lucida*, trans. Richard Howard (New York: Hill and Wang, 1981); Pierre Bourdieu, *Photography: A Middle-Brow Art*, trans. Shaun Whiteside (Stanford: Stanford University Press, 1990); and Susan Sontag, *On Photography* (New York: Farrar, Straus and Giroux, 1977).

17. See Claude E. Shannon and Warren Weaver, *The Mathematical Theory of Communication* (Urbana: University of Illinois Press, 1949).

18. Vilém Flusser's renowned books on photography are *Towards a Philosophy of Photography*, trans. Anthony Mathews (London: Reaktion Books, 2000), and *Into the Universe of Technical Images*. I am referring here, in turn, to his *Does Writing Have a Future?*, trans. Nancy Ann Roth (Minneapolis: University of Minnesota Press, 2011).

19. Henri Bergson, *Matter and Memory*, trans. Nancy Margaret Paul and W. Scott Palmer (London: George Allen & Unwin, 1911), vii.

20. Ibid., 3.

21. Anderson, *Technologies of Vision*, 230.

22. Lagerkvist, *Existential Media*, 3.

23. Borrowing from Lewis Mumford's description of a society as a "megamachine," in *Anti-Oedipus* Gilles Deleuze and Félix Guattari position both capitalism and society as machines. They outline their nested model of machinic organization, whose underlying logic they understand to be cybernetic, in the following terms: "The social machine . . . has men for its parts, even if we view them with their machines, and integrate them, internalize them in an institutional model at every stage of action, transmission, and motricity. Hence the social machine fashions a memory without which there would be no synergy of man and his (technical) machines." Deleuze and Guattari, *Anti-Oedipus*, trans. Robert Hurley, Mark Seem, and Helen R. Lane (Minneapolis: University of Minnesota Press, 1983), 141.

24. In her introduction to the poignantly titled *The Camera as Actor: Photography and the Embodiment of Technology* (London: Routledge, 2021), Amy Cox Hall claims that "the photographer is increasingly intertwined with the machine" (16). She describes the multiplicity of early camera technologies, from Fox Talbot's "mousetrap" cameras that popularized the negative process through to stereo cameras, imaging devices designed for use in outer space, and Harold Edgerton's repatronic camera developed to photograph atomic bomb explosions as "machinic enterprises" (17). She also points out, importantly for my argument here, that "the digital is bringing our attention back to the machine" (19).

25. As Goldberg and Khalili put it in "We Stopped Taking Photos," "The role of images in consolidating power could be evidenced by the desire by some to stop the production or circulation of images: no photography at a checkpoint; arresting journalists; a right-wing mob knocks over video cameras, then attacks a whole pile of equipment—the crowd around them cheers, stomping on the idea of information that operates against their delusions."

26. Ibid.

27. Paul Virilio, *The Vision Machine*, trans. Julie Rose (Bloomington: Indiana University Press, 1994), 22.

28. Reflecting on the loss of this modernist delimitation, Dipesh Chakrabarty points out: "Facing the planetary . . . requires us to acknowledge that the communicative

setup within which humans saw themselves as naturally situated through categories like earth, world, and globe has now broken down, at least partially. Many traditions of thought, including some religious ones, may have considered the earth-human relationship special; with regard to the planet, though, we are no more special than other forms of life" (*The Climate of History in a Planetary Age*, 98).

29. Virilio, *The Vision Machine*, 59.

30. Ibid., 36.

31. Joanna Zylinska, *Nonhuman Photography* (Cambridge, MA: MIT Press, 2017).

32. I first proposed the concept of "eco-eco-punk" in Joanna Zylinska, "Eco-eco-punk: Mediating the Anthropocene with Nam June Paik," in *Media Ecology: Revisiting TV Garden* (Gyeonggi-do: Nam June Paik Art Center, 2021) (published in English and Korean). Some of the theoretical material from that earlier essay has been reworked for this volume. I have been using the "eco-eco crisis" formulation in my previous works, but the phrase was originally proposed by Tom Cohen in "Introduction: Murmurations—'Climate Change' and the Defacement of Theory," in Cohen, ed., *Telemorphosis: Theory in the Era of Climate Change*, vol. 1 (Ann Arbor: Open Humanities Press, 2012), 13–42.

33. Presenting a gritty and dystopian vision of the future, cyberpunk is the original sci-fi genre exploring high-tech heroism in a society on the verge of civilizational collapse, spawning a number of subsequent variants. Steampunk offers a more romanticized response to the threat of civilizational collapse, foregrounding the retrofuturistic aesthetic inspired by the steam engine technology of the early industrial era. Biopunk is a subgenre of cyberpunk that focuses on the biotechnological aspects of the societal transformation (including bioaugmentation and genetic engineering)—and not so much on information technology. Greenpunk is a technophilic movement centered on individuals using, and being affected by the use of, DIY renewable resources, recycling, and repurposing. Ecopunk focuses on infrastructure, production cycles, trade, and trying to make a living in an ecologically depleted world.

34. James Patrick Kelly and John Kessel, "Introduction: Hacking Cyberpunk," in Kelly and Kessel, eds., *Rewired: The Post-Cyberpunk Anthology* (San Francisco: Tachyon Publications, 2007), xii.

35. I first outlined these ideas around my use of artistic and other images in my theoretical work in "Nonhuman Photography: Andrew Dewdney Interviews Joanna Zylinska for unthinking.photography," The Photographers' Gallery, February 11, 2019. I am grateful to Andrew for the provocation and prompt.

36. Maurizio Lazzarato, "After Cinema," in Peter Szendy with Emmanuel Alloa and Marta Ponsa, eds., *The Supermarket of Images* (Paris: Gallimard / Jeu de Paume, 2020), 155.

37. Ibid., 150.

Chapter 1

An earlier and shorter version of this chapter, prefaced by the opening of chapter 2, came out in Joanna Zylinska with Goldsmiths Media, eds., *The Future of Media* (London: Goldsmiths Press, 2022).

1. Quoted in Philip McCouat, "Early Influences of Photography on Art," *Journal of Art in Society* (2012–2015), http://www.artinsociety.com/pt-1-initial-impacts.html

2. Naomi Rosenblum claims that "only in the three primary industrial powers— England, France, and the United States—was this group able to sustain the investment of time and energy necessary to develop the medium technically and in terms of significant use." Rosenblum, *The World History of Photography*, 3rd ed. (New York: Abbeville Press, 1997), 23.

3. McCouat, "Early Influences of Photography on Art."

4. Geoffrey Batchen, *Burning with Desire: The Conception of Photography* (Cambridge, MA: MIT Press, 1997), 93.

5. Jonathan Crary, *Techniques of the Observer: On Vision and Modernity in the Nineteenth Century* (Cambridge, MA: MIT Press, 1990), 10.

6. See Batchen, *Burning with Desire*.

7. Rebecca Solnit, *River of Shadows: Eadweard Muybridge and the Technological Wild West* (London: Penguin, 2004), 81.

8. See Walter Benjamin, *On Photography*, trans. Esther Leslie (London: Reaktion Books, 2015); Susan Sontag, *On Photography* (New York: Farrar, Straus and Giroux, 1977); Solnit, *River of Shadows*.

9. See Ariella Aïsha Azoulay, *Potential History: Unlearning Imperialism* (London: Verso, 2019); Jonathan Beller, *The Message Is Murder: Substrates of Computational Capital* (London: Pluto Press, 2017); Andrew Dewdney, *Forget Photography* (London: Goldsmiths Press, 2021).

10. Batchen, *Burning with Desire*, 207.

11. Ibid., 208–211.

12. Ibid., 208.

13. Roland Barthes, *Camera Lucida*, trans. Richard Howard (New York: Hill and Wang, 1981).

14. See Joanna Zylinska, *Nonhuman Photography* (Cambridge, MA: MIT Press, 2017), 113.

15. Batchen, *Burning with Desire*, 216.

16. Ibid., 214.

17. Vilém Flusser, *Into the Universe of Technical Images*, trans. Nancy Ann Roth (Minneapolis: University of Minnesota Press, 2011), 6.

18. Ibid., 6.

19. See Mark Poster, "An Introduction to Vilém Flusser's *Into the Universe of Technical Images* and *Does Writing Have a Future?*," in Flusser, *Into the Universe of Technical Images*, ix–xxv.

20. Flusser, *Into the Universe of Technical Images*, 60.

21. Nancy Roth, "The Photographer's Part," *Flusser Studies* 10 (November 2011): 14.

22. Ibid.

23. Poster, "An Introduction," xviii–xix.

24. Flusser, *Into the Universe of Technical Images*, 4.

25. Vilém Flusser, *Towards a Philosophy of Photography*, trans. Anthony Mathews (London: Reaktion Books, 2000), 21.

26. Ibid., 29.

27. Ibid., 29–30.

28. Ibid., 30. Google AI researcher Blaise Aguera y Arcas has explained:

> The flexibility of code allows us to make cameras that do much more than producing images that can pass for natural. Researchers like those at MIT Media Lab's Camera Culture group have developed software-enabled nontraditional cameras (many of which still use ordinary hardware) that can sense depth, see around corners, or see through skin; Abe Davis and collaborators have even developed a computational camera that can "see" sound, by decoding the tiny vibrations of houseplant leaves and potato chip bags. So, Flusser was perhaps even more right than he realized in asserting that cameras follow programs, and that their software has progressively become more important than their hardware. Cameras are "thinking machines."

Aguera y Arcas, "Art in the Age of Machine Intelligence," AMI at *Medium*, February 23, 2016, https://medium.com/artists-and-machine-intelligence/what-is-ami-ccd936394a83#.9r2o4bgvq

29. Kenneth Goldsmith, "It's a Mistake to Mistake Content for Content," *Los Angeles Review of Books*, June 14, 2015, https://lareviewofbooks.org/article/its-a-mistake-to-mistake-content-for-content/

30. Flusser, *Towards a Philosophy of Photography*, 49.

31. Ibid., 49.

32. Ibid., 50.

281425168213234158623445824866 stop.

33. Elle Hunt, "Faking It: How Selfie Dysmorphia Is Driving People to Seek Surgery," January 23, 2019, *The Guardian*, https://www.theguardian.com/lifeandstyle/2019/jan/23/faking-it-how-selfie-dysmorphia-is-driving-people-to-seek-surgery

34. Daniel Rubinstein and Katrina Sluis, "A Life More Photographic: Mapping the Networked Image," *Photographies* 1, no. 1 (March 2008): 17–18.

35. Flusser, *Into the Universe of Technical Images*, 132.

36. Elizabeth A. Kessler, "Review of Joanna Zylinska's *Nonhuman Photography*," *CAA Reviews*, February 11, 2019, doi: 10.3202/caa.reviews.2019.18

37. Flusser, *Into the Universe of Technical Images*, 17.

38. Ibid., 19.

39. Ibid., 38, 9.

40. Ibid., 9.

41. Ibid., 32.

42. Ibid., 59.

43. Ibid.

44. Ibid., 60.

45. Dayna Tortorici, "Infinite Scroll: Life under Instagram," *The Guardian*, January 31, 2020, https://www.theguardian.com/technology/2020/jan/31/infinite-scroll-life-under-instagram

46. Flusser, *Into the Universe of Technical Images*, 66.

47. See ibid., 109.

48. Flusser's implicit use of the composting metaphor in his nature—culture—waste—nature cycle has affinities with Donna Haraway's use of the term "compost." Since 2016, "compost" has played an increasingly important role in her organicist and messy ontology of "humusities." See Donna Haraway, *Staying with the Trouble: Making Kin in the Chthulucene* (Durham: Duke University Press, 2016), 32. She writes there: "Staying with the trouble requires making oddkin; we require each other in unexpected collaborations and combinations, in hot compost piles. We become-with each other or not at all" (4).

49. Flusser, *Into the Universe of Technical Images*, 93.

50. Ibid.

51. Ibid.

52. Ibid., 94.

53. Ibid., 127.

54. Ibid., 45.

55. Ibid., 44.

56. Ibid., 28, emphasis added.

57. Amanda Lagerkvist, "Existential Media: Toward a Theorization of Digital Thrownness," *New Media and Society* 19, no. 1 (2017): 96.

58. Ibid., 56.

59. Ibid., 49.

60. Vilém Flusser, *Does Writing Have a Future?*, trans. Nancy Ann Roth (Minneapolis: University of Minnesota Press, 2011), 21.

61. Ibid.

62. Ibid., 120.

63. David Trend, *The End of Reading: From Gutenberg to Grand Theft Auto* (Frankfurt am Main: Peter Lang, 2010), 19.

64. Ibid., 28.

65. Ibid., 28–29.

66. Maryanne Wolf, "Skim Reading Is the New Normal. The Effect on Society Is Profound," *The Guardian*, August 25, 2018, https://www.theguardian.com/commen tisfree/2018/aug/25/skim-reading-new-normal-maryanne-wolf. See also Maryanne Wolf, *Reader Come Home: The Reading Brain in a Digital World* (New York: Harper, 2018).

67. Jean M. Twenge, Gabrielle N. Martin, and Brian H. Spitzberg, "Trends in U.S. Adolescents' Media Use, 1976–2016: The Rise of Digital Media, the Decline of TV, and the (Near) Demise of Print," *Psychology of Popular Media Culture* 8, no. 4 (2019): 342.

68. Ibid., 332.

69. Maryanne Wolf, "There's a Crisis of Reading among Generation Z," *Pacific Standard*, April 29, 2019, https://psmag.com/ideas/theres-a-crisis-of-reading-among -generation-z

70. Wolf, "Skim Reading Is the New Normal." See also Ziming Liu, "Digital Reading," *Chinese Journal of Library and Information Science* (English edition) (2012): 86.

71. Wolf, "Skim Reading Is the New Normal."

72. See Trend, *The End of Reading*, 11.

73. Vilém Flusser, *The Holy See: An Extract from The Last Judgment: Generations* (Pittsburgh and New York: Flugschriften, 2019), 13.

74. Ibid., 17.

75. Trend, *The End of Reading*, 10.

76. Ibid., 17.

77. See Nicholas Carr, *The Shallows: How the Internet Is Changing the Way We Think, Read and Remember* (London: Atlantic Books, 2010)

78. Only an excerpt from this work has been published in English so far. See Flusser, *The Holy See.*

79. Flusser, *The Holy See*, 17–18.

80. Rodrigo Maltez-Novaes, "Translator's Introduction" to Flusser, *The Holy See*, 7–9.

81. Trend, *The End of Reading*, 2.

82. Ibid., 10.

83. Theodor W. Adorno, *Aesthetic Theory* (London: Athlone Press, 1997), 143.

84. Harun Farocki, *Eye/Machine* I, II and III. DVD (Video Data Bank, 2001).

85. Flusser, *Into the Universe of Technical Images*, 46–47.

86. See https://www.youtube.com/watch?v=FV42ocdV6ZA

87. Derrida in Bernard Stiegler and Jacques Derrida, *Echographies of Television* (London: Polity, 2002), 142–143.

88. Ibid., 143.

89. Ibid., 142.

90. Ibid.

91. Flusser, *Into the Universe of Technical Images*, 28.

92. Project used and quoted with the student's permission.

93. https://www.psychologytoday.com/gb/blog/what-shapes-film/201311/3 -reasons-why-were-drawn-faces-in-film; https://www.researchgate.net/publication/22 1513968_Are_people_drawn_to_faces_on_webpages

94. Flusser, *Towards a Philosophy of Photography*, 32.

95. Trevor Paglen, "Invisible Images (Your Pictures Are Looking at You)," *New Inquiry*, December 8, 2016, https://thenewinquiry.com/invisible-images-your-pictures -are-looking-at-you/

96. Trend, *The End of Reading*, 134.

97. "Interview with Marvin Heiferman," included as part of the Seeing Through Photographs course, MoMA, available on Coursera (undated, accessed June 20, 2020).

Chapter 2

1. Victoria Fu in Behzad Farazollahi, Bjarne Bare, and Christian Tunge with Susanne Østby, eds., *Why Photography* (Milan: Skira, 2020), 77.

2. In DL Cade, "Photography as We Know Is Changing, and It's Your Job to Change with It," *Petapixel*, November 8, 2019, https://petapixel.com/2019/11/08 /photography-as-we-know-is-changing-and-its-your-job-to-change-with-it/?mc_cid =947c856268&mc_eid=5bb11290a7.

3. Ibid.

4. Ibid.

5. Trevor Paglen, "Artist's Notes" for the exhibition *A Study of Invisible Images*, September 8–October 21, 2017, Metro Pictures, New York. There are clear resonances between Paglen's aesthetico-political philosophy and Virilio's earlier argument developed in *The Vision Machine* (trans. Julie Rose, Bloomington: Indiana University Press, 1994), especially Virilio's recognition that the perception of the environment is now being shared "between the animate (the living subject) and the inanimate (the object, the seeing machine)" (59–60). Virilio's concept of "seeing machines," and his idea that "sightless vision" (62) is at the heart of the vision machine, have been formative for Paglen's project.

6. Paglen did four postings for the Fotomuseum Winterthur blog under the overall title "Is Photography Over?" This quote comes from posting 2, "Seeing Machines," which develops ideas raised in the first posting ("Is Photography Over?"), March 13, 2014, https://www.fotomuseum.ch/en/explore/still-searching/articles/26978_seeing _machines

7. Félix Nadar, *When I Was a Photographer*, trans. Eduardo Cadava and Liana Theodoratou (Cambridge, MA: MIT Press, 2015), 3.

8. Refik Anadol, *Archive Dreaming*, 2017, https://refikanadol.com/works/archive -dreaming/

9. See Daniel Rubinstein and Katrina Sluis, "A Life More Photographic: Mapping the Networked Image," *Photographies* 1, no. 1 (March 2008): 9–28.

10. Anthony McCosker and Rowan Wilken, *Automating Vision: The Social Impact of the New Camera Consciousness* (London: Routledge, 2020).

11. Ibid., 3, emphasis in the original.

12. Ibid.

13. Ibid., 4.

14. Joanna Zylinska, *Nonhuman Photography* (Cambridge, MA: MIT Press, 2017).

15. In *Life after New Media: Mediation as a Vital Process* (Cambridge, MA: MIT Press, 2012), Sarah Kember and I have proposed the concept of mediation as *"a key trope for understanding and articulating our being in, and becoming with, the technological world, our emergence and ways of intraacting with it, as well as the acts and processes of temporarily stabilizing the world into media, agents, relations, and networks"* (xv, emphasis in the original).

16. See Martin Hand, *Ubiquitous Photography* (Cambridge: Polity Press, 2012).

17. See Sarah Kember, "Ambient Intelligent Photography," in Martin Lister, ed., *The Photographic Image in Digital Culture*, 2nd ed. (Abingdon, UK: Routledge, 2013), 56–76.

18. Matthew Cobb, *The Idea of the Brain: The Past and Future of Neuroscience* (London: Profile Books, 2020), Kindle edition.

19. Ibid.

20. Ibid.

21. In Teodora Cosman, "The Metaphors of Photography and the Metaphors of Memory—Artistic Reflections on an Album of Family Photographs," *Philobiblon* 17, no. 1 (2012): 268–291.

22. Ibid., 274.

23. Rosalind Krauss states that "every photograph is the result of a physical imprint transferred by light reflections onto a sensitive surface. The photograph is thus a type of icon, or visual likeness, which bears an indexical relationship to its object. Its separation from true icons is felt through the absoluteness of this physical genesis, one that seems to short-circuit or disallow those processes of schematization or symbolic intervention that operate within the graphic representations of most paintings." Krauss, "Notes on the Index: Seventies Art in America," *October* 3 (1977): 75.

24. Adam Harvey, "On Computer Vision," *Umbau*, no. 1: "Political Bodies" (2021), Karlsruhe University of Arts and Design (HfG), https://umbau.hfg-karlsruhe.de/posts/on-computer-vision.

25. Cobb, *The Idea of the Brain*, emphasis added.

26. Marvin Heiferman, "Introduction," in Heiferman, ed., *Photography Changes Everything* (New York: Aperture/Smithsonian, 2012), 16

27. Ibid., 20.

28. See Vilém Flusser, *Towards a Philosophy of Photography*, trans. Anthony Mathews (London: Reaktion Books, 2000).

29. Vilém Flusser, *Does Writing Have a Future?*, trans. Nancy Ann Roth (Minneapolis: University of Minnesota Press, 2011), 7.

30. Ibid.

31. Gerhard Richter, *Afterness: Figures of Following in Modern Thought and Aesthetics* (New York: Columbia University Press, 2011), 15.

32. Hubertus von Amelunxen, "Photography after Photography: The Terror of the Body in Digital Space," in von Amelunxen et al., eds, *Photography after Photography: Memory and Representation in the Digital Age*, trans. Pauline Cumbers (Munich: G+B Arts, 1996), 119.

33. Richter, *Afterness*, 23.

34. See the catalog published on the occasion of the "postphotography" exhibition *From Here On*, presented at Arts Santa Monica in Barcelona, Spain, and then at Rencontres d'Arles in 2013: Joan Fontcuberta et al., *From Here On: PostPhotography in the Age of Internet and the Mobile Phone* (Barcelona: RM Verlag, 2013).

35. Liz Wells, "The Limits of Critical Thought about Post-photography," in Wells, ed., *Photography: A Critical Introduction*, 2nd ed. (London: Routledge, 2000), 343.

36. Fred Ritchin, *After Photography* (New York: W. W. Norton, 2009), 183.

37. See Camila Moreiras, "Joan Fontcuberta: Post-photography and the Spectral Image of Saturation," *Journal of Spanish Cultural Studies* 18, no. 1 (2017): 58.

38. Joan Fontcuberta, *The Post-Photographic Condition* (Montreal: Le mois de la photo à Montréal, 2015), 6.

39. Moreiras, "Joan Fontcuberta," 57.

40. Ibid.

41. See Robert Shore, *Post-Photography: The Artist with a Camera* (London: Laurence King, 2014).

42. My formulation also differs from the term "softimage" offered, very much in a post-photographic vein, by Ingrid Hoelzl and Rémi Marie in their book of that name, whereby "the image is not only part of a programme, but it contains its own 'operation code': It is a programme in itself." While I value, and concur with, many of Hoelzl and Marie's analytical insights about the current state of the digital image and its operative agency, my own goal is to examine the force of photographic acts and actions upon us and the world (the latter partly being formed by us through

photographic images), rather than the agential objecthood of the digital image within the computational system of which it is part (i.e., the image become software). In Ingrid Hoelzl and Rémi Marie, *Softimage: Towards a New Theory of the Digital Image* (Bristol, UK: Intellect, 2015), 132.

43. Cobb, *The Idea of the Brain.*

44. William J. Mitchell, *The Reconfigured Eye: Visual Truth in the Post-Photographic Era* (Cambridge, MA: MIT Press, 1992), 3.

45. Ibid., 6–7.

46. Ibid., 18.

47. The phrase is a transposition of John Cage's response, offered in Milan in 1959, to someone enquiring about whether Cage's *Fontana Mix* was still be to considered music: "You must not call it music, if this expression hurts you." See the website of the You Must Not Call It Photography If This Expression Hurts You project: http://youmustnotcallit.photography/index.html

48. Andrew Dewdney, *Forget Photography* (London: Goldsmiths Press, 2021), 3.

49. Ibid., 28.

50. Ariella Aïsha Azoulay, *Potential History: Unlearning Imperialism* (London: Verso, 2019); Jonathan Beller, *The World Computer: Derivative Conditions of Racial Capitalism* (Durham: Duke University Press, 2021); Tina Campt, *Listening to Images* (Durham: Duke University Press, 2017); Mark Sealy *Decolonising the Camera: Photography in Racial Time* (London: Lawrence & Wishart, 2019).

51. Dewdney, *Forget Photography*, 189.

52. Ibid., 196.

53. Ibid., 189.

54. Ibid., 13.

55. Harvey, "On Computer Vision."

56. Ibid.

57. David Campany interviewed by Duncan Wooldridge, "Tomorrow's Headlines Are Today's Fish and Chip Papers: Some Thoughts on 'Response-ability,'" in Ben Burbridge and Annebella Pollen, eds., *Photography Reframed: New Visions in Contemporary Photographic Culture*, 2019 edition (London: Bloomsbury Visual Arts, 2019), 32.

58. See Vilém Flusser, *Into the Universe of Technical Images*, trans. Nancy Ann Roth (Minneapolis: University of Minnesota Press, 2011).

59. Trevor Paglen, "Is Photography Over?," posting on a blog for Fotomuseum Winterthur, March 3, 2014, https://www.fotomuseum.ch/en/explore/still-searching /articles/26977_is_photography_over

Chapter 3

An earlier and much shorter version of this chapter, together with the accompanying images, was first published as an electronic artbook: Joanna Zylinska, *Perception at the End of the World, or How Not to Play Video Games* (Pittsburgh and New York: Flugschriften, 2020).

1. *The Last of Us*, one of the most highly rated and best-selling games of all time, was created by developers Naught Dog for the game console PlayStation 3 in 2013. It was remastered for PlayStation 4 in 2014 and subsequently became known as *The Last of Us Remastered*. This is the version of the game I played, but for the sake of simplicity, I will be referring to *The Last of Us* from now on. In 2020, in the middle of the Covid-19 pandemic, Naught Dog released a sequel, *The Last of Us Part II*. A TV series based on the game premiered on HBO in 2023.

2. Jonathan Crary, *Suspensions of Perception: Attention, Spectacle, and Modern Culture* (Cambridge, MA: MIT Press, 1999), 3.

3. Jonathan Crary, *Techniques of the Observer: On Vision and Modernity in the Nineteenth Century* (Cambridge, MA: MIT Press, 1990), 5.

4. Crary, *Suspensions of Perception*, 3.

5. Norman Bryson, "The Gaze in the Expanded Field," in Hal Foster, ed., *Vision and Visuality* (Seattle: Bay Press, 1988), 107.

6. With this, my argument differs from the one outlined by Winfried Gerling, for whom "The practices of the screenshot and photography in computer games must be differentiated by use and function. If the screenshot is more the spontaneous capture or documentation of a temporary status of the computer for various goals such as retaining the settings in a program, a glitch (disturbance), or a constellation on a website, then photography in the computer is more a photographic activity. Its goal is to retain a specific theme: a situation or a scene." Gerling, "Photography in the Digital," *Photographies* 11, no. 2–3 (September 2, 2018): 157. Gerling's article is fascinating in its tracing of the legacy of the game screenshot back to earlier screen capture techniques in medical and technical photography, but it seems less convincing in imposing such a strict caesura between setting-capture and image-capture, without really taking cognizance of the rich array of artistic practices that playfully veer between screenshotting, in-game photography—and, indeed, the taking of actual photographs of a screen with a camera. The shared kinesthetic aspect of all three, on the level of both the character and the player, is significant for my argument here, even if it manifests itself differently in each case.

7. Matteo Bittanti, "The Art of Screenshoot-ing: Joshua Taylor, Videogame Photographer," in *Mister Bit—Wired IT*, December 24, 2011; http://blog.wired.it/misterbit /2011/12/24/the-art-of-screenshoot-ing-joshua-taylor-videogame-photographer.html

8. Cindy Poremba, "Point and Shoot: Remediating Photography in Gamespace," *Games and Culture* 2, no. 1 (2007): 50.

9. See Seth Giddings, "Drawing with Light: Simulated Photography in Videogames," in Martin Lister, ed., *The Photographic Image in Digital Culture*, 2nd ed. (Abingdon, UK: Routledge, 2013), 46.

10. This is the explanation of Damian Martin's technique as provided by the games website *Kotaku*: "I use a DLP projector connected up to a console or PC and a projection screen. . . . I then photograph the game as it's projected on the screen using two different 35mm cameras and a very high ISO black and white film stock. The reason for this is that photographing a game from a screen would mean the image is broken down into RGB pixels creating a 'screendoor' effect across the image making it obviously digital. The interaction of the soft DLP image and the heavy grain of the 3200 ISO film stock I use is what creates the strange reality of the images—our minds automatically fill in the detail that the grain suggests, making the image feel more real than it does in the game." Rich Stanton, "These Photographs Make Video Game Worlds Look Real," *Kotaku*, March 22, 2018, https://www.kotaku.co.uk/2018/03/22 /these-photographs-make-video-game-worlds-look-real

11. Wasim Ahmad, "It May Be Art, but In-Game Images Aren't 'Photography'," *Fstoppers*, March 24, 2017, https://fstoppers.com/originals/it-may-be-art-game-images -arent-photography-170382

12. Matteo Bittanti, "Interview: Gareth Damian Martin: The Aesthetics of Analogue Game Photography," *GameScenes*, February 4, 2018, https://www.gamescenes.org /2018/04/interview-gareth-damian-martin-the-aesthetics-of-analogue-game-photo graphy.html

13. It was "Shooting Virtual Cities: In-Game Photography Workshop," held on July 7, 2018. I am grateful to Gareth Damian Martin for the inspiration the workshop provided me with—and for bearing with me when I didn't know how to hold a game controller properly.

14. See Vilém Flusser, *Into the Universe of Technical Images*, trans. Nancy Ann Roth (Minneapolis: University of Minnesota Press, 2011), 6.

15. Rune Klevjer, "Enter the Avatar: The Phenomenology of Prosthetic Telepresence in Computer Games," in Hallvard Fossheim, Tarjei Mandt Larsen, and John Richard Sageng, eds., *The Philosophy of Computer Games* (London: Springer, 2012), 17–38. Accessed as a preprint on the author's academia.edu page. I am grateful to Agata Zarzycka for pointing me toward Klevjer's work.

16. For example, in the foreword to David Marr's *Vision*, which is key a reference point in the computer vision field, Shimon Ullman writes: "The book describes a general framework proposed by Marr for studying and understanding visual perception" (xvii). In David Marr, *Vision: A Computational Investigation into the Human Representation and Processing of Visual Information* (Cambridge, MA: MIT Press, 1990).

17. Marr, *Vision*, 3.

18. Ibid.

19. Beau Lotto, *Deviate: The Science of Seeing Differently* (London: Weidenfeld & Nicolson, 2017), Kindle edition.

20. The concept of "naturecultures," signaling a mutually constitutive relationship in the world's ecologies between what Western epistemology has designated as separate domains of "nature" and "culture," arguably organizes the whole of Haraway's oeuvre, but one text where it features particularly prominently is *The Companion Species Manifesto: Dogs, People, and Significant Otherness* (Chicago: Prickly Paradigm Press, 2003).

21. Hal Foster, preface to Foster, *Vision and Visuality*, ix.

22. Ibid., ix.

23. Bryson, "The Gaze in the Expanded Field," 107, emphasis added.

24. Foster, preface to *Vision and Visuality*, x.

25. Martin Jay, "Scopic Regimes of Modernity," in Foster, *Vision and Visuality*, 7.

26. Crary, *Techniques of the Observer*, 14.

27. He writes: "'Light, color, movement,' 'the movement of light,' 'the quick projection of light impulses,' 'light and time,' 'a time form'—such phrases reflect the specific interests of individual filmmakers but taken together they specify film's 'true essence' in terms appropriate to the avant-garde's 'mystique of purity': 'light-space-time continuity in the synthesis of motion,' in Moholy-Nagy's neat formulation." William C. Wees, *Light Moving in Time: Studies in the Visual Aesthetics of Avant-Garde Film* (Berkeley: University of California Press, 1992), 12–13.

28. Ibid., 13.

29. Kjetil Rødje, "Lens-Sense: On Seeing a World as Sensed by a Camera," *Screening the Past*, no. 43 (April 2018), http://www.screeningthepast.com/2018/02/lens-sense-on-seeing-a-world-as-sensed-by-a-camera/#_ednref11

30. Henri Bergson, *Creative Evolution*, trans. Arthur Mitchell (New York: Modern Library, 1944), 362.

31. Alexander Sekatskiy has argued that Bergson's snapshots should really be interpreted as film stills, a shift which allows for a subsequent redemption of photography as a more dynamic and "lively" medium, rather than a mere deadly record of sliced life. Sarah Kember and I made this point in *Life after New Media: Mediation as a Vital Process* (Cambridge, MA: MIT Press, 2012), 78–79. See also Alexander Sekatskiy, "The Photographic Argument of Philosophy," *Philosophy of Photography* 1, no. 1 (2010): 83.

32. See Gilles Deleuze, *Cinema 1: The Movement-Image*, trans. Hugh Tomlinson and Barbara Habberjam (London: Athlone Press, 1986).

33. Gilles Deleuze and Félix Guattari, *What Is Philosophy?*, trans. Hugh Tomlinson and Graham Burchell (New York: Columbia University Press, 1994), 208.

34. Ibid.

35. Kember and Zylinska, *Life after New Media*, 75.

36. See Patricia Pisters, *The Neuro-Image: A Deleuzian Filmphilosophy of Digital Screen Culture* (Stanford: Stanford University Press, 2012).

37. Rebekah Modrak observes that several early theories of vision, developed, among others, by Plato and Euclid, already hinted at a more dynamic process, positing that light particles "were projected out of the eye onto objects," with the eye actively creating the image. This latter model is indeed much closer to our current understanding of perception and vision. Rebekah Modrak with Bill Anthes, *Reframing Photography: Theory and Practice* (London: Routledge, 2011), 4.

38. Joseph Anderson and Barbara Fisher, "The Myth of Persistence of Vision," *Journal of the University Film Association* 30, no. 4 (Fall 1978): 3.

39. Ibid., 6, emphasis added.

40. Ibid.

41. Max Wertheimer, "Experimentelle Studien über das Sehen von Bewegung," *Zeitschrift für Psychologie* 61 (1912): 161–265.

42. Cited in Joseph Anderson and Barbara Anderson (née Fisher), "The Myth of Persistence of Vision Revisited," *Journal of Film and Video* 45, no. 1 (Spring 1993): 7.

43. This is a phenomenon described as beta movement. It is a cognate phenomenon to "phi motion," a concept introduced by Wertheimer in his 1912 paper. Anderson and Anderson offer their own term for what became known as beta movement, arguing as follows: "Since we know that the individual pictures of a motion picture are not really moving, and that our perception of motion is therefore an illusion, and since we *now* know that the effect has nothing to do with persistence of vision or phi movement, we suggest that henceforth the phenomenon of motion in the motion picture be called by the name used in the literature of perception: *short-range*

apparent motion" ("The Myth of Persistence of Vision Revisited," 10). They also indicate that human perception cannot distinguish between *apparent* short-range motion and *actual* motion in the natural world. "To the visual system, the motion in a motion picture *is* real motion," they claim (10).

44. Marc Sommer and Robert Wurtz, "Influence of the Thalamus on Spatial Visual Processing in Frontal Cortex," *Nature* 444 (2006): 374–377.

45. Ibid., 374.

46. Julia Layton, "How Does the Brain Create an Uninterrupted View of the World?," *HowStuffWorks.com*, November 15, 2006, https://science.howstuffworks.com/life/steady-view.htm

47. Ibid.

48. Ibid. Photographer Brian Dilg has challenged any ongoing attempts to see human vision as photographic. Drawing on the latest research in the neurophysiology of perception, Dilg has argued that, unlike a camera, we do not look at a scene once but rather look around it, with our eyes jumping in rapid movements known as saccades. We thus "have a dynamic view, not a camera's fixed perspective." What's more, our gaze is "constantly changing, and we never stop updating our view. Cameras, on the other hand, 'look' once and record the entire scene in a single, static frame." Our vision "is actually a collage of quick snapshots," as what we see is a fluid, constantly updated stream of images. This process is extremely selective, focusing on certain sections of the image stream, comparing them with past ones to make memories—and envisaging some future ones to make predictions. As a result of this frantic activity, "we miss a great deal of what's happening in the present." For Dilg, photography's greatest strength lies in being able to see differently from us—and "to show us what we've missed." Brian Dilg, *Why You Like This Photo: The Science of Perception* (London: Octopus, 2018), Kindle edition.

49. "The Brain Is the Screen: An Interview with Gilles Deleuze," in *The Brain Is the Screen: Deleuze and the Philosophy of Cinema*, ed. Gregory Flaxman (Minneapolis: University of Minnesota Press, 2000), 366.

50. Lotto, *Deviate*.

51. Anderson and Fisher, "The Myth of Persistence of Vision," 7.

52. Richard L. Gregory, *Eye and Brain: The Psychology of Seeing* (Princeton, NJ: Princeton University Press, 1997), 5th ed., 79.

53. David J. Chalmers, "Facing Up to the Problem of Consciousness," *Journal of Consciousness Studies* 2 (1995): 200–219.

54. As argued by Joseph and Barbara Anderson ("The Myth of Persistence of Vision Revisited," 7),

Theories such as Werthiemer's [*sic*] which emphasize a central fusion process were reflected in early film literature, but with little understanding of the physiological mechanisms involved. Frederick A. Talbot, for example, in *Moving Pictures: How They Are Made and Worked* offered an account of this central fusion variation of the persistence of vision theme. The cinematographer, according to Talbot, takes advantage of a "deficiency" of the human eye: "This wonderful organ of ours has a defect which is known as 'visual persistence'." (Talbot 3) Talbot provided one of the most colorful explanations of this so-called defect: "The eye is in itself a wonderful camera. . . . The picture is photographed in the eye and transmitted from that point to the brain. . . . When it reaches the brain, a length of time is required to bring about its construction, for the brain is something like the photographic plate, and the picture requires developing. In this respect the brain is somewhat sluggish, for when it has formulated the picture imprinted upon the eye, it will retain the picture even after the reality has disappeared from sight." (Talbot 4)

According to Talbot, then, each two contiguous images blend or fuse together in the brain, allowing for the perception of smooth, continuous movement. He further compares the brain to a then-contemporary apparatus for slide projection, known as a "dissolving lantern," by means of which one view is "dissolved" into another. (Talbot 5)

55. As Gregory puts it, "Perhaps we won't fully understand the visual brain before we design and make a machine with sophisticated vision" (Gregory, *Eye and Brain*, 79).

56. Two contrasting accounts of visual perception are predominant in the cognitive sciences: the theory of inferential perception, premised on cognitivist thinking, whereby the subject establishes a relationship between the environment and the percept by means of a rational inference, i.e., interpretation, and the theory of direct perception, one that involves a more direct grasping of the relationship between the percept and the information provided by the stimulus. This second theory is the one known as "ecology of perception." Even though I am explicitly identifying with the latter, I do not think the two need to be positioned as strict opposites. In other words, I do not think ecological perception needs to remain completely free from cognitive input for my overall position and argument to stand.

57. Johann Wolfgang von Goethe, *Theory of Colours*, trans. Charles Easdake (1840; Cambridge, MA: MIT Press, 1970), x.

58. Jonathan Crary, "Modernizing Vision," in Foster, *Vision and Visuality*, 34.

59. We should make a sideways nod here to Maurice Merleau-Ponty's phenomenology of perception and the perceiving body, although we also need to be mindful of Bryson's critique of what he sees as corporeal simplification in Merleau-Ponty, with the body positioned as the center from which one looks out onto the world, and not a dynamic agent co-constituted by the living matter around it. See Bryson, "The Gaze in the Expanded Field," 120. However, the metaphysical intimations of Merleau-Ponty's phenomenology of perception, and of his model of the human, are the principal reason for why my journey through theories of perception and vision bypasses his work here—even though I do of course acknowledge Merleau-Ponty's

enormous influence on disciplines such as philosophy of mind, cognitive science, and environmental philosophy.

60. Alva Noë, *Action in Perception* (Cambridge, MA: MIT Press, 2004); Shaun Gallagher, *How the Body Shapes the Mind* (Oxford: Oxford University Press, 2005).

61. See James J. Gibson, *The Perception of the Visual World* (Boston: Houghton Mifflin, 1950).

62. James J. Gibson, *The Ecological Approach to Visual Perception* (Boston: Houghton Mifflin, 1979), 187. This paragraph and the next one have been reworked from my book *Nonhuman Photography* (Cambridge, MA: MIT Press, 2017).

63. Anderson and Anderson, "The Myth of Persistence of Vision Revisited," 11.

64. Modrak, *Reframing Photography*, 10.

65. Ibid., 11.

66. Ibid.

67. Lyle Rexer, *The Critical Eye: Fifteen Pictures to Understand Photography* (Bristol, UK: Intellect, 2019), 59.

68. "Anthropocene, Capitalocene, Chthulucene: Donna Haraway in Conversation with Martha Kenney," in Heather Davis and Etienne Turpin, eds., *Art in the Anthropocene: Encounters among Aesthetics, Politics, Environments and Epistemologies* (London: Open Humanities Press, 2015), 258.

69. Crary, *Techniques of the Observer*, 53.

70. Klevjer, "Enter the Avatar," 32.

71. See Donald D. Hoffman, "Conscious Realism and the Mind-Body Problem," *Mind and Matter* 6, no. 1 (2008): 87–121.

72. See Hanneke Grootenboer, *Treasuring the Gaze: Intimate Vision in Late Eighteenth-Century Eye Miniatures* (Chicago: University of Chicago Press, 2012), 82–88.

73. Klevjer, "Enter the Avatar," 3.

74. Rodchenko and Moholy-Nagy were involved in photographic experiments aimed at displacing human vision by adopting the viewpoint of bird or insect. These radical new viewpoints amounted to what Moholy-Nagy described as a "New Vision," which the new society in the then nascent modern era required, according to his revolutionary intimations. I have read Seers's *Human Camera* project, in which she takes photos with her mouth, as enacting the inherently photographic nature of life itself (see Zylinska, *Nonhuman Photography*, 75–77).

75. Giddings, "Drawing with Light," 42.

76. Rexer, *The Critical Eye*, 59.

77. Nanna Verhoeff, *Mobile Screens: The Visual Regime of Navigation* (Amsterdam: Amsterdam University Press, 2012), 15.

78. Ibid., 13.

79. I am grateful to Sebastian Möring for making this point to me.

80. Poremba, "Point and Shoot," 2.

81. As Lotto argues, "The world exists. It's just that we don't see it. We do not experience the world as it is *because our brain didn't evolve to do so.*" He then adds that "our brains developed not to see reality but just to help us survive the constant flood of intermixed stimuli that would be impossible to process as discrete pieces of information, if it were even possible for them to appear that way." For Lotto, perception is not an end in itself: he argues that we perceive so that we can move. Also, (eye) movement, "combined with a constant search for difference," is the fundamental condition of sight (Lotto, *Deviate*, introduction, Kindle edition).

82. See chapter 3, "Photography after the Human," in Zylinska, *Nonhuman Photography*.

83. See Joanna Zylinska, *The End of Man: A Feminist Counterapocalypse* (Minneapolis: University of Minnesota Press, 2018).

84. Dom Phillips, "Brazil Using Coronavirus to Cover Up Assaults on Amazon, Warn Activists," *The Guardian*, May 6, 2020, https://www.theguardian.com/world/2020 /may/06/brazil-using-coronavirus-to-cover-up-assaults-on-amazon-warn-activists

85. Dominic Rushe and Michael Sainato, "Amazon Posts $75bn First-Quarter Revenues but Expects to Spend $4bn in Covid-19 Costs," *The Guardian*, April 30, 2020, https://www.theguardian.com/technology/2020/apr/30/amazon-revenues-jeff-bezos -coronavirus-pandemic

Chapter 4

An earlier version of this chapter was published as "Beyond Machine Vision: How to Build a Non-Trivial Perception Machine," *Transformations*, no. 36 (2022), special issue on "Artificial Creativity" edited by Bo Reimer and Bojana Romnic.

1. Andreas Broeckmann, "Optical Calculus," paper presented at the conference "Images Beyond Control," FAMU, Prague, November 6, 2020 (online), 1: 1–7. What I am doing here may seem to go against Broeckman's call to use the concept of the machine "only sparingly," and not to extend it beyond specific apparatuses to larger symbolic and social systems. Yet I believe there is an affinity between our positions when it comes to the rationale for what we do. Our respective projects

are both underpinned by an ethical injunction to make knowledge that matters, knowledge that remains anchored in specific affordances—and that can tell us something meaningful about us *and* the world. For me, however, it is through a radical conceptual expansion of the concept of the machine, with its nested layers of meanings, that we may approach this goal (rather than through its sparing and overcautious use). This is because machinic operations are not just metaphorical: there is a materiality to their different layers and functions. See also Andreas Broeckmann, "The Machine as Artist as Myth," *Arts* 8, no. 25 (2019): 1–10; doi: 10.3390/arts8010025. I am grateful to Andreas for our discussion about these issues, and for sharing his texts with me.

2. See Leonardo Impett, "The Image-Theories behind Computer Vision," paper presented at #DHNord2020 "The Measurement of Images," MESHS, updated on November 2020, 10, https://www.meshs.fr/page/the_image-theory_behind_computer _vision. There are some affinities between my approach in this chapter and Impett's statement that the algorithms of computer vision have an ideology, and, more importantly, a philosophy—even if both this ideology and this philosophy tend to remain latent in the dominant scholarship on computer vision.

3. David Hubel and Torsten Wiesel, "Receptive Fields of Single Neurons in the Cat's Striate Cortex," *Journal of Physiology* 148 (1959): 589.

4. Ibid., 575.

5. See David Marr, *Vision: A Computational Investigation into the Human Representation and Processing of Visual Information* (Cambridge, MA: MIT Press, 1982), 4.

6. Shimon Ullman, foreword to Marr, *Vision*, xvii.

7. The sense of perception as information processing which does not necessarily lead to the creation of subjective experience is adopted in the opening pages of Brian Rogers's *Perception: A Very Short Introduction* (Oxford: Oxford University Press, 2017, Kindle edition), with perception being defined as a set of processes that "allow us to extract information from the patterns of energy that impinge on our sense organs." Rogers prefers this definition to the everyday understanding of perception as "our experience of seeing, hearing, touching, tasting, and smelling objects and individuals in the surrounding world."

8. It was the second most popular category in its research database featuring work on AI, with over 800 papers on September 23, 2020:

> Research in machine perception tackles the hard problems of understanding images, sounds, music and video. In recent years, our computers have become much better at such tasks, enabling a variety of new applications such as: content-based search in Google Photos and Image Search, natural handwriting interfaces for Android, optical character recognition for Google Drive documents, and recommendation systems that understand music and YouTube videos. Our approach is driven by algorithms that benefit from processing very large,

partially-labeled datasets using parallel computing clusters. A good example is our recent work on object recognition using a novel deep convolutional neural network architecture known as Inception that achieves state-of-the-art results on academic benchmarks and allows users to easily search through their large collection of Google Photos. The ability to mine meaningful information from multimedia is broadly applied throughout Google. (https://research.google/pubs/?area=machine-perception)

9. See ibid.

10. J. Y. Lettvin et al., "What the Frog's Eye Tells the Frog's Brain," *Proceedings of the Institute of Radio Engineers* 47 (1959): 1950.

11. Algorithmia, "Introduction to Computer Vision: What It Is and How It Works," Algorithmia blog, April 2, 2018, https://algorithmia.com/blog/introduction-to-computer-vision

12. David Chalmers, "What Is Conceptual Engineering and What Should It Be?," *Inquiry: An Interdisciplinary Journal of Philosophy*, published online September 16, 2020, https://doi.org/10.1080/0020174X.2020.1817141, page number refers to the preprint from the author's website, 2.

13. Heinz von Foerster, "Perception of the Future and the Future of Perception," *Instructional Science* 1, no. 1 (1972): 31.

14. Ibid., 33.

15. Ibid., 40.

16. Ibid.

17. Ibid., 41.

18. The concept of "incomputables," derived from the work of mathematician Gregory Chaitin, is premised on the following understanding of computation outlined by Luciana Parisi in "The Alien Subject of AI," *Subjectivity* 12 (2019): 27–48: "Computation involves a performative compression of random quantities (or incomputables) entering the general infrastructure of algorithmic patterning. It is here that machine learning becomes the subjective aim of artificial reasoning insofar as the computational manner of generating learning comes to constitute the machine's structure of being as denaturalising the very image of automated thought" (30). Chaitin's framework of "experimental axiomatics," explains Parisi, involves "the ingression of contingency . . . in causality," whereby "randomness or incomputables, infinite varieties of infinities, become the causal condition of computational processing" (40).

19. See Vilém Flusser, *Towards a Philosophy of Photography*, trans. Anthony Mathews (London: Reaktion Books, 2000), 26–30, 82–92; Vilém Flusser, *Into the Universe of Technical Images*, trans. Nancy Ann Roth (Minneapolis: University of Minnesota Press, 2011), 19.

20. Von Foerster, "Perception of the Future and the Future of Perception," 43.

21. See Jonathan Crary, *Suspensions of Perception: Attention, Spectacle, and Modern Culture* (Cambridge, MA: MIT Press, 1999).

22. Adrian Daub, *What Tech Calls Thinking: An Inquiry into the Intellectual Bedrock of Silicon Valley* (New York: Farrar, Straus and Giroux, 2020, Kindle edition).

23. Ibid.

24. Daub is quite blunt in his assessment: "The tech industry we know today is what happens when certain received notions meet with a massive amount of cash with nowhere else to go" (ibid.).

25. Ibid.

26. Parisi, "The Alien Subject of AI," 32.

27. Ibid., 30.

28. Parisi writes, "Chaitin explains that computation is defined by the tendencies of information to increase in size. Like the infinite counting of numbers, there is no end to information. Deductive reasoning therefore cannot sufficiently describe what happens in the logical thinking of machines. From this standpoint, one can suggest that incomputables—as infinite varieties of infinities (or randomness)—delineate the trajectory of computation from and towards infinity. This already implies that computation as the current mode of instrumentalisation of reasoning does not directly correspond to the material-historical constitution of media or the practical knowledge" (ibid., 48).

29. Ibid., 38.

30. In making this strategic distinction, I am mindful of Humberto Maturana and Francisco J. Varela's intimation developed in *Autopoiesis and Cognition: The Realization of the Living* (Dordrecht: Reidel, 1972) that perception is *already* a form of cognition—although cognition for them stands for more than pure thought. Indeed, they conceptualize both perception and cognition as distinctly biological phenomena.

31. George N. Reeke Jr. and Gerald M. Edelman, "Real Brains and Artificial Intelligence," *Daedalus* 117, no. 1 (Winter 1988): 143.

32. The concept of "neural networks" was introduced by two researchers at the University of Chicago, Warren McCullough and Walter Pitts, in 1944. Neural networks kept falling in and out of favor in AI research through the last century but came into their own with the recent developments in machine learning.

33. Reeke and Edelman, "Real Brains and Artificial Intelligence," 145.

34. Ibid., 153.

35. See Donald D. Hoffman, *The Case against Reality: How Evolution Hid the Truth from Our Eyes* (Cambridge, MA: MIT Press, 2019).

36. As they argue, "It is clear that the notion of information preexisting in the world must be rejected. The essential requirement for learning, logic, and the other mental functions that are the usual subjects of AI research is the prior ability to categorize objects and events based on sensory signals reaching the brain. The variety of sensory experiences is both vast and unique for each individual. The categories themselves are not present in the environment but must be constructed by each individual according to what is adaptive for its species and its own particular circumstances. The a priori specification of rules for categorization, applicable to all individuals and all contexts, is precluded by the complexity, variability, and unpredictability of the macroscopic world. To make matters worse, the categories constructed by an organism cannot be fixed but must constantly change in response to new experiences and new realities in its part of the environment. The only way categories constructed in this individualistic manner can be validated is by constant coupling back to the world through behavior" (Reeke and Edelman, "Real Brains and Artificial Intelligence," 155).

37. "Phenotypically, Darwin III has three sensory modalities: vision, touch, and kinesthesia (or 'joint sense'). It may have one or two eyes with lateral and vertical orbital motions, and one or more arms with multiple joints, each controlled by motor neurons in specified repertoires." Gerald M. Edelman and George N. Reeke Jr., "Is It Possible to Construct a Perception Machine?," *Proceedings of the American Philosophical Society* 134, no. 1 (March 1990): 48.

38. Ibid., 36.

39. Ibid., 37. As they put it, "categorization can be seen in essence as an adaptive mapping of the external world onto impoverished representations of itself within a perceptual system" (ibid.).

40. Ibid.

41. Reeke and Edelman, "Real Brains and Artificial Intelligence," 157.

42. Tim Ingold, "Beyond Biology and Culture: The Meaning of Evolution in a Relational World," *Social Anthropology* 12, no. 2 (2004), 209–221.

43. Ibid., 213.

44. Ibid., 216.

45. Ingold explains: "And if you ask how biological and cultural factors are distinguished, they will say that the former are genetically transmitted, whereas the latter are transmitted by such non-genetic means as imitation or social learning. Thus, despite their initial denials, biology is tied to genes after all, as indeed the logic of neo-Darwinism requires. The implied essentialisation of biology as a constant of

human being, and of culture as its variable and interactive complement, is not just clumsily imprecise. It is the single major stumbling block that up to now has prevented us from moving towards an understanding of our human selves, and of our place in the living world, that does not endlessly recycle the polarities, paradoxes and prejudices of western thought" (ibid., 217).

46. As Claudio Celis Bueno and María Jesús Schultz Abarca point put, drawing on Bernard Stiegler's philosophy, "The 'bracketing off' of inherited prejudice to perceive reality 'in itself' is an illusion that conceals the fact that technology permanently modifies our internal senses of perception and memory. Naked human vision too is always already machine vision. Human vision, like machinic vision, depends on the surfaces of inscription that function as an external faculty of imagination." Celis Bueno and Schultz Abarca, "Memo Akten's *Learning to See*: From Machine Vision to the Machinic Unconscious," *AI and Society* (2020), https://doi.org/10.1007 /s00146-020-01071-2

47. Alex Hern, "Google's Solution to Accidental Algorithmic Racism: Ban Gorillas," *The Guardian*, January 12, 2018, https://www.theguardian.com/technology/2018/jan /12/google-racism-ban-gorilla-black-people

48. In Tom Simonite, "The Best Algorithms Struggle to Recognize Black Faces Equally," *Wired*, July 22, 2019, https://www.wired.com/story/best-algorithms-struggle -recognize-black-faces-equally/

49. Safia Noble, *Algorithms of Oppression: How Search Engines Reinforce Racism* (New York: New York University Press, 2018, Kindle edition).

50. Ibid.

51. "Layers of Abstraction: A Pixel at the Heart of Identity," https://shinjitoya.com /space-art-tech/

52. @Dantley on Twitter, September 19, 2020.

53. Noble, *Algorithms of Oppression*.

54. In Mitra Azar, Geoff Cox, and Leonardo Impett, "Introduction: Ways of Machine Seeing," *AI and Society* 36 (2021): 1093–1104, https://doi.org/10.1007/s00146-020 -01124-6. The special issue of the journal *AI and Society* titled "Ways of Machine Seeing," edited by Azar, Cox, and Impett, explores the problems of (and with) machine vision through a multidisciplinary framework. Departing from John Berger's proposition, made in his canonical *Ways of Seeing* (London: British Broadcasting Corporation and Penguin Books, 1972), 10, that "every image embodies a way of seeing," it explores how "machines, and, in particular, computational technologies, change the way we see the world."

55. Maturana and Varela themselves did not posit such a shift, but it was subsequently accomplished, building on their ideas, by sociologist Niklas Luhmann.

56. Maturana and Varela, *Autopoiesis and Cognition*, 136.

57. Ingold, "Beyond Biology and Culture," 218.

58. Ibid.

59. John Armitage, "Accelerated Aesthetics: Paul Virilio's *The Vision Machine*," *Angelaki* 2, no. 3 (1997): 203.

60. John Johnston, "Machinic Vision," *Critical Inquiry* 26 (Autumn 1999): 32.

61. Shoshana Zuboff, *The Age of Surveillance Capitalism: The Fight for a Human Future at the New Frontier of Power* (New York: Public Affairs, 2019, Kindle edition).

62. Ibid.

63. Leif Wetherby, "Data and the Task of the Humanities," in Creative AI Lab, ed., *001: Aesthetics of New AI* (London: Serpentine Galleries, October 2020), 47.

64. Ibid.

65. Pharmacology, a concept derived from Jacques Derrida ("The Pharmakon" in *Dissemination*, trans. Barbara Johnson [Chicago: University of Chicago Press, 1981], 95–119), became operative in many of Stiegler's later works, which were devoted to the analysis of the conditions of computational capitalism—and of the socioeconomic misery this particular political formation had brought about. Importantly, Stiegler's work was not just diagnostic: he was committed to finding openings within, and passages through, the desperation and nihilism enacted by the automatic decision-making and the disindividuation of the human under those political and economic conditions. As he put it, "From such a perspective the question of innovation must be taken very seriously—and not just treated as an ideological discourse based on the storytelling of marketing. Innovation clearly has a real economic function: it evidently constitutes a production of negentropy. But what has now become obvious is that this negentropy produced in the short term generates far higher entropy in the long term. The whole question of organology and its pharmacology in the neganthropic field resides in the fact that the *pharmakon* can be toxic and curative only to the extent (and in the excess) that it is both entropic and negentropic." Bernard Stiegler, *Automatic Society*, vol. 1: *The Future of Work*, trans. Daniel Ross (Cambridge: Polity Press, 2017),100.

66. Ibid., 9, 7.

67. Ariella Aïsha Azoulay, *Potential History: Unlearning Imperialism* (London: Verso, 2019), 4.

68. Ibid., 5.

69. Michael Hardt and Antonio Negri, *Empire* (Cambridge, MA: Harvard University Press, 2000), xii.

70. https://recognitionmachine.vandal.ist/

71. Azoulay, *Potential History*, 8.

72. I am grateful to Mark Amerika for this poetic-philosophical formulation, offered to me as a question following my talk at the "Artificial Creativity" conference, Malmö University, Sweden, November 19–20, 2020 (online).

Chapter 5

1. Deleuze develops the argument about the force of cinema and its ability to shift our perception in many of his works, including *Cinema 1* (London: Athlone Press, 1986) and *Francis Bacon: The Logic of Sensation* (London: Continuum, 2003). John Johnston points out that it is in the latter book, which engages with Bacon's paintings, that Deleuze highlights photography's inability to enact the deterritorialization of vision. The French philosopher sees the photographic medium as too banal and too static. Photography's flatness (and hence weakness) is presented by Deleuze—and, in his reading, by Bacon—not only in relation to cinema but also to painting: "photographs operate by either resemblance or convention, analogy or code; in either case, they are not a means of seeing but are themselves what we see, and we end up seeing only them. . . . More to the point, unlike painting, photographs cannot produce an intensity of sensation or, rather, cannot produce differences within sensation." John Johnston, "Machinic Vision," *Critical Inquiry* 26 (Autumn 1999): 34. My reading of photography is very different from Deleuze's. I have previously discussed it in chapter 3 of *Life after New Media: Mediation as a Vital Process*, co-written with Sarah Kember (Cambridge, MA: MIT Press, 2012). This chapter does not therefore spend time on countering Deleuze's position, but rather delves straight into the photography-cinema nexus while seeing the relationship between the two media as less oppositional—and as enabling a more hybrid novel practice to emerge from this relationship.

2. The "radical opposition" between film understood in terms of the "being there" of the thing, and photography understood in terms of it "having been there," was proposed by Roland Barthes in "The Rhetoric of the Image," in *Image, Music, Text*, trans. Stephen Heath (New York: Hill and Wang, 1977), 45.

3. Maurizio Lazzarato, "After Cinema," in Peter Szendy with Emmanuel Alloa and Marta Ponsa, eds., *The Supermarket of Images* (Paris: Gallimard / Jeu de Paume, 2020), 150.

4. David Green and Joanna Lowry, foreword to Green and Lowry, eds., *Stillness and Time: Photography and the Moving Image* (Brighton: Photoworks; Photoforum, 2006), 7.

5. This proposition was made by Gusztáv Hámos, Katja Pratschke, and Thomas Tode in "Viva Photofilm: Moving / Non-moving," trans. Finbarr Morrin, text written for

the program of *PhotoFilm!*, a screening event held on March 5–13, 2010, at Tate Modern, London, and organized by Tate Modern, the Goethe-Institut London, and the CCW Graduate School, University of the Arts, London.

6. Ingrid Hoelzl and Rémi Marie, *Softimage: Towards a New Theory of the Digital Image* (Bristol, UK: Intellect, 2015), 23.

7. Ibid., 12.

8. Ibid., 17.

9. Lazzarato, "After Cinema," 150.

10. Ibid., 150–151.

11. Ibid., 151.

12. Ibid., 152.

13. David Green, "Marking Time: Photography, Film and Temporalities of the Image," in Green and Lowry, *Stillness and Time*, 20.

14. See Lazzarato, "After Cinema," 155.

15. Griselda Pollock, "Dreaming the Face, Screening the Death: Reflections for Jean-Louis Schefer on La Jetée," *Journal of Visual Culture* 4, no. 3 (2005): 291.

16. See Joanna Zylinska, *The End of Man: A Feminist Counterapocalypse* (Minneapolis: University of Minnesota Press, 2018); and the accompanying photofilm, *Exit Man* (2018).

17. Hámos, Pratschke, and Tode, "Viva Photofilm."

18. Janet Harbord, *Chris Marker: La Jetée* (London: Afterall Books, 2009), 2.

19. Nadine Boljkovac, "Book Review: *La Jetée*," *Studies in European Cinema*, published online May 24, 2019, doi: 10.1080/17411548.2019.1621720.

20. Chris Darke, *La Jetée* (London: BFI and Palgrave, 2016), 84.

21. Boljkovac, "Book Review: *La Jetée*."

22. Harbord, *Chris Marker*, 4.

23. Ibid.

24. https://bengrosser.com/projects/computers-watching-movies/

25. Hámos, Pratschke, and Tode, "Viva Photofilm."

26. Sy Taffel's essay "Automating Creativity," which includes a documentary made by the author (using automated software to produce the film's soundtrack), explores

ways in which "Digital automation is . . . central to enabling forms of contemporary creative media production." Taffel also explores how the progressing use of automation in creative practice can be "a potential source of concern surrounding precarity and the future of employment in the creative industries" (in *Screenworks*, September 2019, https://doi.org/10.37186/swrks/10.1/2).

27. Chris Marker, "Interview," *Film Comment* 39, no. 4 (2003): 40, special edition "Around the World with Chris Marker: Part II Time Regained."

28. See Joanna Zylinska, *Nonhuman Photography* (Cambridge, MA: MIT Press, 2017), 51, 63, 126.

29. Steven Humblet, "Interview with Marc De Blieck," in Humblet, ed., *Off Camera* (Amsterdam: Roma Publications, 2021), ix.

30. Steven Humblet, editorial text, in Humblet, *Off Camera*, xiv.

31. We can borrow here, among others, from the work of Rosi Braidotti. In her book *The Posthuman* (Cambridge: Polity Press, 2013), Braidotti outlines an agenda for "post-human Humanities," a discipline premised on a radical reinvestment in critical thought and a creative engagement with technology. She writes: "The image of thought implied in the post-anthropocentric definition of the Human . . . stresses radical relationality, that is to say non-unitary identities and multiple allegiances. As this shift occurs in a globalized and conflict-ridden world, it opens up new challenges in terms of both post-secular and post-nationalist perspectives. . . . Against the prophets of doom, I want to argue that technologically mediated post-anthropocentrism can enlist the resources of bio-genetic codes, as well as telecommunication, new media and information technologies, to the task of renewing the Humanities. Posthuman subjectivity reshapes the identity of humanistic practices, by stressing heteronomy and multi-faceted relationality, instead of autonomy and self-referential disciplinary purity" (144–145).

32. For an expansion of this idea see Donna Haraway, "Situated Knowledges: The Science Question in Feminism and the Privilege of Partial Perspective," *Feminist Studies* 14, no. 3 (Autumn 1998): 575–599.

33. The optic flow refers to the apparent flow of objects experienced by the observer in their visual field as they move through space. See James J. Gibson, *The Perception of the Visual World* (Boston: Houghton Mifflin, 1950).

34. See Zylinska, *Nonhuman Photography*, 42–43, 53, 191; and Kember and Zylinska, *Life after New Media*, 75.

35. https://thispersondoesnotexist.com/

36. See chapter 7 in Joanna Zylinska, *AI Art: Machine Visions and Warped Dreams* (London: Open Humanities Press, 2020).

37. All these are names of deep-learning generative models using neural networks, which are algorithms partially modeled on the neural architecture of the human or animal brain. A GAN (generative adversarial network) is a generative technology using two neural networks positioned as opponents, with one generating convincing outputs, the other assessing them. GPT (generative pre-trained transformer) is a natural language model that generates human-like text using statistical probability. Originally applied to text, GPTs are now also embedded into more complex models that generate images. Diffusion is a two-stage model that introduces noise into the dataset and then attempts to recover the original data by attempting to reverse the diffusion process. CLIP (contrastive language-image pre-training) is a model trained on image-text pairs which is then used to categorize images and predict text that relates to them. The latest models that generate images (as well as generating public interest and anxiety) usually combine several models as part of their architecture.

38. Young cited in A. Ploin, R. Eynon, I. Hjorth, and M. A. Osborne, *AI and the Arts: How Machine Learning Is Changing Artistic Work*, report from the Creative Algorithmic Intelligence Research Project (Oxford: Oxford Internet Institute, University of Oxford, 2022), 24.

39. Ibid., 37.

40. As I explained in *AI Art*, "the term *parergon*, referring to a supplementary remark, additional material or ornament whose function is merely to embellish the main work (i.e., the *ergon*), has been immortalised in art theory by Jacques Derrida. In his reading of Kant's *Critique of Judgement* included in *The Truth in Painting*, Derrida takes issue with the idea of a self-contained nature of the work of art, conveyed by the belief in its supposed intrinsic value and beauty, by literally bringing the work's framing into the picture. 'A parergon comes against, beside, and in addition to the ergon, the work done [*fait*], the fact [*le fait*], the work, but it does not fall to one side, it touches and cooperates within the operation, from a certain outside. Neither simply outside nor simply inside' (Derrida 1987, 54). The supposedly secondary function of the framing, be it literal or conceptual, is argued to be actually foundational to the artwork's existence and recognition as an artwork, as its very existence delineates and preserves the artwork's identity. For Derrida, a work of art is therefore never self-contained, it always depends on its parerga—frames, ornaments, commentaries—if it is to be recognised in its proclaimed uniqueness and singularity" (95).

41. The sound files came from the following sources: https://freesound.org/people /miastodzwiekow/sounds/127244/ (miastodzwiekow); https://freesound.org/people /PhonosUPF/sounds/487266/ (PhonosUPF); https://freesound.org/people/ITheReal GooglekatClaire/sounds/496602/ (ITheRealGooglekatClaire).

42. Gene Kogan and lkkchung, "Neural Synthesis, Feature Visualization, and Deep-Dream Notes," *GitHub* (2017), https://github.com/ml4a/ml4a-guides/blob/master /notebooks/neural-synth.ipynb.

43. In 2015 Google released a computer vision program called DeepDream, which I discuss further in chapter 6. Designed by Alexander Mordvintsev and using a convolutional neural network, it operated by attempting to identify and enhance patterns in images, leading to the algorithm "noticing" human eyes or puppies in any regular image—because these were the things the program most often "saw" in its training phase.

44. Safia Noble, *Algorithms of Oppression: How Search Engines Reinforce Racism* (New York: New York University Press, 2018); Joy Buolamwini and Timnit Gebru, "Gender Shades: Intersectional Accuracy Disparities in Commercial Gender Classification," *Proceedings of Machine Learning Research* 81 (2018): 1–15, http://proceedings.mlr .press/v81/buolamwini18a/buolamwini18a.pdf; Virginia Eubanks, *Automating Inequality: How High-Tech Tools Profile, Police, and Punish the Poor* (New York: Macmillan Press, 2018); Catherine D'Ignazio and Lauren F. Klein, *Data Feminism* (Cambridge, MA: MIT Press, 2020).

45. Pollock, "Dreaming the Face," 287.

46. Ibid., 294.

47. Ibid., 301.

48. Ibid.

49. Ibid., 304.

50. Ibid., 302.

51. Robert Azzarello cited in Nicole Seymour, *Bad Environmentalism: Irony and Irreverence in the Ecological Age* (Minneapolis: University of Minnesota Press, 2018), 25.

52. Seymour, *Bad Environmentalism*, 25.

53. See ibid., 3.

54. Ibid., 23.

55. Astounded by GPT-3's results, on April 15, 2022, Steven Johnson published a gushing piece in the *New York Times Magazine* titled "A.I. Is Mastering Language. Should We Trust What It Says?" It led to linguist Emily Bender penning a rather sobering response, "On NYT Magazine on AI: Resist the Urge to Be Impressed," *Medium*, April 18, 2022, in which she challenged the claim, made by both impressionable journalists and the company behind GPT-3, Open AI, that the model had "mastered" language. She explained that this supposed "mastery" amounted to GPT-3 having "been programmed to produce strings of text that humans who speak that language find coherent"—itself not an insignificant achievement, but one that was far from showing signs of what we humans understand as intelligence. Bender also warns us against conflating the model's apparent textual coherence with understanding and trustworthiness. "Just because that answer was correct doesn't mean

the next one will be," she points out, while signaling that it is our mental labor of endowing the model with human traits and establishing an intersubjective relationship with it that make it (seem to be) a credible conversational partner.

56. Ian Bogost, "Generative Art Is Stupid," *Atlantic*, January 13, 2023, https://www.theatlantic.com/technology/archive/2023/01/machine-learning-ai-art-creativity-emptiness/672717/.

57. Harbord, *Chris Marker*, 16.

58. Ibid., 25–26.

59. Vilém Flusser, "Photography and History," in *Writings*, ed. Andreas Ströhl, trans. Erik Eisel (Minneapolis: University of Minnesota Press, 2002), 128.

60. Ibid., 127.

61. Harbord, *Chris Marker*, 26.

62. Flusser, "Photography and History," 130.

63. Ibid., 126.

64. Daniel A. Chávez Heras, "Spectacular Machinery and Encrypted Spectatorship," *APRJA* 8, no. 1 (2019): 176.

65. Ben Burbridge, *Photography after Capitalism* (London: Goldsmiths Press, 2020), 74.

66. Chávez Heras, "Spectacular Machinery and Encrypted Spectatorship," 180.

67. Katrina Sluis, "Collaborating with Machines," *Photoworks* 21 (2014): 156.

Chapter 6

1. See Jason N. Pitt et al., "WormBot, an Open-Source Robotics Platform for Survival and Behavior Analysis in *C. elegans*," *GeroScience* 41, no. 6 (2019): 961–973, doi: 10.1007/s11357-019-00124.

2. In *Back to the Future* (1985, dir. Robert Zemeckis).

3. John Tagg, "Mindless Photography," in J. J. Long, Andrea Noble, and Edward Welch, eds., *Photography: Theoretical Snapshots* (London: Routledge, 2008), 21.

4. See https://www.nasa.gov/topics/universe/features/cobe_20th.html

5. Vasily Zubarev, "Computational Photography Part I: What Is Computational Photography?," *dpreview*, June 3, 2020, https://www.dpreview.com/articles/9828658229/computational-photography-part-i-what-is-computational-photography/2. Zubarev explains further: "That's how any mobile camera works today. At least the top ones.

Buffering allows implementing not only zero shutter lag, which photographers begged for so long, but even a negative one. By pressing the button, the smartphone looks in the past, unloads 5–10 last photos from the buffer and starts to analyze and combine them furiously. No need to wait till the phone snaps shots for HDR or a night mode—let's simply pick them up from the buffer, the user won't even realize. In fact, that's how Live Photo is implemented in iPhones, and HTC had it back in 2013 under a strange name Zoe."

6. Sy Taffel, "Google's Lens: Computational Photography and Platform Capitalism," *Media, Culture and Society* 43, no. 2 (2021): 237–255.

7. Matthew Cobb, *The Idea of the Brain: The Past and Future of Neuroscience* (London: Profile Books, 2020, Kindle edition).

8. Cobb points out that the very idea of sensation involving a physical change to the bodily substrate goes back to the seventeenth century. Evident in the notion of "impression," it conveyed the belief "that perception involves a physical trace, altering the shape or function of the nerves, through some kind of pressure" (ibid.).

9. Ibid.

10. Ibid.

11. Bence Nanay, "Mental Imagery," in Edward N. Zalta, ed., *The Stanford Encyclopedia of Philosophy* (Winter 2021 edition), https://plato.stanford.edu/archives/win2021/entries/mental-imagery/.

12. Referring to a dialogue on the language of metaphysics between Aristos and Polyphilos in Anatole France's *The Garden of Epicurus*, Derrida posits: "The primitive meaning, the original, and always sensory and material, figure . . . is not exactly a metaphor. It is a kind of transparent figure, equivalent to a literal meaning (*sens propre*). It becomes a metaphor when philosophical discourse puts it into circulation. Simultaneously the first meaning and the first displacement are then forgotten. The metaphor is no longer noticed, and it is taken for the proper meaning. A double effacement. Philosophy would be this process of metaphorization which gets carried away in and of itself." Jacques Derrida, *Margins of Philosophy*, trans. Alan Bass (Chicago: University of Chicago Press, 1982), 211.

13. Ibid., 213.

14. See Ron Chrisley, "Philosophical Foundations of Artificial Consciousness," *Artificial Intelligence in Medicine* 44 (2008): 119–137; Giorgio Buttazzo, "Artificial Consciousness: Utopia or Real Possibility?," *Computer* 34 (2001): 24–30, 0.1109/2.933500; Antonio Chella and Riccardo Manzotti, *Artificial Consciousness* (London: Imprint Academic, 2017).

15. Antonio Damasio, *The Feeling of What Happens: Body, Emotion and the Making of Consciousness* (San Diego: Harcourt, 1999), 4.

16. Ibid., 125.

17. Ibid., 9.

18. Ibid.

19. Ibid.

20. Ibid.

21. Ibid., 11.

22. https://ai.googleblog.com/2015/06/inceptionism-going-deeper-into-neural.html

23. Christian Szegedy et al., "Going Deeper with Convolutions," eprint from arXiv:1409.4842, submitted September 17, 2014, 1.

24. Min Lin, Qiang Chen, and Shuicheng Yan, "Network In Network," *CoRR*, abs/1312.4400, 2013. In Network In Network, the general linear model of perception "is replaced with a 'micro network' structure which is a general nonlinear function approximator. In this work, we choose multilayer perception [i.e., an algorithm used for supervised learning of binary classifier] as the instantiation of the micro network, which is a universal function approximator and a neural network trainable by back-propagation" (1).

25. Damasio, *The Feeling of What Happens*, 171.

26. Ibid., 126.

27. Ibid., 148.

28. Ibid., 24.

29. Ibid., 16.

30. Ibid., 122.

31. Benjamin Libet et al., "Time of Conscious Intention to Act in Relation to Onset of Cerebral Activity (Readiness-Potential)—The Unconscious Initiation of a Freely Voluntary Act," *Brain* 106, no. 3 (1983): 623–642; and Benjamin Libet, "Unconscious Cerebral Initiative and the Role of Conscious Will in Voluntary Action," *Behavioral and Brain Sciences* 8, no. 4 (1985): 529–566.

32. Damasio, *The Feeling of What Happens*, 127.

33. Anil Seth states that "we generally experience ourselves as being continuous and unified across time. We can call this the subjective stability of the self." Seth, *Being You: A New Science of Consciousness* (London: Faber & Faber, 2021, Kindle edition).

34. Quoted in Ben Lindbergh, "Making Sense of the Science and Philosophy of 'Devs,'" *The Ringer*, April 10, 2020, https://www.theringer.com/tv/2020/4/10/21216149/devs-hulu-quantum-physics-philosophy-alex-garland

35. Seth, *Being You*.

36. Seth argues: "The perceptual experience of volition is a self-fulfilling perceptual prediction, another distinctive kind of controlled—again perhaps a controlling—hallucination. . . . Experiences of volition are useful for guiding *future* behaviour, just as much as for guiding *current* behaviour [as] our sense of free will is very much about feeling we 'could have done differently.' . . . The feeling that I could have done differently does *not* mean that I actually could have done differently. Rather, the phenomenology of alternative possibilities is useful because in a future similar, but not identical, situation I might indeed do differently" (ibid.).

37. For Seth, "what we experience as causality is a perceptual inference, in the same way that all our perceptions are projections of our brain's structured expectations onto and into our sensory environment—exercises in the beholder's share." This leads him to posit that "the self is another perception, another controlled hallucination, though of a very special kind. From the sense of personal identity—like being a scientist, or a son—to experiences of having a body, and of simply 'being' a body, the many and varied elements of selfhood are Bayesian best guesses, designed by evolution to keep you alive" (ibid.).

38. Ibid.

39. Ibid.

40. See Giulio Tononi and Gerald M. Edelman, "Consciousness and Complexity," *Science* 282, no. 5395 (1998): 1846–1851.

41. Seth, *Being You*.

42. Ibid.

43. Paul Virilio, *The Vision Machine*, trans. Julie Rose (Bloomington: Indiana University Press, 1994), 61.

44. Ibid., 59.

45. Bluecore website, https://www.bluecore.com/blog/pulling-back-curtain-value-predictive-technology/

46. Ibid.

47. Quoted in Eric Siegel, "When Does Predictive Technology Become Unethical?," *Harvard Business Review*, October 23, 2020, https://hbr.org/2020/10/when-does-predictive-technology-become-unethical.

48. Quoted in Scott Prevost, "Making Visual Search Smarter: How AI Understands Creative Intent," *Petapixel*, March 29, 2021, https://petapixel.com/2021/03/29/making-visual-search-smarter-how-ai-understands-creative-intent/.

49. Ibid.

50. Taffel, "Google's Lens," 9.

51. Nick Montfort, *The Future* (Cambridge, MA: MIT Press, 2017), xii.

52. John Naughton, "Forget Zuckerberg and Cook's Hypocrisy—It's Their Companies That Are the Real Problem," *The Guardian*, February 6, 2021, https://www
.theguardian.com/commentisfree/2021/feb/06/mark-zuckerberg-tim-cook-facebook
-apple-problem.

Chapter 7

This chapter was developed from a short piece, "Loser Images: A Feminist Proposal for Post-Anthropocene Visuality," that I wrote for Harriet Harriss and Naomi House, eds., *Design Studio*, vol. 4: *Working at the Intersection: Architecture after the Anthropocene* (London: RIBA Publishing, 2022).

1. See the BBC Radio 5 podcast *What Planet Are We On?* (2020–ongoing) and Ireland's RTÉ reality TV show, *What Planet Are You On?* (2019–2020).

2. Nick Montfort, *The Future* (Cambridge, MA: MIT Press, 2017), 35.

3. Liam Young, ed., "Machine Landscapes: Architectures of the Post Anthropocene," special issue of *Architectural Design*, no. 257 (January-February 2019).

4. Dipesh Chakrabarty, *The Climate of History in a Planetary Age* (Chicago: University of Chicago Press, 2021), 78.

5. Gayatri Chakravorty Spivak, "Planetarity," in *Death of a Discipline* (New York: Columbia University Press, 2003), 72.

6. Ibid.

7. Ibid., 93.

8. Nigel Clark and Bronislaw Szerszynski, *Planetary Social Thought: The Anthropocene Challenge to the Social Sciences* (London: Polity, 2020), 1.

9. Barnosky et al. cited in ibid., 6.

10. Clark and Szerszynski, *Planetary Social Thought*, 7.

11. Ibid., 8.

12. Martin Guinard, Eva Lin, and Bruno Latour, "Coping with Planetary Wars," *e-flux Journal*, no. 114 (December 2020), https://www.e-flux.com/journal/114/366104
/coping-with-planetary-wars/.

13. Yuk Hui, "For a Planetary Thinking," *e-flux Journal*, no. 114 (December 2020), https://www.e-flux.com/journal/114/366703/for-a-planetary-thinking/.

14. Ibid.

15. Spivak, "Planetarity," 74.

16. Chakrabarty, *The Climate of History in a Planetary Age*, 75.

17. Brand's original question was "Why Haven't We Seen a Photograph of the Whole Earth Yet?"

18. John Tresch, "Cosmic Terrains (of the Sun King, Son of Heaven, and Sovereign of the Seas)," *e-flux Journal*, no. 114 (December 2020), https://www.e-flux.com /journal/114/364980/cosmic-terrains-of-the-sun-king-son-of-heaven-and-sovereign -of-the-seas/.

19. Ibid.

20. Al Gore, "The Digital Earth: Understanding Our Planet in the 21st Century," speech given at the California Science Center in Los Angeles on January 31, 1998, and published as a leaflet by the Open GIS Consortium. This is the captivating vision Gore presented to his audience: "Imagine, for example, a young child going to a Digital Earth exhibit at a local museum. After donning a head-mounted display, she sees Earth as it appears from space. Using a data glove, she zooms in, using higher and higher levels of resolution, to see continents, then regions, countries, cities, and finally individual houses, trees, and other natural and man-made objects."

21. Leon Gurevitch, "Google Warming: Google Earth as Eco-machinima," *Convergence* 20, no. 1 (2014): 89.

22. Ibid., 97.

23. Elizabeth A. Povinelli, *Geontologics: A Requiem to Late Liberalism* (Durham: Duke University Press, 2016, Kindle edition). As Povinelli points out, "it is increasingly clear that the anthropos remains an element in the set of life only insofar as Life can maintain its distinction from Death/Extinction and Nonlife." She lists the following four principles which have been inspired by Karrabing analytics:

1. Things exist through an effort of mutual attention. This effort is not in the mind but in the activity of endurance.

2. Things are neither born nor die, though they can turn away from each other and change states.

3. In turning away from each other, entities withdraw care for each other. Thus the earth is not dying. But the earth may be turning away from certain forms of existence. In this way of thinking the Desert is not that in which life does not exist. A Desert is where a series of entities have withdrawn care for the kinds of entities humans are and thus has made humans into another form of existence: bone, mummy, ash, soil.

4. We must de-dramatize human life as we squarely take responsibility for what we are doing.

For a discussion of the Povinelli-inspired concept of posthuman gestationality, see Amanda Boetzkes, "Posthuman Planetarity," *The Large Glass: Journal of Contemporary Art, Culture and Theory* 27/28 (2019): 63–66.

24. Ibid.

25. Franco "Bifo" Berardi, introduction to Hito Steyerl, *The Wretched of the Screen* (Berlin: Sternberg Press, 2012), 10.

26. Boetzkes, "Posthuman Planetarity," 62.

27. James Gibson, *The Ecological Approach to Visual Perception* (Boston: Houghton Mifflin, 1979), 148.

28. Ibid., 140.

29. Ibid., 148.

30. In a summary of his best-known book, Noë explains the working of visual perception in the following terms: "If we think of what is visible in terms of projective geometry and artificial perspective, then, however paradoxical it may sound, vision is not confined to the visible. We visually experience much more than that. We experience what is hidden (occluded) and what is out of view. For example, we have a sense of the visual presence of the back of a tomato when we look at one sitting before us, even though the back of the tomato is out of view; and we experience the circularity of a plate, its actual shape, even when, seen from an angle, the circularity itself can't be seen. Or consider your sense of the detail of the scene before your eyes now. You have a sense of the presence [of] the detail; the scene is replete with detail. But it is not the case that you seem to yourself actually to see all the detail; you can no more see every bit of detail in sharp focus and high resolution than you can see the tomato from all sides at once. Just as the back of the tomato shows up in your experience although it is hidden from view, so the detailed scene before you shows up in your experience, although the detail outstrips by far what can be taken in at a glance. The world outstrips what we can take in at a glance; but we are not confined to what is available in a glance." Alva Noë, "Précis of *Action in Perception*," *Philosophy and Phenomenological Research* 76, no. 3 (May 2008): 660.

31. Alva Noë, *Action in Perception* (Cambridge, MA: MIT Press, 2004), 156, emphasis in the original.

32. Ibid., 112.

33. Gibson, *The Ecological Approach to Visual Perception*, 293.

34. Ibid.

35. Ibid. I am building here on the argument proposed by Sarah Kember and me in chapter 3 of *Life after New Media: Mediation as a Vital Process* (Cambridge, MA: MIT Press, 2012).

36. See Vilém Flusser, *Into the Universe of Technical Images*, trans. Nancy Ann Roth (Minneapolis: University of Minnesota Press, 2011).

37. Lukáš Likavčan and Paul Heinicker, "Planetary Diagrams: Towards an Autographic Theory of Climate Emergency," in Tomas Dvořák and Jussi Parikka, eds., *Photography Off the Scale: Technologies and Theories of the Mass Image* (Edinburgh: Edinburgh University Press, 2021), 211.

38. Gibson, *The Ecological Approach to Visual Perception*, 203.

39. Spivak, "Planetarity," 72.

40. Mark Dorrian, "The Aerial View: Notes for a Cultural History," *Strates* 13 (2007), http://journals.openedition.org/strates/5573. In his piece Dorrian is primarily preoccupied with static images of the solid ground, but his classification fits more than adequately the activity of the mobile drone eye.

41. Ibid.

42. Ibid.

43. Ibid.

44. Ibid.

45. Rachel Handforth and Carol A. Taylor, "Doing Academic Writing Differently: A Feminist Bricolage," *Gender and Education* 28, no. 5 (2016): 629.

46. Sarah Kember and Joanna Zylinska, "Media Always and Everywhere: A Cosmic Approach," in Ulrik Ekman et al., eds., *Ubiquitous Computing, Complexity and Culture* (New York: Routledge, 2016), 225.

47. For an insightful discussion of the use of drones to deliver abortion pills in Poland and map state violence against women in Mexico see Erinne Paisley, "Catching a Glimpse of the Elusive 'Feminist Drone,'" *Datactive* blog, March 31, 2020, https://data -activism.net/2020/03/blogpost-catching-a-glimpse-of-the-elusive-feminist-drone/.

48. Anna Feigenbaum, "From Cyborg Feminism to Drone Feminism: Remembering Women's Anti-Nuclear Activisms," *Feminist Theory* 16, no. 3 (2015): 284.

49. Ibid.

50. Heather McLean, "In Praise of Chaotic Research Pathways: A Feminist Response to Planetary Urbanization," *Environment and Planning D: Society and Space* 36, no. 3 (2018): 547.

51. Ibid.

52. Ibid., 548.

53. Ibid.

54. In my working method here I am indebted to Donna Haraway, especially her *Modest_Witness@Second_Millennium: FemaleMan©_Meets_OncoMouse™* (New York: Routledge, 1997) and *The Companion Species Manifesto: Dogs, People, and Significant Otherness* (Chicago: Prickly Paradigm Press, 2003).

55. McLean, "In Praise of Chaotic Research Pathways," 552.

56. Ewa Majewska, "Feminist Art of Failure, Ewa Partum and the Avant-Garde of the Weak," *Widok / View: Theories and Practices of Visual Culture* 16 (2016), http://pismowidok.org/index.php/one/article/view/370/918/, 3.

57. Ibid., 1.

58. Ernst van Alphen, *Failed Images: Photography and Its Counter-Practices* (Amsterdam: Valiz, 2018), 56.

59. Ibid., 12.

60. See Lyle Rexer, *The Edge of Vision: The Rise of Abstraction in Photography* (New York: Aperture, 2013), for an exposition of that alternative view, one that claims that abstraction, with its failure to represent, has been a constitutive aspect of photographic history, and not just a mere aberration.

61. Van Alphen, *Failed Images*, 39.

62. Flusser, *Into the Universe of Technical Images*, 19.

63. Rexer, *The Edge of Vision*, 13.

64. See Sean Cubitt, "The Mass Image, the Anthropocene Image, the Image Commons," in Dvořák and Parikka, *Photography Off the Scale*, 25–40.

65. Hito Steyerl, "In Defense of the Poor Image," *e-flux Journal*, no. 10 (November 2009), https://www.e-flux.com/journal/10/61362/in-defense-of-the-poor-image/.

66. Amanda Lagerkvist, *Existential Media: A Media Theory of the Limit Situation* (Oxford: Oxford University Press, 2022), 6.

67. Tereza Stejskalová, "Online Weak and Poor Images: On Contemporary Feminist Visual Politics," in Dvořák and Parikka, *Photography Off the Scale*, 98.

68. Same Engine indexes 19 million images from Reddit, Instagram, and Pinterest. See https://same.energy/

69. Majewska, "Feminist Art of Failure," 21.

70. Stejskalová, "Online Weak and Poor Images," 101.

71. Gary Hall, *Pirate Philosophy: For a Digital Posthumanities* (Cambridge: MIT Press, 2016), 140.

72. Ibid.

73. Sarah Sharma, "A Manifesto for the Broken Machine," *Camera Obscura* 35, no. 2 (2020): 173.

74. Stejskalová, "Online Weak and Poor Images," 107.

75. Michal Šimůnek, "The Failed Photographs of Photography: On the Analogue and Slow Photography Movement," in Dvořák and Parikka, *Photography Off the Scale*, 152.

76. James Patrick Kelly and John Kessel, "Introduction: Hacking Cyberpunk," in Kelly and Kessel, eds., *Rewired: The Post-Cyberpunk Anthology* (San Francisco: Tachyon Publications, 2007), xii.

77. Ibid., 11.

78. Nam June Paik, interviewed by Nicholas Zurbrugg, Sydney, April 10, 1990, *SCAN+*, no. 3, 14.

79. This point has been elaborated by Lars Movin in "The Zen Master of Video. Nam June Paik: Between Minimalism and Overkill," in *Nam June Paik: Driving Media*, ed. Agnieszka Kubicka-Dzieduszycka and Krzysztof Dobrowolski (Wrocław: WRO Art Center, 2009), 180.

80. Nicole Seymour, *Bad Environmentalism: Irony and Irreverence in the Ecological Age* (Minneapolis: University of Minnesota Press, 2018), 4–5.

81. Graig Uhlin, "Monkeywrenched Images: Ecocinema and Sabotage," *New Review of Film and Television Studies* 18, no. 3 (2020): 321, doi: 10.1080/17400309.2020.1790480. Uhlin's concept of monkeywrenching is borrowed from the practice of ecological sabotage and "involves the destruction of property and infrastructure to defend nature from industrial development." He reappropriates this concept for figurative use, to describe an aesthetic strategy whereby filmmakers adopt a visually destructive or "ugly" look in their work, often purposefully damaging the image or its substrate, for activist purposes. "A monkeywrenched cinema is one that produces an aesthetic suspension or temporal delay in film's depiction of non-human nature as a means of expressing a non-interventionist ethical relation to the world," he suggests (302).

Conclusion

1. See Joanna Zylinska, *Minimal Ethics for the Anthropocene* (Ann Arbor: Open Humanities Press, 2014).

2. See Neil Stephenson, *Snow Crash* (New York: Bantam Books, 1992), a novel in which the idea of the metaverse was first enacted—although in a more explicitly dystopian way—and Dave Eggers, *The Circle* (New York: Knopf, 2013).

3. See Ben Burbridge, *Photography after Capitalism* (London: Goldsmiths Press, 2020).

4. https://www.oculus.com/experiences/quest/2046607608728563/?locale=en_GB

5. The Oculus does have a functionality for storing screenshots from games and other apps, but it was not enabled for this particular "experience," at least not in January 2022.

6. Maria-Jose Viñas and Mike Carlowicz, "Despite Antarctic Gains, Global Sea Ice Is Shrinking," *NOAA Climate.gov*, March 5, 2019; updated June 3, 2021, https://www.climate.gov/news-features/features/despite-antarctic-gains-global-sea-ice-shrinking.

7. Victoria Ivanova and Kay Watson, *Future Art Ecosystems*, vol. 2, *Art x Metaverse*, ed. Sarah Shin (London: Serpentine Galleries, 2021), 5.

8. See ibid., 19–20.

9. Amanda Lagerkvist, *Existential Media: A Media Theory of the Limit Situation* (Oxford: Oxford University Press, 2022), 221.

Bibliography

Adorno, Theodor W. *Aesthetic Theory*. London: Athlone Press, 1997.

Aguera y Arcas, Blaise. "Art in the Age of Machine Intelligence." AMI at *Medium*, February 23, 2016, https://medium.com/artists-and-machine-intelligence/what-is-ami-ccd936394a83#.9r2o4bgvq.

Ahmad, Wasim. "It May Be Art, but In-Game Images Aren't 'Photography.'" *Fstoppers*, March 24, 2017, https://fstoppers.com/originals/it-may-be-art-game-images-arent-photography-170382.

Algorithmia. "Introduction to Computer Vision: What It Is and How It Works." Algorithmia blog, April 2, 2018, https://algorithmia.com/blog/introduction-to-computer-vision.

Amelunxen, Hubertus von. "Photography after Photography: The Terror of the Body in Digital Space." In *Photography after Photography: Memory and Representation in the Digital Age*, ed. Hubertus von Amelunxen et al., trans. Pauline Cumbers, 115–123. Munich: G+B Arts, 1996.

Anadol, Refik. *Archive Dreaming*. 2017, https://refikanadol.com/works/archive-dreaming/.

Anderson, Joseph, and Barbara Anderson [née Fisher]. "The Myth of Persistence of Vision Revisited." *Journal of Film and Video* 45, no. 1 (Spring 1993): 3–12.

Anderson, Joseph, and Barbara Fisher. "The Myth of Persistence of Vision." *Journal of the University Film Association* 30, no. 4 (Fall 1978): 3–8.

Anderson, Steve F. *Technologies of Vision: The War between Data and Images*. Cambridge, MA: MIT Press, 2017.

Armitage, John. "Accelerated Aesthetics: Paul Virilio's *The Vision Machine*." *Angelaki* 2, no. 3 (1997): 199–209.

Azar, Mitra, Geoff Cox, and Leonardo Impett. "Introduction: Ways of Machine Seeing." *AI and Society* 36 (2021): 1093–1104, https://doi.org/10.1007/s00146-020-01124-6.

Azoulay, Ariella Aïsha. *Potential History: Unlearning Imperialism*. London: Verso, 2019.

Barthes, Roland. *Camera Lucida*. Trans. Richard Howard. New York: Hill and Wang, 1981.

Barthes, Roland. "The Rhetoric of the Image." In *Image, Music, Text*, trans. Stephen Heath. New York: Hill and Wang, 1977.

Batchen, Geoffrey. *Burning with Desire: The Conception of Photography*. Cambridge, MA: MIT Press, 1997.

Beller, Jonathan. *The Message Is Murder: Substrates of Computational Capital*. London: Pluto Press, 2017.

Beller, Jonathan. *The World Computer: Derivative Conditions of Racial Capitalism*. Durham: Duke University Press, 2021.

Bender, Emily. "On NYT Magazine on AI: Resist the Urge to Be Impressed." *Medium*, April 18, 2022, https://medium.com/@emilymenonbender/on-nyt-magazine-on-ai -resist-the-urge-to-be-impressed-3d92fd9a0edd.

Benjamin, Walter. *On Photography*. Trans. Esther Leslie. London: Reaktion Books, 2015.

Berardi, Franco "Bifo." Introduction to Hito Steyerl, *The Wretched of the Screen*. Berlin: Sternberg Press, 2012.

Berger, John. *Ways of Seeing*. London: British Broadcasting Corporation and Penguin Books, 1972.

Bergson, Henri. *Creative Evolution*. Trans. Arthur Mitchell. New York: Modern Library, 1944.

Bergson, Henri. *Matter and Memory*. Trans. Nancy Margaret Paul and W. Scott Palmer. London: George Allen & Unwin, 1911.

Bittanti, Matteo. "The Art of Screenshoot-ing: Joshua Taylor, Videogame Photographer." *Mister Bit—Wired IT*, December 24, 2011, http://blog.wired.it/misterbit/2011 /12/24/the-art-of-screenshoot-ing-joshua-taylor-videogame-photographer.html.

Bittanti, Matteo. "Interview: Gareth Damian Martin: The Aesthetics of Analogue Game Photography." *GameScenes*, February 4, 2018, https://www.gamescenes.org /2018/04/interview-gareth-damian-martin-the-aesthetics-of-analogue-game-photo graphy.html.

Boetzkes, Amanda. "Posthuman Planetarity." *The Large Glass: Journal of Contemporary Art, Culture and Theory* 27/28 (2019): 62–71.

Bogost, Ian. "Generative Art Is Stupid." *Atlantic*, January 13, 2023, https://www .theatlantic.com/technology/archive/2023/01/machine-learning-ai-art-creativity -emptiness/672717/.

Boljkovac, Nadine. "Book Review: *La Jetée*." *Studies in European Cinema*, published online May 24, 2019, doi: 10.1080/17411548.2019.1621720.

Bourdieu, Pierre. *Photography: A Middle-Brow Art*. Trans. Shaun Whiteside. Stanford: Stanford University Press, 1990.

Braidotti, Rosi. *The Posthuman*. Cambridge: Polity Press, 2013.

Bratton, Benjamin H. *The Stack: On Software and Sovereignty*. Cambridge, MA: MIT Press, 2016.

Broeckmann, Andreas. "The Machine as Artist as Myth." *Arts* 8, no. 25 (2019): 1–10, doi: 10.3390/arts8010025.

Broeckmann, Andreas. "Optical Calculus." Paper presented at the conference "Images Beyond Control," FAMU, Prague, November 6, 2020 (online), 1: 1–7.

Bryson, Norman. "The Gaze in the Expanded Field." In *Vision and Visuality*, ed. Hal Foster, 87–113. Seattle: Bay Press, 1988.

Buolamwini, Joy, and Timnit Gebru. "Gender Shades: Intersectional Accuracy Disparities in Commercial Gender Classification." *Proceedings of Machine Learning Research* 81 (2018): 1–15, http://proceedings.mlr.press/v81/buolamwini18a/buolamwini18a.pdf.

Burbridge, Ben. *Photography after Capitalism*. London: Goldsmiths Press, 2020.

Buttazzo, Giorgio. "Artificial Consciousness: Utopia or Real Possibility?" *Computer* 34 (2001): 24–30, 0.1109/2.933500.

Cade, DL. "Photography as We Know Is Changing, and It's Your Job to Change with It." *Petapixel*, November 8, 2019, https://petapixel.com/2019/11/08/photography-as-we-know-is-changing-and-its-your-job-to-change-with-it/?mc_cid=947c856268&mc_eid=5bb11290a7.

Campany, David, interviewed by Duncan Wooldridge. "Tomorrow's Headlines Are Today's Fish and Chip Papers: Some Thoughts on 'Response-ability.'" In *Photography Reframed: New Visions in Contemporary Photographic Culture*, ed. Ben Burbridge and Annebella Pollen. 2019 edition. London: Bloomsbury Visual Arts, 2019.

Campt, Tina. *Listening to Images*. Durham: Duke University Press, 2017.

Carr, Nicholas. *The Shallows: How the Internet Is Changing the Way We Think, Read and Remember*. London: Atlantic Books, 2010.

Celis Bueno, Claudio, and María Jesús Schultz Abarca. "Memo Akten's *Learning to See*: From Machine Vision to the Machinic Unconscious." *AI and Society* (2020), https://doi.org/10.1007/s00146-020-01071-2.

Chakrabarty, Dipesh. *The Climate of History in a Planetary Age*. Chicago: University of Chicago Press, 2021.

Chalmers, David. "Facing Up to the Problem of Consciousness." *Journal of Consciousness Studies* 2 (1995): 200–219.

Chalmers, David. "What Is Conceptual Engineering and What Should It Be?" *Inquiry: An Interdisciplinary Journal of Philosophy*, published online September 16, 2020, https://doi.org/10.1080/0020174X.2020.1817141.

Chávez Heras, Daniel A. "Spectacular Machinery and Encrypted Spectatorship." *APRJA* 8, no. 1 (2019): 170–182.

Chella, Antonio, and Riccardo Manzotti. *Artificial Consciousness*. London: Imprint Academic, 2017.

Chrisley, Ron. "Philosophical Foundations of Artificial Consciousness." *Artificial Intelligence in Medicine* 44 (2008): 119–137.

Clark, Nigel, and Bronislaw Szerszynski. *Planetary Social Thought: The Anthropocene Challenge to the Social Sciences*. London: Polity, 2020.

Cobb, Matthew. *The Idea of the Brain: The Past and Future of Neuroscience*. London: Profile Books, 2020. Kindle edition.

Cohen, Tom. "Introduction: Murmurations—'Climate Change' and the Defacement of Theory." In *Telemorphosis: Theory in the Era of Climate Change*, vol. 1, ed. Tom Cohen, 13–42. Ann Arbor: Open Humanities Press, 2012.

Cosman, Teodora. "The Metaphors of Photography and the Metaphors of Memory—Artistic Reflections on an Album of Family Photographs." *Philobiblon* 17, no. 1 (2012): 268–291.

Cox Hall, Amy, ed. *The Camera as Actor: Photography and the Embodiment of Technology*. London: Routledge, 2021.

Crary, Jonathan. "Modernizing Vision." In *Vision and Visuality*, ed. Hal Foster, 29–44. Seattle: Bay Press, 1988.

Crary, Jonathan. *Suspensions of Perception: Attention, Spectacle, and Modern Culture*. Cambridge, MA: MIT Press, 1999.

Crary, Jonathan. *Techniques of the Observer: On Vision and Modernity in the Nineteenth Century*. Cambridge, MA: MIT Press, 1990.

Cubitt, Sean. "The Mass Image, the Anthropocene Image, the Image Commons." In *Photography Off the Scale: Technologies and Theories of the Mass Image*, ed. Tomas Dvořák and Jussi Parikka, 35–40. Edinburgh: Edinburgh University Press, 2021.

Damasio, Antonio. *The Feeling of What Happens: Body, Emotion and the Making of Consciousness*. San Diego: Harcourt, 1999.

Darke, Chris. *La Jetée*. London: BFI and Palgrave, 2016.

Daub, Adrian. *What Tech Calls Thinking: An Inquiry into the Intellectual Bedrock of Silicon Valley*. New York: Farrar, Straus and Giroux, 2020. Kindle edition.

Deleuze, Gilles. "The Brain Is the Screen: An Interview with Gilles Deleuze." In *The Brain Is the Screen: Deleuze and the Philosophy of Cinema*, ed. Gregory Flaxman, 365–374. Minneapolis: University of Minnesota Press, 2000.

Deleuze, Gilles. *Cinema 1: The Movement-Image*. Trans. Hugh Tomlinson and Barbara Habberjam. London: Athlone Press, 1986.

Deleuze, Gilles. *Francis Bacon: The Logic of Sensation*. Trans. Daniel W. Smith. London: Continuum, 2003.

Deleuze, Gilles, and Félix Guattari. *Anti-Oedipus*. Trans. Robert Hurley, Mark Seem, and Helen R. Lane. Minneapolis: University of Minnesota Press, 1983.

Deleuze, Gilles, and Félix Guattari. *What Is Philosophy?* Trans. Hugh Tomlinson and Graham Burchell. New York: Columbia University Press, 1994.

Derrida, Jacques. *Margins of Philosophy*. Trans. Alan Bass. Chicago: University of Chicago Press, 1982.

Derrida, Jacques. "The Pharmakon." In *Dissemination*, trans. Barbara Johnson, 95–119. Chicago: University of Chicago Press, 1981.

Dewdney, Andrew. *Forget Photography*. London: Goldsmiths Press, 2021.

Dewdney, Andrew. "Nonhuman Photography: Andrew Dewdney Interviews Joanna Zylinska for unthinking.photography." The Photographers' Gallery, February 11, 2019, https://unthinking.photography/articles/interview-with-joanna-zylinska.

D'Ignazio, Catherine, and Lauren F. Klein. *Data Feminism*. Cambridge, MA: MIT Press, 2020.

Dilg, Brian. *Why You Like This Photo: The Science of Perception*. London: Octopus, 2018. Kindle edition.

Dorrian, Mark. "The Aerial View: Notes for a Cultural History." *Strates* 13 (2007), http://journals.openedition.org/strates/5573.

Dvořák, Tomas, and Jussi Parikka, eds. *Photography Off the Scale: Technologies and Theories of the Mass Image*. Edinburgh: Edinburgh University Press, 2021.

Edelman, Gerald M., and George N. Reeke Jr. "Is It Possible to Construct a Perception Machine?" *Proceedings of the American Philosophical Society* 134, no. 1 (March 1990): 36–73.

Eggers, Dave. *The Circle*. New York: Knopf, 2013.

Eubanks, Virginia. *Automating Inequality: How High-Tech Tools Profile, Police, and Punish the Poor*. New York: Macmillan, 2018.

Farazollahi, Behzad, Bjarne Bare, and Christian Tunge with Susanne Østby, eds. *Why Photography*. Milan: Skira, 2020.

Farocki, Harun. *Eye/Machine* I, II and III. DVD. Video Data Bank, 2001.

Feigenbaum, Anna. "From Cyborg Feminism to Drone Feminism: Remembering Women's Anti-Nuclear Activisms." *Feminist Theory* 16, no. 3 (2015): 265–288.

Flusser, Vilém. *Does Writing Have a Future?* Trans. Nancy Ann Roth. Minneapolis: University of Minnesota Press, 2011.

Flusser, Vilém. *The Holy See: An Extract from The Last Judgment: Generations*. Pittsburgh and New York: Flugschriften, 2019.

Flusser, Vilém. *Into the Universe of Technical Images*. Trans. Nancy Ann Roth. Minneapolis: University of Minnesota Press, 2011.

Flusser, Vilém. "Photography and History." In *Writings*, ed. Andreas Ströhl, trans. Erik Eisel, 126–132. Minneapolis: University of Minnesota Press, 2002.

Flusser, Vilém. *Towards a Philosophy of Photography*. Trans. Anthony Mathews. London: Reaktion Books, 2000.

Fontcuberta, Joan. *The Post-Photographic Condition*. Montreal: Le mois de la photo à Montréal, 2015.

Fontcuberta, Joan, et al. *From Here On: PostPhotography in the Age of Internet and the Mobile Phone*. Barcelona: RM Verlag, 2013.

Gallagher, Shaun. *How the Body Shapes the Mind*. Oxford: Oxford University Press, 2005.

Gerling, Winfried. "Photography in the Digital." *Photographies* 11, no. 2–3 (September 2, 2018): 149–167.

Gibson, James J. *The Ecological Approach to Visual Perception*. Boston: Houghton Mifflin, 1979.

Gibson, James J. *The Perception of the Visual World*. Boston: Houghton Mifflin, 1950.

Giddings, Seth. "Drawing with Light: Simulated Photography in Videogames." In *The Photographic Image in Digital Culture*, ed. Martin Lister, 2nd ed., 41–55. Abingdon, UK: Routledge, 2013.

Goethe, Johann Wolfgang von. *Theory of Colours*. Trans. Charles Easdake (1840). Cambridge, MA: MIT Press, 1970.

Goldberg, Ariel, and Yazan Khalili. "We Stopped Taking Photos." *e-flux Journal*, no. 115 (February 2021), https://www.e-flux.com/journal/115/374500/we-stopped-taking-photos/.

Goldsmith, Kenneth. "It's a Mistake to Mistake Content for Content." *Los Angeles Review of Books*, June 14, 2015, https://lareviewofbooks.org/article/its-a-mistake-to-mistake-content-for-content/.

Gore, Al. "The Digital Earth: Understanding Our Planet in the 21st Century." Speech given at the California Science Center in Los Angeles on January 31, 1998, and published as a leaflet by Open GIS Consortium.

Green, David. "Marking Time: Photography, Film and Temporalities of the Image." In *Stillness and Time: Photography and the Moving Image*, ed. David Green and Joanna Lowry, 9–21. Brighton: Photoworks; Photoforum, 2006.

Green, David, and Joanna Lowry. Foreword to *Stillness and Time: Photography and the Moving Image*, ed. Green and Lowry, 7–8. Brighton: Photoworks; Photoforum, 2006.

Gregory, Richard L. *Eye and Brain: The Psychology of Seeing*. 5th ed. Princeton, NJ: Princeton University Press, 1997.

Grootenboer, Hanneke. *Treasuring the Gaze: Intimate Vision in Late Eighteenth-Century Eye Miniatures*. Chicago: University of Chicago Press, 2012.

Guinard, Martin, Eva Lin, and Bruno Latour. "Coping with Planetary Wars." *e-flux Journal*, no. 114 (December 2020), https://www.e-flux.com/journal/114/366104/coping-with-planetary-wars/.

Gurevitch, Leon. "Google Warming: Google Earth as Eco-machinima." *Convergence* 20, no. 1 (2014): 85–107.

Hall, Gary. *Pirate Philosophy: For a Digital Posthumanities*. Cambridge, MA: MIT Press, 2016.

Hámos, Gusztáv, Katja Pratschke, and Thomas Tode. "Viva Photofilm: Moving / Non-moving." Trans. Finbarr Morrin. Text written for the program of *PhotoFilm!*, a screening event held March 5–13, 2010, at Tate Modern, London, and organized by Tate Modern, the Goethe-Institut London, and the CCW Graduate School, University of the Arts, London.

Hand, Martin. *Ubiquitous Photography*. Cambridge: Polity Press, 2012.

Handforth, Rachel, and Carol A. Taylor. "Doing Academic Writing Differently: A Feminist Bricolage." *Gender and Education* 28, no. 5 (2016): 627–643.

Haraway, Donna. "Anthropocene, Capitalocene, Chthulucene: Donna Haraway in Conversation with Martha Kenney." In *Art in the Anthropocene: Encounters among Aesthetics, Politics, Environments and Epistemologies*, ed. Heather Davis and Etienne Turpin. London: Open Humanities Press, 2015.

Haraway, Donna. *The Companion Species Manifesto: Dogs, People, and Significant Otherness*. Chicago: Prickly Paradigm Press, 2003.

Haraway, Donna. *Modest_Witness@Second_Millennium: FemaleMan©_Meets_Onco-Mouse.™* New York: Routledge, 1997.

Haraway, Donna. "Situated Knowledges: The Science Question in Feminism and the Privilege of Partial Perspective." *Feminist Studies* 14, no. 3 (Autumn 1998): 575–599.

Haraway, Donna. *Staying with the Trouble: Making Kin in the Chthulucene*. Durham: Duke University Press, 2016.

Harbord, Janet. *Chris Marker: La Jetée*. London: Afterall Books, 2009.

Hardt, Michael, and Antonio Negri. *Empire*. Cambridge, MA: Harvard University Press, 2000.

Harvey, Adam. "On Computer Vision." *Umbau*, no. 1: "Political Bodies" (2021). Karlsruhe University of Arts and Design (HfG), https://umbau.hfg-karlsruhe.de/posts/on-computer-vision.

Heiferman, Marvin. "Introduction." In *Photography Changes Everything*, ed. Heiferman. New York: Aperture/Smithsonian, 2012.

Hern, Alex. "Google's Solution to Accidental Algorithmic Racism: Ban Gorillas." *The Guardian*, January 12, 2018, https://www.theguardian.com/technology/2018/jan/12/google-racism-ban-gorilla-black-people.

Hoelzl, Ingrid, and Rémi Marie. *Softimage: Towards a New Theory of the Digital Image*. Bristol, UK: Intellect, 2015.

Hoffman, Donald D. *The Case against Reality: How Evolution Hid the Truth from Our Eyes*. Cambridge, MA: MIT Press, 2019.

Hoffman, Donald D. "Conscious Realism and the Mind-Body Problem." *Mind and Matter* 6, no. 1 (2008): 87–121.

Hubel, David, and Torsten Wiesel. "Receptive Fields of Single Neurons in the Cat's Striate Cortex." *Journal of Physiology* 148 (1959): 574–591.

Hui, Yuk. "For a Planetary Thinking." *e-flux Journal*, no. 114 (December 2020), https://www.e-flux.com/journal/114/366703/for-a-planetary-thinking/.

Humblet, Steven. "Interview with Marc De Blieck." In *Off Camera*, ed. Steven Humblet, vii–x. Amsterdam: Roma Publications, 2021.

Humblet, Steven, ed. *Off Camera*. Amsterdam: Roma Publications, 2021.

Hunt, Elle. "Faking It: How Selfie Dysmorphia Is Driving People to Seek Surgery." *The Guardian*, January 23, 2019, https://www.theguardian.com/lifeandstyle/2019/jan/23/faking-it-how-selfie-dysmorphia-is-driving-people-to-seek-surgery.

Impett, Leonardo. "The Image-Theories behind Computer Vision." Paper presented at #DHNord2020, "The Measurement of Images," MESHS, updated on November 2020, 10, https://www.meshs.fr/page/the_image-theory_behind_computer_vision.

Ingold, Tim. "Beyond Biology and Culture: The Meaning of Evolution in a Relational World." *Social Anthropology* 12, no. 2 (2004): 209–221.

Ivanova, Victoria, and Kay Watson. 2021. *Future Art Ecosystems*, vol. 2, *Art x Metaverse*, ed. Sarah Shin. London: Serpentine Galleries.

Jay, Martin. "Scopic Regimes of Modernity." In *Vision and Visuality*, ed. Hal Foster, 3–23. Seattle: Bay Press, 1988.

Johnson, Stephen. "A.I. Is Mastering Language. Should We Trust What It Says?" *New York Times Magazine*, April 15, 2022, https://www.nytimes.com/2022/04/15/magazine/ai-language.html.

Johnston, John. "Machinic Vision." *Critical Inquiry* 26 (Autumn 1999): 27–48.

Kelly, James Patrick, and John Kessel. "Introduction: Hacking Cyberpunk." In *Rewired: The Post-Cyberpunk Anthology*, ed. James Patrick Kelly and John Kessel. San Francisco: Tachyon Publications, 2007.

Kember, Sarah. "Ambient Intelligent Photography." In *The Photographic Image in Digital Culture*, ed. Martin Lister, 2nd ed., 56–76. Abingdon, UK: Routledge, 2013.

Kember, Sarah, and Joanna Zylinska. *Life after New Media: Mediation as a Vital Process*. Cambridge, MA: MIT Press, 2012.

Kember, Sarah, and Joanna Zylinska. "Media Always and Everywhere: A Cosmic Approach." In *Ubiquitous Computing, Complexity and Culture*, ed. Ulrik Ekman et al., 226–236. New York: Routledge, 2016.

Kessler, Elizabeth A. "Review of Joanna Zylinska's *Nonhuman Photography*." *CAA Reviews*, February 11, 2019, doi: 10.3202/caa.reviews.2019.18.

Klevjer, Rune. "Enter the Avatar: The Phenomenology of Prosthetic Telepresence in Computer Games." In *The Philosophy of Computer Games*, ed. Hallvard Fossheim, Tarjei Mandt Larsen, and John Richard Sageng, 17–38. London: Springer, 2012.

Kogan, Gene, and lkkchung. "Neural Synthesis, Feature Visualization, and Deep-Dream Notes." *GitHub* (2017), https://github.com/ml4a/ml4a-guides/blob/master/notebooks/neural-synth.ipynb.

Krauss, Rosalind. "Notes on the Index: Seventies Art in America." *October* 3 (1977): 68–81.

Lagerkvist, Amanda. *Existential Media: A Media Theory of the Limit Situation*. Oxford: Oxford University Press, 2022.

Lagerkvist, Amanda. "Existential Media: Toward a Theorization of Digital Thrown-ness." *New Media and Society* 19, no. 1 (2017): 96–110.

Layton, Julia. "How Does the Brain Create an Uninterrupted View of the World?" *HowStuffWorks.com*, November 15, 2006, https://science.howstuffworks.com/life /steady-view.htm.

Lazzarato, Maurizio. "After Cinema." In *The Supermarket of Images*, ed. Peter Szendy with Emmanuel Alloa and Marta Ponsa, 149–156. Paris: Gallimard / Jeu de Paume, 2020.

Lettvin, J. Y., et al. "What the Frog's Eye Tells the Frog's Brain." *Proceedings of the Institute of Radio Engineers* 47 (1959): 1940–1951.

Libet, Benjamin. "Unconscious Cerebral Initiative and the Role of Conscious Will in Voluntary Action." *Behavioral and Brain Sciences* 8, no. 4 (1985): 529–566.

Libet, Benjamin, et al. "Time of Conscious Intention to Act in Relation to Onset of Cerebral Activity (Readiness-Potential)—The Unconscious Initiation of a Freely Voluntary Act." *Brain* 106, no. 3 (1983): 623–642.

Likavčan, Lukáš, and Paul Heinicker. "Planetary Diagrams: Towards an Autographic Theory of Climate Emergency." In *Photography Off the Scale: Technologies and Theories of the Mass Image*, ed. Tomas Dvořák and Jussi Parikka, 211–230. Edinburgh: Edinburgh University Press, 2021.

Lin, Min, Qiang Chen, and Shuicheng Yan. "Network in Network." *CoRR*, abs /1312.4400, 2013.

Lindbergh, Ben. "Making Sense of the Science and Philosophy of 'Devs.'" *The Ringer*, April 10, 2020, https://www.theringer.com/tv/2020/4/10/21216149/devs-hulu-quantum -physics-philosophy-alex-garland.

Liu, Ziming. "Digital Reading." *Chinese Journal of Library and Information Science* (English edition) (2012): 85–94.

Lotto, Beau. *Deviate: The Science of Seeing Differently*. London: Weidenfeld & Nicolson, 2017. Kindle edition.

Majewska, Ewa. "Feminist Art of Failure, Ewa Partum and the Avant-Garde of the Weak." *Widok / View: Theories and Practices of Visual Culture* 16 (2016), 1–28, http:// pismowidok.org/index.php/one/article/view/370/918/.

Maltez-Novaes, Rodrigo. Translator's introduction to Vilém Flusser, *The Holy See: An Extract from The Last Judgment: Generations*. Pittsburgh and New York: Flugschriften, 2019.

Manovich, Lev. "Introduction: How to See One Billion Images." In *Cultural Analytics*. Cambridge, MA: MIT Press, 2020.

Marker, Chris. "Interview." *Film Comment* 39, no. 4 (2003), special edition, "Around the World with Chris Marker: Part II Time Regained."

Marr, David. *Vision: A Computational Investigation into the Human Representation and Processing of Visual Information*. Cambridge, MA: MIT Press, 1990.

Maturana, Humberto, and Francisco J. Varela. *Autopoiesis and Cognition: The Realization of the Living*. Dordrecht: Reidel, 1972.

McCosker, Anthony, and Rowan Wilken. *Automating Vision: The Social Impact of the New Camera Consciousness*. London: Routledge, 2020.

McCouat, Philip. "Early Influences of Photography on Art." *Journal of Art in Society* (2012–2015), http://www.artinsociety.com/pt-1-initial-impacts.html.

McLean, Heather. "In Praise of Chaotic Research Pathways: A Feminist Response to Planetary Urbanization." *Environment and Planning D: Society and Space* 36, no. 3 (2018): 547–555.

Mitchell, William J. *The Reconfigured Eye: Visual Truth in the Post-Photographic Era*. Cambridge, MA: MIT Press, 1994.

Modrak, Rebekah, with Bill Anthes. *Reframing Photography: Theory and Practice*. London: Routledge, 2011.

Montfort, Nick. *The Future*. Cambridge, MA: MIT Press, 2017.

Moreiras, Camila. "Joan Fontcuberta: Post-photography and the Spectral Image of Saturation." *Journal of Spanish Cultural Studies* 18, no. 1 (2017): 57–77.

Movin, Lars. "The Zen Master of Video. Nam June Paik: Between Minimalism and Overkill." In *Nam June Paik: Driving Media*, ed. Agnieszka Kubicka-Dzieduszycka and Krzysztof Dobrowolski, 166–185. Wrocław: WRO Art Center, 2009.

Nadar, Félix. *When I Was a Photographer*. Trans. Eduardo Cadava and Liana Theodoratou. Cambridge, MA: MIT Press, 2015.

Nanay, Bence. "Mental Imagery." In *The Stanford Encyclopedia of Philosophy* (Winter 2021 edition), ed. Edward N. Zalta, https://plato.stanford.edu/archives/win2021/entries/mental-imagery/.

Naughton, John. "Forget Zuckerberg and Cook's Hypocrisy—It's Their Companies That Are the Real Problem." *The Guardian*, February 6, 2021, https://www.theguardian.com/commentisfree/2021/feb/06/mark-zuckerberg-tim-cook-facebook-apple-problem.

Noble, Safia. *Algorithms of Oppression: How Search Engines Reinforce Racism*. New York: New York University Press, 2018. Kindle edition.

Noë, Alva. *Action in Perception*. Cambridge, MA: MIT Press, 2004.

Noë, Alva. "Précis of *Action in Perception.*" *Philosophy and Phenomenological Research* 76, no. 3 (May 2008): 660–665.

Paglen, Trevor. "Artist's Notes." For the exhibition *A Study of Invisible Images*, September 8–October 21, 2017, Metro Pictures, New York.

Paglen, Trevor. "Invisible Images (Your Pictures Are Looking at You)." *New Inquiry*, December 8, 2016, https://thenewinquiry.com/invisible-images-your-pictures-are-looking-at-you/.

Paglen, Trevor. "Is Photography Over?" Four postings for the Fotomuseum Winterthur blog, March 1–April 15, 2014, https://www.fotomuseum.ch/de/series/is-photography-over/.

Paik, Nam June. Interview by Nicholas Zurbrugg, Sydney, April 10, 1990. *SCAN+*, no. 3.

Paisley, Erinne. "Catching a Glimpse of the Elusive 'Feminist Drone.'" *Datactive* blog, March 31, 2020, https://data-activism.net/2020/03/blogpost-catching-a-glimpse-of-the-elusive-feminist-drone/.

Parisi, Luciana. "The Alien Subject of AI." *Subjectivity* 12 (2019): 27–48.

Phillips, Dom. "Brazil Using Coronavirus to Cover Up Assaults on Amazon, Warn Activists." *The Guardian*, May 6, 2020, https://www.theguardian.com/world/2020/may/06/brazil-using-coronavirus-to-cover-up-assaults-on-amazon-warn-activists.

Pisters, Patricia. *The Neuro-Image: A Deleuzian Filmphilosophy of Digital Screen Culture.* Stanford: Stanford University Press, 2012.

Pitt, Jason N., et al. "WormBot, an Open-Source Robotics Platform for Survival and Behavior Analysis in *C. elegans.*" *GeroScience* 41, no. 6 (2019): 961–973, doi:10.1007/s11357-019-00124.

Ploin, A., R. Eynon, I. Hjorth, and M. A. Osborne. *AI and the Arts: How Machine Learning Is Changing Artistic Work.* Report from the Creative Algorithmic Intelligence Research Project. Oxford: Oxford Internet Institute, University of Oxford, 2022.

Pollock, Griselda. "Dreaming the Face, Screening the Death: Reflections for Jean-Louis Schefer on La Jetée." *Journal of Visual Culture* 4, no. 3 (2005): 287–305.

Poremba, Cindy. "Point and Shoot: Remediating Photography in Gamespace." *Games and Culture* 2, no. 1 (2007): 49–58.

Poster, Mark. "An Introduction to Vilém Flusser's *Into the Universe of Technical Images* and *Does Writing Have a Future?*" In Vilém Flusser, *Into the Universe of Technical Images*, ix–xxv. Minneapolis: University of Minnesota Press, 2011.

Povinelli, Elizabeth A. *Geontologies: A Requiem to Late Liberalism.* Durham: Duke University Press, 2016. Kindle edition.

Prevost, Scott. "Making Visual Search Smarter: How AI Understands Creative Intent." *Petapixel*, March 29, 2021, https://petapixel.com/2021/03/29/making-visual -search-smarter-how-ai-understands-creative-intent/.

Reeke Jr., George N., and Gerald M. Edelman. "Real Brains and Artificial Intelligence." *Daedalus* 117, no. 1 (Winter 1988): 143–173.

Rexer, Lyle. *The Critical Eye: Fifteen Pictures to Understand Photography*. Bristol, UK: Intellect, 2019.

Rexer, Lyle. *The Edge of Vision: The Rise of Abstraction in Photography*. New York: Aperture, 2013.

Richter, Gerhard. *Afterness: Figures of Following in Modern Thought and Aesthetics*. New York: Columbia University Press, 2011.

Ritchin, Fred. *After Photography*. New York: W. W. Norton, 2009.

Rødje, Kjetil. "Lens-Sense: On Seeing a World as Sensed by a Camera." *Screening the Past*, no. 43 (April 2018), http://www.screeningthepast.com/2018/02/lens-sense-on -seeing-a-world-as-sensed-by-a-camera/#_ednref11.

Rogers, Brian. *Perception: A Very Short Introduction*. Oxford: Oxford University Press, 2017. Kindle edition.

Rosenblum, Naomi. *The World History of Photography*. 3rd ed. New York: Abbeville Press, 1997.

Roth, Nancy. "The Photographer's Part." *Flusser Studies* 10 (November 2011).

Rubinstein, Daniel, and Katrina Sluis. "A Life More Photographic: Mapping the Networked Image." *Photographies* 1, no. 1 (March 2008): 9–28.

Rushe, Dominic, and Michael Sainato. "Amazon Posts $75bn First-Quarter Revenues but Expects to Spend $4bn in Covid-19 Costs." *The Guardian*, April 30, 2020, https://www.theguardian.com/technology/2020/apr/30/amazon-revenues-jeff-bezos -coronavirus-pandemic.

Sealy, Mark. *Decolonising the Camera: Photography in Racial Time*. London: Lawrence & Wishart, 2019.

Sekatskiy, Alexander. "The Photographic Argument of Philosophy." *Philosophy of Photography* 1, no. 1 (2010): 81–88.

Seth, Anil. *Being You: A New Science of Consciousness*. London: Faber & Faber, 2021. Kindle edition.

Seymour, Nicole. *Bad Environmentalism: Irony and Irreverence in the Ecological Age*. Minneapolis: University of Minnesota Press, 2018.

Shannon, Claude E., and Warren Weaver. *The Mathematical Theory of Communication*. Urbana: University of Illinois Press, 1949.

Sharma, Sarah. "A Manifesto for the Broken Machine." *Camera Obscura* 35, no. 2 (2020): 171–178.

Shore, Robert. *Post-Photography: The Artist with a Camera*. London: Laurence King, 2014.

Siegel, Eric. "When Does Predictive Technology Become Unethical?" *Harvard Business Review*, October 23, 2020, https://hbr.org/2020/10/when-does-predictive-technology -become-unethical.

Simonite, Tom. "The Best Algorithms Struggle to Recognize Black Faces Equally." *Wired*, July 22, 2019, https://www.wired.com/story/best-algorithms-struggle-recognize -black-faces-equally/.

Šimůnek, Michal. "The Failed Photographs of Photography: On the Analogue and Slow Photography Movement." In *Photography Off the Scale: Technologies and Theories of the Mass Image*, ed. Tomas Dvořák and Jussi Parikka, 140–157. Edinburgh: Edinburgh University Press, 2021.

Sluis, Katrina. "Collaborating with Machines." *Photoworks* 21 (2014): 154–156.

Solnit, Rebecca. *River of Shadows: Eadweard Muybridge and the Technological Wild West*. London: Penguin, 2004.

Sommer, Marc, and Robert Wurtz. "Influence of the Thalamus on Spatial Visual Processing in Frontal Cortex." *Nature* 444 (2006): 374–377.

Sontag, Susan. *On Photography*. New York: Farrar, Straus and Giroux, 1977.

Spivak, Gayatri Chakravorty. "Planetarity." In *Death of a Discipline*. New York: Columbia University Press, 2003.

Stanton, Rich. "These Photographs Make Video Game Worlds Look Real." *Kotaku*, March 22, 2018, https://www.kotaku.co.uk/2018/03/22/these-photographs-make -video-game-worlds-look-real.

Stejskalová, Tereza. "Online Weak and Poor Images: On Contemporary Feminist Visual Politics." In *Photography Off the Scale: Technologies and Theories of the Mass Image*, ed. Tomas Dvořák and Jussi Parikka, 97–110. Edinburgh: Edinburgh University Press, 2021.

Stephenson, Neil. *Snow Crash*. New York: Bantam Books, 1992.

Steyerl, Hito. "In Defense of the Poor Image." *e-flux Journal*, no. 10 (November 2009), https://www.e-flux.com/journal/10/61362/in-defense-of-the-poor-image/.

Stiegler, Bernard. *Automatic Society*, vol. 1: *The Future of Work*. Trans. Daniel Ross. Cambridge: Polity Press, 2017.

Stiegler, Bernard, and Jacques Derrida. *Echographies of Television*. London: Polity, 2002.

Szegedy, Christian, et al. "Going Deeper with Convolutions." Eprint from arXiv:1409.4842, submitted September 17, 2014.

Taffel, Sy. "Automating Creativity." *Screenworks*, September 2019, https://doi.org /10.37186/swrks/10.1/2.

Taffel, Sy. "Google's Lens: Computational Photography and Platform Capitalism." *Media, Culture and Society* 43, no. 2 (2021): 237–255.

Tagg, John. "Mindless Photography." In *Photography: Theoretical Snapshots*, ed. J. J. Long, Andrea Noble, and Edward Welch, 16–30. London: Routledge, 2008.

Toister, Yanai. *Photography from the Turin Shroud to the Turing Machine*. Bristol: Intellect, 2020.

Tononi, Giulio, and Gerald M. Edelman. "Consciousness and Complexity." *Science* 282, no. 5395 (1998): 1846–1851.

Tortorici, Dayna. "Infinite Scroll: Life under Instagram." *The Guardian*, January 31, 2020, https://www.theguardian.com/technology/2020/jan/31/infinite-scroll-life-under -instagram.

Trend, David. *The End of Reading: From Gutenberg to Grand Theft Auto*. Frankfurt am Main: Peter Lang, 2010.

Tresch, John. "Cosmic Terrains (of the Sun King, Son of Heaven, and Sovereign of the Seas)." *e-flux Journal*, no. 114 (December 2020), https://www.e-flux.com/journal /114/364980/cosmic-terrains-of-the-sun-king-son-of-heaven-and-sovereign-of-the -seas/.

Twenge, Jean M., Gabrielle N. Martin, and Brian H. Spitzberg. "Trends in U.S. Adolescents' Media Use, 1976–2016: The Rise of Digital Media, the Decline of TV, and the (Near) Demise of Print." *Psychology of Popular Media Culture* 8, no. 4 (2019): 329–345.

Uhlin, Graig. "Monkeywrenched Images: Ecocinema and Sabotage." *New Review of Film and Television Studies* 18, no. 3 (2020): 301–324, doi: 10.1080/17400309.2020 .1790480, 321.

Ullman, Shimon. Foreword to David Marr, *Vision: A Computational Investigation into the Human Representation and Processing of Visual Information*. Cambridge, MA: MIT Press, 1990.

van Alphen, Ernst. *Failed Images: Photography and Its Counter-Practices*. Amsterdam: Valiz, 2018.

Verhoeff, Nanna. *Mobile Screens: The Visual Regime of Navigation*. Amsterdam: Amsterdam University Press, 2012.

Viñas, Maria-Jose, and Mike Carlowicz. "Despite Antarctic Gains, Global Sea Ice Is Shrinking." *NOAA Climate.gov*, March 5, 2019; updated June 3, 2021, https://www .climate.gov/news-features/features/despite-antarctic-gains-global-sea-ice-shrinking.

Virilio, Paul. *The Vision Machine*. Trans. Julie Rose. Bloomington: Indiana University Press, 1994.

von Foerster, Heinz. "Perception of the Future and the Future of Perception." *Instructional Science* 1, no. 1 (1972): 31–43.

Wees, William C. *Light Moving in Time: Studies in the Visual Aesthetics of Avant-Garde Film*. Berkeley: University of California Press, 1992.

Wells, Liz. "The Limits of Critical Thought about Post-photography." In *Photography: A Critical Introduction*, ed. Liz Wells. 2nd ed. London: Routledge, 2000.

Wertheimer, Max. "Experimentelle Studien über das Sehen von Bewegung." *Zeitschrift für Psychologie* 61 (1912): 161–265.

Wetherby, Leif. "Data and the Task of the Humanities." In *001: Aesthetics of New AI*, ed. Creative AI Lab, 36–49. London: Serpentine Galleries, October 2020.

Wolf, Maryanne. *Reader Come Home: The Reading Brain in a Digital World*. New York: Harper, 2018.

Wolf, Maryanne. "Skim Reading Is the New Normal. The Effect on Society Is Profound." *The Guardian*, August 25, 2018, https://www.theguardian.com/commentis free/2018/aug/25/skim-reading-new-normal-maryanne-wolf.

Wolf, Maryanne. "There's a Crisis of Reading among Generation Z." *Pacific Standard*, April 29, 2019, https://psmag.com/ideas/theres-a-crisis-of-reading-among-generation-z.

Young, Liam, ed. "Machine Landscapes: Architectures of the Post Anthropocene." Special issue of *Architectural Design*, no. 257 (January-February 2019).

Zubarev, Vasily. "Computational Photography Part I: What Is Computational Photography?" *dpreview*, June 3, 2020, https://www.dpreview.com/articles/9828658229 /computational-photography-part-i-what-is-computational-photography/2.

Zuboff, Shoshana. *The Age of Surveillance Capitalism: The Fight for a Human Future at the New Frontier of Power*. New York: Public Affairs, 2019. Kindle edition.

Zylinska, Joanna. *AI Art: Machine Visions and Warped Dreams*. London: Open Humanities Press, 2020.

Zylinska, Joanna. "Eco-eco-punk: Mediating the Anthropocene with Nam June Paik." In *Media Ecology: Revisiting TV Garden*. Gyeonggi-do: Nam June Paik Art Center, 2021.

Zylinska, Joanna. *The End of Man: A Feminist Counterapocalypse*. Minneapolis: University of Minnesota Press, 2018.

Zylinska, Joanna. *Minimal Ethics for the Anthropocene*. Ann Arbor: Open Humanities Press, 2014.

Zylinska, Joanna. *Nonhuman Photography*. Cambridge, MA: MIT Press, 2017.

Index